BRITISH FILM POSTERS

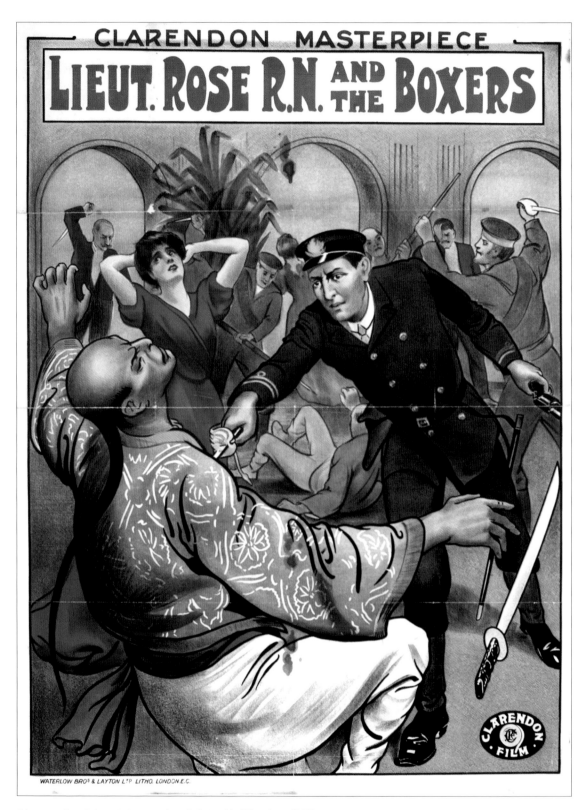

Lieutenant Rose R.N. and the Boxers (1911). Printed by Waterlows. (BFI)

BRITISH FILM POSTERS

An Illustrated History

SIM BRANAGHAN

Edited by Steve Chibnall

 Publishing

First published in 2006 by the
BRITISH FILM INSTITUTE
21 Stephen Street, London W1T 1LN

The British Film Institute's purpose is to champion moving image culture in all its
richness and diversity across the UK, for the benefit of as wide an audience as possible,
and to create and encourage debate.

Cover design: Ketchup
Front cover illustrations: *The Man in the White Suit* (Alexander Mackendrick, 1951)
– artwork by A. R. Thompson from a design by S. John Woods (Ealing Studios/
The J. Arthur Rank Organisation/Universal Pictures); *One Million Years B.C.*
(Don Chaffey, 1966) – design and illustration by Tom Chantrell (Hammer Film
Productions Limited/Seven Arts Productions/Associated British-Pathé
Limited/Twentieth Century-Fox Film Corporation).
Back cover illustrations: *Lieutenant Rose and the Boxers* (Percy Stow, 1911);
Lisztomania (Ken Russell, 1975) – design and illustration by Vic Fair
(Goodtimes Enterprises/VPS/Warner Bros. Pictures); *Hell Drivers* (Cy Endfield,
1957) – illustration by Angelo Cesselon, from a design by Eric Pulford
(Aqua Film Productions Ltd./Rank Organisation; *The Crying Game*
(Neil Jordan, 1992) – design and illustration by David Scutt (British Screen
Productions/Channel Four Films/Palace).

Set by D. R. Bungay Associates, Burghfield, Berkshire
Printed in the UK by Cambridge University Press, Cambridge

British Library Cataloguing-in-Publication Data
A catalogue record for this book is available from the British Library

ISBN (pbk) 1-84457-221-8
ISBN (hbk) 1-84457-148-3

CONTENTS

ACKNOWLEDGMENTS

The main part of this book is made up of original research based on a series of about sixty interviews conducted over the period July 2001–July 2003. The author would particularly like to thank the following for all their patience and kindness: Chris Achilleos, Fred Atkins, Nancy Attwood, Tom Beauvais, Mike Bell, Michael Bennallack-Hart, Alan Broomhead, Paul Brown-Constable, Peter Brunton, Brian Bysouth, Tom, Shirley, Jaqui and Louise Chantrell, John Chapman, Mike Cohen, Roger Coleman, Greg Edwards, Vic Fair, Mike Francis, Gina Fratini, Ian Freeman, Teddy Green, James Halfhyde, Roger Hall, Ian Hedger, Stan Heudebourck, Colin Holloway, Graham Humphreys, David Kemp, Ron Lawrence, Peter Lee, Brian McIlmail, Peter Mennim, Philip Nevitsky, Ray Norton, Marilyn O'Neons, Ken Paul, Sam Peffer, Eric and Alma Pulford, Arnaldo Putzu, John Raymer, Pida Ripley, Ivan Rose, Peter Rosen, Graham Rowsell, Brian Sanders, Dave Sands, Marcus Silverside, Marjorie Stockle, Jan Styles, Tony Tenser, Cecil Vieweg, John Warren, Alan Wheatley, Mike Wheeler, Dave Witherden, Michael Wood, Ray Youngs and Fred Zentner.

Special mentions must also go to Janine Prosser at Hendon Reference Library for cheerfully following up endless obscure queries, Ali Langton in Nottingham for some invaluable local research into Stafford's Netherfield works, and Dawn Andrews for being encouraging in general. This book is for Lena and Rowan, who have always been gratifyingly enthusiastic about 'Daddy's Posters'! The author can be contacted at quadcrown@hotmail.co.uk.

PREFACE

If We Cannot Appreciate Great Trash …

Film posters are currently extremely fashionable yet very little documented, at least in this country. Only two serious studies of British posters have ever been published: the BFI's *Projecting Britain* (1982), which dealt purely with Ealing's distinctive output, and Greg Edwards's *Book of the International Film Poster*[1] (1985), which contained a short chapter on the UK's contribution in general. In the fifteen years that these books have been out of print, film posters have become very big business indeed, yet a properly researched history of the subject has never appeared. This book aims to put that right. The story of its creation stretches back over twenty-five years, and I feel that a brief account of how it came to be written is justified.

From fairly early childhood, I seem to have possessed those two essential attributes of the determined collector: an irresistible fascination with detail and an intuitive joy in simply accumulating things. My interests in dinosaurs and Greek mythology naturally progressed to fantasy and horror films, and my collecting attention from DC and Marvel comics to the popular 'monster magazines' of the time … *House of Hammer*, *World of Horror*, *Monster Mag* and so on.

At the beginning of 1980, shortly after my thirteenth birthday, I spotted an advertisement in the back pages of *Film Review* magazine for a 'Movie Mania Midlands Film Fair' to be held on Saturday 9 February at Birmingham's Central Hall on Corporation Street:

> Over 30 stalls specialising in film posters, stills, soundtracks, books, magazines, scrapbooks, film star postcards & cigarette cards, 8mm films, theatre books & programmes, and all vintage cinema items. Refreshments all day. Admission: Adults 25p OAPs & Children 15p. Come and buy, sell, swap, barter or browse.

This sounded interesting, and a likely place to pick up back issues of *Famous Monsters of Filmland*, so I decided to go along and investigate.

The fair was poorly attended. A handful of middle-aged men in dark mackintoshes drifted around the cavernous hall, occasionally stopping at a table to flip through the contents of a particular box. Somewhere in one of the corners a tape recorder was playing a tinny selection of *Great Western Themes*. The stallholders puffed away on pipes, while their wives quietly sat knitting or chatting to each other. A serving hatch near the entrance dispensed cups of tea and cake. It was a quintessentially English scene.

Pinned up around the walls and quickly catching the eye was a selection of large and colourful film posters of the sort I had seen displayed outside Walsall's ABC cinema: *Brides of Dracula*, *The Comancheros*, *The Enforcer*, *Star Wars*, *Day of the Triffids*. In combination with Ennio Morricone's evocative background music, they seemed somehow vividly exciting and powerful. Despite the low-key surroundings, I immediately felt I had stumbled into a thrilling new collecting world that instantly eclipsed my previous attachment to simple fan magazines.

The most popular stall had a permanent group of about half a dozen onlookers standing around it in a semi-circle. A huge six-inch-thick pile of posters was open flat in the middle of the trestle table, and the nearest man was slowly flipping through these while others watched, throwing in the odd appreciative comment and occasionally reaching forward to slide out and pay for a particular example … *Dracula Has Risen from the Grave*, *Get Carter*, *Carry On Cowboy*. These older titles, I soon learned, were £2 each. Newer posters that were no more than about five or six years old cost £1.

I bought my first poster from the pile that afternoon (a quad for *Monsters from an Unknown Planet* (1975), which I had enjoyed the previous year in a revival matinee at the Wolverhampton Odeon), along with various stills, lobby cards and pressbooks. Over the next fifteen years, I bought more and more, gradually focusing on posters over other publicity material, and then eventually on British posters alone. Quads seemed to me self-evidently the best international format: Belgian posters usually had exceptional artwork, but were too small to be really impressive; while French posters suffered from the opposite problem – much too big to display easily or store flat; American one-sheets were the right size, but frequently seemed restricted by their portrait aspect. Only the 30" x 40" broadside quad felt properly cinematic in the opportunities it provided for epic landscapes of excitement, intrigue and mayhem.

Throughout this period my knowledge of the posters I was systematically acquiring was limited to what I saw with my own eyes: most of them seemed to be printed by one of three main companies, either W. E. Berry of Bradford, Stafford & Co. of Netherfield, or Lonsdale & Bartholomew of Nottingham (I had no idea at the time that the last two were, in fact, the same firm), and my two favourite artists were exotic-sounding foreigners by the names of Chantrell and Putzu. Chantrell was clearly some sort of elegant Gallic sophisticate; Putzu sounded like a mysterious Aztec god. From the apparent length of their careers, I assumed they were both almost certainly dead.

I was wrong. Shortly after moving to London in summer 1995, I happened to hear that Tom Chantrell (so much for my elegant Frenchman) was still very much alive and based somewhere in the capital. He was in the phonebook, so I rang him up, introduced myself and brazenly asked if he would like to meet up for a drink to talk about his career. He did, and we met a few days later, on a sunny Monday afternoon in a Kensington pub.

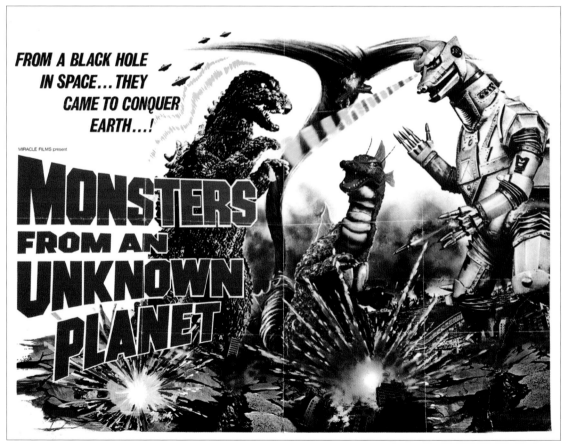

Monsters from an Unknown Planet (1975). No printer credited, but probably Broomhead Litho. Artwork adapted from the original Japanese campaign, although the landscape and explosion to the left of Godzilla have been added by a British illustrator, probably Ted Baldwin. (AC)

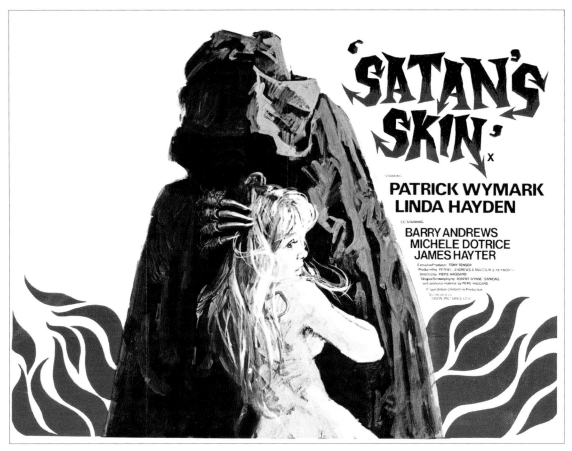

Satan's Skin (1971). Printed by Bovince. Illustration by Arnaldo Putzu, probably from a design by Eddie Paul. This classic British horror poster, and the others in this introductory section of the book, were among the author's first purchases in his early teens. (AC)

We quickly hit it off and, thereafter, met regularly in various pubs and cafés around Victoria. Tom was entertaining company, and I soon came to think of him as a friend rather than as an interesting celebrity acquaintance.

My actual interest in the history of British posters was still rather vague and I rarely bothered to question Tom systematically about his career, which was just as well, as he was often simply not in the mood to discuss it, preferring instead to gossip about politics and current affairs, or straightforward family chit-chat. It never occurred to me to try to locate or contact any other artists during this period – there seemed no particular reason to want to do so.

One evening in summer 2001, I rang Tom's home and his wife Shirley answered. She explained that Tom was in hospital, having suffered a minor heart attack. It didn't sound particularly serious – he was apparently sitting up in bed and grumbling as usual – but I arranged to visit him anyway on the following Sunday with his family. As soon as we

arrived it was immediately clear that the situation was far more serious than I had thought and, as fate would have it, Tom died only a couple of hours later. This sad fluke of timing is the real reason for this book's existence.

Because of this hospital visit, I was invited by the family to speak at Tom's funeral, alongside his daughters, Jaqui and Louise, plus friend Ray Youngs – a tremendous and very moving privilege. At the wake following the ceremony, I met three of Tom's original colleagues from the agency for the first time: Youngs, Tom Beauvais and John Chapman. A couple of Tom's artwork scrapbooks had been brought along and, as these three friends flipped through them, sparking a stream of anecdotes, jokes and reminiscences about the old days, two things began to occur to me. The first was what a fantastic story there was to be told about the creation of vintage British film posters, a subject that had previously been completely unexplored. The second was, quite simply, that this story would have to be pieced together very

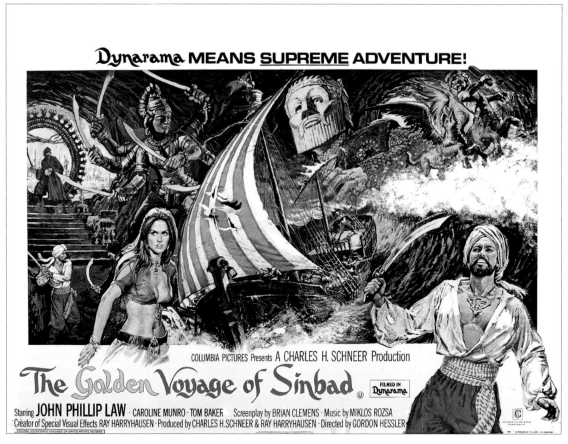

The Golden Voyage of Sinbad (1973). Printed by W. E. Berry. Illustration by Brian Bysouth, from a design by Eric Pulford. This was one of Bysouth's first freelance assignments, following his departure from Downton's in 1973. (AC)

quickly, as almost all the relevant artists, printers and agency executives were now well into their respective retirements, and in a few years' time an entire generation of memories would be lost for ever.

Tom's death and the experience of his funeral was the final catalyst that prompted me to begin work on this book. Over the two years following those events, I have tracked down and interviewed just about every important surviving character involved in the business in this country, building up what I am confident is the most complete picture of the subject it is now possible to assemble.

This book is neither a collectors price guide nor a formal graphic design survey of the field – very few film posters are genuinely significant works of art, and to try to discuss them on this basis seems to me pointless. Pauline Kael once wrote: 'Movies are so rarely great that if we cannot appreciate great trash we have very little reason to be interested in them'[2] – and this is the eminently sensible line that this book takes.

What, then, is the alternative focus of this study? It is, I hope, really a book about *people* – in fact, it is a book about some of the great unknown names of British cinema: Eric Pulford, Tom Chantrell, Vic Fair, Brian Bysouth, Arnaldo Putzu, Renato Fratini, Downton Advertising, Allardyce Palmer, Stafford & Co, W. E Berry Ltd, and many, many more, offering some belated recognition to a largely forgotten group of talents who helped make cinema going in this country a uniquely exciting experience. If it has an aim, it is perhaps to begin the rediscovery of this 'lost generation' of British commercial artists and their employers, whose gloriously colourful, shamelessly bombastic, often outrageous and occasionally brilliant contributions to our popular culture are only now starting to be properly appreciated.

For me, the assembling of this story has been book-ended by two deaths: Tom Chantrell in July 2001, whose passing prompted me to begin work on this book in the first place, and Eric Pulford almost exactly four years later in July 2005, at just

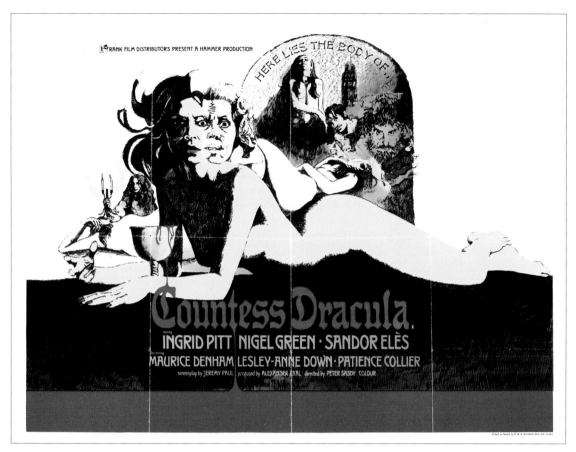

Countess Dracula (1971). Printed by Broomhead Litho. Design and illustration by Vic Fair. A gaudy but stylish Hammer poster, featuring one of Fair's trademark juxtapositions, this time the contrastingly youthful and aged faces of Ingrid Pitt in the title role. (AC)

the point that the book had been formally accepted for publication by the BFI. It would be a cliché to say that I wish Tom and Eric were still around to read it, but if it contributes to the public re-evaluation of their work, which is now so obviously overdue, it will have served its purpose.

Explanatory note on illustrations

All landscape posters illustrated in this book are 30" x 40" quad crowns, and all portrait posters 40" x 27" one-sheets, unless otherwise stated. Similarly, all illustrations reproduced are either from the Author's Collection (AC) or the British Film Institute's archives (BFI), unless otherwise credited.

Sim Branaghan, November 2005

INTRODUCTION

Selling *The Sellout*

Illustrated film posters first appeared in Britain around 1910, concurrent with the earliest purpose-built cinemas, and vanished with striking suddenness during the mid-1980s, as a struggling film industry hit its deepest depression. Very few of their artists were particularly well known or respected, and the majority of their designs were generic variations on a handful of fairly well-worn themes. The posters were created solely to lure the public into paying to see films that usually had little or no chance of matching the excitements promised by their frequently unrestrained advertising – indeed, this often brazen overstatement is now a large part of their kitsch appeal. So why are they worth considering at all? Quite simply because they represent a major seventy-five-year tradition of popular British art that has, up to now, been completely overlooked.

Projected film shows began in London in February 1896, but since these were mostly novelty attractions on theatrical variety bills, the first fifteen years or so of British film posters were of the purely letterpress theatre bill type. As the films themselves developed into longer, more complex narratives (two-reel, twenty-minute features first appeared around 1910), larger pictorial posters, which initially drew on the long-established illustrative traditions of Victorian theatrical melodrama, started to replace the old variety bills. As the 'star system' rose to prominence during the First World War, more ambitious portraits and montages slowly began to take precedence over the use of a single dramatic scene.

Initially, film posters came in a profusion of shapes and sizes, but, by the Second World War, a distinctively British format began to emerge: the landscape 'Quad Crown', size 30" x 40". This enabled artists, who had previously often been expected to adapt American designs, to begin

developing a specifically British illustrative approach, mirroring the compositional shape of the classic 3:4 cinema screen ratio itself.[3] In the post-war years, the look of the British quad came to be determined by half a dozen London advertising agencies and the handful of commercial artists who had ended up working in their respective creative departments. This generation of designers and illustrators mostly reached retirement age during the 1980s, just at the point when the UK film business sank to its lowest ebb. With promotional budgets now heavily cut back, and the emergence of sophisticated new technology that enabled photographic designs to be put together quickly and cheaply on a computer screen, the old illustrated film poster quietly faded away. By 1986, most of the artists had retired, the agencies that employed them had vanished, and the two or three original printing companies had moved on to other, more lucrative, markets. An era was over.

This book tells the inside story of a unique part of Britain's film business, which, as a sidelight, illuminates not only the history of the national cinema itself, but the whole field of popular visual culture in the UK over the last century. This is a 'big picture' in every way, and as a convenient starting point it might be helpful first to consider the process of producing a poster, from conception to design, printing, distribution and display. Let us take, for example, a typical espionage thriller from 1975, Peter Collinson's *The Sellout*.

The Sellout was a British/Italian co-production, shot entirely in Israel, starring Richard Widmark, Oliver Reed and Gayle Hunnicutt as three ex-spies double-crossing each other in Jerusalem. It had a complex but fairly generic plot, and was clearly going to be sold principally on its highly commercial mix of violent action, tough-guy heroes and Hunnicutt's glamorous sex appeal. The film

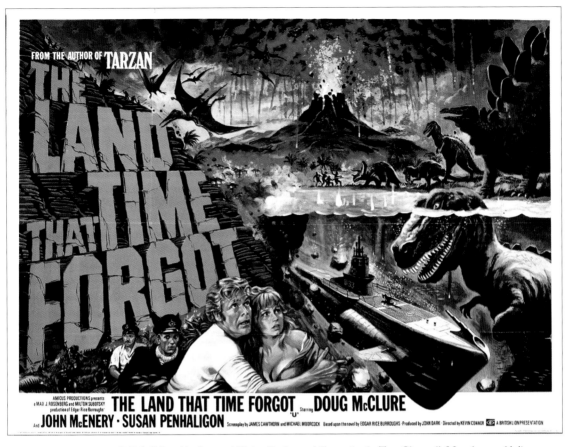

The Land that Time Forgot (1974). Printed by Leonard Ripley. Design and illustration by Tom Chantrell. More lost world dinosaurs. That Day-Glo orange title on the cliff-face is unmistakeably Chantrell. (AC)

was made by Warner Bros, and distributed in the UK by the joint Columbia-Warner company from their offices at 135 Wardour Street. Their head of publicity was the veteran Al Shute, and in late 1975 (with the film scheduled for release in April the following year) he would have contacted Warners' agency, Downton Advertising, a little further down Wardour Street, to commission a poster.

Downton's chief designers, Eric Pulford, Vic Fair, John Stockle and Colin Holloway, would have been invited to attend a private showing of the film in Warners' basement viewing theatre. They would then have been given a selection of stills from the film, plus any other reference material already available, and asked to come up with some ideas. Downton's designers worked competitively, and each of their rough layouts (and they may have submitted two or three apiece) would have been presented to Columbia-Warner's executives by Pulford for discussion and selection. Sometimes a single image was picked out and approved, and sometimes (to the frustration of the designers) a montage of various bits from several different

designs was ordered. In this case, Pulford's earliest successful attempt was a smart minimalist layout of a hand holding a gun pointing upwards on a plain white background, the illustration's contours cleverly containing three star portraits, and a couple of small action scenes of a car chase and explosion. This fairly obvious combination of ideas was provisionally agreed, but the star portraits were to be enlarged and separated from the gun-hand. In Pulford's second, formally approved, 'rough', a smaller revolver appears in the centre on a dark background, surrounded by three big bullet-holed portraits, along with a car-chase vignette at bottom right, crashing through some packing cases.[4]

This layout was then given to Downton's regular illustrator of the period, Arnaldo Putzu, to produce the finished artwork. Putzu was at the time based with the design studio Feref Associates, in their offices at 16 Little Portland Street, a couple of minutes' walk away just north of Oxford Circus. He would have taken about two days to complete the finished painting, using gouache and acrylic on 24" x 34" artboard, for a fee of around £300. His

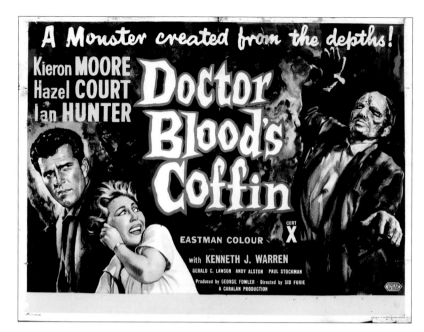

Doctor Blood's Coffin (1960). Printed by Stafford. Illustration by Bill Wiggins, probably from a design by Eddie Paul. Kieron Moore's portrait is noticeably more finished than Hazel Court's here, suggesting Wiggins may simply have run out of time on this one. (AC)

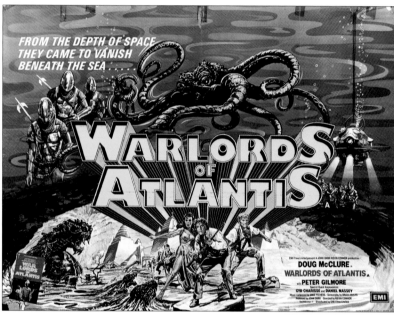

Warlords of Atlantis (1978). Printed by W. E. Berry. Illustration by Josh Kirby, probably from a design by Eddie Paul. Fantasy subjects like this were well known as Kirby's favourites, and he was regularly commissioned by Feref accordingly. (AC)

final artwork is very close to Pulford's original layout, with the exception of the car chase, which has now evolved into a leap over a truck against a background explosion. As he had little real creative input on this occasion, Putzu did not bother signing the illustration. Reed and Widmark have formal top billing above the title, Hunnicutt in third place below. The tagline is placed to the right of Reed's portrait: 'They have 24 hours to outfox the CIA … the KGB ... and each other!'

The next stage was to get the finished poster printed. Columbia-Warner (in common with all the other UK distributors) had, by this point,

contracted out responsibility for its paper advertising to National Screen Service (NSS), who operated from conveniently central offices at 27 Soho Square. NSS's chief print buyer throughout the 1970s was Ian Hedger, and Al Shute would have supplied Hedger with Putzu's finished artwork, and an advertising budget, based on the projected 'scale of the release' for the upcoming film. In 1976, there were just over 1,500 cinema screens still operational in the UK, and *The Sellout* would have had a full circuit release on the big ABC chain. Hedger would therefore have worked out an overall print run for the poster

based on this information, taking in percentages for the West End premiere, London Transport, British Transport, 'Away from Theatre' sites and the circuit release itself. The final amount ordered is likely to have been in the region of 3,000 copies.[5]

By the mid-1970s, NSS was effectively alternating its poster orders between the two major surviving printers: Lonsdale & Bartholomew in Nottingham, and W. E. Berry in Bradford, generally depending on which firm could take the job soonest.[6] In this case it was Berrys, and the artwork would have been hand-delivered to their printing works on Nesfield Street in Manningham, where print manager Peter Lee would have overseen the production process. The first step was to photograph the artwork four times, using a different filter on each occasion, to create the colour-separation negatives. These negatives were then projected onto four full-size 'film positives', and these, in turn, used to expose the four individual printing plates needed, one for each ink colour: yellow, red, blue and black. These would then have been fixed onto the presses (a pair of George Mann two-colour quad printers), and the requisite 3,000-copy run printed off in a couple of hours.[7] The artwork would have been returned to Downton's, and the posters immediately put on a train down to NSS's West London warehouse at 15 Wadsworth Road in Perivale, where the despatch department would have organised their distribution to individual cinemas. This could happen in one of two ways: some were simply posted out, while others were delivered straight to cinemas with the film prints by Film Transport Services, a dedicated haulage company based nearby at Apex Corner on London's North Circular Road.

Almost all the posters thus distributed would have been pasted straight onto local hoarding sites rented by the cinemas themselves. Each individual theatre would also have had three or four front-of-house glazed poster frames, which could take a loose quad clipped inside for illuminated display. Many copies would additionally have been pasted

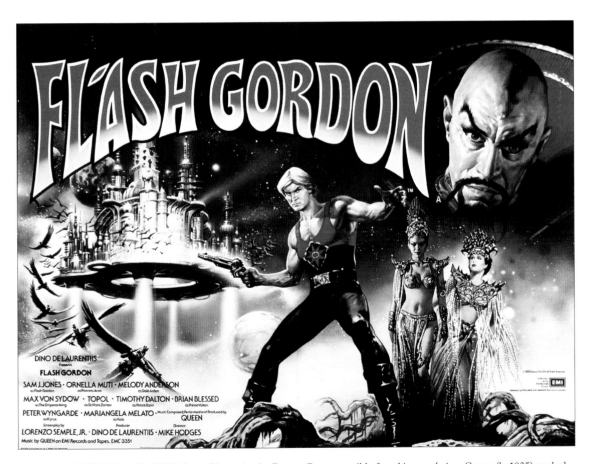

Flash Gordon (1980). Printed by W. E. Berry. Illustration by Renato Casaro, possibly from his own design. Casaro (b. 1935) worked regularly on British posters over the 1980s, but always from his studio in Rome. (AC)

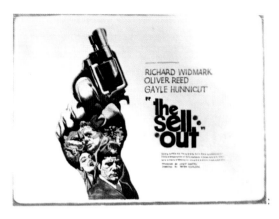

Eric Pulford's preliminary poster design for *The Sellout* (1975), with the portraits part of the gun-hand.

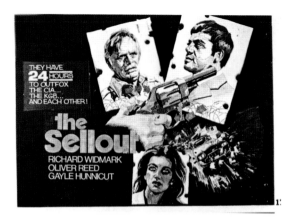

Pulford's second, revised 'finished rough', with the portraits now enlarged and separated from the gun.

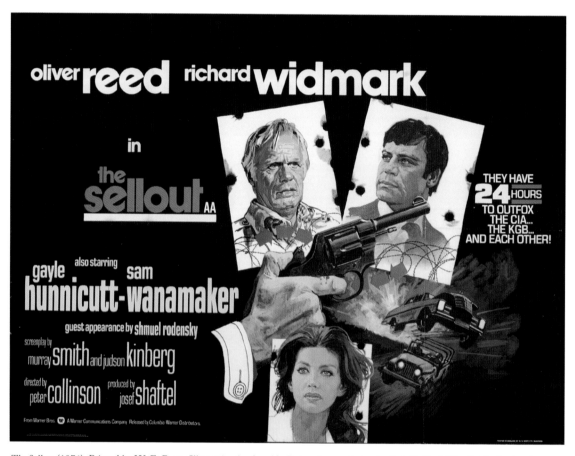

The Sellout (1976). Printed by W. E. Berry. Illustration by Arnaldo Putzu, from a design by Eric Pulford. The finished printed poster, with very minor amendments by Putzu to Pulford's original layout. (AC)

up on London's Underground system, and around the country's provincial railway stations. The poster itself was also advertised on the cover of the film's promotional pressbook, with an instruction to cinema managers to order any additional copies direct from NSS at 32p each. At the end of the film's initial run, in April 1976, the vast majority of these used posters would simply have been pasted over or thrown away. A handful would have found their way into cinema basements or been taken home by enthusiastic projectionists. A small but growing collectors' 'black market' was in operation by this point, and a couple of hundred spare copies would have found their way into the hands of the

half-dozen casual dealers then involved, possibly via one or two of London Transport's more discreetly entrepreneurial billposters. Surviving copies are still circulating thirty years later for £10–20 each.

That, then, is how a poster made the journey from scribbled design idea to disposable advertising accessory to nostalgic collectable. The agencies and personnel came and went over the previous sixty years, but the process remained much the same. From the life cycle of an individual poster we now turn to the life cycle of the cinema poster business. The book is organised in two historical sections – pre- and post-war – and each separately covers the basic aspects of printing techniques, film industry developments, changes in format and design strategies, and the major artists and printing companies involved. Part One also includes a chapter on Ealing's celebrated posters, while Part Two has additional extended coverage of the advertising agencies and the NSS. The history of film poster collecting and dealing is discussed in the book's Postscript, which also attempts to finally locate vintage British film posters as the last glorious flourish in a long and honourable tradition of popular art.

A Daughter in Revolt (Harry Hughes, 1926) Printed by Weiner. (BFI)

PART ONE

1896–1945

CHAPTER 1

Film Distribution and Exhibition in the UK: Novelty Becomes Industry

The history of film distribution and exhibition in the UK remains a relatively neglected field of study, but is of vital importance to the understanding of how British film posters developed for two reasons. First, it is the distribution companies who actually commission film publicity and, second, the size and nature of the exhibition context influences the quantity and nature of the publicity produced.

The story of the cinema in Britain really begins on the evening of Thursday 20 February 1896, when two competing scientific demonstrations took place in London, apparently more or less simultaneously – the Parisian Lumière brothers' Cinematographe projector at the Regent Street Polytechnic, and Highbury engineer Robert Paul's similar Theatrograph at Finsbury Technical College. The success of these demonstrations quickly led to their transfer to rival music halls on Leicester Square: the Lumière's Cinematographe opened at the Empire

on 9 March, while Paul's Theatrograph premiered at the Alhambra (since replaced by the Odeon) two weeks later on the 25th.[1] For about the first ten years of its life, the cinema was thus simply another attraction on music hall variety bills, though travelling showmen also put on regular performances in fairground tents or rented public halls, and disused shops were sometimes temporarily converted into so-called 'penny gaffs'.[2] The handful of pioneer British film-makers operating before the turn of the century were led by Paul himself (who built his own studio to the north of Muswell Hill in 1898) and his friend Cecil Hepworth, who set up a similar base in a converted Walton-on-Thames villa later the same year. There were also about half a dozen other names involved, sometimes ex-magic lantern showmen or touring theatrical impresarios of the period.

Originally producers like Paul and Hepworth simply sold prints of their films outright to

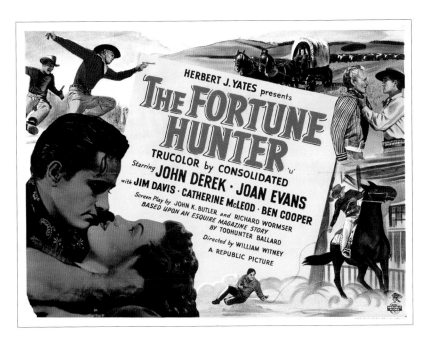

The Fortune Hunter (1954). Printed by W. E. Berry, designer unknown. The quads in this, and the later post-war Distribution chapter, are all Western-themed. One poster per studio has been selected – this is a typical Republic 'oater'. (AC)

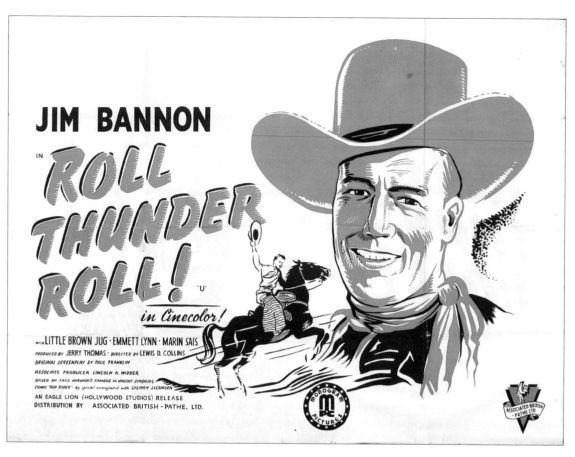

Roll Thunder Roll! (1949). Printer uncredited and designer unknown. This is a cheerful two-colour hand-cut silkscreen from Monogram. (AC)

showmen for so many pence per foot, but in 1897, two itinerant showmen, J. D. Walker and E. G. Turner, began renting their film collection to colleagues for single showings. This proved so successful that they set up a company, Walturdaw, probably Britain's first fully fledged distributor. The French producer Leon Gaumont opened a British office in Cecil Court, off London's Charing Cross Road, in 1898, distributing his own and other producers' films. When another important French pioneer, Charles Pathé, followed him soon after, Cecil Court briefly became known as 'Flicker Alley'. Gaumont's British manager, Colonel A. C. Bromhead, is said to have initiated the system of exclusive booking contracts, whereby the highest bidder could be sure that the same film would not be shown in the same area by any of his rivals.[3] Two similarly influential British renters of the period, Jurys and Wardour Films, subsequently followed suit, beginning a restrictive practice (eventually known as 'barring') that would survive for over fifty years.

A key early American distributor was the Warwick Trading Company, originally Edison's British representative, which was also located in Cecil Court. Warwick was run by US entrepreneur Charles Urban, who in 1907 set up his own company, financing and distributing the films of G. A. Smith and George Méliès among others, and began the great move westwards to Soho by opening the first film office on Wardour Street (in what is now Game Zone amusements). In May 1908, he opened the street's first viewing theatre, Urbanora House (now Las Vegas Amusements), and the competition followed his lead. Wardour Street neatly bisects Soho, from Oxford Street in the north, down to Leicester Square in the south. In the 1890s it had been the centre of London's violin manufacture, and was also notorious for its fake-antique shops, leading to a dual-purpose nickname of 'the street of fiddles'. By the outbreak of the First World War, however, it had become the business centre of the British

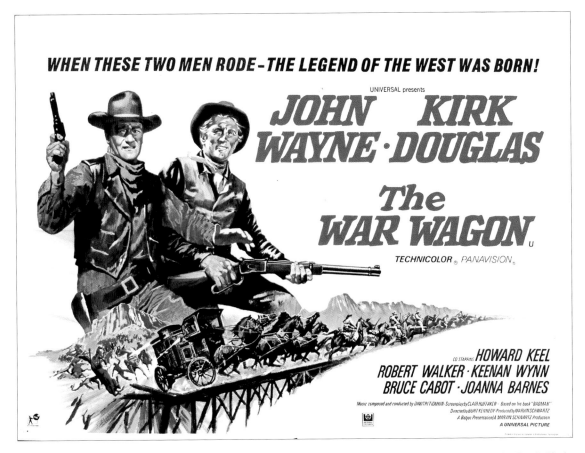

The War Wagon (1967). Printed by Lonsdale & Bartholomew. Illustration by Renato Fratini, probably from a design by Eric Pulford. A Universal production, but distributed in the UK by Rank, so the poster carries both logos. (AC)

film industry. This immediately led to the standard joke that it was 'the only street in London that was shady on both sides'.

By this time, the emergent Hollywood companies had opened offices in London – the first two were Essanay and Vitagraph – and began to dominate the market in Britain, via the highly restrictive practices of blind- and block-booking. With the huge popularity of the earliest American stars like Chaplin, Pickford and Fairbanks, their UK-based distributors were able to oblige exhibitors to take whole packages of films, either sight unseen (blind) or en masse (block), simply in order to obtain a copy of the latest Chaplin etc. among them. This situation was eventually addressed in 1927 by the Cinematograph Films (Quota) Act, an attempt to protect outmanoeuvred UK producers by introducing a rising minimum quota of British films for rental and exhibition. The principle of the quota would remain for almost sixty years, until it was finally abolished in 1985.

By the 1930s, each of the Hollywood 'majors' – MGM, Paramount, Fox, Radio (RKO) and Warners – and 'minors' – Columbia, Universal and United Artists – had established distribution businesses, based in and around Wardour Street, for the purposes of handling their own and their British quota films.[4] In contrast, the only two British companies, among a host of small film renters, to control similarly powerful distribution outfits were Rank and Associated British. Rank rented as General Film Distributors (GFD) between 1935 and 1955, having initially taken control of Gaumont's distribution wing, while Associated British was tied up with Pathé from 1933. Rank actually took over the distribution of Universal's films in the late 1930s (while Universal handled Rank films in America), thus absolving the Hollywood company from the obligations of the quota. This arrangement remained in place up to the end of the 1960s.

The success of Rank and ABC lay in 'vertical integration' – the ownership of cinemas in which its films were guaranteed exhibition. Purpose-built

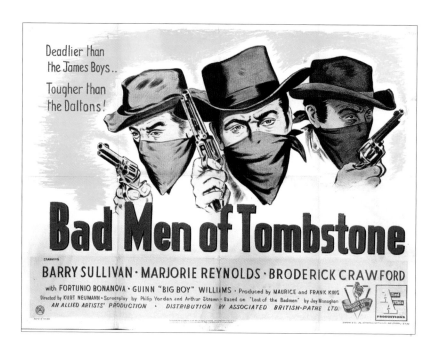

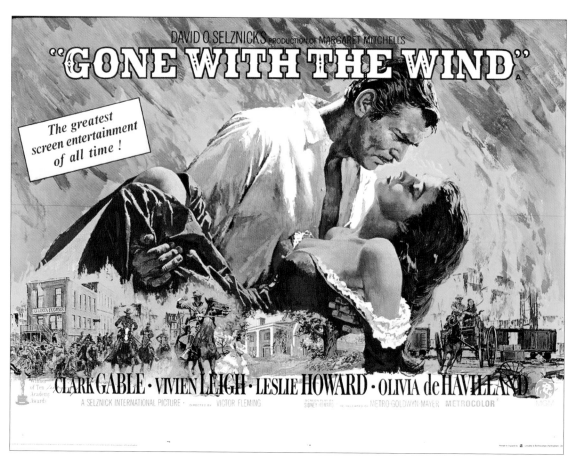

Gone with the Wind (1939). Printed by Lonsdale & Bartholomew. Illustration from the US campaign by Howard Terpning. A popular 1968 reissue and not strictly a Western. (AC)

cinemas in Britain date back to around 1910, when new licensing regulations, designed to protect the public from the fire hazards associated with dangerously inflammable film stock, closed many of the old 'penny gaffs'. The first cinema chains also began to be built in this period, notably the Provincial Cinematograph Theatres (PCT) circuit, which featured particularly elegant and luxurious interiors and began attracting a more middle-class audience, turning an 'evening at the pictures' into a special occasion for the first time.[5] By 1920, there were an estimated 4,000 cinemas operating in Britain, though many of these were still crude conversions of often ancient premises, or theatres running film shows as a supplement to live variety.[6] In 1921, the first 'super cinemas' began to appear, featuring two floors of seating, in the circle (balcony) and stalls (ground floor). The arrival of sound in 1927 forced many of the older, shabbier 'fleapits' to close and, despite the huge wave of construction that took place over the following decade, by 1934 the number of operational cinemas had only increased to 4,300 in total.[7]

From the end of the 1920s, consolidation began, with the large circuits being built via the absorption of smaller operations. The Gaumont British Picture Corporation (absorbing the PCT circuit) appeared in 1927, as did the Associated British Picture Corporation, combining three existing circuits into the ABPC chain. In terms of distribution, Gaumont was soon tied up with Fox, and ABPC with Warners, while Oscar Deutsch's Odeon chain was in partnership with United Artists by 1937. Other popular circuits appearing at this point include the Granada and Essoldo chains, but perhaps the key event was J. Arthur Rank's acquisition of the Gaumont and Odeon chains in 1941. Although the Board of Trade initially required Rank to run the two circuits separately, this effectively set up the great Odeon/ABPC duopoly that dominated British exhibition for the next fifty years. The long-term effects of this concentration of power will be discussed in Chapter 5. First, we must examine the context of advertising and display in which the emergent film business began to sell its wares.

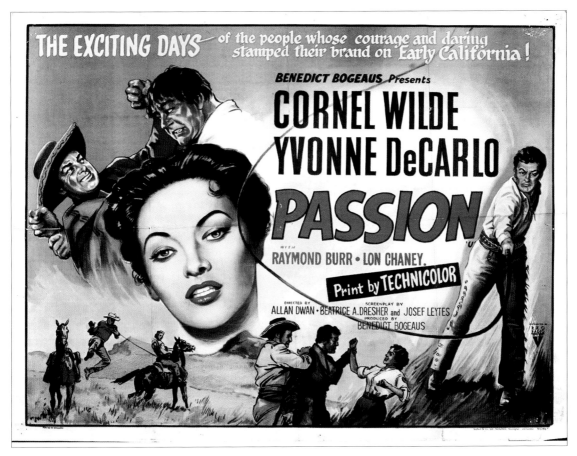

Passion (1954). Printed by Stafford. Illustrator uncertain, but possibly Bill Wiggins. A fantastic Yvonne De Carlo portrait for this over-excited RKO melodrama. (AC)

CHAPTER 2

The Birth of the Film Poster: Printing Techniques, Billposting, Formats and Design Strategies

Before the 20th century, the posting of advertisements in Britain's streets was a chaotic and often violent affair. Advertisers handed their posters over to 'billposters' who, armed with a brush and bucket of paste, would flypost wherever they could, and dump whatever stock remained. There was considerable competition for the better sites, and the defacement of the work of rivals was a regular occurrence. Affrays between billposters were also frequent – most of the early charges against them fell under the heading of breaches of the peace. The actual renting of sites is thought to have begun in Leeds in 1863, after a certain Edward Sheldon clashed violently with a rival at

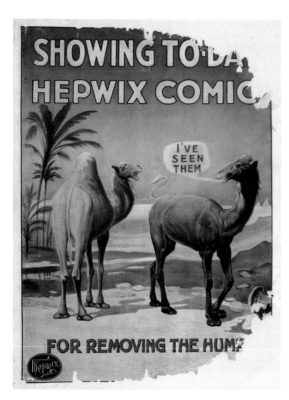

Hepwix Comic. No printer credited. A quirky stock poster from about 1912, featuring a rather laboured visual pun. (BFI)

a popular site used by both, and returned home so shaken that he vowed never to risk such injury again. His wife sensibly suggested that he should establish a legal right to the site in question by renting it from its owner, thus introducing the whole business of rented hoardings for the first time. In actual fact, the trade had already begun to organise itself by this point – a mixed group of billposters from Lancashire, Yorkshire and the Midlands had met in Manchester in 1861 to form the United Kingdom Bill Posters Association (UKBPA), the first official trade association. The general 'poster boom' of the period led to London's walls again becoming 'crowded with innumerable carelessly put up placards', and to the passing of the Advertising Stations Ratings Act (1889), which attempted to organise this chaos, and bring it under some sort of effective control.[8] It empowered local authorities to levy charges for public advertising on vacant land, occupied premises and along the public highway.

The billposters were further harassed by pressure groups who campaigned against the hoardings themselves, on moral or aesthetic grounds. The most influential of these was the National Society for Checking the Abuses of Public Advertising (SCAPA), established in 1893 by W. B. Richmond RA, ostensibly to 'promote and support legislation giving local authorities greater control over the size and siting of outdoor advertisements, and wider powers to tax them'.[9] In fact, SCAPA had been provoked into life by one of the minor sensations of 1890 – the so-called 'Zaeo Affair', in which a poster featuring a 'lady gymnast' then appearing at the London Aquarium had contrived to give the impression that she actually performed in the nude. The public outcry that followed this disgraceful scandal (admissions at the Aquarium more than doubled over the next twelve months) was severe

enough to frighten the London Billposters Protection Organisation into setting up a six-man Committee of Censorship that October. It quickly gained a comical reputation for its often timid and prudish decisions. Matters came to a head in August 1902 with the appearance of a controversial poster for the touring melodrama *Because I Love You*, described at the time as being 'of a revolting nature, containing the figure of a creature in the form of a man, but with the talons and beak of an eagle or vulture'. The uproar that followed its banning forced the Censorship Committee to overhaul their constitution the following year, to include representation from the Theatrical Managers Association and several other interested bodies. SCAPA continued its high-profile campaigns against the 'Horrors of the Hoardings' until the 1907 Advertising Regulations Act effectively pulled the rug from under its feet by finally limiting local authority control to hoardings over twelve feet high.

The British film poster developed during precisely this period, and drew its inspiration from the advertising associated with the nineteenth-century theatre and music hall.[10] Standard-format letterpress bills of about 30" x 10" were in common use by the 1850s, occasionally employing crude woodcut illustrations. As well as announcing plays and variety acts, these were also sometimes sold to audiences as an early form of programme, and the distinctive tall, thin shape originally derived from the impracticality of studying anything larger in the cramped confines of a theatre seat. This basic format persisted right up to the close of the 19th century for variety bills, and was used for the earliest film posters. The first illustrated theatre posters printed on steam-powered lithographic presses began to appear in England in the late 1860s.[11] These were smaller than the previous letterpress/woodcut posters, but represented a clear revolution in terms of the subtlety and delicacy of their full-colour illustrations. They also ensured that the frequently illiterate billposters pasted their bills the right way up.

The first major British playbill to gain national attention was a striking woodcut by W. H. Hooper from Fred Walker's design for Wilkie Collins's *The Woman in White* at the Olympic Theatre in 1871. Early British lithographic posters, in contrast, aimed for a rather pallid respectability by simply reproducing Royal Academy pictures or

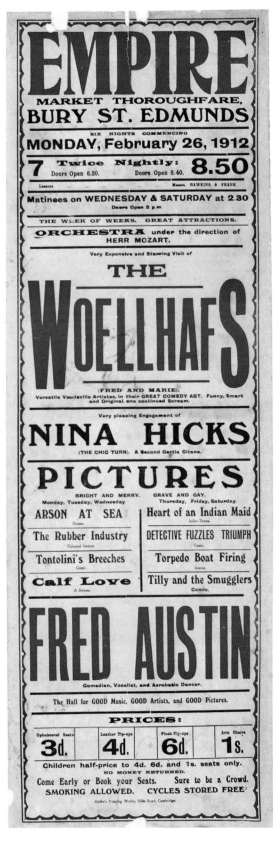

Empire Bill. A typical 30" x 10" music hall letterpress bill from 1912. With few exceptions, the first fifteen years or so of British film posters all followed this basic non-illustrated format. (BFI)

Animated Pictures. Printed by Banks. Another stock poster of about 1912, this time stoutly patriotic in tone. Note the blank yellow space at the bottom of the design, for local show overprintings. (BFI)

led by the famous duo of Dudley Hardy and John Hassall. Hardy quickly developed his own distinctively lively and humorous style for Gilbert and Sullivan's series of comic operas, while his friend Hassall was responsible for boisterous travel subjects like the classic 'Skegness is So Bracing', among many others. The pair in fact produced much of their best poster work while under contract to David Allen. Other British artists, working mostly in theatrical playbills, included Sidney Ransom (who habitually signed his work backwards, as Mosnar Yendis), George Albert Morrow, Will True, Stewart Browne, Alec Richie and several others. Their strong outlines, blaring colours and cheerful lettering created a distinctive English poster style, of which the most characteristic component was an irrepressible sense of humour.[14]

Posters like these were made possible by the development of chromolithography – or colour printing via a sequence of precisely aligned, hand-drawn plates. This was initially a fairly expensive process, and its widespread use in Britain only

occasionally employing RA artists to design original works, a job for which most of them were temperamentally quite unsuited – 'vulgar commercial puffing', as Walter Crane described it.[12] The most famous of these was probably Sir John Millais's *Bubbles*, a twee portrait of his grandson that became a huge success when sold to Pears Soap in 1887. The three genuinely revolutionary British poster artists of the 1890s were Aubrey Beardsley, whose strikingly modern, Japanese-style illustrations sparked much contemporary controversy, and the so-called 'Beggarstaff Brothers', James Pryde and William Nicolson, who, in contrast, developed a radical silhouette approach, simply cutting out shapes in coloured paper and pasting them onto flat boards.[13] Both Beardsley and the Beggarstaffs produced a few theatrical designs each, but the uncompromising and highly individual appearance of their work meant that it was not particularly successful commercially.

British film posters themselves would spring from the much more conservative comic/theatrical traditions of straightforward narrative illustration,

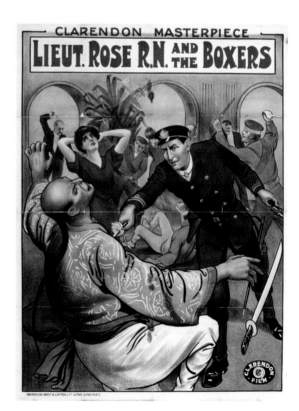

Lieutenant Rose R.N. and the Boxers (1911). Printed by Waterlows. The earliest illustrated British poster for an individual film in the BFI archive, with a stirring action-packed design. Take that, Sir! (BFI)

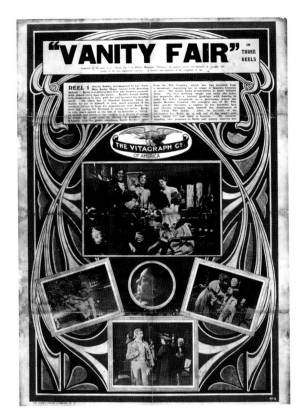

Vanity Fair (1911). Printed by Cassio Press. The first instalment of a three-reel American serial adaptation, with a decorative photomontage design typical of imported US films of the period. (BFI)

a match that naturally complemented the growing theatrical connections. The next step was to move into billposting (initially in Belfast) to offer a full service to local touring companies. One of the leading theatrical touring managers of the day, Fred Mouillot, had entered into an exclusive agreement to obtain all of his touring publicity from the firm, and this went so well that by 1895 William Allen, in collaboration with Mouillot and another entrepreneur named Mackenzie, had set up a partnership to acquire and operate theatres themselves.

By the turn of the century, Allens had added a huge new printing works on a twelve-acre site close to the Harrow and Wealdstone railway station in north-west London, and was employing a staff of over eighty artists and lithographic craftsmen. The firm's billposting interests rapidly spread to Liverpool, then outwards across Lancashire and the north of England into Scotland, by strategically buying up existing local firms. After the First World War, this would become its core business as

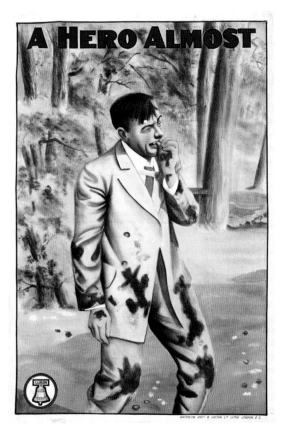

A Hero Almost (1911). Printed by Waterlows. Judging by the state of his suit, our frustrated hero has just emerged from a particularly muddy pond. This is actually an American film, so the artwork may be a straight adaptation of an original US design. (BFI)

began to take off properly in the 1880s, as its costs gradually decreased.[15] The key twin landmarks in this respect would probably be the establishment of ambitious new premises by the period's two principal theatrical printers: Stafford & Co. of Nottingham in 1880, and David Allen & Sons of Belfast in 1884.[16]

David Allen (1830–1903) founded his firm in 1857 as a simple jobbing printer, chiefly turning out newspapers and journals. In 1873, the company also began printing occasional letterpress posters, gradually focusing on the theatrical trade and quickly moving into lithographic printing. The business generated by the new technology enabled the company to move from a string of small premises to a flagship works on Corporation Street in Belfast city centre, and four years later, in 1888, to open a London office on the corner of Leicester Street and Lisle Street, just off Leicester Square. The London move was the suggestion of David Allen's ambitious third son, William, who there met his future wife (and later chairman of the company) the well-known actress Cissy Grahame,

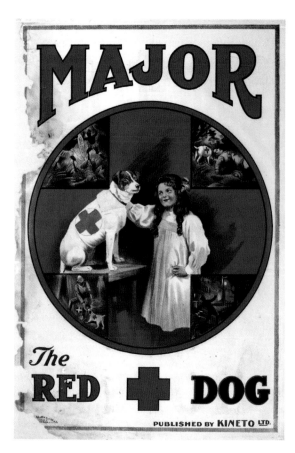

Major the Red Cross Dog (1911). Printed by David Allen. An appealing design for a typically sentimental melodrama set during the Zulu war. (BFI)

what one of its later chairmen called 'the Golden Age of the British theatrical poster' came to an end, and the age of the film poster began.[17]

While Allens found this transition a difficult one to negotiate, their rival printer, Stafford & Co., readily accepted the arrival of cinema. Of all the British printing firms to handle film posters, Staffords were undoubtedly the biggest. Although it is difficult to gauge *overall* output, as only about a half of all posters actually carry any printer's credit, of those that do, Staffords were responsible for around 50 per cent. In other words, at least a quarter of all British film posters were printed by a single company, over a period of almost one hundred years' continuous production, from one printing works on the outskirts of Nottingham.

Stafford & Co. was founded in 1845 by two enterprising printers, John Gascoyne Stafford and Thomas William Stevenson, with premises originally in Nottingham city centre. Quickly adopting the new steam-powered litho presses in the late 1860s, the firm soon established a national reputation as theatrical printers. In 1880, the company relocated to a new purpose-built works on Curzon Street, Netherfield, on the very easternmost fringe of Nottingham, ideally positioned for rail distribution between Carlton, on the old Midland Line, running to the east coast, and Colwick, on the Great Northern Line, running north/south.[18]

A lengthy profile of the firm's Netherfield works appeared in the summer 1887 edition of *Nottingham Illustrated*, and the account gives a fascinating insight into the company's operation, ten years before the cinema had even appeared. The company's chief business, we are told, was in 'those large and artistically executed theatrical and pictorial posters which have now become such familiar objects on every advertisement hoarding'. The Netherfield works themselves covered 'an area of about 40 yards long by 17 yards wide, exclusive of annexes' and were 'capitally lighted on both sides [with] iron columns and bolted girders supporting the floors'. There were 130 employees, producing a variety of 'scenes from plays, representations of menageries, circuses, athletic sports, horticultural and agricultural shows, races and other exhibitions'. Stevenson and Stafford were both pictured sporting identical walrus moustaches, and one accompanied the reporter on his tour, which began in the composing and letterpress room, 'where all the setting up is done for the streamers, posters, window bills, hand bills, circulars and other printed matter'. Next stop was the ink-making factory, specially erected on the premises after it was discovered that 'some of the colours, which the firm formerly purchased, would not stand the effects of light and rain when exposed'. In the artists' room, the designers were 'busily employed in making the necessary sketches and keystones, drawing on stones in black and colour'. As the report explains,

> the designer originates a picture in watercolour; it is then sketched full size required, drawn on the stone, and, when finished, a proof taken, and placed against the wall surrounding the lofty apartment. It then becomes the duty of the colour artists to see that each colour stone is 'worked' to produce the same effect.[19]

In the machine room, the reporter discovered that each of the eight George Mann litho-machines printed one colour only: 'it is astonishing to note the variety of tints imparted to a picture in three

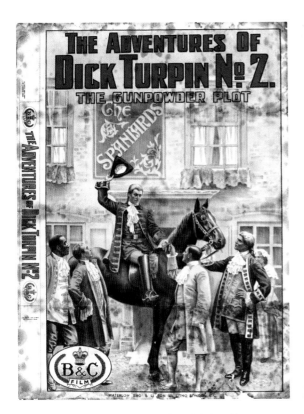

The Adventures of Dick Turpin No. 2 (1912). Printed by Waterlows. One of a series of films about the dandy highwayman whom we're too scared to mention. The detachable left-hand border contains the instruction 'Cut here and paste onto Programme Board'. (BFI)

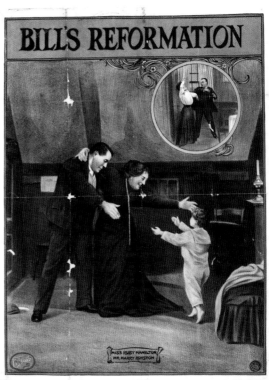

Bill's Reformation (1912). Printed by Weiner. Our flawed hero gives up the bottle after rescuing his baby from an attempted kidnap by the nurse. The earliest British poster in the BFI archive to include a billing credit for its stars, Ruby Hamilton and Harry Royston. (BFI)

or four printings; of course this number is exceeded in better class posters, but may be taken as a fair average nonetheless'.[20]

The visit continued through the paper store, and then into the stockrooms above the letterpress and artists' rooms. These were 'some 30 yards long, 16 yards wide and four yards high', fitted with racks 'containing posters of various theatrical and other show folk, ready to be sent out to order', which overall comprised an impressive 400 tons of stock. The stockrooms led on to the collating department, where the posters were checked and arranged together, prior to packaging. The final stop was 'the offices and private rooms of the principals, comfortably and suitably furnished and fitted', evidence of 'the prosperity of the business'.

By May 1901, Stafford & Co. was already in the fledgling film poster business, as evidenced by this advertisement in the theatrical magazine *The Era*:

Stafford & Co. Theatrical Printers, Netherfield, Nottingham. Have a large and varied stock of pictorials suitable for the following – Dramas, Comedies and Farcical Comedies, Burlesques and Comic Operas, Comic Scenes and Dancers, Ladies' Heads and Figures, Pierrots and Pierrettes, Circuses, Acrobats, Menageries, Music Halls, *Cinematographs*, War, Magicians, Ventriloquists, Dioramas, Ghosts, Minstrelsy, etc. Illustrated lists post-free. Courteous attention to all enquiries. Letterpress Posters and Window Bills effectively displayed and promptly executed. Write for estimates. (Author's emphasis)[21]

In fact, one of the jobs in progress noted by the reporter during the 1887 visit had been 'the letterpress stereotyping of a portion of a large order for Poole's well known Diorama'. Poole's Dioramas (later renamed Myrioramas, following the addition of the popular 'Pepper's Ghost' illusion to the performances) were an early forerunner of the cinema, and from mid-1897 the Pooles added the new cinematograph attraction to their shows as a 'support feature'. These were still touring in

1906, and were eventually only suspended by the advent of the Great War, by which time the cinema had emerged as the leading attraction of the day. Stafford probably had a long-standing contract to supply Poole's publicity, and would therefore have printed some of the very earliest British film posters, though at this stage these were still mostly of the letterpress variety familiar from music-hall bills. Possibly one of Stafford's earliest illustrated posters for a film was a handsome three-sheet for *Cowboy Millionaire* (1909), featuring a full-height portrait of its hero leaning forward laconically with one foot on a barrel.

Poster formats have their roots in the Victorian 'Imperial' system of paper measurements vaguely formalised during the mid-19th century, though there is no official 'launch date' as such.[22] The basic size was, naturally, the Imperial itself, at 30" x 22", and most other size names evocatively reflected this regal theme, including Royal, Emperor, Elephant, Grand Eagle and Crown.[23] All of the Imperial sizes listed above could also be doubled, or quadrupled, and the size at the heart of British theatrical printing was actually the 'Crown'

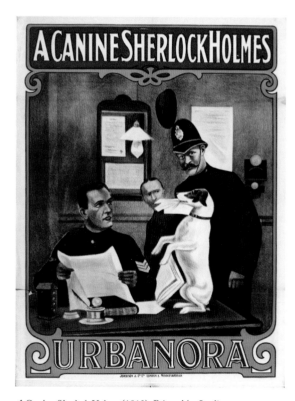

A Canine Sherlock Holmes (1912). Printed by Jordison. A particularly jolly illustration, with another heroic dog centrestage, and an equally impressive moustache on the watching constable. (BFI)

(15" x 20"), as the 'Double Crown' was adopted as the standard poster format in Britain after the Advertising Stations Ratings Act.[24] The two major variations we are interested in are the 'Quad Crown' (30" x 40", landscape) and 'Double Quad Crown' (60" x 40", portrait). Even here, though, things are never simple, as there is also a second, rarer, version of the Quad Crown (60" x 20", portrait), commonly known as a 'Door Panel' for obvious reasons. The smallest standard size was the 'Lift Bill' (16½" x 22", portrait), predominantly for use on Underground escalators.

In contrast, US film poster sizes are based on multiples of a 'sheet', originally taken from the nineteenth-century American circus-poster format of 42" x 28" (portrait).[25] When formally adopted by the film business in 1910, this was shrunk slightly to 41" x 27" to make the standard 'one-sheet', the size still employed today. The next size up from a one-sheet is a three-sheet (81" x 41", portrait), followed by a six-sheet (81" x 82") and finally the billboard-scale twenty-four sheet. One-sheets can also be halved, to (unsurprisingly) half-sheets (22" x 28", landscape). Such is Hollywood's international dominance that the one-sheet format has been adopted as the standard film poster size in many other territories besides the USA. For a time this also included Britain, where, in order to sell their films abroad (in particular to Canada and, later, various African and Middle-Eastern States), British distributors began producing 'International One-Sheets', which at 40" x 27" were actually one inch shorter than their US counterparts. Britain also produced domestic half-sheets, three-sheets, six-sheets and even billboards for its own films. The larger sizes were initially described by the number of Double Crowns they contained, and thus, misleadingly, sounded twice as large as their American counterparts. The bigger formats usually had to be printed in several sections, as the largest size most printing presses could take was 60" x 40" – the Double Quad Crown.

We can now explore how these different sizes fit into the early history of British film posters. Three collections have been used to piece together this history: the BFI's unique Stills, Posters and Designs archive held at Berkhamsted; the extensive private collection of 1930s pressbooks and advertising held in Steve Chibnall's British Cinema Archive; and a now long-forgotten travelling exhibition put together in 1977 by the Welsh Arts

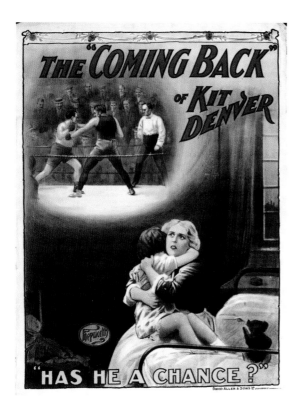

The Coming Back of Kit Denver (1912). Printed by David Allen. More heavy Edwardian sentimentality, as an unemployed miner turns to boxing to support his starving family. (BFI)

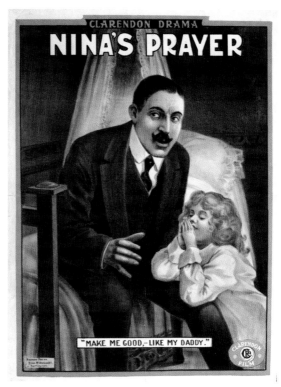

Nina's Prayer (1912). Printed by Barway Press. Another flawed hero gives up the bottle again, this time after overhearing his daughter's tearful prayer. (BFI)

Council. 'Selling Dreams – British and American Film Posters 1890–1976' was an impressive achievement at the time, which, unfortunately, has never really been re-created anywhere since. It featured a specially compiled collection of more than 180, mostly British, posters presented in chronological order, showing the gradual development of the form. Examples of early posters illustrated in the catalogue were as follows.[26]

The first four exhibits are typical music-hall bills from between 1899 and 1916. These all measure about 30" x 10" (i.e. a double crown split vertically), and are purely typographic, listing various attractions, including the 'Cinematograph', in block sections down the poster. The example from the Britannia Theatre of Varieties in Glasgow (1899) describes this as 'the photo-electric sensation of the century!', even though it is actually placed at the foot of the bill. A very rare illustrated poster from this period is a double crown for the Curzon Hall, Birmingham, from around 1900. Printed by David Allen, with artwork by George Albert Morrow, it depicts the heads and shoulders of about a dozen appreciative members of an audience looking up at a blank screen illuminated by the beam of a projector.

The screen itself has been overprinted with the details and prices for the hall's film shows – 'Edison's Life-Size Animated Pictures' – the subjects being 'China and Boer Wars', and the possibly even more exciting 'Reproductions of Life in Birmingham'.

The next large batch of British posters date from between 1911 and 1914, and were obviously occasioned by both the construction of the first purpose-built cinemas and the subsequent arrival in this country of the two big American distributors Vitagraph and Essanay in 1912. As with the Curzon Hall example, many early film posters were so-called 'stock designs', featuring a blank space for the overprinting of local show details. This blank area was often incorporated into the design as a cinema screen, which was either being watched by an audience or beamed from a projector operated by a pretty girl. The next stage in this stylistic development was represented by Thomas Edison's Motion Picture Patents Company stock one-sheet designs of 1910–12. These had illustrated borders in two or three colours, incorporating the production company's trademark, and a blank central space containing the title of the film, a plot synopsis and a photograph supplied by the

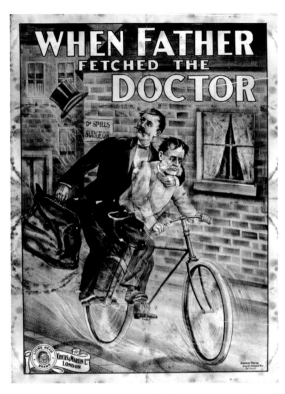

When Father Fetched the Doctor (1912). Printed by Barway Press. Other films in this popular series include *When Father Laid the Carpet on the Stairs* and *When Father Eloped with the Cook*, posters for which tragically seem not to have survived. (BFI)

Stonehouse and Francis X. Bushman'. This practice dated back only to 1910, when independent producer Carl Laemmle, later to found Universal Studios, lured Florence Lawrence away from her old company, Biograph, to work for him, and devised an elaborate stunt to publicise this.[27] The established producers had previously refrained from putting their stars' names on the posters for fear of encouraging extravagant salary demands, and Lawrence had originally simply been known as 'The Biograph Girl', but this soon changed for ever. The first *British* star was Gladys Sylvani, promoted by Cecil Hepworth in films like *Rachel's Sin* (1911).[28]

By around 1910, original artwork had started to appear in British posters – the first example in the BFI collection is the cheerfully xenophobic *Lieutenant Rose R.N. and the Boxers* (1911), in which our gallant hero is seen stabbing a representative of the Yellow Peril. In Charles Urban's *A Canine Sherlock Holmes* (1912), a dog is depicted sitting on a police-station desk presenting

producer. When Vitagraph and Essanay opened offices in London, this style was imported for their British posters. These measured 40" x 30" (a portrait quad, as distinct from the slimmer US one-sheets), and were mostly printed by either Jordison & Co. or Waterlow Bros. & Layton Ltd. The Vitagraph posters feature the company logo at the top, and elaborate floral borders surrounding one or two large stills, with a three- or four-line synopsis below the title. The Essanay posters are similar, but place the title at the top and company logo at the bottom, with decorative geometric designs in the borders. The overall effect is of a rather ornate book cover of the period. The titles are typically melodramatic: *As Fate Would Have It* from Vitagraph ('It turns out all right. She turns down the man she doesn't love. Waits for the man she does, and turns 'round and marries him'); and *The Virtue of Rags* from Essanay ('A unique drama of wealth versus conscience').

One immediately noticeable feature of these posters is that they were beginning to sell the films on the basis of their stars. *The Virtue of Rags*, for instance, was proud to be 'Presenting Ruth

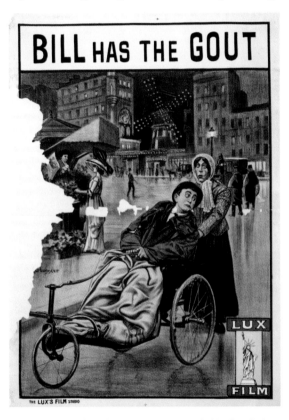

Bill Has the Gout (1912) No printer credited. A film for which the phrase 'They just don't make them like that any more' was surely invented. The possibility of sequels – 'Bill Has Scurvy', 'Bill Develops Septicemia' – must have been a tempting proposition for the producers. (BFI)

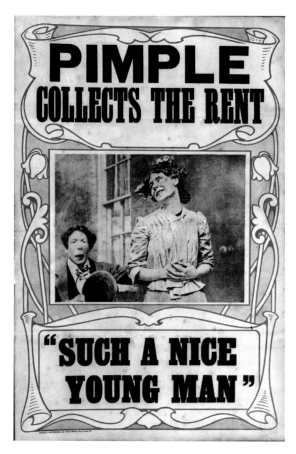

Pimple Collects the Rent (1912). Printed by Suttley. A Double Crown (30" x 20") format for this entry into the enormously popular slapstick series, written, directed and performed by Fred Evans. There were an astonishing 136 Pimple films, including *Pimple Does the Turkey Trot*. (BFI)

a letter in its mouth to a startled bobby. Artwork obviously allowed a much freer reign for more imaginative design strategies – *The Fairy Bottle*, also 1913, shows two leprechauns offering the magic bottle to a delighted Irish yokel, while the beautifully rendered fairy herself hovers discreetly among some trees to the right. We can be fairly certain that no similar scene would have featured in the film itself.[29] 'Selling Dreams' included similarly striking designs, distinctively cinematic illustrations in their own right. *The Girl in the Armchair* (1912) has a melodramatic montage featuring the eponymous heroine seated on the right, looking back towards a sinister pair of hands testing the combination lock of a safe positioned behind her. The style of the artwork is loose, but effectively urgent. Another singular composition is *The House of Mystery* (1913), in which three men cower at the foot of a moonlit flight of stairs looking up towards a windowed gallery, along which an eerie phantom

is drifting, its spectral arm pointing dramatically out of frame. The overall effect is chillingly gothic.

Stock posters, however, were still in use at this point, by now advertising individual companies. A design from 1914, illustrated by George Mitchell in traditional comic style, shows a dishevelled toff sitting in the road, his hat knocked off, as behind him silhouetted rioters fight to gain entry to a cinema. The caption is 'Great Scott! They must be showing a HEPWORTH FILM'. Another Jordison poster from the same period has a caricature policeman illustrated against a vivid orange background, carrying the caption 'We always have on hand a KEYSTONE COMEDY'.

The beginnings of what later became the British 'international' one-sheet can also be dated to this period. 'Selling Dreams' includes several British posters of 1912 printed by Waterlows, which although still 40" x 30", feature a three-inch border on the left containing the film's title printed vertically up the side, rather in the manner of a

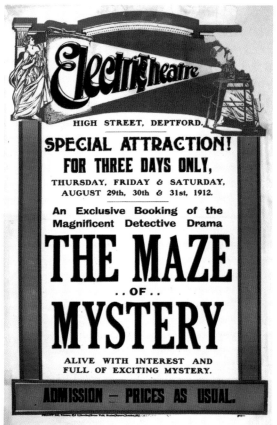

The Maze of Mystery (1912). Printed by Pollitt. An interesting stock letterpress poster – in this case for the Electric Theatre, Deptford – of a type that lingered on well into the 1920s. (BFI)

book spine, along with the printed instruction 'Cut here and paste onto Programme Board' – one assumes for possible display in a non-English-speaking country if the film was exported. A particularly amusing example of this style is *Lieutenant Daring RN and the Photographing Pigeon*, in which a rather nervous Lt Daring is held at gunpoint by two moustachioed villains, while the heroine, sporting a large and impressive hat, looks on blankly from behind a sofa. British three-sheets were also introduced at this time. The only contemporary example in 'Selling Dreams' is for the first (Italian) version of Lord Lytton's *Last Days of Pompeii* (1912), a dramatic but curious design in which an apparently blinded man and woman reach out helplessly in a darkened room.[30] The poster now seems prophetic of the war that was to engulf Europe two years later.

Among the minor effects of the Great War were not only the depletion of the British film industry and its further displacement by Hollywood, but the restriction of the poster business. There was a shortage of printing inks, which mostly originated as 'artificial coal-tar dyes' from Germany. Reds and blues were in particularly short supply, and had

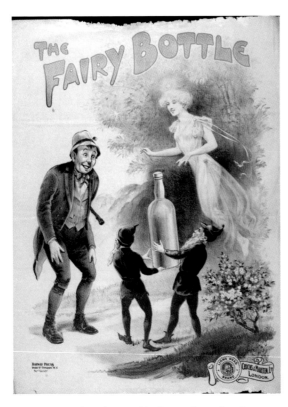

The Fairy Bottle (1913). Printed by Barway Press. A really charming illustration for this early British fantasy. (BFI)

quintupled in price during the first year of the war alone. In March 1916, the newly formed Royal Commission on Paper cut imports by one-third of the 1914 figure. This shortage of raw materials, and a slack demand for advertising space, forced printers and billposters to retrench. Additionally, following the Conscription Act of 1916, manpower became very limited, the obvious solution to which was the employment of women as billposters. One such early pioneer gave a frank and fascinating account of her experiences:

Most people think billposting a queer job for a woman, but I was tired of being in a corset factory, and wanted outdoor work, so when I saw an advertisement for women to take up the job I answered it and feel much better for the change. There is plenty of variety in the work, and much more to learn than you would think. I had to practise a long time before I could use a paste brush and post a bill properly. A poster covered with paste is as bad as sticky fly-paper to get mixed up with. Then I had to learn the different kinds of posters received from the printers, and how to sort and fold them, and the way to load a van.

I had two months training before going my first round without a man to superintend, but we girls have now been going out by ourselves for about six weeks. We go in motor or horse vans in parties of three – one to drive, and two to post. Handling the ladders is rather awkward, but especially light ones are given to us. Special uniforms – dark blue overalls, divided skirts, and black waterproof sou'wester hats – are provided, so I am alright for climbing ladders, and have worked so high as twenty feet up. It was rather giddy work at first, but luckily I have not dropped a paste pot on anybody's head yet. I have been chaffed and laughed at a good deal, but have to put up with that, though I sometimes feel I should like to give those who jeer a dab with the paste brush. I am only keeping things going until the war is over, and am not doing any man out of a job, so I get on very well with the men billposters.[31]

Throughout the war, the paper restriction orders grew steadily tighter. In April 1917, the maximum poster size permissible was limited to a four-sheet (a double quad crown) – the Government's original proposition had been a double crown, and this was only overturned after mass protest from the trade.

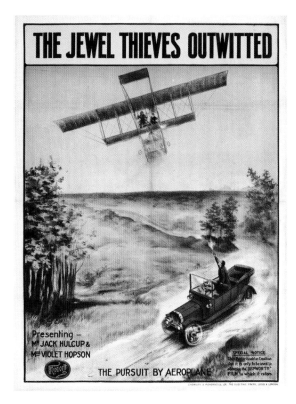

THE JEWEL THIEVES OUTWITTED

Presenting –
Mr JACK HULCUP &
Mrs VIOLET HOPSON

THE PURSUIT BY AEROPLANE

The Jewel Thieves Outwitted (1913). Printed by Chorley &
Pickersgill. A thrilling Cecil Hepworth melodrama, and another
prominent billing credit for its stars, in this case Jack Hulcup
and Violet Hopson. (BFI)

By April 1918, the import of paper had been cut
to one-sixth of the 1914 figure, and the printing
companies were becoming desperate. The previous
month, the Government had requisitioned Allens'
Harrow printing works for the use of the
Stationery Office, an act that effectively ended the
company's large-scale involvement in printing.[32]
Allens struggled on with two small presses in
Liverpool (letterpress) and Wandsworth
(lithography), but neither was profitable and both
closed in 1933, followed by the Belfast works in
1940.[33] Their billposting business, however, was
going from strength to strength, and, with
hindsight, was the activity the firm should have
immediately concentrated on following the loss
of the Harrow works.

Hardly any British film posters from the First
World War period have survived, and examples
from the early post-war years are barely more
numerous. In the 'Selling Dreams' exhibition, the
years 1915–31 are represented by US one-sheets
only, with not one single British poster in
evidence.[34] The 1920s were hard times for printers
trying to specialise in British cinema posters, as

the percentage of indigenous companies' share of
screen time sank to less than 5 per cent. Allens,
once the leading theatrical printer, certainly did not
believe that the business offered by film distributors
could replace the shrinking revenues from the ever-
smaller numbers of touring companies and
provincial theatres:

> During the decade between 1920 and 1930,
> the theatrical touring business, which had kept
> the machines at the Belfast factory turning for
> three quarters of a century, simply disappeared.
> Nor could the turnover be replaced by printing
> orders from the film companies. The majority
> of films were imported from America, where huge
> runs of posters were turned out to cover world
> distribution. An additional run of 5,000 or 10,000
> posters for the British market could be knocked
> off the machines in America for a fraction of
> the price which would pay for a new poster for the
> British Isles, executed in a British printing works.
> Only a high tariff [i.e. import duty] could have
> compelled the production in Britain of posters
> for American films, and the electorate was not

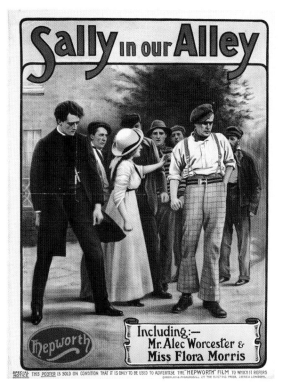

Sally in our Alley

Including:–
Mr. Alec Worcester &
Miss Flora Morris

Hepworth

SPECIAL NOTICE THIS POSTER IS SOLD ON CONDITION THAT IT IS ONLY TO BE USED TO ADVERTISE THE HEPWORTH FILM TO WHICH IT REFERS
CHORLEY & PICKERSGILL LTD THE ELECTRIC PRESS, LEEDS & LONDON.

Sally in Our Alley (1913). Printed by Chorley & Pickersgill.
Another domestic Hepworth drama, continuing his
revolutionary tactic of selling his films on the basis of their
actors. (BFI)

yet in the mood for tariffs. At the end of the twenties, Parliament was still only dickering with the 'safeguarding of industries'.[35]

However, while it is true that US films rapidly came to dominate British cinemas, domestic producers like Hepworth and Barker were still regularly turning out films requiring their own posters, and, moreover, some US firms (in particular, Essanay and Associated Biograph) were undoubtedly employing British printers to produce UK posters for their releases. Several other big British printing firms of the time – Stafford, Waterlows and Jordison are prominent names – did successfully involve themselves in the new market for illustrated film posters.[36] Perhaps Allens, as a family firm, was quite simply temperamentally averse to any real involvement with the cinema, being instead deeply tied sentimentally to their theatrical past. After the crucial loss of the Harrow

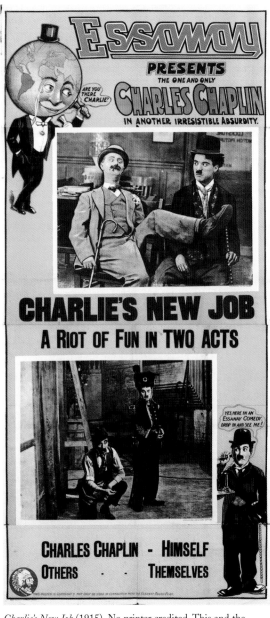

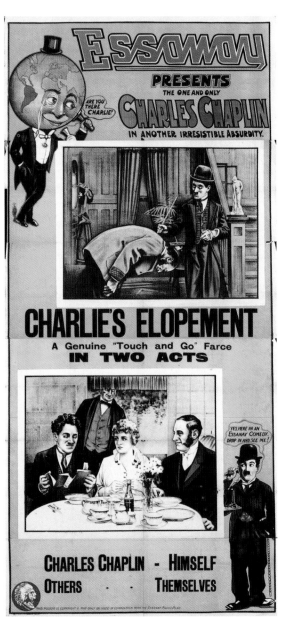

Charlie's New Job (1915). No printer credited. This and the adjacent poster are matching 90" x 40" three-sheets, utilising an economical stock format to advertise Chaplin's latest comic shorts – only the title and two accompanying photos needed to be changed. (BFI)

Charlie's Elopement (1915). No printer credited. The companion three-sheet to the adjacent poster. Stock posters like these were not only cheap to design and print, they would also have helped build audience familiarity through simple repetition. (BFI)

works, the firm ultimately lacked both the will and the means to take on the emerging film poster market, and consequently left the way open for their competitors.[37]

Among those competitors was the company that would become the second most important printer of British film posters (after Stafford): W. E. Berry Ltd. The company was originally set up in 1888 on 13 Currer Street, Bradford, by William Berry, who ran the firm in collaboration with a partner for about fifteen years. However, in the early 1900s, his son, William Edward Berry, succeeded him, but quickly found that he could not get along with his father's ex-partner – they accordingly split, and W. E. Berry set up on his own. William Edward's first significant move, sometime around 1910, was the acquisition of new premises, an old nine-bay three-storey Victorian factory at the bottom end of Nesfield Street in Manningham, to the north-west of Bradford city centre.[38] By 1920, the firm was producing posters for various aspects of the entertainment business, and one of its vaudeville clients, McNaughton, introduced William Edward to Fred Martin of Paramount. Martin began giving the company a steadily increasing amount of work. As well as printing for Paramount, Berrys also originally distributed all of Paramount's posters (including those produced by other printers). This generated so much business that, in the late 1920s, a new single-storey extension was built onto the side of the original works on Nesfield Street, which the family always maintained was essentially 'paid for by Paramount'.[39]

Although W. E. Berry discovered how lucrative the printing and distribution of cinema posters could be, times were generally hard for British films in the 1920s. However, a boost was given to the design of their posters by the involvement of the advertising agencies. The 'advertising agent' as a profession has actually existed in Britain since the early 19th century – two of the oldest firms recorded are John Haddon & Co. (1814) and G. Street & Co. (1830), though these initially operated strictly as straightforward 'space-brokers', simply buying up column inches in the newspapers and periodicals of the time, then selling this space

on piecemeal to private advertisers for a modest profit. Actual creative work did not begin to creep in until the 1890s, when agencies gradually started hiring freelance copywriters and illustrators to give their ads a more professional appearance. This development was partly prompted by the launch in 1896 of the *Daily Mail*, the first London newspaper to allow large broken-column advertisements featuring both eye-catching 'display type' and simple line illustrations.[40]

The Ten Commandments (1923). Printed by W. E. Berry. Possibly the earliest surviving film poster from this important printer, and in a unique 30" x 10" format, apparently never used again for a British poster of this type. (BFI)

The 1920s were advertising's breakthrough decade in creative terms, due, as John Treasure has commented, to the emergence of

two groups of people: printers who were developing many new, and reviving the best of the old, typefaces; and young post-war designers looking to change things, who were immediately receptive to both these printers, and the new ideas in design and style coming from post-war Germany.[41]

The two most important British agencies of the 1920s in this respect were S. H. Benson (est. 1893) and W. S. Crawford (est. 1914), who employed the widely influential art directors John Gilroy and Ashley Havinden respectively.[42] The earliest confirmed involvement of an independent agency in British film publicity is Greenly's handling of the Paramount account from 1922. America lagged behind Britain in employing agencies in film work, presumably as the Hollywood studios were hugely better resourced, and thus in a position to keep their publicity in-house for longer.[43] Historically, there were six individual agencies involved in film advertising

A Daughter in Revolt (1926). Printed by Jordison. The first of two different designs for this comic melodrama, this version focuses on its heroine, and her undeniably shapely legs. (BFI)

in Britain, of which two later merged, while two others subsequently spun off independent design studios, who then went on to compete directly with their 'parents'. Accounts passed around between these agencies over time. The original six all date from the inter-war years: Greenly's, United Kingdom Advertising, Downton's, Allardyce Palmer, Dixons and Rex Publicity:

- Greenly Ltd was first set up in 1918, and by 1936 was based at 5 Chancery Lane WC2. The agency handled the Paramount account, which for forty-five years was run by Greenly's chief art director, Frank 'Mary' Pickford, who dealt directly with Paramount publicity men Jerry Lewis and (later) Leslie Pound.[44] While most of the agency's work consisted of adapting Paramount's American campaigns, Pickford would design the many 'extras' that were involved in the marketing and distribution of a film – from front-of-house displays to literature for premieres. Greenly's must also have produced original designs for the increasing number of Paramount-British productions after 1930.

- United Kingdom Advertising Co. Ltd was formed in 1923, with offices at 25 Shaftesbury Avenue on Piccadilly Circus, and was quickly handling display advertising and the design of blotters for the Post Office.[45] In early 1933, the agency was involved in a dramatic legal battle with *Reynolds Illustrated News*, which had published a salacious exposé of a dubious London nightclub (named the Thames Riviera) that UK was leasing. The agency promptly sued for libel, and the case was reported in *The Times* on 8 March. The article described UK's principal business as 'billposters and general advertising contractors … especially [for] the advertising of theatres, cinema houses, restaurants and the like', and it seems clear that by this point UK was heavily involved in cinema advertising work. By the end of the war, the agency was running two major film accounts: MGM and half of United Artists.[46]

- Downton, Hill & Pawsey was also established in 1923, at 35 Surrey Street, Strand WC2, and by the end of the 1930s was being run by the brothers Charles and Fred Collins, plus a third partner named Curwen. Another firm the entrepreneurial Collins brothers owned at the

time was Charles Alexander, a hair-salon equipment-supplier based in Surbiton, whose financial director was John Davis, better known as the chief accountant of the Odeon cinema chain. When Rank acquired Odeon at the end of 1941, the connection with Downton's must have been quickly made. Apparently, Rank at first tried to buy the firm outright, until it was pointed out that it was considered unethical (at least at that time) for a company to control its own advertising agency.[47] After some negotiation, a less direct arrangement was made, and a new company, Downton Advertising Ltd, was registered at Companies House in June 1942. The agency handled the accounts of the Rank-Odeon-Gaumont group, United Artists and British Lion.

- Allardyce Palmer was founded in 1930 by George Allardyce and H. E. Palmer, originally based at 4 Carmelite Street EC4. When Allardyce acquired two large film accounts, Warners and Fox, around 1936, their co-tenant in these offices was Bateman Artists, an older design studio of about a dozen staff, itself first established in 1925 by Bill Bateman at 44–5 Fleet Street. Allardyce began employing Bateman Artists to produce their film poster artwork.[48]

- Arthur S. Dixon was originally founded in 1933 at 1 Portsmouth Square WC2, and at some point before the end of the Second World War began handling the Columbia and Disney accounts.

- Finally, Rex Publicity first appear in Kelly's Street Directory in 1936, where they are uniquely described as 'Specialists in Cinema Publicity', based at 31 Golden Square W1. By 1942, they had moved to 149 Lupus Street, Victoria SW1, and were exclusively handling the ABC circuit's publicity, an account they managed to hang onto (apart from one short blip) for more than forty years. Rex's managing director was George Stewart, who had started out as a journalist on Glasgow's *Jewish Echo* newspaper in the early 1930s, writing a small 'film notes' column as a reward for first selling advertising space to the relevant cinemas.[49] This 'Glasgow Connection' (with Associated-British chiefs John Maxwell and Robert Clark) undoubtedly later accounted for Rex's long relationship with the ABC chain.

We will revisit these agencies in Part Two, but first we must return to the poster designs of the 1920s.

The tiny handful of British posters that have survived from the era of jazz and the General Strike give only the most tantalising glimpse of possible riches. The majority of these posters are three-sheets (then known as six-sheets), the smallest size printed for many films. Two examples from 1920, *The Way Women Love* and *Hearts and Treasures*, are typical of the period. *Hearts and Treasures* has lush artwork by Cecil Barber, showing its glamorous blonde heroine luxuriating in the sunshine of her country-house patio while sporting a fetching pink gown. *The Way Women Love* is even more contrived, with a clearly disconcerted man opening his front door to an unexpected late-night caller, a mysterious woman in matching red hat and coat. A third Mercury Film Service release, *Impulse* (1922), has a similar domestic scene: a young couple having a heart-to-heart, as their maid eavesdrops in front of an adjacent fireplace. All of these use full-length figures to fill the height of the 90" x 40" format, but their designs cannot really be described as anything other than painfully stilted.

A Daughter in Revolt (1926) Printed by Weiner. This second design emphasises the dramatic night-time chase sequence. (BFI)

College (1927). No printer credited. This is a 22" x 28" half-sheet, a popular format for lobby display that began to emerge at around this time. There are no clues as to whether this example was printed here or in America, but it certainly ended up being used in a British cinema. (BFI)

Wait and See (1928). This and the following six illustrations show the 'poster pages' of several early pressbooks, and demonstrate the variety of formats and designs available during the transition to sound. In this broad comedy, Walter Forde is tricked into believing he is heir to a fortune. (Courtesy of Steve Chibnall)

More imaginative are two other three-sheets of 1921, *Polly* and *Fight in the Thieves Kitchen*, both short films in separate multi-episode series. *Polly*, one of twenty-eight macabre short stories making up a 'Grand Guignol Series', has a melancholy portrait of its heroine at the top, above an aerial view of London with St Paul's in the foreground. The artwork, by Dick Baker, is in striking green and orange against a flat black background. *Fight in the Thieves Kitchen* is more lively, its central portion illustrated with a bright scene of various bobbies arresting a group of flat-capped thugs. This is from a series entitled 'Tales of the Life of a Great Detective', but uses its three-sheet format rather less effectively, the bottom third being made up purely of breathless text, verbosely attempting to sell the excitement of the story.

Among the vertical quads (i.e. 40" x 30") to have survived is *The Sea Urchin* (1926), a romantic comedy starring the popular Betty Balfour as a dancer in a Paris nightclub in trouble with the club owner – she is rescued by a pilot, and they stow away together to Cornwall. The comic poster shows her peeping out of a barrel featuring the cast and credit details printed over it, against a plain orange background. Two other surviving posters in this format are a couple of alternative designs for *Daughter in Revolt* (1926), a comedy in which a lord's daughter is suspected of burglary after she changes places with a friend for a prank. The designs deliberately emphasise the farcical storyline.

POSTERS

6-Sheet No 1, 2/3 each 48-Sheet, 15/- each 6-Sheet No. 2, 2/3 each

12-Sheet No. 1, 4/6 each Double Crown, 6d. each 12-Sheet No. 2, 4/6 each

High Treason (1929). An interesting and eerily prescient fantasy, set a decade into the future, in which a group of women unite in 1940 to prevent unscrupulous financiers engineering a Second World War. Some hope. (Courtesy of Steve Chibnall)

One was printed by J. Weiner, a long-established London theatrical printers, and the other by Jordison & Co., who printed many of the most vivid of the early illustrated posters, but are now better known for their railway work.[50]

In the main, British posters from the silent era appear innocent and unthreatening. Time has endowed them with period charm; but in their day, some aroused consternation among moral guardians, just as theatre posters had done. *The Times* periodically reported on the shifting battleground of film poster censorship, from the appearance of the earliest illustrated posters around 1910. One of the first skirmishes appeared in the issue of 20 October 1916, under the heading 'Cinema Posters – Control under the New Censorship'. The report began, 'Some interesting details of the proposed new cinema censorship and its aims were given by Mr Herbert Samuel, to a deputation which waited upon him from the billposting trade on the subject of billposting and the cinematograph.' The suggestion was that the Home Secretary (Samuel) was 'considering the advisability of appointing censors', and referred back to the historical campaigns of SCAPA and co., which had led to the billposters forming their own censorship committee. Mr Charles Pascall, the billposters' spokesman, explained to Samuel that his committee had rejected an average of six poster designs per week over the previous three years. He also gave an assurance that 'When a poster was

condemned … it would not appear on any hoarding in the United Kingdom', but crucially admitted that his committee 'could not control the hoardings outside cinema palaces'.

Pascall was obviously anxious to avoid state intervention in poster censorship, and referred Samuel to relevant 'correspondence with Vitagraph, Exclusive, Moss Empires, Transatlantic Film Company and others, and said that a conference of the trade was held some weeks ago at which cinematograph proprietors were present who expressed their appreciation of [the billposters' committee] and were willing to fall into line'. Samuel was conciliatory, and acknowledged that it was 'greatly to the credit of the trade' that they were so proactive, but warned that

> some of the posters advertising cinema plays had given a good deal of offence here and there, and many of them were of an ultra-sensational character, and had a bad effect on young people. There were also the posters (over which the billposting trade had no control) which were on the premises of cinema theatres themselves […] There was a general desire that there should be some power to cope with the evils that had to some extent arisen in the past, and might arise in the future, relating to [these] cinema posters.

Samuel obviously had in mind some committee attached to the recently established British Board of

Film Censors (BBFC), and advised the billposters to contact this when it was up and running.

Predictably, the problem posters were usually not British designs, but those imported from countries like America and Italy. French design could also be problematic, as evidenced in the short report entitled 'A Film Poster Banned' in *The Times* of 16 February 1922. This set the tone of the debate for the next sixty years:

> We are informed that the authorities of the underground railway have refused to allow the exhibition on their stations of a poster advertising the French film 'L'Atlantide', which is running for a season at the Royal Opera House, Covent Garden. It represents a female figure rather scantily covered. Mr Walter Wanger, who is directing the film season at Covent Garden, contended yesterday that there was nothing suggestive about the poster, and that it was 'atmospheric' rather than definite. On

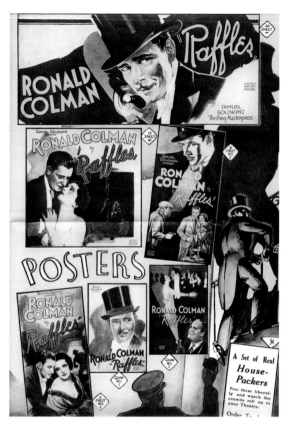

Raffles (1930). Ronald Colman as the dashing gentleman thief, coming out of retirement to carry out one last job, in order to save a suicidal schoolfriend from disgrace. (Courtesy of Steve Chibnall)

> behalf of the Underground, it was stated that although it might not offend most people, yet the minority had to be thought of.

Local outcries of this type seem to have been intermittent throughout the 1920s. One amusing letter on the topic, adopting a more tongue-in-cheek tone than usual, appeared on 10 May 1929:

> Sir, At Addlestone in Surrey, I see there have been protests to the local council about cinema posters being displayed in the town as being 'disgusting and offensive to the taste of pure-minded passers-by'. I am perhaps not pure-minded enough to add weight to such a protest, but I have long wanted to protest against 95% of the cinema posters that are pasted on the hoardings on the grounds of their being 'disgusting and offensive to the taste of people with any taste at all'. When one reads of the thousands of dollars and pounds spent on the production of quite ordinary films, to say nothing of super ones, and remembers the good French cinema posters we

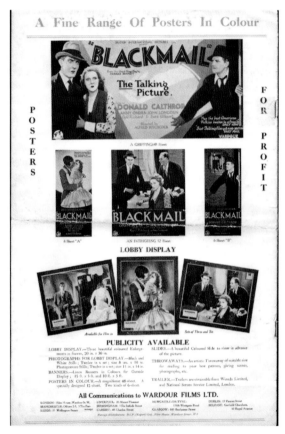

Blackmail (1929). The heroine is actually being blackmailed for stabbing a lecherous artist, and let's face it, we all know what they're like. As with most of the other pressbook-illustrations reproduced here, copies of the posters themselves are extremely unlikely to have survived. (Courtesy of Steve Chibnall)

used to see in this country before the War, it seems strange those in authority should not spend a little more trouble to commission tolerably decent posters. At present they seem content to get any lithographer's apprentice to enlarge a photograph on the stone, and print it in any colours that happen to be handy.

Even assuming the photographic basis were insisted upon, what an amazing opportunity for some of our young artists (and older ones for that matter) to produce a series of posters of real taste, well treated, worth looking at, that would 'talk' better than the heroes of many 'talkies'. It cannot be for want of money (for much of the trash now displayed is expensive to print); it cannot be for want of talent among the artists (for am I not one myself?): it can only be lack of thought, not troubling to perfect every detail of production that accounts for no offensive being taken against these posters that are so 'offensive to the taste' of so many passers-by, including, yours faithfully, Hesketh Hubbard, E4 Albany, Piccadilly W1.

Most authorities describe 1927 as a benchmark year for British cinema, as this was the year that saw not only the coming of sound but also the passing of the Quota Act, which quickly had a profound effect on indigenous film production. The popular perception of Hollywood as a 'Dream Factory' also dates from this time, as it entered what is widely considered to be its Golden Age, producing glamorous and sophisticated entertainments sold around the world on the basis of their internationally famous stars. The pressbooks in the Steve Chibnall collection depict the growing variety and sophistication of the film publicity campaigns in the transition from silent to 'talking pictures' and the importance of posters in an increasingly competitive market. New Era's campaign for the Stoll-Hugon silent production *The Temple of Shadows* (1927) – an exotic 'Romance of the Orient', made in France but starring the British actress Queenie Thomas – featured only three sizes of poster. The largest is a 48-sheet, while the smallest is a six-sheet. All carry no copy beyond the title, and the names of the distribution and production companies and the two stars. By the time New Era distributed one of the first of the new 'quota films' – *Q Ships* (1928), a patriotic tale of Britain's defeat of the U-boat menace – it offered a greater choice of 'posters with Pulling

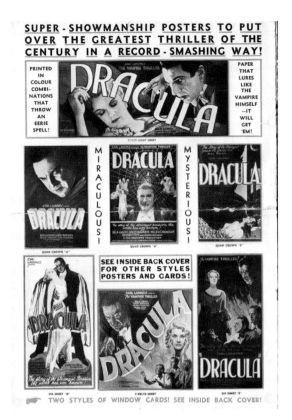

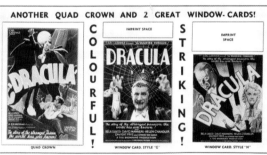

Dracula (1931). The film that began the first great American horror cycle. All ten alternative formats naturally highlight the delightfully campy star performance. (Courtesy of Steve Chibnall)

Power'. While the artwork was as crude as ever, there was now an alternative six-sheet, a double crown, a linen banner in two sizes, a box-office card strung for hanging and a choice of four expensive painted wooden signs (available from Cinema Signs Ltd of 147 Wardour Street). Rather less extravagantly, another British distributor, Butchers Film Service, advertised Walter Forde's first full-length English comedy, *Wait and See* (1928), with only three photomontaged posters. However, Butchers assured exhibitors that 'These attractive bills give a foretaste of the mirth provoking qualities of Walter Forde's Greatest Comedy', while

the copy on the 48-sheet guaranteed 'Chuckles! Laughs!! Shrieks!!! Spasms!!!!'.

The pressbooks in the Chibnall archive suggest that most American distributors initially offered imported original posters to exhibitors who needed to promote Hollywood products. A comparison of United Artists' British and American pressbooks for *Raffles* (1930) reveals that the posters for the UK were identical to those used in the USA, save for the subtraction of the American window card. The British campaign book even uses the original American artwork for its poster page, blanking out the window card and substituting a description of the remaining posters as 'A Set of Real House-Packers. Post them liberally and watch the crowds roll up to your Theatre.' The only other change is in the nomenclatures given to the different poster formats. This mainly involves a doubling of the number of sheets: thus the American '24-sheet' becomes a British '48-sheet', the American 'six-sheet' is renamed a '12-sheet', the alternative 'three-sheets' are now 'six-sheets', and the two variant 'one-sheets' are re-designated as vertical 'quads'. The set is dominated by the image of a suave and debonair Ronald Colman, but also illustrates his 'love interest' in the form of Kay Francis, and relegates a more criminal form of nocturnal activity to the background.

While the *Raffles* pressbook recommends a host of appropriate 'catchlines', the posters themselves carry no taglines or promotional copy beyond the name of the film's star. Ronald Colman was presumably thought to be a sufficient draw. On the other hand, the 1931 poster campaign for Universal's *Dracula* was an orgy of lurid imagery and florid prose. The British pressbook announces 'Super-Showmanship Posters to put over the Greatest Thriller of the Century in a Record-Smashing Way', and informs exhibitors that they have been printed in 'colour-combinations that throw an eerie spell!', creating 'Paper that lures like the Vampire himself'. As well as a 48-sheet full of erotic menace, there is a clumsily designed 12-sheet, two rather poorly rendered six-sheets, two variant window cards and half-sheets, and no fewer than four vertical quads. Most announce the film as 'The Vampire Thriller' and carry the tagline: 'The story of the strangest Passion that the world has ever known!'. Although the set is striking, there is little sense of a unity of design. Most of the posters derive from Universal art director Karoly

Grosz's original American campaign (including the 'insert' poster illustrated by Grosz himself), but some may have been added for the UK release.[51] One-sheets have again become vertical quad crowns without alteration. A variety of artists has been used, and the 12-sheet looks like a collaborative effort. There has been no attempt to create a logo for the film, each artist being allowed a free hand in the typography of the title in either red or yellow. The different styles of quads would have allowed the exhibitor to pick the appropriate image for his or her locality. One has a simple image of a brooding Bela Lugosi, which would have been acceptable, perhaps, in more culturally conservative areas. Another features a more frightening photographic image of Lugosi in a menacing pose behind a spider's web. The remaining two quads offer greater sensationalism for thrill-hungry patrons: one (identical to the cover of the Grossett & Dunlop film tie-in edition of Bram Stoker's novel) includes the daring partial exposure of the vampire victim's breast; while the other (also American in origin) presents a wildly homoerotic version of 'the strangest Passion that the world has ever known'), as a distinctly camp rendering of Lugosi reaches out for a lad on the deck of a ship.

This sort of imagery was guaranteed to spark further concern among moral entrepreneurs. The

Rome Express (1932). Some effectively urgent graphics here, featuring yet another blackmailed starlet, this time forced to help a gang of crooks steal a valuable painting aboard the eponymous train. (Courtesy of Steve Chibnall)

That's a Good Girl (1933). An early British musical set in France, featuring a rather convoluted comic match-making plot. Note that the 'quad' is still portrait format. (Courtesy of Steve Chibnall)

concern deepened as more of Universal's horror films began to cross the Atlantic, and UK cinemagoers were treated to more unrestrained designs by Karoly Grosz. Universal's 'house artist' had a very distinctive style, employing gloomy expressionist motifs and sickly looking greens, reds and yellows to create startlingly oppressive illustrations, including those for *Frankenstein* (1931), *The Mummy* (1932), *The Old Dark House* (1932), *The Invisible Man* (1933), *Murders in the Rue Morgue* (1932 – a particularly morbid triumph), *Bride of Frankenstein* (1935) and *Dracula's Daughter* (1936).[52] The latter, with its fairly overt lesbian subtext, caused especial outrage.[53] Within a couple of months of *Frankenstein*'s appearance, however, the distributors were already in hard retreat. *The Times* of 28 July 1932 carried a report headlined 'Rules for Exhibition of Film Posters – Objectionable Matter to be Banned', which explained:

> Film renters in this country have agreed, after consultation with the British Board of Film Censors, to ban any poster which might be considered objectionable. The secretary of the Kinematograph Renters Society of Great Britain and Ireland stated yesterday that members of the society had agreed to observe the following three rules: No poster which is considered objectionable, or one which exhibits a scene not in the film, shall be exhibited; all publicity matter, including

> programmes, shall also conform to this rule; and the certificate A (Adults Only) or U (Universal) shall appear on all posters and publicity matters. 'These rules', said the secretary, 'will come into operation immediately the current stock of posters is used up. All the members have been circularised, and have agreed to abide by the rules. A year ago, this society circularised all the renters, urging them more carefully to scrutinize their publicity matter, in order to avoid giving any cause for attacks on the trade. There was an improvement then, but I reminded them two or three months ago, and the present decision is the culmination of our work in this direction.

This report drew a smug letter of congratulation from the billposters' censorship committee itself:

> Sir, As President of the British Poster Advertising Association, may I congratulate the cinema industry on its decision to set up a voluntary censorship of the posters it displays outside picture houses? For the past 42 years my association, in conjunction with the London Poster Advertising Association, has had a censorship committee at work, and the fact that nothing of an objectionable character is allowed on the commercial hoardings is, I think, a tribute to its work. Our committee, we claim, has done all that an official censorship could possibly have done, and that without cost to the

public purse. If the new cinema poster censorship is as effective, we shall have good ground to congratulate ourselves that our example has been followed. As we told Mr Shortt, the film censor, when the question came up some weeks ago, we shall be very glad to put at his disposal the experience we have gained in our work. May I formally renew that offer, and say that we shall be very glad to co-operate in any way possible with the new Cinema Poster Censorship Committee? I am Sir, yours very truly, C. W. Gardner, BPAA, 48 Russell Square WC1.[54]

A purer example of humbug would be hard to find.

In January 1933, following lobbying from concerned organisations like the NSPCC, the BBFC began to award certain 'A' films (to which children could be admitted if accompanied by a 'responsible adult') an additional 'Horrific Advisory' classification, beginning with Carl Dreyer's *Vampyr* (1932).[55] Six months later, in June,

the London County Council ensured that these films had a special notice, 'THIS FILM IS UNSUITABLE FOR CHILDREN', attached to each cinema's category board, 'in letters not less than 1½" high'.[56] Four years later (June 1937), the BBFC finally introduced the 'H for Horrific' certificate excluding under-sixteens, and it remained in force (although comparatively little-used) until its replacement in January 1951 with the general-purpose Adults Only 'X'.[57]

Direct poster censorship and the 'H' certificate were, by and large, restrictions that affected imported posters and films. Indigenous British poster campaigns were generally more restrained in their imagery and copy. Wardour's campaign for Alfred Hitchcock's *Blackmail* (1929), for instance, steered clear of anything that might offend the sensibilities of respectable patrons. Only one advertising block utilised the now iconic image of Anny Ondra in her camiknickers, knife in hand. The posters 'Gripping 48-sheet' did not even

Duck Soup (1933). An American-printed half-sheet, which was clearly imported into Britain for use, since it features the then-recent innovation of a BBFC certificate stamp. This must be the most brilliantly designed of all Marx Brothers' posters. (BFI)

trumpet it as the first British talkie (perhaps because competitors may have beaten it onto general release). Instead, it was declared 'The Talking Picture', and patriotic sentiment was mobilised with two press endorsements: 'Best talking film yet – AND BRITISH' (*Daily Mail*), and 'Has the best American Talkies beaten to a frazzle' (*Daily News*). But the artwork was as static as the reference stills it was copied from, as were the 'Intriguing 12-sheet' and the two variant six-sheets. Unfortunately, none of these posters survives. In fact, it was believed that there were no remaining examples of British posters for Hitchcock's pre-war films until the discovery of two different three-sheets (87" x 40") for *The 39 Steps* (1935), which were auctioned at Christie's in 1997.[58]

The Gaumont-British campaign for the first British science-fiction talkie, Maurice Elvey's *High Treason* (1929), was a little more dynamic. Billing it as 'The World's Greatest Talkie', Gaumont tried

hard to give this 'Spectacular Film Forecast of Love and Life in 1940' a suitably modernist poster design, especially in its 48-sheet. But bets were hedged and conventionally rendered 12- and six-sheets – which placed the emphasis on the relationship between Benita Hume and Jameson Thomas, and gave little suggestion of the film's futuristic theme – were offered as alternatives. Again, rather more striking images of Miss Hume adjusting a garter atop a skyscraper, and New York being bombed and gassed by airships were relegated to the advertising blocks. Wardour, who distributed BIP's films, created a more memorable campaign for Victor Saville's 'Thrilling Spy Drama' *The W Plan* (1930). The posters demonstrate the power of the logo – in this case, a giant 'W' superimposed over the wide-eyed stare of a German soldier. It featured in all of the picture's advertising, from double crown to 48-sheet, and there was at last a sense that a British campaign had been art-directed. The importance attached

You're Telling Me (1934). A second example of this type of imported half-sheet, featuring another BBFC stamp, and an effective caricature of its curmudgeonly hero. (BFI)

to poster promotion was evident in Wardour's bedsheet-sized pressbook for the popular nautical comedy *The Middle Watch* (1930). 'Say it with POSTERS!', proclaimed the back page, which displayed a handsome set of five, including a 'wonderful, specially-designed 12-sheet', all graphically roped together.

Perhaps Gaumont learned from the success of the Wardour campaigns, because it made a rather better fist of marketing Walter Forde's hit thriller *Rome Express* (1932), with poster graphics that managed to capture a sense of speed and intrigue. The posters were given a common logo, with the typography suggesting a locomotive in full steam. But, although the pressbook insisted that 'there's a poster for every need', it offered only four designs, none smaller than a six-sheet.[59] Gaumont-British saw no need to increase the selection, even for a potential blockbuster like *Rhodes of Africa* (1936). The company prided itself on quality rather than quantity, and it managed to produce four beautifully rendered posters for *Rhodes*

The Ghost Goes West (1935). No printer credited. A striking three-sheet for this light-hearted comedy, with Robert Donat in full Highland regalia. (BFI)

Peg of Old Drury (1935). Printed by Waterlows. Another big three-sheet, with a fine sketch of Anna Neagle in vivid 18th-century costume. (BFI)

Everything is Thunder (1936). Printed by Stafford. Another landmark – the earliest example in the BFI archive of a landscape 30" x 40" quad crown poster. The gradual adoption of this format would revolutionise the design of British film posters. (BFI)

that stand comparison with most of the artwork being used in Hollywood. The pressbook advised exhibitors, some of whom were still tempted to save money and make their own ads, to 'Sell it with Posters', but added:

> They must be the right kind of posters. We have all seen the handwritten letter-press bill, crudely executed in lurid colours. It finds no place among our accessories for we believe that a well-designed, excellently lithoed pictorial bill more than justifies the little extra cost. Why not sell pictures with pictorial matter?[60]

Gaumont certainly created a more confident and assured campaign for their 1936 science-fiction picture *The Tunnel* than they had for their earlier effort in the genre, *High Treason*. The arresting dominant image of Richard Dix staring darkly from behind the glass of his oxygen helmet was well supported by some nice period imaginings of future transport.

By 1935, United Artists, the only American company that consistently distributed 'quality' British films, were setting the standards for the overall design of marketing campaigns, if not always for the beauty of poster illustrations. Their pressbooks, even for medium-budget pictures like British & Dominion's *While Parents Sleep* and *Where's George?* (both 1935), are full-blown campaign manuals, advising on every detail of film promotion in a dossier with colour-coded pages. Showmen were told that the larger posters for Criterion's more ambitious *The Amateur Gentleman* (1936) had been 'specially designed and executed in brilliant colours so that they will attract from a great distance', and that the duo-colour double crown was 'designed to get your message across in a clear and distinctive manner'. The campaign for *While Parents Sleep* lapsed into poetry – 'Tell them with these Posters Bold – and they'll be worth their Weight in Gold' – and recommended that the different sizes of poster be used in sequence:

> Plaster the town; post these pictorials wherever you have a site. Build up your campaign by commencing with six-sheets, then on to twelve-sheets and finishing up with forty-eight-sheets. It's a big picture and the way to big business is to bill big!

The design progress made by United Artists, Gaumont and other distributors by the mid-1930s did not go entirely unnoticed by filmgoers. For example, A. Thomas of Cardiff wrote in appreciation to the fan magazine, *Picturegoer*:

During the past few years kinema posters have improved beyond measure. Gone are the gaudy caricatures, greatly exaggerated incidents that may, or may not, have appeared in the films. In their place is an all-round high standard and a general level of good taste. Indeed, the best posters are works of art. I remember particularly the fine study of the head of 'Tiger' King that served to advertise *Man of Aran* [Gaumont-British, 1934]. The lovely pastel of Elizabeth Bergner in pensive mood, issued for *Escape Me Never* [United Artists, 1935], was worthy of framing. The highland scenery posters for *The Thirty-Nine Steps* [Gaumont-British] were superior to those used by travel agencies. Modern posters have not only beauty, but wit and subtlety. The solitary top hat and exclamation mark publicising the latest Fred Astaire and Ginger Rogers musical means more than a whole string of the ripest superlatives.[61]

Of course, not everyone shared these views. Bernard Heath of Brighton put the case for the prosecution in the same issue of the magazine:

While we have reached an undreamed of standard of film entertainment, the most tawdry and vulgar form of advertising films still persists. Highly-coloured, ugly and exaggerated posters, vulgarly ornate cinemas, silly slogans and a glut of superlatives to describe each new picture. […] Kinema should be on the same dignified footing as the theatre, and cut out all this shoddy cheap advertisement.

While there is increasing evidence of thoughtful art direction in the 1930s, even towards the end of the decade, a leading British distributor like GFD could still happily mount a curate's egg of a campaign, such as the one for Carol Reed's *Bank Holiday* (1938). Individually, the posters are striking, and the 12-sheet – in which the windows of the railway carriage ape the appearance of a strip of celluloid – is inspired, but there is a complete absence of any continuity of design. Sometimes, British distributors seemed to find it hard to grasp

His Lordship (1936). Printed by Stafford. Another very early quad, for a popular comic drama. At this stage designers were still including blank areas for overprinting of local show details, as can be seen here at bottom right. (BFI)

Ball at Savoy (1936). Printed by Jordison. A very bright and cheerful three-sheet, this seems to be one of the very last posters to carry a Jordison credit, since the name does not appears on subsequent quads. (BFI)

the unique selling point of their product. With the first British feature in colour, it should have been easy, but, while 20th Century-Fox's American campaign for *Wings of the Morning* (1937) stressed that the picture was 'In Natural Technicolor!', the British posters preferred to announce the presence of Irish tenor John McCormack. One had to scan the small print to discover that it was not the customary British black-and-white film. The critically praised *Ourselves Alone* (1936) could also

claim to be more than the usual British black-and-white film, but its posters' tagline – 'Impassioned Drama of Young Irish Hearts in Rebellion Fighting for Freedom and Ideals' – hardly prepared audiences for its Anglo-Irish police heroes.

Domestic poster campaigns were now developing their own conventions that suggested the genre and characteristics of the film. For instance, comedy, the staple genre of British cinema in the 1930s, was connoted by cartoon and caricature. United Artist's campaign for *Chick* (1936) is a perfect example. All the posters include caricatures of the star of the picture, the sleepy-eyed Sidney Howard. The distinctive facial features of comic actors like Jack Hulbert, Tom Walls, Ralph Lynn, Will Hay and the members of the Crazy Gang lent themselves easily to the caricaturist's art. Gaumont's posters for Walls and Lynn's Gainsborough farce, *Stormy Weather* (1935), and those produced by GFD for Gainsborough's Crazy Gang knock-about, *OK for Sound* (1938), show how effective the use of cartoon imagery could be. However, Jack Hulbert's pendulous chin was the only point of recognition in the crudely executed posters that promoted London Film's *Paradise for Two* (1937), in a campaign that marked a low point in United Artists' publicity. This did not stop the pressbook claiming that the set of posters, 'modern in style and as brilliant as the wit of the picture', had been illustrated by 'skilled artists' and was a 'Paradise for Showmen'. The quality of artwork had been a good deal better in the posters advertising the same distributor's Jack Buchanan vehicle, *That's a Good Girl* (1933), but United Artists' ad hoc approach to art direction was a weakness in what were usually carefully thought-out promotional campaigns.

For a romantic comedy like *School for Husbands* (1937), which starred Rex Harrison and Diana Churchill, GFD combined cartoons of two figures in top hat and tails with realist portraits of the stars. The posters targeted a female audience with the tagline: 'A Comedy for Wives'. Similarly, while the largest and smallest posters for *Gangway* (1937) featured photorealist paintings of the film's star, Jessie Matthews, the 12-sheet offered a caricature of Miss Matthews with the disturbing suggestion that enterprising showmen might cut out the eyes and place them on a roller to make them move to and fro.[62] This sort of suggestion was usually reserved for portraits of the monstrous antagonist

in horror films. Showmen were certainly encouraged to mutilate the 12-sheet for *Dark Eyes of London* (1938): 'Use the large head of Lugosi as a cut-out. Mount it on compo-board and use green lights in the eyes. The lights should be the blinker variety, for they are more arresting.'[63] Many large posters of the 1930s were designed to be cut up and used for stand-up displays in cinema lobbies, and this cannot have improved the survival chances of pictorial paper that would now be worth a king's ransom to collectors.

In a cinema that depended so much on the appeal of stars, portraiture was usually vital to poster design. Therefore, it is not surprising to find paintings of the cadaverous face of George Arliss dominating any action in the posters for Gaumont-British's *Doctor Syn* (1937); and the well-known visage of Tom Walls presiding over the thrilling and mysterious elements in the three GFD designs for Gainsborough's *Strange Boarders* (1938). It was not unusual for thrillers to be marketed on the basis of their stars, and so Gordon Harker's name appears above the title of *The Frog* (1937), while his portrait is the central element in GFD's imaginative graphics for this Edgar Wallace mystery. Adaptations of best-sellers and literary classics would often incorporate a copy of the book into their poster designs. The 12- and 48-sheets for Asquith's 'Epic of Gallipoli', *Tell England* (1931), both depicted Ernest Raymond's popular novel in the background.

Occasionally, poster campaigns would employ wider advertising conventions to soothe consumer fears. Thus, in the anxious period of readiness before the Second World War, London Films released *Farewell Again* (1937), a story of love and separation, centring on a troop ship. Announcing that 'Some of the finest artists in the land have been commissioned to design and execute the posters', United Artists offered six- and 12-sheets that were rendered in the style of modernist travel posters, suggesting romantic visits to foreign parts rather than military preparations.

Given that there were more than 4,000 cinemas in Britain in the 1930s and that a billboard poster was standard for first features, there must have been a large number of advertising hoardings in the country's towns and cities. This may, in part, have been a consequence of the slum clearance and new build taking place at the time. The hoardings concealed building work and protected the public

Chick (1936). Printed by Waterlows. A fine caricature of popular comedian Sidney Howard, in the title role of a humble college porter who inherits an earldom. (BFI)

from its dangers. The posters for outdoor advertising were large, and frequently located at a distance from the cinema. As these bills would have been pasted up, very few remain. Not surprisingly, the first three 1930s British posters featured in the 'Selling Dreams' exhibition are all UK half-sheets: the Marx Brothers' *Duck Soup* (1932), W. C. Fields's *You're Telling Me* (1933) and Max Reinhardt's *Midsummer Night's Dream* (1934). These are all identifiably British, as they each carry a BBFC 'U' certificate stamp, a convention that first began during this period. Both the Fields and Marx Brothers' posters use simple but effective caricatures of their comic heroes – *Duck Soup* is particularly brilliant, reducing Groucho to his constituent facial elements of a wavy centre-parting, glasses, moustache and cigar. *Midsummer Night's Dream*, in contrast, features a beautifully stylised rendering of the fairy Titania against a starry background. The British half-sheet became quite widespread in the 1940s and early 1950s, but had fallen out of use by about 1960. Surviving examples, generally printed on heavy card stock, are often distinguished by having a corner cut off, or torn away. This was due to distributors

The Rat (1937). Printed by Stafford. A breathlessly melodramatic quad featuring Anton Walbrook as a thief falsely accused of murder, and Ruth Chatterton as the socialite who eventually saves him. This poster may actually be for the 1944 reissue. (BFI)

The Divorce of Lady X (1938). Printed by Waterlows. An early Ealing distributors quad, with a strikingly spare design. The blank space for local overprintings is still apparent at the bottom. (BFI)

demanding proof of the poster's destruction if it was not returned – thus, the convention arose among exhibitors of simply removing a corner, and occasionally posting a bundle of these scraps back en masse.

The half-sheet was designed for lobby, rather than outdoor, display, and, by mid-decade, there is evidence of a growing shortage of poster sites and increasing competition for their use. It is within this context that Britain's unique contribution to international film poster formats emerged. Two British posters from the BFI collection pretty much mark its birth. *Everything is Thunder* and *His Lordship*, released in August and November 1936 respectively, appear to be the two earliest surviving examples of the *landscape* 30" x 40" quad crown format. Both were printed by Stafford for Gaumont-British and feature straightforward large star portraits to illustrate their melodramatic plotlines. In November, the same company offered a landscape quad for *Windbag the Sailor*, illustrated with a caricature of Will Hay. An interesting point about this quad is that the blank rectangle at its top gives a clue to its intended use. The early quad was designed for outdoor sites where billposting space was at a premium, and could be pasted anywhere it

was given wall-space. The upper rectangle could be printed with the name of the cinema showing the film and the supporting feature, a service offered by the distributor for an additional tuppence each if more than twenty-five were ordered. The intention was clearly that the quad should be used to pepper the locality with advertisements.

We are never likely to know the name of the designer who first came up with the idea of returning the quad crown format to its traditional horizontal orientation for British film posters, but he is likely to have been an employee of Gaumont-British. It is tempting to wonder whether the landscape half-sheets of the early 1930s may have led someone to make the obvious association (and certainly many 1940s quads for American films are simply near-identical adaptations of the original US half-sheet designs), but what seems inarguable is that the 'landscape quad' is the most aesthetically pleasing format of all film posters. Not only does it mirror the classic 3:4 ratio of the traditional cinema screen, but its size, at 30" x 40", is large enough to be satisfyingly cinematic without being too large to display, store or handle comfortably. It is perhaps a little surprising that no other countries have ever adopted it for themselves.

The conversion to the landscape quad format seems to have occurred gradually during the late 1930s. United Artists were still using the old vertical 40" x 30" format in 1937 for Alexander Korda's *The Drum* – a majestic illustration of Sabu riding a white charger. But in the same year *Snow White and the Seven Dwarfs*, the first of Disney's full-length animated features, is in a horizontal format, as are two posters from 1939 and 1940, *The Four Feathers* and *The Thief of Bagdad*, another couple of Korda epics. All of these attractively use the landscape format to full advantage: *Snow White* incorporates a panoramic display of the seven dwarfs around their heroine; *The Four Feathers* employs three big portraits of its stars; while, most striking of all, *The Thief of Bagdad* features a fine composition of minarets and shadowy villains below Sabu, who flies overhead through a starry

The Four Feathers (1939). Printed by Stafford. From around this point, the quad really begins to come into its own. This is a particularly strong layout for Korda's epic adventure, emphasising the characters, but also featuring smaller action scenes to provide a sense of spectacle. (BFI)

This Man in Paris (1939) A second adventure with a crime-busting London reporter. The excited pressbook blurb highlights the growing popularity of the 'landscape quad' format during the late 1930s, proving that Yvette Fielding is not the first person to be impressed by a virile medium. (Courtesy of Steve Chibnall)

night sky on his magic carpet. The new format was evidently popular with showmen, and was adopted by other distributors in the wake of the 1938 Films Act, which introduced a new minimum cost test for quota registration. A quad crown was offered by Paramount to promote its first hit thriller under the new quota rules, *This Man Is News* (1938). While far from as aesthetically pleasing as the film's twelve-sheet, the quad's versatility, and the opportunities it provided for customising, proved irresistible. The pressbook for the film's sequel, *This Man in Paris* (1939), described its quad as a 'virile medium for building up box-office business!', and commented on the success of its earlier campaign:

- The two-colour pictorial Quad Crowns (40" x 30") which Paramount are featuring on most special productions have 'caught on' and are becoming increasingly popular among 'live' showmen in all parts of the country.
- So wide has grown the demand for these handy-sized posters, that our Ad.-Sales Department have decided to establish their issue as a regular feature. *This Man in Paris* Quad Crowns are printed attractively in two colours, and their pictorial design puts over with marked degree the thrilling and exciting character of the production. A generous allowance of space for theatre credits and individual over-printing matter is also included in the lay-out.

- Ad-Sales Quad Crowns are ideal for all those small spots about town for which larger posters cannot cater, and in addition to being effective, prove an economic proposition.

By 1940, the landscape quad was firmly established as the main UK film poster format, a fact that did not overly endear itself to Hollywood, as it meant that the artwork for each and every US one-sheet import had to be laboriously redesigned to fit the new horizontal style. Suddenly the possibility of creating entirely new and often more excitingly cinematic layouts opened up for a generation of British commercial artists.

The Second World War had a profound effect on every aspect of British cinema, from the circumstances of production (numerous technicians were called up, and most studios were requisitioned), through to the striking new spirit of confidence apparent in many of the films themselves. The period also saw the filmgoing audience rise to its all-time peak in 1946, as the population flocked to escape the pressures and deprivations of the home front. One of the most immediate of these was, of course, rationing, and in terms of the country's film posters, paper rationing had a particularly serious long-term impact.

Britain has traditionally always imported much of its paper, along with almost all of the raw materials used in domestic papermaking. From April 1940, paper was rationed, and seven months

Dr Renault's Secret (1942). Printed by Stafford. The 'H' certificate was already well established by the time this was released in 1942, but the 'secret' was obviously not quite horrible enough to merit one, only gaining an 'A'. (AC)

The Invisible Man's Revenge (1945). Printed by W. E. Berry. This was almost certainly designed by Eric Pulford, and is one of the fairly small handful of original shockers to gain the infamous 'H for Horrific' certificate. (AC)

later, in November, imports of foreign paper were banned. Supplies were allocated to printers and publishers on the basis of their use of paper during the last full year of peace: this was initially 60 per cent, but quickly decreased following the German invasion of Norway, which effectively closed off the industry's principal source of essential wood-pulp imports. After 1940, as the supply situation for the printing industry worsened, the quality of the paper produced necessarily became very poor indeed. 'Waste paper salvage' was now a vital part of the war effort, and every last piece of unnecessary 'scrap paper' in the country (including, for example, any

old advertising posters still lying around in stockrooms or office basements) was collected together to be taken to the pulping mills. William Allen described some of the effects on the printing and billposting business in his company history: 'The first paper control order was issued the day before war was declared, and as many as 73 orders were promulgated in the next six and a half years – nearly one a month.' Efforts were made both to find materials that would replace paper – 'white Holland linen' was the most effective substitute, but its supply was likewise soon restricted – and also prolong the life of bills on the hoardings:

With varnish it was found possible to preserve posters for periods up to six months. It had to be applied after the posters were on the hoardings, since varnishing beforehand sealed the paper and prevented the paste from drying. Cinema posters, which had to be changed at short intervals, had varnished headings, and changes of programme were posted as required in the small space left.

Women billposters were once again called into service, although they were now allowed to work no higher than ten feet up. The provisions of the Government's 'Paper Control Orders' remained in force, as part of post-war austerity regulations, until March 1949, when they were belatedly repealed almost exactly nine years after they were first introduced.

The long-term consequences of paper rationing are twofold. First, most existing examples of wartime posters were printed on such poor quality paper, their condition is often extremely fragile, with many being in various stages of disintegration – and this is where they have survived at all. As part of the period's economies, large sheets of paper were often reused – some wartime quads have old maps or political/propaganda or theatre posters printed on their reverse, while others are frequently several inches smaller than the standard 30" x 40" format. With paper shortages worsening, a few quads were eventually even printed on linen.[64] The second effect of paper rationing is that it quite simply provides a dramatic cut-off point for British film posters, in terms of their wide availability. Posters from the period prior to its repeal at the end of the 1940s have always been extremely scarce, as comparatively few survived the endless wartime pulping. From about 1945, availability gradually improves, but the repeal of rationing in 1949 marks the essential dividing line between posters that most enthusiasts will only ever see reproduced in books and those that they might actually have a chance of owning for themselves.

Brief Encounter (1945). Printed by Chromoworks. Very probably designed by Eric Pulford, a strikingly moody illustration for this classic British weepie, emphasising the emotional isolation of its two stiff-upper-lip lovers. (BFI)

CHAPTER 3

Artists: 'Rather Low Grade Work' – Arnold Beauvais and Dudley Pout

The Tales of Hoffman (1951). Printed by Stafford.
Design and illustration by Marc Stone. A stylish three-sheet
(in the post-war 81" x 40" size) for Powell and Pressburger's
landmark fantasy. (BFI)

Established critical opinion in Britain has always regarded commercial art (with a few notable exceptions) as an inferior creative enterprise. What is rather less well appreciated, though, is that even within the field itself there are distinct levels of 'respectability' in operation, which mostly depend on the particular market being served. Film work – at least in this country – has for various historical reasons always come somewhere near the bottom of this tacit pecking order, well below most publishing illustration, for example, and considerably behind the more avant-garde world of public transport and travel advertising.

One result of this state of affairs is that film poster artists overall are a pretty anonymous bunch. Many posters were simple one-offs, given to an independent freelancer at short notice, and any attempt to list *every* artist who ever produced a British poster would be a futile, if not impossible, endeavour. Despite this rather unpromising scenario, a handful of artists have built successful long-term careers creating film publicity in Britain over the last century. Some of the bigger names (with long-established reputations in the business) quite regularly signed their better posters, but many others did not, and in any case the distributors generally frowned upon this practice – the posters existed to sell the films, not promote their creators' egos. Art directors would often routinely paint out the signature on any piece of work they received as a preliminary matter of course, and even if the name happened to survive this retouching, it was often later cropped from the design during the subsequent repro preparation at the printers.[65]

There are two distinct disciplines involved in most commercial art – design and illustration – which are generally quite separate. Some designers did their own illustration, and a few illustrators had a certain amount of design input, but a finished

poster was usually the result of a close collaboration between two (or more) talents. A further complication in this terminology is the phrase 'graphic design' (first coined in 1922 by William Addison Dwiggins), which began to gain currency in the 1950s. Graphic design is a generic term combining typography, illustration, photography and printing in one overall 'package' and, from 1961, British art colleges began offering degree courses in the subject (as part of the newly introduced 'Diploma in Art and Design' qualification), one of the first being the London College of Printing.[66] However, the traditional 'closed shop' of UK film publicity meant that only a small handful of such graduates actually became involved in the business prior to the mid-1980s, and so the phrase itself – though now practically ubiquitous elsewhere – will not recur in these pages. In contrast, virtually all the artists we are about to discuss would have been either self-taught or apprenticed, and those with any formal art school training would traditionally have studied fine art, and subsequently got involved in the commercial side either by accident or simply in order to earn a living.

Interviewed by Steve Chibnall in 1991, bookjacket artist Pat Owen (b. 1931) was asked whether art colleges were important to his generation:

> Not in my day they weren't. No it was left to you – if you wanted to be an illustrator you had to go about it in your own way. At Brighton College of Art the first thing that they told you was that you would never make any money out of painting, and illustration wasn't recognised anyway … In those days they taught basic, classic drawing, and you had to make of it what you could. I had a few seminars with a guy called Herrick, who was a pre-war illustrator, and there was another chap called Lance Cattermole who I think had done some commercial drawing. They would just tell you what they knew, but there was no course on illustration as such. You just had to learn to draw and get on with it as best

Kidnapped (1959). Printed by Stafford. Illustration by Jock Hinchliffe, who may also have designed it. Hinchliffe painted most of Disney's live-action adventures of the period. (AC)

you could. You had to go and get a job in a studio to learn the procedures, and then, if you felt up to it, you risked all and became a freelance. You either went to Artist Partners or Tudor Arts – there was no real commercialism in it at all.[67]

Up to the end of the First World War, the bigger poster-printing firms kept large teams of designers under contract to produce artwork for clients, the cost of the design work being routinely included in the overall printing package on offer.[68] David Allen & Sons, for instance, employed Dudley Hardy, John Hassall and six or seven others between about 1888 and 1918 to work full time designing theatrical posters, while Stafford & Co. of Nottingham had a similar arrangement in place with Thomas Phillips.[69] After 1918, the situation changed, with commercial artists instead often becoming attached to the creative departments of the bigger advertising agencies. Ashley Havinden of W. S. Crawford Ltd is one example.[70] Throughout this period there were also, naturally, large numbers of freelance artists around,

independent types who did not wish to become tied to one particular company, but who would, in some cases, have been known for their poster work, and thus regularly employed on a one-off basis.

Some of the most significant illustrators of posters after the Second World War began their careers designing and painting the massive front-of-house displays that advertised films outside the big metropolitan cinemas. Progressive Publicity was the biggest of the London manufacturers of cinema front-of-house displays. Other names involved in this side of the business included Leon Goodman Displays, Studio Torron, De Frene Advertising, Art Display Services and Bovince. Some of these companies also printed posters. The two leading examples of artists who started out with display companies like these are Roger Hall and Sam Peffer (the latter will be discussed in Part Two). Born in London's St Barts hospital on Boxing Day 1914, Hall grew up in Islington. His father was a stoker at Wimbledon Power Station, and his young son had a talent for drawing and painting. A few months after leaving school at fifteen, he got a job

The Fiend Who Walked the West (1958). No printer credited, but probably Stafford. Illustration by Jock Hinchliffe, possibly from his own design. The very muscular faces are unmistakeably Hinchliffe. (AC)

as a junior at the nearby London Art Service. LAS was one of the firms specialising in cinema display work, producing huge 48-sheet posters, banners and other advertising for cinema fronts and foyers. Hall quickly found himself working upstairs filling in the lettering on these. The artists themselves worked downstairs – the roll-call then included Bill Wiggins and Lionel Slater – and Hall, though still very shy, was desperate to join them. Eventually, Slater suggested that he produce a specimen illustration to show to chief artist Oscar Brown, and Hall painted a portrait of a town crier from a recent *Saturday Evening Post* cover he had seen. When this was shown to Brown, the latter's terse instruction was 'Start downstairs on Monday', and Hall began mixing up paints and running the usual errands, gradually getting involved in painting 'life-size star heads on panels' for display.[71] He spent every weekend studying the great portraitists in the Tate and National Gallery – 'Sergeant was my God' – and gradually developed a realistic style that became rather more popular than the generally slapdash efforts of his rivals. After a couple of

years, he was effectively working on his own, taking in the cinema orders and designing up to twenty portrait panels a week from supplied stills and publicity brochures, painting in size and distemper. Considering the amount of work he was turning out, Hall felt a pay rise was in order and asked for his 17/6 per week to be made up to £1, but the bosses prevaricated and, by now far more confident in his own abilities, Hall simply 'packed up my brushes, and walked out' shortly after his eighteenth birthday.

Fortunately, a fresh opportunity presented itself with Art Display Services (ADS), a new firm based in 'an old banana warehouse' off Shaftesbury Avenue, and supplying hand-painted cut-out cinema foyer displays. This involved producing figure work in addition to straightforward portraits, and the staff boasted ex-LAS hands Wiggins and Slater, plus later arrivals Les Warner, John Morley and a character known simply as 'Beaumont', a scenic artist of some brilliance, who had previously worked for the Doyly Carte theatre company. In 1933, aged nineteen, Hall produced one of his

Snow White and the Seven Dwarfs (1937). Printed by Stafford. Design and illustration by Arnold Beauvais. The charming original quad for Disney's breakthrough animated feature. (BFI)

most memorable assignments, a huge twenty-foot-high picture of Charles Bickford, made up of twelve pieces of 5" x 5" plywood, for display at the top of the Regal, Marble Arch. He continued working on such spectacular assignments until his call-up in 1941.

The work could be dangerous. Bill Wiggins, employed by display firm Progressive Publicity, was one day painting with a colleague in a cradle, high up above the entrance to the Odeon, Leicester Square, when one of the supporting cables snapped. Wiggins and the other man were left hanging on for dear life as the cradle swung to and fro across the front of the cinema like a gigantic pendulum. Fortunately, he survived this hair-raising experience.[72]

While artists like Hall, Peffer and Wiggins went on to work for leading poster design studios after the Second World War, the simple passage of time has meant that many pre-war illustrators are now almost completely forgotten. Sometimes, all we are left with are tantalising signatures appearing on the few surviving posters from the period – Dick

Baker, George Mitchell, Cecil Barber and Albert Morrow are all examples of names from this era about whom essentially nothing is known.[73] It would take a dedicated researcher with considerable time and resources to uncover anything of their personal backgrounds. Even where an artist later worked extensively for one particular distributor, the situation can be no better. Marc Stone was employed by Gaumont-British throughout the 1930s, producing a series of lively double crowns for the London Pavilion, including the remake of Griffith's *Broken Blossoms* (1936), and a striking art deco three-sheet for Boris Karloff's *The Ghoul* (1933) in morbid green and black. He supposedly worked 'from a garret on Wardour Street' during this period, and later designed propaganda posters during the Second World War, but no further information about his career has emerged.[74] He was still working in the 1950s, though: British Lion's *Tales of Hoffman* (1951) carries his signature.

Jock Hinchliffe, apparently originally from Perth, had an even longer career, working mostly

The Seven Year Itch (1955). Printed by Stafford. Illustration by Arnold Beauvais from a design by Alan Oldershaw. Given to Beauvais Senior at the last minute, as Tom Chantrell happened to be away on holiday. (BFI)

Arnold Beauvais in 1975, aged 89, taken for an exhibition of his paintings in a Marlow gallery. (Courtesy of Tom Beauvais)

for Fox, and later Disney.[75] One of his earliest posters seems to be John Ford's *The Iron Horse* (1924), and his prolific output continued over the next thirty-five years. He was still designing quads for Fox Westerns at the end of the 1950s, including *Frontier Gun* (1958) and *The Fiend Who Walked the West* (1958), plus Disney live-actioners like *Davy Crockett and the River Pirates* (1956). Again, though, all we seem to be left with is his distinctive flourish of a signature. Fortunately, two important names from the 1920s and 1930s are much better documented, and their individual careers can thus be discussed in some detail. The first of these two 'pioneers' is Arnold Beauvais.

The Beauvais family has a long and distinguished history in art.[76] Charles Henri Beauvais (1862–1911) was born in Marseille, and became a talented painter and lithographic artist (later featuring prominently in Benezit, the artists' directory).[77] When he arrived in England, aged twenty, Charles worked for a firm of lithographers on Southwark Bridge Road – possibly Waterlow Bros. & Layton Ltd. He soon became involved with his landlady's daughter, Anne Corfield, later marrying her in Bexley Heath parish church. The couple eventually had six children: four boys and two girls. Their third child, Arnold Victor Beauvais, was born in Rushey Green, Catford,

in April 1886. By 1900, he was working in his father's studio on lithographic poster design during the day, and studying in the evenings at the Bolt Court Art School on Fleet Street. In 1903, Charles Henri returned to Marseille to open a new commercial studio, and Arnold went with him, spending sixteen months studying in Paris before rejoining his father full time in the studio. Charles Henri died in 1911, and for the next two years Arnold took over the running of the studio, while also working as a theatrical cartoonist/caricaturist, with an official theatre pass to attend productions on a professional basis. During this period he also began seriously to pursue his other great love, music, training with an opera company as a leading bass singer. However, in 1913, with war clouds already on the horizon, he decided to return permanently to England.

Arnold rented a studio on Chancery Lane, and continued his poster design work, while still singing opera in his spare time. In 1919, he joined the Old Vic theatre company, playing the part of Ferrando in *Il Trovatore*, a hit that led to leading roles in about a dozen or so other productions. Despite this success (he later sang on the radio for early broadcasts from Savoy Hill, and even recorded for Columbia), by the late 1920s his art and music commitments had become incompatible,

Bambi (1942). Printed by Stafford. Designer unknown. Illustration by Arnold Beauvais. Another landmark Disney poster. Like all their major animated features, this was re-released every seven years up to the 1980s, each time with a new quad design. (BFI)

and he was forced to make a choice. He chose his poster work. One of his most famous campaigns in the 1920s was for Joe Lyons restaurants – the 'Where's George?' ads, which featured various characters in comic situations posing the question (one showed a girl tied to some railway tracks in the path of an approaching train), to which the answer was always 'Gone to Lyonch!' He also worked for various other companies including Black & White Whisky, Younger's Scotch Ales and a popular toothpaste firm of the time, designing press ads, magazine illustrations, cartoons, children's books and even jigsaws.

Arnold Beauvais's film work seems to have begun in the mid-1920s, initially for Ideal Films. One of his earlier posters was *The Stranger* (1928), a Western starring Tom Tyler, and – as a freelancer – he worked for many other distributors over the next thirty years, including RKO, Warners, MGM and Walt Disney. Some of his more famous posters include: *Adventures of Robin Hood* (1938), *Hunchback of Notre Dame* (1939), *Swiss Family*

Robinson (1940), *They Flew Alone* (1941), *Days of Glory* (1944), *Up in Arms* (1944 – and all the subsequent Danny Kaye films), *Tarzan and the Leopard Woman* (1946) and the original releases of Disney's *Snow White*, *Bambi* (1942), *Alice in Wonderland* (1951), *Peter Pan* (1953) and *Treasure Island* (1950), plus a plethora of the company's nature films. Probably his last poster was for *The Seven Year Itch* (1955), featuring the famous image of Marilyn Monroe's billowing skirts. It is one of the classic film posters of the 1950s, and a fitting exit.[78]

The posters themselves were not Beauvais's only film work, however – he also produced a famous series of caricatures for *Picture Show* and *Film Weekly* magazines in the 1930s and 1940s, depicting such stars as Charles Laughton and Marlene Dietrich, using then relatively new airbrush techniques. He additionally sometimes painted large-scale figures for cinema foyer display, working from reference stills. These were principally for Howard Hughes's RKO films, and were generally

Cinderella (1950). Printed by Stafford. Designer unknown. Illustration by Arnold Beauvais. Middle-period Disney, when their fairy-tale adaptations had begun to lapse into formula. (BFI)

completed with the use of a 'pantograph' – a drawing aid incorporating a sort of trellis arrangement that can be adjusted to give an enlarged tracing of an original image. He also illustrated 'book of the film' spin-offs, principally Disney pictures, for Collins of Glasgow.

Beauvais's film work dried up following the disintegration of RKO during the mid-1950s, and in 1956 he reduced his commercial art commitments to devote more time to his oil paintings, a particular favourite being Cornish coastal scenes around Bude. His last regular assignments were centre-spreads of 'The Old Woman Who Lived in a Shoe' for *Jack & Jill* comic, published by Amalgamated Press. He delivered two of these intricate illustrations a month up to 1963, when, aged seventy-seven, he finally retired. In summer 1975, Phillips & Sons gallery in Marlow held a major retrospective exhibition of his work. Despite failing eyesight, Beauvais continued to paint right up to his death, aged ninety-eight, in 1984. As his son Tom recalls, 'He was a real inspiration to me … a very kind man, always

encouraging, and a tremendously versatile artist. I admired him very much.' As we shall see in the next section, his son has himself enjoyed an equally interesting career in commercial art.

In contrast to the cosmopolitan Beauvais family, the second early artist we can consider never ventured far from his native Kent. Dudley Pout (1908–86), despite his prodigious output, would probably now be as obscure as most of his contemporaries, but for the fact that in 1982 he wrote and published a modest autobiography, *The Life and Art of One Man of Kent*, documenting his twin passions of painting and farming.[79]

Pout came from a traditional Kentish farming background: his father, E. J. Pout (1850–1930), farmed over 2,000 acres in various scattered parcels of land, breeding shire horses, as had his father before him. Dudley was born in November 1908, one of six children (three boys and three girls) on Frogs Island Farm, Herne. In 1912, the family moved to Greenhill Farm, nearer Herne Bay, and Dudley's earliest memories are of the

requisitioning of the family's farms during the Great War, and their subsequent use as billets for the waves of soldiers being sent across to France, most of whom, as he notes, were never to return. In 1918, the family moved again, to Studd Farm on the Herne Bay–Whitstable road, and Pout began to attend Swalecliffe village school, where the headmistress recognised and encouraged the youngster's drawing skill. In spring 1921, he was interviewed by the principal of Margate School of Art, and later awarded a full-time art scholarship as the youngest pupil ever to be accepted. He received further early encouragement from other sources: Captain Harry Rowntree, of the Artists' Rifles (billeted with Pout's grandparents during the war), and Eva Crofts, Laura Knight's sister, who stayed at Studd Farm for a summer holiday and allowed the admiring schoolboy to watch her paint local landscapes. At this stage, Pout simply 'painted from nature', recording the multitude

of wild and domestic animals wandering around the neighbourhood farms.

Attending art school in Margate meant leaving home at 7 a.m. and returning at 10.00 p.m., and, not surprisingly, Pout's family had mixed feelings about his training. His aunts, in particular, were shocked at the life-drawing classes – 'Nude ladies? With nothing on at all?' At fifteen, he submitted an original design for a poster advertising the 1924 Whitstable Horse Show. Following his tutor's advice, he employed a distinctive modernist style, just then coming into fashion, but this style proved too radical for the show's judging panel (just as it would for many film distributors), and was not selected. Following this disappointment, Pout had to leave art school, as his parents regarded it merely as a hobby, and expected their son to rejoin life on the farm. He continued to draw in his spare time, though, particularly the fast sports saloon cars then beginning to appear on Kent's country lanes.

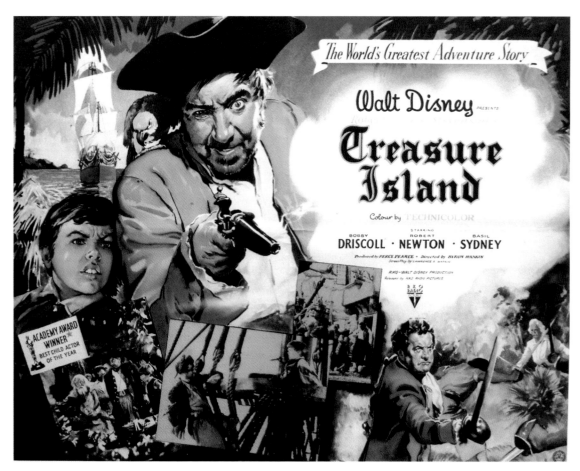

Treasure Island (1950). Printed by Stafford. Design and illustration by Arnold Beauvais. A vivid half-sheet for Disney's first live-action feature, focusing on its unforgettable scenery-chewing central performance. An eighteen-year-old Tom Beauvais was allowed to do the lettering. (Courtesy of Tom Beauvais)

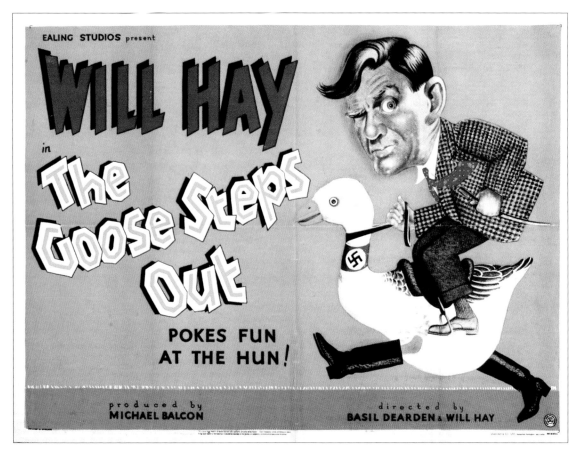

EALING STUDIOS present

WILL HAY
in
The Goose Steps Out

POKES FUN
AT THE HUN!

produced by
MICHAEL BALCON

directed by
BASIL DEARDEN & WILL HAY

The Goose Steps Out (1942). Printed by Stafford. Design and illustration by Dudley Pout. A fantastic Will Hay caricature on this popular wartime comedy, deliberately aiming to boost morale by spoofing the Axis. (BFI)

Sending off a few samples of his work, Rover later offered him employment at Coventry, but he declined, having no desire to specialise in car advertising. In March 1930, the Herne Bay Press also offered him a position on the local paper, but it was a visit to Dover that was to open up a new career path. Pout recalled seeing the luxurious new Granada super cinema:

> On the front of house were large, hand-painted portraits of the film stars, attractive displays in the foyer and panels with cut-out letters advertising the forthcoming programmes. Here was art in an entirely new form. I think that if the principal of my art school had known that one of his past pupils was about to seek employment doing this rather low-grade work, he would have been shocked and disappointed. It seemed a fortunate coincidence that the East Coast Poster Service in Dover, who were supplying all this new type of cinema advertising, needed another artist. I started the following week. […] An entirely new life had opened before me,

living in town, and working indoors. My art school method of working was far too slow. Speed was of the essence, and there had to be a profit at the end of the artwork. There were no holidays with pay – we had to take a break when things were slack.

The firm both designed posters and printed them using silkscreen techniques.[80] One of Pout's first printed posters seems to have been Chaplin's *City Lights* in 1931; but he had only been working at Dover for two years when he took a new job at Chatham, managing the Stoll Art Studios, set up by Herbert Webster, manager of the Empire Theatre, to give Stoll a competitive edge over the other local cinemas:

> At the Stoll Studios, with five assistants, we carried out the complete advertising from press and posters to vestibule displays. Some of the posters were so large that it was impossible to see them complete until the billposters pasted them up. When an Act of Parliament was brought in, we ceased to produce

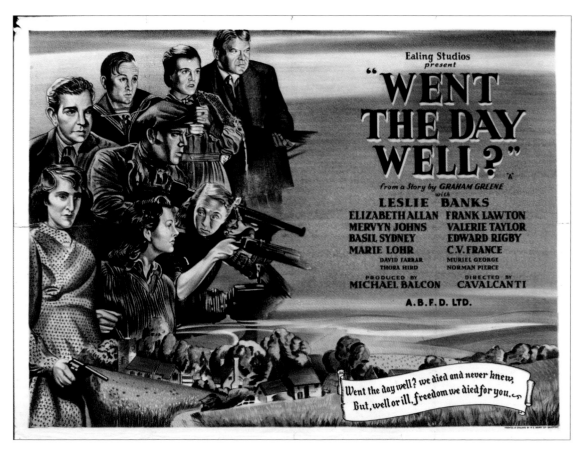

Went the Day Well? (1942). Printed by W. E. Berry. Design and illustration by Dudley Pout. A powerful design for Ealing's grim wartime masterpiece. (BFI)

many of the larger posters. It was against the law to put up advertising matter other than on approved sites and hoardings. Being involved with so much film work, I began to think how much more rewarding it would be if I could design the original posters for the film companies.

But Pout knew that to achieve this ambition he would need to work in London, so when one of the Wardour Street distributors (probably Gaumont-British) advertised for a publicity manager, he applied and was given the post:

[M]y new appointment proved to be short-lived. Rumours of takeovers began to circulate, and when they happened, many lost their jobs. I was offered a post as assistant to the publicity manager with a drop in salary. The 1930s was not a time to be choosy, with a wife and two small boys to support (my daughter was to be born a few years later, during London's worst fire blitz in May 1941).[81] It was now a question of keeping one's eyes open for opportunities. A leading Fleet Street advertising

agency required another general artist for their studio, and I applied, although most of my work had been for film companies, and managed to get a foot in. I gained some valuable experience drawing advertisements for all sorts of products, particularly using scraperboard techniques for detail work.

Dudley Pout at work in the Stoll Art Studios, Chatham, in 1934.

In September 1939, war was declared, and Pout was made a special constable, working eight-hour shifts. For a time he commuted daily to Fleet Street from Herne Bay, but when bombing began in earnest twelve months later, the family moved to Ealing, as Pout's wife felt they had to be together. It proved a convenient place to be:

> My experience in the film world enabled me to be of some use to the publicity manager of United Artists, who introduced me to Sir Michael Balcon, the Ealing Studios producer, and other members of the Ealing crowd. Here was an opportunity on my doorstep to design posters and press advertisements in my off-duty hours. It was drawing, duty and ducking when the bombs came too close for comfort. Soon I was designing the publicity for such films as *The Goose Steps Out* [1942], *The Foreman Went To France* [1941], *Went the Day Well?* [1942], *The Black Sheep of Whitehall* [1941], and many more.

His work for Ealing helped to establish him as a freelance artist, and he decided not to return to the advertising agency. His memories of the time include the procedures involved in poster creation:

> [B]efore any ideas or drawings were put on paper, I would attend a private showing of the film with the publicity manager of the company concerned. We would discuss what the best selling point of the film would be to feature on the posters. Correct billing was very important – the star or stars were placed above the title, and the supporting cast were set below. Credits varied in size in relation to the importance and popularity of the star, and were so much per cent of the title size. Next came the question of how many colours were to be used – two, three, or four. Every extra colour raised the cost of printing. After producing what is called a 'finished rough' and having it approved, the artwork was then completed. The lettering of titles, stars and credits was all done by hand.

By the end of the 1940s, although Pout's work was well known in Wardour Street, he decided that the long-term prospects for British film production were not bright, and began to diversify, illustrating

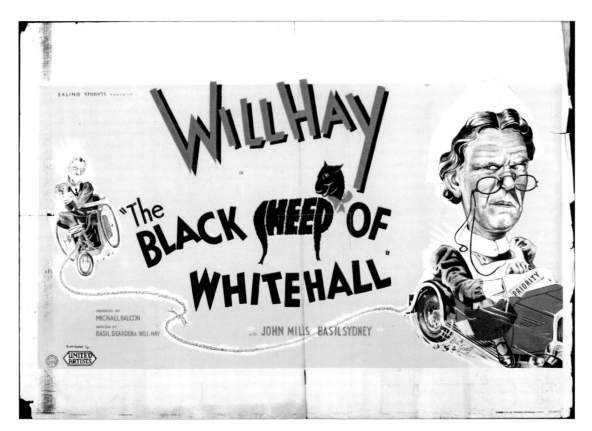

The Black Sheep of Whitehall (1941). Printed by Stafford. Design and illustration by Dudley Pout. Another energetic Will Hay poster, with an inventive treatment of the title. (BFI)

bookjackets and drawing for magazines, and children's papers like *Eagle* and *Girl*. Publishing illustration thus gradually supplanted Pout's film work over the early 1950s. One of his last major poster designs seems to have been the Western classic *High Noon* (1952). After a brief spell in Orpington, Pout had bought a small farm in another part of Kent at Biddenden (between Tunbridge Wells and Ashford), but his wife's health began to decline – she died in the late 1950s – and he began to devote himself more and more to his farming, chiefly breeding cattle, and later free-range poultry. By 1973, he was ready to retire to a smaller property in Biddenden, where he produced

nostalgic oil paintings of the pre-war Kentish farming scene, and continued to do a little design and illustration work for local businesses and the village Silver Jubilee celebrations. After mounting a modest retrospective at the annual arts exhibition, and completing his autobiography, Dudley Pout passed away in 1986.

Arnold Beauvais and Dudley Pout thus represent the two best-documented careers in the obscure world of pre-war film posters. Before considering the better-illuminated post-war scene, it is worth pausing to consider the posters of the company for whom Pout worked during the war: Ealing Studios.

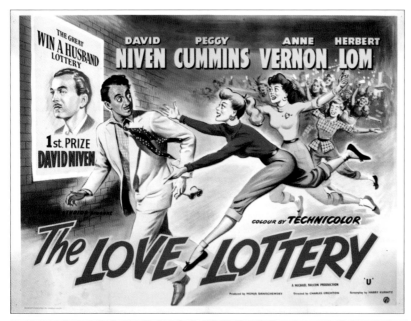

The Love Lottery (1953). Printed by Charles & Read. Illustration by Dudley Pout, possibly from a design by Eric Pulford. One of two different quad designs for this rather feeble late Ealing comedy – the other, by Brian Robb, is quirkier and less obviously commercial. (BFI)

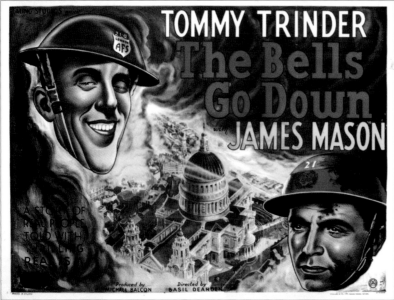

The Bells Go Down (1943) Printed by Stafford. Design and illustration by Dudley Pout. Another slice of life from Ealing, showing real reality in all its realistic realism. (BFI)

CHAPTER 4

A Sophisticated Interlude: Ealing Studios and the Battle of Art vs. Commerce

By and large, most British film posters are not works of art. The majority of them are examples of commercial illustration, which, of course, is not to say they are without merit or interest on their own terms. But, just as popular cinema is essentially a business, the posters that advertise it are often little more than a basic sales pitch, designed solely to attract and engage the public. Genuine aesthetic value will not have been the first priority. Every rule has an exception, though, and for UK posters, Ealing Studios' output between 1938 and 1955 is

generally accepted as a unique contribution, and, without question, the definitive high-water mark of British cinema art.

Ealing's career has been carefully documented elsewhere, so a brief summary should suffice here.[82] The studios were first built in 1902 by British film pioneer Will Barker, on a four-acre site comprising the combined rear gardens of two houses fronting Ealing Green. The original stages were rebuilt and converted to sound at the end of the 1920s, and acquired in 1930 by a new company, Associated

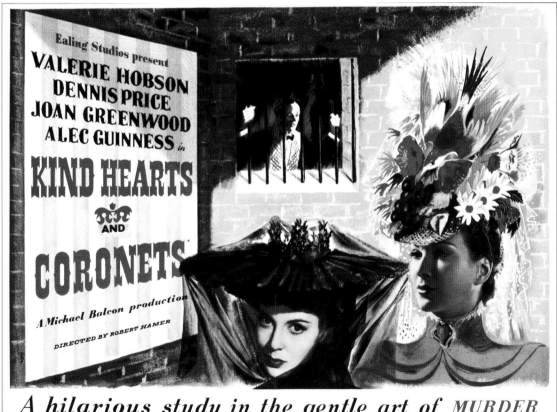

Kind Hearts and Coronets (1949). Printed by Graphic Reproductions. Design and illustration by James Fitton (1899–1982).
A colourful quad for this stylish black comedy, now generally considered to be Ealing's masterpiece. (BFI)

Talking Pictures. The dynamic and hugely influential producer Michael Balcon took control of ATP in 1938, and shortly after his arrival the company's on-screen name changed to Ealing Studios. For the next twenty years, Balcon oversaw the production of almost a hundred distinctive films, across an impressively wide range of genres. Between 1944 and 1955, Ealing enjoyed a highly successful distribution deal with Rank. However, in 1956, following the sale of the studios to the BBC, Balcon was forced to relocate to MGM-British at Borehamwood, and his company, already looking increasingly stuffy and parochial, rapidly ran out of steam. The final Ealing film, *The Siege of Pinchgut*, was released in 1959, following which the company, by then virtually forgotten by cinemagoers of the time, simply faded away.

The posters for Ealing's films have always been so highly thought of that in 1982, when David Wilson's book celebrating them was published, Bevis Hillier felt able to state in his introduction that 'I would think it fair to suggest that the Ealing posters have a higher place in the canon of world poster art … than Ealing films occupy in movie history.'[83] This is a major claim, and the present account (which inevitably draws on Hillier's introduction) will outline the background that makes such a contention possible.

One of Balcon's first moves, following his arrival in 1938, was the appointment of Monja Danischewsky as head of publicity for the studio. Danischewsky (1911–94), or 'Danny' as he was known to everyone at Ealing, was born in Russia, but had arrived in England with his family, aged eight. After a background in commercial art, he became involved with film advertising in the early 1930s, and by 1934 was working as a publicity director for Capitol Films, a company run by Max Schach, one of several Hungarian producers so important in British cinema of the period. Encouraged by Balcon, Danischewsky began to pursue a policy of employing recognised artists to produce Ealing's posters. Few serious artists had worked on film posters in Britain prior to the war,

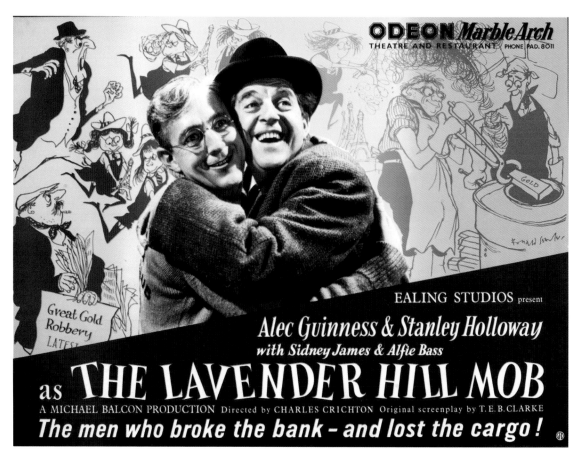

The Lavender Hill Mob (1951). Printed by Graphic Reproductions. Illustration by Ronald Searle (b. 1920) from a design by S. John Woods. The combination of a joyous Guinness and Holloway amid Searle's anarchic cartoons is irresistible. (BFI)

partly due to the cinema's downmarket image, and partly because of the relatively poor pay in comparison with the rates offered by 'respectable' companies like London Transport and Shell-Mex.[84] Danischewsky, however, ensured that Ealing always paid the appropriate fees.

Notable early examples of the new policy are the posters for wartime comedies like George Formby's *Let George Do It* (1940), with a lively caricature by Peter Lambda, and Will Hay's *The Ghost of St Michael's* (1941) by George Chapman, which employs a familiar 'vanishing point' perspective motif that recurred frequently in other Ealing posters of the period. However, the company's real 'house artist' during the war, who is never mentioned in any of the usual accounts, was Dudley Pout. Already living in Ealing, Pout began to work regularly for Danischewsky, initially, as we have seen, on Will Hay comedies like *The Black Sheep of Whitehall* and *The Goose Steps Out*, but soon tackling more serious subjects such as *The Foreman Went to France* and *Went The Day Well?*.

However, Pout's style proved too commercial for Danischewsky and Balcon, so he later tended to work on the international (distributor's) one-sheets, rather than the domestic quads. Several of his posters are reproduced, uncredited, in Wilson's *Projecting Britain*, for the sole purpose of being compared unfavourably to their more sophisticated quad counterparts. Hillier dismisses them as being 'as raucously conformist as an Ivy League fraternity on a pantie raid', an intriguing image that perhaps says more about Hillier than it does about Pout. The artist, nonetheless, went on to produce posters regularly for Ealing up to the end of the 1940s, but to be fair, his contribution is not really part of the work that eventually made their reputation.

Most of Ealing's 1940s posters were printed by Waterlow & Sons Ltd, a venerable 150-year-old London company that had printed railway posters, postage stamps and even banknotes from major premises on Birchin Lane and, later, London Wall. As Waterlow Bros. & Layton Ltd, they had entered the film poster business before the First World

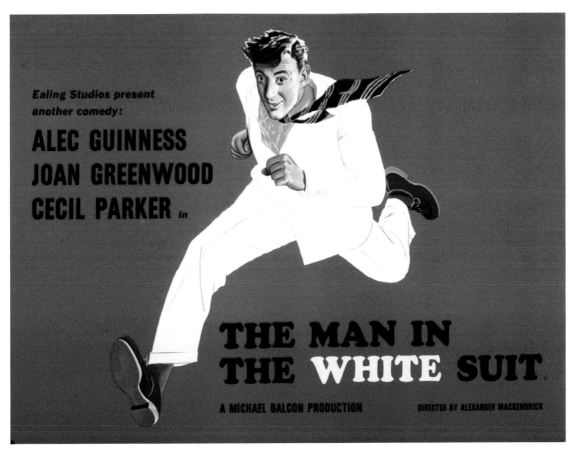

The Man in the White Suit (1951). Printed by Graphic Reproductions. Illustration by A. R. Thompson (1894–1979) from a design by S. John Woods. Another iconic image of Alec Guinness. (BFI)

Nicholas Nickleby (1947). Printed by Graphic Reproductions. Design and illustration by Edward Ardizzone (1900–79). A very distinctive design, not at all popular with the distributors, Rank. (BFI)

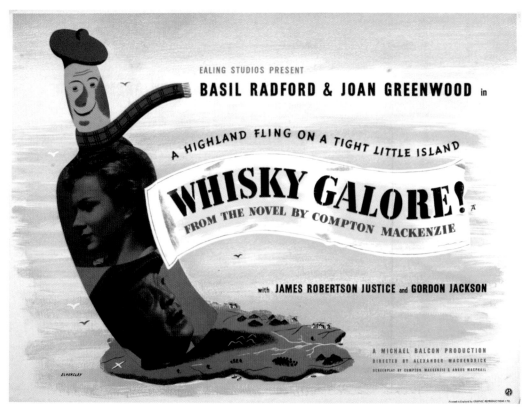

Whisky Galore! (1949). Printed by Graphic Reproductions. Design and illustration by Tom Eckersley (1914–97). An appealing design for one of the studios' trademark whimsical comedies. (BFI)

War, printing early versions of what would later become the international one-sheet format.[85] When they took on Ealing's business, Waterlows were still recovering from a disaster that struck in 1930. A confidence trickster managed to convince the firm that he worked for the Bank of Portugal, and persuaded them to print a large quantity of Portuguese banknotes for him. The real bank was not amused and promptly sued Waterlows for £1 million (close to £30 million today), a devastating financial blow from which the firm never fully recovered.[86]

When Danischewsky took advantage of Balcon's 'promotion within the ranks' policy to move into scriptwriting in 1943, his replacement was the man more or less single-handedly responsible for the Ealing poster success – Sydney John Woods (1915–86). Woods trained as a graphic designer and painter, and also became an art critic. In the 1930s, he exhibited abstract paintings, and promoted the style in his journal articles. He also designed posters for the Old Vic, Covent Garden and Sadler's Wells, and by the end of the decade was in the film industry, working for Fox's publicity department. After joining Ealing in 1943, he worked directly under Balcon from 1947 until the studios' demise in 1959.

According to a contemporary appreciation by Catherine Lejeune, Woods's art department was 'tucked away in a small street near Marble Arch'.[87] Here, Woods revealed perhaps his greatest skill as an 'impresario, marshalling, encouraging, and exploiting to best advantage the talents of other artists', as Hillier puts it, going on to compare him with Jack Beddington of Shell and Frank Pick of London Transport. Woods's 'stable' of artists eventually included such luminaries as John Piper, Edward Bawden, James Fitton, John Minton, Mervyn Peake, Edward Ardizzone, Leslie Hurry, Ronald Searle, Barnett Freedman, James Boswell, Reginald Mount and more than a dozen others.[88] Woods described his approach as follows:

> I decided which artists to commission, both in relation to their work and in relation to what I thought was the feeling of the film. Some of the artists, such as Bawden, were experienced in lettering. But some of them were purely painters, and with them I worked closely on the lettering. Apart from that, I wanted the artists to give their own interpretation of the subject.[89]

Woods's art direction often amounted to collaboration with other artists to produce joint works: *Champagne Charlie* (1944) celebrated the folk-art traditions of English music hall, and incorporated drawings by Eric Fraser, plus the distinctive 'harlequin' lettering (by Barnett Freedman) used in many other Ealing posters of the 1950s. For *Passport to Pimlico* (1949) Woods created a photomontage around a cartoon by Nicolas Bentley. Other classic Woods collaborations were with Ronald Searle (creator of the St Trinian's cartoons) for *The Lavender Hill Mob* (1951), and with A. R. Thompson for *The Man in the White Suit* (1951), featuring an appealing graphic of Alec Guinness striding between the credits, against a vivid red background.

Edward Bawden designed two posters for Ealing: *The Titfield Thunderbolt* (1953), the ultimate train-enthusiast film, in which the credits appear in the steam emerging from the locomotive's funnel; and *Hue & Cry* (1946), the film that began the run of classic Ealing comedies. Bawden was a poster veteran, having produced several designs for London Transport, and later recalled that he made about six visits to the studios at Ealing Green, dealing mainly with Danischewsky:

> I was given a completely free hand … Perhaps I ought to have been given more guidance. I worked completely in the dark never saw a film being shot, never saw the finished film before I designed the poster, though I was sent still photographs.[90]

His preliminary sketches for the two posters are now in the Cecil Higgins museum, Bedford.

James Fitton RA produced the posters for both *Kind Hearts and Coronets* (1949), possibly Ealing's finest comedy, and also probably its weakest, *Meet Mr Lucifer* (1953), an insipid satire on television, then cinema's great enemy. Of *Kind Hearts*, Fitton later recollected, 'I went down to the studios at Ealing and made sketches. I also had lunch in a pub with Alec Guinness and some of the other actors, and made more sketches.'[91] This kind of involvement was almost unique in a business where illustrators were usually thrown a handful of stills and told to get on with it. Fitton's background was with Frank Pick, who had talent-spotted him at a Leicester Galleries exhibition. For Pick, he produced posters like 'Variety for a Change' of a tightrope-bicyclist at the Holborn Empire, and

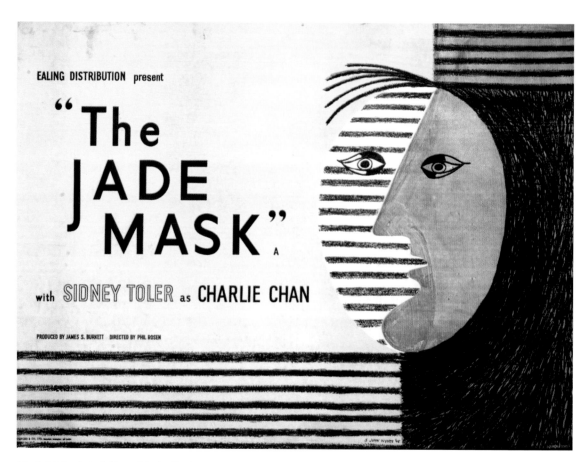

The Jade Mask (1945). Printed by Stafford. Design and illustration by S. John Woods. A striking semi-abstract design for this late Charlie Chan entry. Woods's steadfast refusal to include any element from the film itself is admirable. (BFI)

'Just a Step by Underground' of Sadler's Wells ballet dancers, both of which Woods had seen, and felt showed just the lightness of touch he required.

Edward Ardizzone, best known as a children's book illustrator, was responsible for two distinctive posters – *Nicholas Nickleby* (1947) and *The Magnet* (1950). The latter, an appealing drama about a child who gets involved in various adventures with his toy magnet, was a particularly suitable subject, but as with several of Ealing's artists, Ardizzone's work was not enormously popular with the distributor Rank. His design for *Nicholas Nickleby* was dubbed 'too intellectual', while *The Magnet* had an alternative one-sheet by Simmons commissioned to sell the film overseas.[92] Another artist with a long experience of poster design was Tom Eckersley. In 1934, he had begun a successful partnership with Eric Lombers, and the pair produced popular work for London Transport, Shell-Mex, the GPO, the BBC and Austin Reed. Working alone, he designed the poster for *Whisky Galore!* (1949), another classic comedy, and

coincidentally the first Ealing film produced by Monja Danischewsky, progressing further up the studio ladder from his days as head of publicity.

John Piper's connection with Ealing was twofold – Piper's wife, Myfanwy, had played hockey with S. John Woods in a scratch team prior to her marriage, and Piper himself knew Michael Balcon, via their joint involvement in Benjamin Britten's English Opera Group before the war. Piper produced posters for two Ealing dramas in 1945 – *Pink String and Sealing Wax*, with a still of Googie Withers superimposed on artwork of a Brighton terrace, and the even more atmospheric *Painted Boats*. The latter employed the folk art of the English canals, and featured an elaborate cartouche around the title lettering derived from a rubbing Piper had made of a Nottinghamshire slate tomb. Piper also apparently designed a poster for *The Bells Go Down* (1943), with Tommy Trinder, but the version finally used was Dudley Pout's.

Ealing's posters were not just for the company's own films; they also acted as a distributor for other

producers, including US imports like Monogram's *Charlie Chan* series, and created posters accordingly. Among the *Charlie Chan* designs are such distinctive offerings as Woods's semi-abstract *The Jade Mask* (1945), Clifford Rowe's dramatic *The Chinese Cat* (1945) and Mervyn Peake's ghoulish *Black Magic* (1944). However, Ealing began to produce its own chillers at the end of the war in the form of two classic ghost films. The first, *Halfway House* (1944), a drama about a haunted inn, had a fairly literal poster design by Matvyn Wright, described by Woods as 'a good artist who completely gave up art – and anyone connected with it – about the late 1950s'.[93] However, the studios' masterpiece, *Dead of Night* (1945), offered a truly nightmarish poster by Leslie Hurry, in grotesque purples and yellows.[94] *Projecting Britain* reproduces both the quad and the vertical 'door panel' versions of this for comparison.[95] The quad is dominated by a huge menacing bat, while the door panel positions two smaller bats at the top of the design, both of which appear to be horribly amused at the supernatural goings-on below. Hurry

himself had been 'discovered' by the ballet dancer Robert Helpmann at one of his exhibitions, and made his name by designing the ominous set for the ballet of *Hamlet* in 1942.[96]

Surrealism was a recurring style in several of Ealing's posters. *The Captive Heart* (1946), a prisoner-of-war film, has a poster by John Bainbridge that depicts a literal winged heart trapped behind a barbed wire grid. H. A. Rothholz's design for *They Came to a City* (1944) also has a distinctly surreal ambience, and features the already-noted 'vanishing point perspective' motif later used in *Behind These Walls* (1947) by S. John Woods, *Train of Events* (1949) by Reginald Mount, *Passport to Pimlico* by Woods again, and Simmons's one-sheet for *The Magnet*.

Among the themes featuring in several post-war Ealing films, and explored in their posters, is colonialism. The first picture set in Australia was *The Overlanders* (1946), with a cheery Western-style poster by Walter Goetz. The third in the series, *Bitter Springs* (1950), has a poster usually attributed to Robert Medley on stylistic grounds.[97]

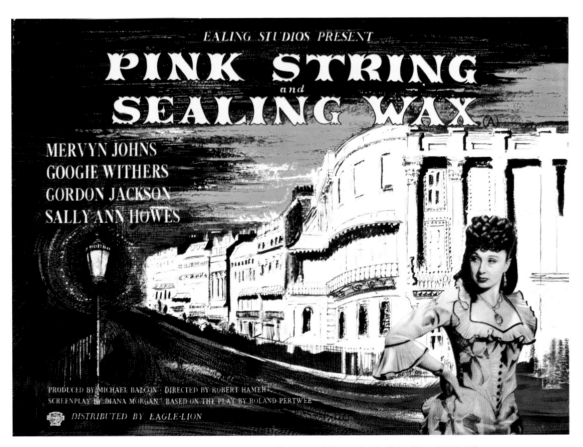

Pink String and Sealing Wax (1945). Printed by Chromoworks. Design and illustration by John Piper (1903–92).
An atmospheric poster for this downbeat Brighton melodrama. (BFI)

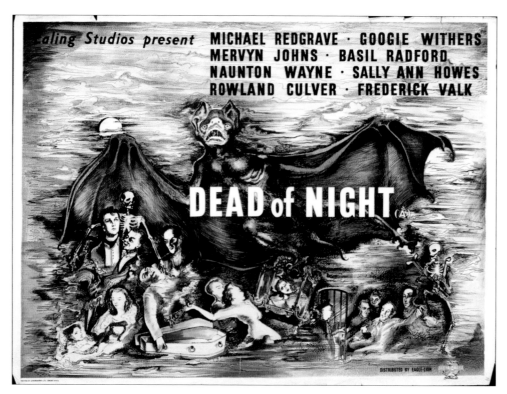

Dead of Night (1945). Printed by Chromoworks. Design and illustration by Leslie Hurry (1909–78).
A truly nightmarish image for this supernatural portmanteau – the boss-eyed bat is a particular triumph. (BFI)

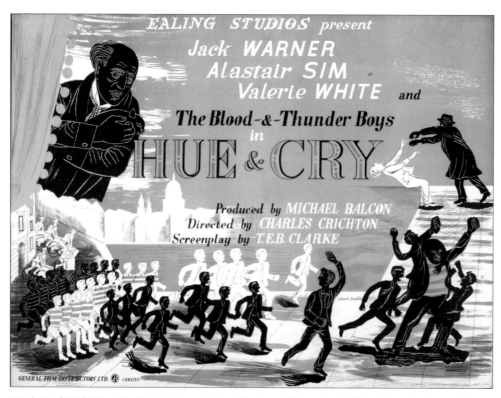

Hue & Cry (1946). Printed by Graphic Reproductions. Design and illustration by Edward Bawden (1905–89).
An exceptionally cheery image for the film that began the classic run of Ealing comedies. (BFI)

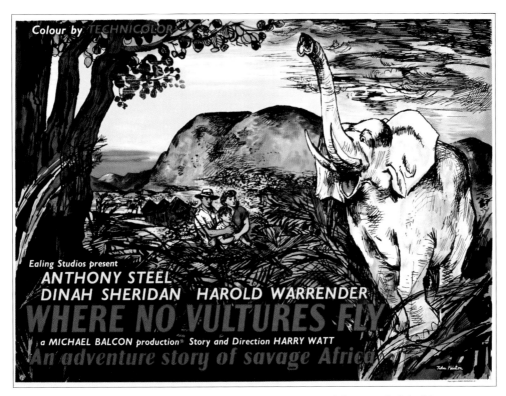

Where No Vultures Fly (1951). Printed by Graphic Reproductions. Design and illustration by John Minton (1917–57). A particularly vivid example of Minton's bold style for this conservationist drama. The artist committed suicide just six years later. (BFI)

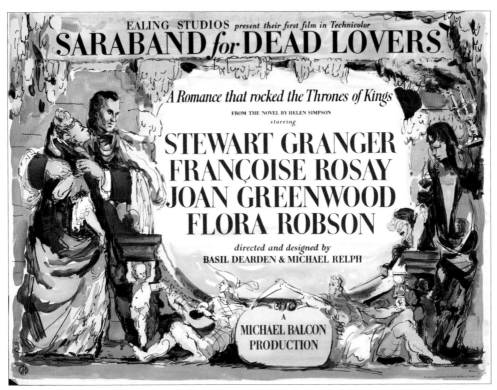

Saraband for Dead Lovers (1948). Printed by Graphic Reproductions. Design and illustration by Robert Medley (1905–94). A deliberately arty composition for this period costume drama, not at all Ealing's usual subject, and a costly financial flop. (BFI)

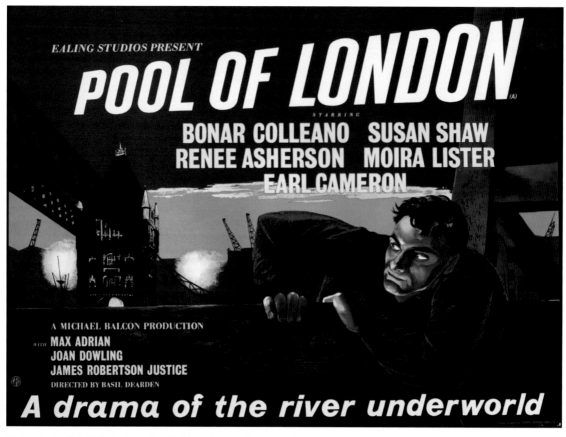

Pool of London (1951). Printed by Graphic Reproductions. Design and illustration by James Boswell (1906–71). A powerfully moody image for this criminal potboiler. (BFI)

John Minton designed striking posters for the second film in the series, *Eureka Stockade* (1949), about the Australian gold rush, and also for *Where No Vultures Fly* (1951), a conservationist drama set in Africa. Featuring bold colours and uncompromising heavy black outline, Minton's forceful style is also displayed in the rather more subdued *Loves of Joanna Godden* (1947). Like John Piper, Minton belonged to the Romantic Revival of the early 1940s, and was much influenced by Samuel Palmer's watercolour paintings. He committed suicide in 1957.

Another popular genre at Ealing was the social drama, and the best of these often had posters designed by James Boswell, who was responsible for *It Always Rains on Sunday* (1947), *The Blue Lamp* (1950), *Pool of London* (1951), *His Excellency* (1951) and *The Gentle Gunman* (1952), his dramatic, vivid style being ideally suited to such gritty subjects. But, like other Ealing illustrators, his style was hardly geared to a conventional popular taste, which favoured a more realist approach. Therefore, Ealing sometimes hedged its

bets, if a poster seemed *too* wilfully uncommercial. Charles Murray produced a powerful design for *The Cruel Sea* (1953), a literal interpretation of the title as a stormy night-time seascape. However, this design also lacked any detail that might give a clue to the film's content, and an alternative quad by Colin Walklin featured silhouettes of two ships, and a portrait of Jack Hawkins in his officer's cap, superimposed over a considerably brighter sea background.

At the time of their appearance, the Ealing posters received a great wave of solid support, including celebratory articles by Osbert Lancaster (*The Architectural Review*, February 1949), James Laver (*Art & Industry*, 1949), Jack Beddington (*Penrose Annual*, 1949) and Bernard Denvir (*Art*, February 1955). However, fashions in art criticism change, and by the time a review of the 'Selling Dreams' exhibition appeared in the *Guardian* in September 1977, their writer Richard Cork felt able to dismiss the Ealing contribution as 'wayward, idiosyncratic, and risibly genteel'. In noting this opinion, Bevis Hillier truculently points

out that 'The opposite to this verdict, which would presumably describe the kind of film poster of which Mr Cork approves, is "predictable, conformist, and unamusingly boorish"' – although, as we have seen, Hillier is no less scathing himself when discussing the 'raucously conformist' Dudley Pout, for instance.[98] Ultimately, however, the Ealing posters somehow captured the ethos of the studio itself – not just its comic whimsy, but what Hillier calls its 'fixity of moral purpose', which stemmed directly from Balcon's own paternalist convictions. In *Forever Ealing*, published in 1981 (the year before *Projecting Britain* appeared), George Perry discusses the studios' poster artists:

> Their work may have lacked the eye-catching hard-sell technique of their Hollywood counterparts, but they advertised not only the film, but something of Ealing's steadfast seriousness of purpose. Ealing was one part of the British film industry which fitted into the prevailing tradition of left-of-centre, middle class, cultural earnestness that was then apparent in such institutions as Penguin Books,

Picture Post, much of the BBC and especially William Haley's brave creation of 1946, the Third Programme, the *Manchester Guardian*, as it was still known, London Transport's publicity department, the *News Chronicle*, and perhaps its largest but least enduring manifestation, the Festival of Britain.

By the mid-1950s, Ealing's posters, like the films they were advertising, seemed to be losing their way. Brian Robb's *The Love Lottery* (1953) looks much like any other comic poster of the period, and Winslade's design for *West of Zanzibar* (1954), a second African adventure, is similarly mediocre. The last 'classic' Ealing poster is probably Reginald Mount's quad for the studios' final great comedy, *The Ladykillers* (1955), featuring distinctive caricatures of its five eccentric criminals above trademark 'harlequin' lettering for the title. Ealing Studios' comedies left an indelible print on Britain's national cinema, and remain influential on today's film-makers. We shall see, in Part Two, whether the spirit of the Ealing poster designs was to be found elsewhere in post-war cinema.

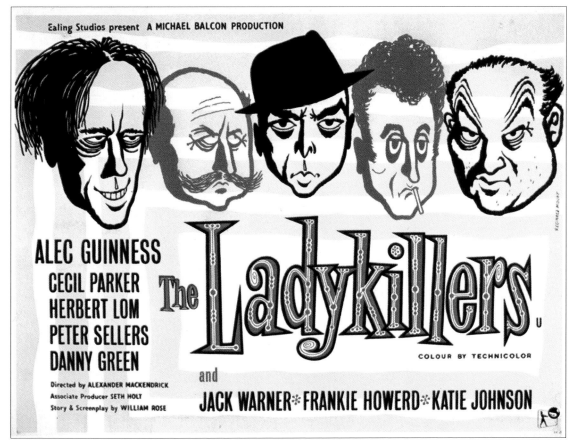

The Ladykillers (1955). Printed by Tintern Press. Design and illustration by Reginald Mount (1906–79). A classic series of caricatures for what was the studios' last great black comedy. (BFI)

No Place for Jennifer (Henry Cass, 1949). Printed by Electric Modern. (AC)

PART TWO

1946–86

CHAPTER 5

Film Distribution and Exhibition in the UK: Boom Turns to Bust

We have already noted that by the mid-1930s film distribution in Britain was dominated by seven Hollywood companies – Columbia, Fox, MGM, Paramount, RKO, United Artists and Warners – and their two big UK counterparts, the vertically integrated Rank and Associated British. In 1954, Disney belatedly set up its own international distribution arm, but the 1950s in general saw the beginnings of company rationalisation, as the film business began to shrink. RKO closed in 1957 (followed by the smaller Republic studio two years

later), and an important distribution merger was effected in 1958 between Associated British and Warner Bros. to create the influential combine Warner-Pathé, also taking in Allied Artists (previously Monogram) and, later, the UK independent Anglo-Amalgamated. However, Warner-Pathé was itself dissolved in 1969 on the takeover of Associated British by EMI (the same year that Rank and Universal finally parted company), and the beginning of the 1970s saw the squeeze really begin for the film industry in this

Last of the Redskins (1947). Printed by Stafford. Designer unknown. Kicking off a second selection of Western posters, to complete the sequence of major distributors begun in Part One, this is a dramatic hand-drawn litho for Columbia. (AC)

country. The distributors reacted by entering into a series of complex mergers that progressively centralised power, and these are best expressed as a straightforward chronology:

1970 Paramount and Universal merge into Cinema International Corporation (CIC)
1970 MGM-EMI merge
1971 Columbia-Warner merge
1972 Fox-Rank merge
1973 MGM join CIC
1978 EMI join Columbia-Warner, to make Columbia-EMI-Warner (CEW)
1981 United Artists join CIC, which is renamed United International Pictures (UIP)
1982 Fox and Disney merge into United Kingdom Film Distributors (UKFD)

Thus, by 1982, distribution was controlled by just four big companies – UIP, CEW, UKFD and (to a considerably lesser extent) Rank. However, at the end of 1987, Fox and Disney once again split, and so did CEW. The almost immediate demise of EMI, followed by Carlton's purchase of Rank in 1997, meant that by 2006, UK distribution was controlled by the five remaining Hollywood firms – the combine UIP, plus Columbia, Warners, Fox and Buena Vista (Disney). Together, these accounted for 75 per cent of the UK box office.

Of course, this is not the whole story. There have always been around a hundred different distributors operating in Britain; it is just that the other ninety or so companies have all been 'independents', handling smaller films (both British and American) for the smaller circuits, and have thus possessed only a minor overall market share and little influence.[1] Despite this, several of the names are fondly remembered, and the independents often handled many of the more interesting and offbeat films. Since the war, some of the bigger 'indies' have included: British Lion (very much the 'third force' after Rank and Associated British, but who never acquired a cinema circuit of its own and distributed jointly

Sand (1949). Printed by Stafford. Designer unknown. A cheerful hand-drawn litho, probably by the same craftsmen responsible for the *Redskins* quad, this time for 20th Century Fox. (AC)

The Adventures of Don Coyote (1947). Printed by Electric Modern. Designer unknown. Hand-drawn litho, with a good-looking hero and rather clever punning title, for United Artists. (AC)

with Columbia as BLC between 1961 and 1967); Eros (cheaper British programmers and reissues); Anglo-Amalgamated (who handled the early films from American exploiteers AIP between 1956 and 1969); Miracle (who specialised in 'continental films'); Grand National (generally popular reissues); Gala (foreign-language titles for the arthouses); along with Butchers, Exclusive, Monarch, Regal, Tigon, New Realm, Golden Era and many others. By the early 1980s, the two remaining chief independents were ITC (owned by Lew Grade) and Brent Walker (owned by ex-boxer-turned-property tycoon George Walker), who each had tie-ups with the American 'mini-majors' Lorimar and Orion respectively. However, both were defunct by the end of the decade. The sole surviving 'original' indie is Entertainment, first set up in 1977, and now on a par with the US majors.

At the end of the war, with Hollywood at its peak, almost 500 new feature films were released every year in Britain. By 1955, this number had dropped to 350, and it hovered around this level until the crisis of the early 1970s, when it fell to an average of about 250 films annually, the figure that still roughly applies today. The Quota Act ensured that, of these, *British* films always accounted for about 25 per cent of the total figure, at least up to the regulation's abolition in 1985, when the number fell to around 10 per cent annually.

Cinemagoing boomed during the war. In 1946, a staggering 1,635 million admissions were achieved, the highest figure ever. This meant that, on average, every man, woman and child in the country visited the cinema once every ten days. Cinemagoing in this period, and for some time afterwards, was a social habit in which the actual choice of film was often a fairly minor consideration. By 1948, there was an all-time peak of 4,723 cinemas operating in Britain.[2] Of these, ABC had 442, Odeon 317 and Gaumont 304, and although these only amounted to just over a fifth of the overall total, they had a disproportionate power, as they were virtually guaranteed the first showings of the best films. To make a reasonable

Mark of the Renegade (1951). Printed by W. E. Berry. Designer unknown, but possibly Eric Pulford. A potboiler Universal Western distributed in the UK by Rank, with both company logos reproduced at the bottom. (AC)

profit for its distributors, a big film had to get a circuit release, and a complex monopoly situation was clearly in operation.[3]

Extended runs were confined to London's West End cinemas, and planned well in advance. Elsewhere, films usually ran for six days from Monday, with Sundays often being devoted to popular reissues. There was no question of films being held over – other cinemas were waiting their turn. Films began their general release in the London suburbs, and full release throughout the country could take as long as six months. Generally, programmes consisted of two feature-length films with a newsreel and trailers. The supporting feature had its own poster. In the late 1950s, however, the concept of the 'double feature' – two films of roughly equal stature, with a combined poster – began to become a significant force in film marketing. The independent cinemas and small circuits survived on a diet of films that had not gained a major circuit release, 'second run' screenings of major circuit pictures and reissues.

The quad was now firmly established as the poster format of choice for the exhibition business. Advertising executive Alan Wheatley recalls that the flagship 'launch pad' cinemas in the West End were heavy users. The Odeon, Leicester Square, for instance, would have kept about 500 quad sites.[4] The continually rising cost of these site rentals was in fact a contributory factor to the later decline in print runs. In the 1950s local newsagents would have regularly been given a couple of free tickets to display a weekly changing quad, but this practice had begun to fade out by the early 1960s. In the great tradition of 'billposting', another cheap – though strictly illegal – option was flyposting. According to Wheatley, the best-known name on this side of the business, from the 1950s right through to the 1970s, was 'Terry the Pill'. Terry apparently did well out of his Wardour Street clientele, running a couple of Rolls-Royces and holidaying regularly on the Costa del Sol. He would take between 200 and 400 quads per film, and employ a team of students to drive round in

an old van, quickly slapping them up all over central London.[5] The Town & Country Planning Act of 1990 further drastically reduced the number of legitimate sites available.

Cinema attendances began to decline in the 1950s, slowly at first, then gaining an alarming momentum as television increased in popularity, and the 'family audience' was steadily stripped away. In spite of experiments with widescreen and 3-D projection, annual attendances more than halved between 1956 and 1960, from 1,100 million to 500 million, and the number of cinemas fell from 4,400 to 3,030. Finally, in 1958 Rank merged the Gaumont and Odeon chains into a single 'Rank Release', and began ruthlessly pruning its less profitable cinemas, which were often in prime city-centre sites, and represented valuable real estate for potential sale.[6] By the 1960s, there were effectively only two big circuits, Odeon and ABC, in operation. Redundant cinemas were converted to dance halls, bowling alleys and bingo clubs, or pulled down to make way for supermarkets and

office blocks. Some older Odeons (and, later, Essoldos) were sold to the Classic chain, which consolidated its position as the third largest circuit by the end of the decade.[7] The old alliances meant that Rank was still tied to Universal, United Artists, Paramount, Fox, Columbia and Disney, which was clearly too many for one circuit. By the end of the 1960s, both Paramount and Universal had defected to ABC, who were already linked to Warners and MGM, so the two circuits had four Hollywood companies each.

Between 1960 and 1970, attendances dropped further, from 500 million to 193 million, and the number of cinemas fell from 3,030 to 1,530. A major new initiative was obviously needed. The next step was conversion of the remaining profitable cinemas into multi- (usually three) screen 'film centres'. This began in 1970, though most were converted over summer 1973 – the circle was generally kept as the largest screen, while the stalls were closed off and divided centrally to make two new cinemas. However, even this 'tripling' boom

Tonka (1958). Printed by Stafford. Illustration by Jock Hinchliffe, who may also have designed it. A Disney family Wwestern with a rip-roaring illustration, featuring Hinchliffe's trademark highlights. (AC)

El Dorado (1967). Printed by Lonsdale & Bartholomew. Illustration from Paramount's US campaign by Mitchell Hooks. Hooks (b. 1923) worked for the influential Fredman-Chaite Studios in New York, alongside Bob Peak, Robert McGinnis, Frank McCarthy, Jack Thurston, Bernie Fuchs and others. (AC)

Cattle Town (1952). Printed by Stafford. Designer unknown. Another epic hand-drawn litho, this time in just two colours, for Warner Bros. (AC)

could only halt the inexorable decline temporarily, and by 1982 the number of screens still open was back to 1,430, the level of ten years earlier. The old single-week runs were abandoned, with popular films getting a standard two-week showing. The mid- to late 1970s was the era of the blockbuster, and big hits like *Jaws* (1975) or *Star Wars* (1977) could now stay on the smaller 'Screen Threes' of local cinemas for months.

'Tripling' had a knock-on effect on poster formats, leading to a rationalisation of the larger sizes. The use of the giant six-sheet (81" x 80") had in any case been in decline since the end of the 1950s, and the size was little seen after the tripling boom. Additionally, by the mid-1970s, the three-sheet (81" x 40") had been almost completely replaced by the double quad crown (60" x 40"), which was a more economical format, as it could be printed in a single section for use at bus stops and underground stations.[8] Before 1980, virtually *all* British posters were originally machine-folded at the printing works, by passing through a series of automatic rollers. Quads and international one-sheets were folded in half three times, into eight panels ('octavo'). When these were later posted out by NSS, they were often folded in half again, into sixteen panels ('sextodecimo'), as this gave a convenient folded size of 7½" x 10", equivalent to a set of stills, the two items then easily fitting into a standard foolscap envelope.[9] After about 1980, posters were increasingly left unfolded, but the practice did not disappear altogether until the advent of double-sided printing in 1990.

The early 1980s saw the end of many traditional aspects of exhibition in Britain. Double bills and reissues vanished, as did the 'full supporting programme' and Saturday-morning children's shows. With the demise of most of the older independent distributors, cheaper international 'exploitation' films vanished from the nation's small screens. The explosive popularity of video appeared to many observers to be the final straw, and the mid-1980s were undoubtedly the darkest days for British cinema. In 1984, the worst year of all, attendances were down to 54 million. This meant

that every man, woman and child in Britain was now visiting the cinema on average once a year, and a 'trip to the pictures' had often become an annual Christmas or birthday treat. By this point, there were only 660 cinemas still open, with a total of 1,246 screens between them (about 50 per cent being single-screen independents). Odeon had 75 cinemas with 194 screens, while ABC had 107 cinemas with 287 screens. In the space of just thirty years, six out of every seven British cinemas had closed. The only new growth in film exhibition was the gradual emergence of the subsidised regional film theatres, which began to attract an upmarket audience of film buffs, rather than movie fans.[10]

Despite this bleak outlook, there were still some entrepreneurs who saw opportunities to be taken. The Israeli cousins Menachem Golan and Yoram Globus had purchased an ailing American distributor, Cannon, in 1979, and used the company brand name to build up a rapidly expanding empire based in Britain. In 1982, they purchased the Classic chain (Britain's third largest, with 67 cinemas and 130 screens), then followed this in 1985 by acquiring the Star circuit (fourth largest, with 40 cinemas and 106 screens) – together these gave Golan and Globus a bigger market share than Rank. Their greatest coup, though, was in April 1986, when the audacious duo acquired Thorn-EMI, including its ABC cinema chain. Together with the Classics and Stars, this briefly gave Cannon a whopping 40 per cent of UK screens. The Cannon purchase of EMI in many ways marks the end of an era in British exhibition. Within three years, the company's unorthodox financial methods had led to its ignominious collapse, and the hapless ABC chain was subsequently sold on several times, and effectively decimated. Resurrection for an apparently doomed industry was just around the corner, however, and the imminent 'rise of the multiplex' will be discussed in a later section. First, though, we can dive straight back into the cheap and cheerful world of the traditional British quad, with a look at the next period of 'Formats and Design Strategies', in the post-war years.

CHAPTER 6

Formats and Design Strategies:
Terrifying! Nerve-Shattering! Blood-Curdling!

With the repeal of paper rationing in 1949, the physical quality of film posters (and their subsequent survival rate) dramatically improved. By now, the quad was established as the poster of choice for most advertising purposes, increasingly replacing the smaller letterpress posters for individual local cinemas. The latter had tiny print runs, came in all shapes and sizes, and were displayed in local shops and cafés, but as the number of cinemas still open declined dramatically over the 1950s and 1960s, they ceased to be produced. According to Peter Lee of the printers W. E. Berry, print runs on quads in the post-war period varied between about 1,000 and 5,000, depending on the film and the scale of the release. Exceptionally, the *Carry On*s had up to 20,000 printed. Big blockbusters like *Jaws* or *The Sound of Music* (1966) would have had quad runs of about 10,000, and would also have had other sizes and formats produced, like large 24-sheet hoarding posters. An average circuit release of the 1960s, in contrast, would have been between 4,000 and 6,000 copies, but by the early 1980s this had declined to 2,000 or less. As poster-sizes increase, print runs correspondingly decrease – the three-sheet format, for instance, would rarely have exceeded 400–500 copies.[11]

The design conventions for film posters, which had been established in the 1930s, remained largely in place in the post-war years. Realist rendering, featuring star portraits and significant scenes derived from photo-reference, was the norm, while caricature remained an option for comedy subjects. However, Ealing's experiments with style and composition, and willingness to use artists from other fields of design and illustration, were replicated in some instances. Not surprisingly, Michael Powell and Emeric Pressburger were foremost among those film-makers who were prepared to look 'outside the box' when it came to publicity images. The posters for their first post-war film, *A Matter of Life and Death* (1946), featured a collection of sketches by *Vogue* fashion artist Francis Marshall, who had already designed the posters for the musical *London Town* (1946). The results were certainly distinctive, but Marshall's line drawings lacked the impact of more conventional approaches that used more arresting blocks of colour.[12] Four years later, the posters for Powell and Pressburger's Associated British film *The Elusive Pimpernel* (1950) swung to the other extreme, and seemed clearly influenced by the Beggarstaff Brothers, with their large areas of flat colour and minimal detail. A contemporary Associated British quad advertising Cavalcanti's *For Them That Trespass* (1949) either aped the style of John Minton or was designed by Minton himself.[13] Within a couple of years, Associated British were (deliberately or not) employing Ealing artists, including Ronald Searle (*Castle in the Air*, 1952), Charles Mozley (*The Second Mrs Tanqueray*, 1952) and Frederick Middlehurst (*Background*, 1953).

A more obvious example of the influence of Ealing's approach to poster design would be Group 3, founded in 1951 to make use of new 'Eady Levy' money by producing modest but sincere pictures that could act as a training ground for young directors, designers and technicians. Group 3 was run by John Grierson and John Baxter, but Michael Balcon was also involved, which might explain why so much of the company's output seemed deliberately Ealingesque – whimsical comedies, and the occasional worthy social drama. Group 3 certainly followed Ealing's lead with its posters – *The Brave Don't Cry* (1952) by James Boswell, *Laxdale Hall* (1952) by Osbert Lancaster and *The Oracle* (1953) by Ronald Searle being particularly outstanding examples.[14] Despite

The Second Mrs Tanqueray (1952). Printed by W. E. Berry. Design and illustration by Charles Mozley (1914–91). A typically stylish poster by ex-Ealing artist Mozley, for this Associated British theatrical adaptation. (BFI)

Laxdale Hall (1952). Printed by W. E. Berry. Design and illustration by Osbert Lancaster (1908–86). A terrific comic design for this whimsical Group 3 farce. Art critic Lancaster had previously championed the Ealing posters in his journal articles. (BFI)

The Pure Hell of St Trinians (1959). Printed by Charles & Read. Design and illustration by Ronald Searle. The most iconic naughty schoolgirls of them all. Searle is now sadly the only surviving artist from Ealing's stable. (AC)

Saturday Night and Sunday Morning (1960). Printed by Stafford. Unsigned, but almost certainly the work of S. John Woods, this terrific design emphasises Albert Finney's defiantly amoral rebellion. (Courtesy of Lynda Wigfall)

Repulsion (1965). Printed by Broomhead Litho. Design and illustration by Jan Lenica (1928–2001). A really striking illustration by Lenica, catching the oppressive atmosphere of Polanski's British debut. (AC)

Seven Samurai (1954). Printed by Ward & Foxlow. Design and illustration by Peter Strausfeld. A typically distinctive lino-cut by Strausfeld, with an energetic portrait of Toshiro Mifune. (BFI)

its good intentions, however, Group 3 was not a success, and had been wound up by the end of 1955, after managing to produce a respectable twenty films (Balcon had made ninety altogether at Ealing Green). Along with Ealing's imminent demise, Group 3's passing marks the end of the brief period in which British cinema dared to flirt with serious artistic ambition for its posters.

This is not to say that outstanding designs have never appeared since, rather that the continuity of purpose was lost, and later examples are at best intermittent. Good posters are inevitably generally linked with good cinema, and Woodfall's breakthrough 'new wave' dramas of the early 1960s all enjoyed striking designs. *Saturday Night and Sunday Morning* (1960) – uncredited, but almost certainly the work of Ealing's S. John Woods – has a pugnacious Albert Finney shaping up in the centre of vivid green and red stripes carrying the title and credits, a potent symbol of the fighting form British cinema felt it was just then discovering. Woods actually signed another powerful collage for *The Loneliness of the Long Distance Runner* (1962), featuring a similarly defiant anti-hero in Tom Courtenay, and Enzo Apicella's design for *A Taste of Honey* (1961) appealingly conveys the drab but cheery milieu of the film.[15]

Tony Tenser, who, in the 1950s, was publicity manager for independent distributor Miracle Films ('If it's a good film, then it's a Miracle', as he liked to joke), later agreed to the hiring of Polish artist Jan Lenica (1928–2001) to design posters for his twin attempts at prestige, *Repulsion* (1965) and *Cul-de-Sac* (1966), the first two films made in Britain by Roman Polanski.[16] *Repulsion*, in particular, is a powerful design, the surrealistic silhouette of a falling woman eerily evoking Catherine Deneuve's nightmarish descent into madness. Another rare example of a deliberately surreal British quad of the period is Harry Gordon's psychedelic design for *Wonderwall* (1969).

One major series of 'alternative' British posters now receiving increasing attention are the Academy Cinema designs by Peter Strausfeld (1910–80), which appeared from the early 1950s through to the end of the 1970s.[17] The Academy Cinema on Oxford Street opened in 1913, but by the late 1920s had fallen on hard times and was due to be converted into a shopping arcade, until Elsie Cohen of the original Film Society acquired it in 1928 to be run as an arthouse. Its director/manager after the war was a German émigré George Hoellering, who had been interned during the conflict with fellow artist Peter Strausfeld, originally of Cologne. Following the war, Hoellering hired Strausfeld to design all the Academy's posters, featuring many of the great foreign-language classics and cult underground successes of world cinema. Strausfeld employed a very simple but effective style, using woodcuts and linocuts to produce often almost medieval-looking designs, in complete contrast to the slick appearance of most contemporary film advertising. The posters became a distinctive London landmark, having very small print runs of only 300–500, mostly printed by the Westminster Press, and later Ward & Foxlow. The sequence came to an end on Strausfeld's death in 1980, and six years later the Academy itself finally closed.

Cartoonists were used from time to time, if their style seemed particularly suited to the subject matter. Apart from the obvious example of Ronald Searle, other well-known contributors have included the popular Michael Ffolkes with *Lucky Jim* (1957), Terence 'Larry' Parkes with *Carry On Doctor* (1968), Norman Thelwell with *It Shouldn't Happen to a Vet* (1976) and, later, the more acerbic Gerald Scarfe with *The Wall* (1982) and Ralph Steadman with *Withnail and I* (1986).

By the 1970s, most film advertising had become so conservative that very few British posters of the period qualify for consideration on artistic grounds. David Hockney designed the quad for *A Bigger Splash* (1974), featuring a swimming pool montage, perhaps the only genuine 'household name' to have been involved in the field, while the pop artists Philip Castle and Allen Jones collaborated on a striking androgynous design for the sci-fi drama *The Final Programme* (1973). But examples like these became few and far between. The 1980s were of even less interest, though the British producer and distributor, Palace Pictures, maintained a higher design standard than most. The poster for Palace's *The Company of Wolves* (1984) was a brave attempt to do something different – an arty collage involving juxtaposed still-life photography (by Andy Seymour) and star portraits, arranged within a decorative illustrated border by Alan Lee. The following year, Jamie Reid, the Situationist designer responsible for most of the Sex Pistols' influential graphics, produced an attractive quad for

Carry On Doctor (1968). Printed by Tintern Press. Design and illustration by Terence 'Larry' Parkes (1927–2003). Parkes contributed several of the *Carry On* title-sequence cartoons, but this was his only poster for the series. (AC)

It Shouldn't Happen to a Vet (1976). Printed by Lonsdale & Bartholomew. Design and illustration by Norman Thelwell (1923–2004). With his famous series of pony cartoons, Thelwell was an ideal choice to illustrate this second James Herriot adaptation. (AC)

bittersweet Merseyside drama *Letter to Brezhnev* (1985). Palace Pictures started life as an arthouse distributor before famously scuppering themselves with a short-lived and financially disastrous move into high-risk production. However, Palace's posters were always elegantly designed and striking, and the firm persevered with illustration for some time after most of their contemporaries had effectively abandoned it. The artist usually employed on their quads was David Scutt, who contributed several coolly stylish designs for titles like *Mona Lisa* (1986), *Absolute Beginners* (1986) and *The Crying Game* (1992), though he is now better known for his popular bookjacket work on Bernard Cornwell's *Sharpe* series and Philip Pullman's *His Dark Materials* trilogy.

If the 'Ealing poster policy' had only a limited influence on post-war design, the wild imaginings of Universal's Karoly Grosz had a much greater impact. It was, in fact, in the developing fields of 'adults only' cinema and the 'double feature' that much of the liveliest and most controversial design work took place. The introduction of the 'X' certificate in January 1951 indicated a major shift in the moral climate and an acceptance of film as a medium for exploring serious and controversial themes. It also led to film posters themselves gradually breaking away from the more formal design strategies of previous years to employ increasingly brash and freewheeling styles. By the end of the decade, Britain's more commercially minded producers had latched onto the idea of using the 'X' to attract the newly identified teenage audience, luring them into cinemas with the promise of more provocatively sensational entertainment. The period thus saw the beginnings of domestic 'exploitation' cinema, marked by the appearance of successes like *The Quatermass Xperiment* (1955) – note the deliberately misspelled title – and *Nudist Paradise* (1957), the first fully fledged British sex film.[18] This downmarket but resolutely popular trend led to a flood of international horror and sexploitation films in British cinemas over the next twenty-five years.

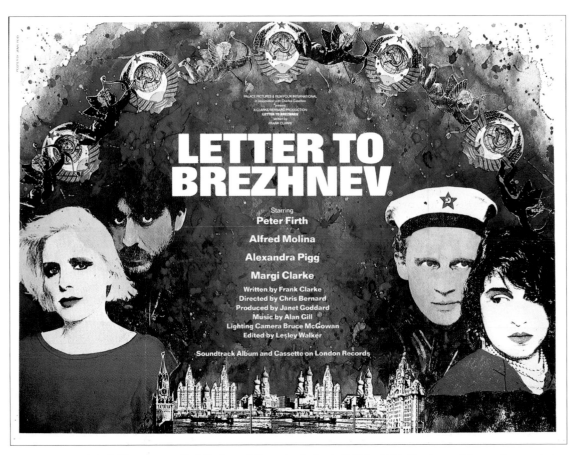

Letter to Brezhnev (1985). No printer credited. Design and illustration by Jamie Reid (b. 1947). Here's one of the very last genuinely distinctive artist-designed British film posters. (Courtesy of Lynda Wigfall)

Jack the Ripper (1958). No printer credited. Design and illustration by Olga Lehmann (1912–2001). One of only two women artists featured in this book, Lehmann had a varied commercial career, entering the film business in 1941, and eventually specialising in costume and set design. (AC)

As television dramatically increased in popularity over the 1950s, distributors cast around for different ways to sell their films, eventually coming up with a new approach at the end of the decade – the double feature programme. Of course, 'double bills' had existed in British cinema since the Quota Act, with the main feature typically being American and the supporting feature British. The 'quota quickie' industry of the 1930s had sprung up directly to supply a never-ending stream of these chiefly nondescript thrillers, and production continued up the mid-1960s, with such popular series as *Scotland Yard*, *The Scales of Justice* and *The Mysteries of Edgar Wallace*.[19] Although the posters for the quota quickies had sometimes been quite extravagant, the post-war advertising usually reflected the B-film's lowly status. The posters were generally just one- or two-colour silkscreens, although some examples, notably Baker & Berman's slightly more ambitious Tempean thrillers of the 1950s, had vividly atmospheric full-colour lithographs.

However, this particular level of British production was eventually ended by changes in exhibition practices. The double feature paired two films of equal status, typically eighty-minute exploitation pictures of one kind or another.

The 'double feature' as a marketing concept originated in the American drive-ins, and reached Britain around 1957. Films were generally paired by genre. One of the earliest examples of this, the twin American shockers *I Was a Teenage Frankenstein/Blood Is My Heritage*, were released by Anglo-Amalgamated (early market leaders in importing cheap US exploitation) in autumn 1958 with an outrageous quad promising 'Nothing like this in all the History of Horror!'. The two separate feature panels (in livid green, based on the original one-sheet designs) are placed at a jaunty angle to each other against a red background, with yellow blocks dotted around the border containing the tongue-in-cheek taglines 'FIENDISH … FRENZIED … BLOODCHILLING! … NOT for the squeamish! … DON'T come before dinner!

The Flesh Is Weak (1957). Printed by Stafford. Designer unknown. An early British sexploitationer, possibly the first deliberately provocative enough to earn an 'X' certificate. (AC)

Nudist Paradise (1958). No printer credited and designer unknown. Britain's first fully fledged sex film, albeit without any actual sex. A very wholesome-looking design, which could be advertising Weetabix or Ryvita. (AC)

…' and so on. Double features became an integral part of British exhibition for twenty-five years, until their rapid disappearance in the mid-1980s. By about 1960, plenty of production companies were gearing themselves up to turn out a steady string of modest features that could be deliberately paired off and promoted in this way – the leading exponents of the approach in Britain were, of course, Hammer films.

Between 1961 and 1971, Hammer released twelve classic horror double bills, from *Curse of the Werewolf*/*Shadow of the Cat* (both 1961), through to *Dr Jekyll and Sister Hyde*/*Blood from the Mummy's Tomb* (both 1971) ten years later.[20] After 1971, with the market rapidly shrinking, the company found its films tied up with whatever exploitation genre happened to be in vogue that particular year: first, motorcycle-gang melodramas (*The Vampire Lovers*, 1970/*Angels from Hell*, 1968 and *Lust for a Vampire*, 1971/*The Losers*, 1968), then later still, kung-fu actioners (*Frankenstein and the Monster from Hell*, 1974/*The Fists of Vengeance*,

1972 and *Captain Kronos Vampire Hunter*, 1974/*Girl with the Thunderbolt Kick*, 1968). For each of these releases there would be both a double-feature quad *and* two single-feature counterparts available. The double features are by far the most attractive posters, as they were almost always full-colour lithographs. The single features are generally one- or two-colour silkscreens only, though some work better than others, depending on the strength of the original design. *Plague of the Zombies* (1966), in Day-Glo green with a vivid white-on-black title, is powerfully effective, but *The Reptile* (1966), executed in an unappealing sickly yellow, simply looks ugly, and half the detail of its original artwork is obscured.

After 1970, when Hammer switched to purely British finance (from Rank and EMI), international one-sheets rather than single quads were produced for some of their co-features, depending on the distribution deal involved. Thus, of Hammer's later epics, *Blood from the Mummy's Tomb* is a one-sheet, *Frankenstein and*

The Case of the Pearl Payroll (1953). No printer credited and designer unknown. A lively hand-cut silkscreen for this typical 1950s second feature. Like the subsequent Edgar Wallace series, these eventually became regular fixtures on late-night television. (AC)

Teenage Frankenstein/Blood is My Heritage (1958). Printed by Display Productions. Artwork adapted from the US campaigns by Albert Kallis. One of the earliest exploitation double bills to hit British cinemas, this one clearly had its tongue firmly in its cheek. (AC)

Frankenstein and the Monster from Hell/The Fists of Vengeance (1972). Printed by W. E. Berry. Illustration by Bill Wiggins from a design by Eddie Paul. A typical 1970s double bill, with brash mix'n'match genres. If traditional gothic horror didn't appeal, how about a chop-socky kung fu epic? (AC)

the Monster from Hell is a single quad and *Captain Kronos Vampire Hunter* is neither, being apparently available *only* in the double-feature format.

Horror and fantasy films had always been at the cutting edge of cinema showmanship, and, up to the late 1960s, the pressbooks from companies like Hammer, Anglo-Amalgamated and Compton, who specialised in brass-neck exploitation, were full of outlandish suggestions for pulling in the punters. The quad poster was often central to these schemes. For Grand National's 1960 reissue double bill of *The Fly* ('Terrifying! Nerve Shattering! Bloodcurdling!') and *The Wasp Woman* ('SEE: strong men forced to satisfy a passion no human knows! SEE: a beautiful woman by day – a lusting queen wasp by night!'), the pressbook carried a bold recommendation:

> IMPORTANT NOTICE. We have produced a striking four colour quad crown poster of outstanding design to assist in the exploitation of this programme. We urge you to use as many of these quads as possible. Remember – IT ALWAYS PAYS TO ADVERTISE!

For Hammer's *Kiss of the Vampire* (1963), cinema managers unable to cope with the idea of 'building a model gravestone for use in your foyer' were still being encouraged to employ the same tactic that had been recommended by Universal more than thirty years before, when Dracula was first released:

> use the 40" x 30" blow up of Noel Willman. [Fangs fully bared in fury] Cut out the eye holes, and insert dim green lamps, on a flicker switch if possible. Have it cut out and mounted on the front of house, under the canopy with the words COME INSIDE AND SEE ME – BUT DON'T DARE COME ALONE

In the pressbook for Anglo's *Vengeance of Fu Manchu* (1968), half a page is devoted to:

> THE SEAT SELLING QUAD POSTER. Price 3/6d. each. With its tremendous visual impact value, this fully coloured poster, which is dominated by the unusual treatment of the title and its illustration of Christopher Lee as Dr Fu Manchu, is an accessory that should be widely used on Public Information panel sites and in place of normal letterpress quad crowns. Cut out

sections could also be utilised in the theatre, placing them in front-of-house glass doors, and on interior mirrors.

Similar advice is issued in many other 'hard-sell' exploitation pressbooks of the time. *Jack the Giant Killer* (1961) recommends that cinema managers 'DOUBLE YOUR EFFORTS to bang the drum for bigger box-office receipts.' In addition to using yet more 30" x 40" blow ups (replacing the eyes of a dragon with red gelatine and another flashing light) and painting 'Giant Footprints' on pavements adjacent to his premises, 'Mr Manager' was also advised that 'Our brightly coloured quad posters have already received favourable reaction. In addition to using the posters on your regular positions, book extra sites on major roads leading to your theatre.'

Predictably, the sensational advertising associated with Hammer and the double feature reawakened the issue of poster censorship. *The Times* of 23 May 1957 carried the story 'Outdoor Advertising Awards – Censorship of Cinema Posters Suggested':

> The 'unspeakable vulgarity and dishonesty' of some cinema posters was referred to by Lord Mancroft, Parliamentary Secretary, Ministry of Defence, in London yesterday when presenting certificates to winners of the national outdoor advertising awards for 1956. He supported the remarks of Mr Bruce Farquhar, president of the British Poster Advertising Association (BPAA), who praised the general standard of posters, but added that it was a pity that the same could not be said for cinema posters generally. 'It is rarely, if ever, that you see on the silver screen inside, the luscious confectionary depicted on the posters outside', he said, and suggested the setting up of a joint censorship committee for film posters.

Readers by this point may well be developing a certain sense of déjà vu. In a special supplement of 30 October 1961, celebrating the centenary of the BPAA, *The Times* was able to report 'Last year the links with [the BPAA and] the cinema industry were strengthened when a representative of the Poster Associations was invited to join the censorship committee of the Kinematograph Renters Society.' This was clearly as near to 'joint censorship' as the film industry was then prepared to get.

Campsite Massacre/Hellcat Mud Wrestlers (1983). Printed by Broomhead Litho. Design and illustration by Tom Chantrell. Words fail us completely here. From this point there was clearly only one direction British cinema could effectively go: upwards. (AC)

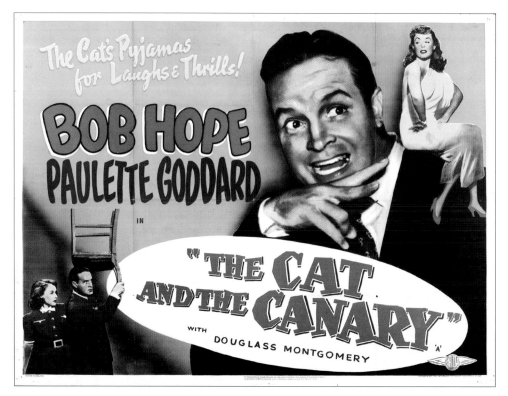

The Cat and the Canary (1939). Printed by Stafford. Designer unknown. A fine example of a reissue poster, in this case from 1953, as can be determined by Stafford's serial number in the bottom right-hand corner. Eros released scores of such reissues during the 1950s. (AC)

Hammer continued to be a thorn in the flesh of the censors. The company's posters were always colourful and shocking, and, like the films themselves, increasingly pushed the boundaries of the acceptable. The early horror titles (being licensed from Universal) were chiefly distributed by Rank, and promoted by striking posters from Bill Wiggins (the Karoly Grosz of the Downton's agency) like *Dracula* (1958), *The Mummy* (1959) and *Curse of the Werewolf* (1960). *The Mummy* is possibly a unique instance of a poster directly influencing a film's content. The pre-production quad design featured a distant policeman shining his torch's beam straight through a gaping hole in the mummy's torso, a startling image bearing no resemblance to any scene in the script. When star Peter Cushing caught sight of this, he insisted on an action sequence being inserted into the film in which he dramatically thrusts a harpoon into the monster's chest, in a conscientious attempt to at least partially justify the poster imagery. 'You should never cheat the audience,' admonished the upright Cushing.[21]

This sort of material won Hammer few friends among the contemporary critics. 'Only a sick society could bear the hoardings, let alone the films,' fumed Derek Hill in a *Sight & Sound* article of 1959.[22] However, Hammer's studio head, James Carreras, was entirely unabashed at this sort of controversy, and, from the mid 1960s, used his company's brand name as a major selling point in the posters themselves. 'From Hammer, the House of Horror', gloated the prominent central panel on the 1966 double bill *Rasputin the Mad Monk/The Reptile* by Tom Chantrell, the company's 'house artist' of the period. By 1971, and Mike Vaughan's quad for *Hands of the Ripper*, the blood red block-letter phrase 'HAMMER HORROR' at the top of the design is actually larger than the film's title below it.[23] However, by the early 1970s, some of Hammer's posters had become genuinely extreme. Posters for their 1970–1 'lesbian vampire' series (*The Vampire Lovers, Lust for a Vampire, Twins of Evil*) aggressively exploited the films' 'flesh and blood' focus, while Arnaldo Putzu's pre-production artwork on titles such as *Dr Jekyll and Sister Hyde* (1971) was often eye-poppingly gory. Not surprisingly, the letter columns of *The Times* once again began to buzz with irritation, the issue of 18 February 1971 containing the following:

Sir, Am I alone in finding more and more film posters on the Underground highly objectionable and offensive? I believe the LTE should take action and refuse to display posters containing offensive words and imagery. Yours faithfully, C. Warren Pyne, Woodford Green, Essex.

The Kinematograph Renters Society finally took action in January 1974, setting up the Advertising Viewing Committee (AVC) in an attempt to pre-empt criticism of individual distributor's poster campaigns, and to contain a general feeling that matters were getting out of hand.[24] Informally known as The Poster Committee, the AVC met every two weeks at the KRS's headquarters on Soho's Golden Square to vet all the new 'X' certificate poster designs. Those that were passed carried a little oval logo stating 'Advertising Approved – Advertising Viewing Committee'.

By the time that the committee was formed, 'sexploitation' was in full swing as a genre, and artists like Tom Chantrell considered it their duty to keep up a running battle with the AVC over where the line could be drawn. In Chantrell's case, his posters for such films as the Mary Millington sex comedies always started out with their heroines completely naked. These would come back from the AVC with a straight 'No', and the artist would be required to add bikinis or other details, obscuring the offending body parts. Sometimes he found quite ingenious solutions to this: in *Private Vices & Public Virtues* (1977), he scattered artistic petals across the controversial areas. Occasionally, though, the policy could create unexpected difficulties. In his design for *Through the Looking Glass* (1978), a naked couple are depicted having rather rough sex, reflected in the shards of a broken mirror. The AVC objected, and asked for some of the pieces of mirror to be removed, to soften the image. The problem was, the more pieces of mirror Chantrell painted out, the more luridly suggestive the poster became. In the end, his original design was reluctantly approved and printed, whereupon it immediately fell foul of several (upheld) complaints to the Advertising Standards Authority, itself first established in 1962.[25]

By the late 1970s/early 1980s, Hammer had dropped out of feature-film production, sexploitation had moved on to video and the double feature had run out of steam. Some of

The Story of Robin Hood (1951). Printed by Stafford. Designer unknown. A lively hand-drawn litho for the first release of this Disney live-actioner, actually the final film to be shot at Denham Studios. (AC)

The Story of Robin Hood (1951). Printed by Sales & Display Services. Illustration by Arnaldo Putzu for this 1972 reissue. Putzu has quite closely followed the original design, but this poster is as unmistakeably 1970s as its predecessor is 1950s. (AC)

Creature from the Black Lagoon (1954). No printer credited and designer unknown. A 1962 reissue for this popular monster movie, one of a series of classic Universal horrors Rank re-released over the early 1960s. (AC)

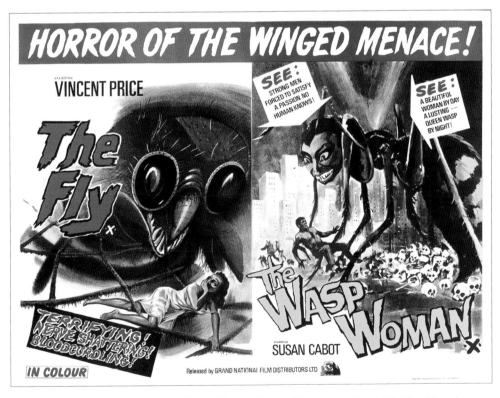

The Fly/Wasp Woman (1958). Printed by Electric Modern. Designer(s) unknown, though *The Wasp Woman* is probably the American Albert Kallis. This is an early 1960s reissue for two of the most terrifying films featuring people turning into giant insects ever made. (AC)

Through the Looking Glass (1978). No printer credited, but probably Bovince. Design and illustration by Tom Chantrell. About as near-the-knuckle as British film posters got, with Catharine Burgess and Jamie Gillis enjoying a lively game of Twister. (AC)

the smaller distributors were reduced to pairing off the most ill-matched tat, in an effort to simply keep going. Few who have seen Tom Chantrell's jaw-dropping quad for *Campsite Massacre/Hellcat Mud Wrestlers* (1983) can easily forget it, and posters like these are a potent reminder of a period when the cinema in Britain really did seem to be nearing the end of a final, terminal, decline. But while the industry in general actually enjoyed a dramatic revival from the mid-1980s onwards, the double bill vanished for good. The last great horror double feature to terrify British cinemagoers was in fact a reissue pairing of *Nightmare on Elm Street/The Evil Dead* in September 1986 – by this point, distributors were not even bothering to print new double-bill posters, and in this instance simply sent cinemas the previous year's *Elm Street* quad by Graham Humphreys for their display cases.

A close cousin of the double-bill poster (at least in terms of contemporary collecting status) is the reissue. Reissues have existed since the beginnings of cinema, but like double bills effectively vanished in Britain in the mid-1980s, as the advent of home video swiftly eliminated their box-office potential. Virtually the only contemporary examples are restored BFI prints of classic films from the National Film Archive, which play mainly in the regional film theatres. The standard of different reissue posters can vary enormously, with a handful arguably being superior to the original release, where they perhaps feature more effective artwork or depict a particular scene that has since become famous. One example of this is the original poster for *Alien* (1979), with its minimalist design by Philip Gips, showing a hatching alien egg positioned above a sinister nest of shadowy embryos. When the film was reissued in 1982 (supported by *The Fog*), the new quad had a practically retro design featuring the Alien itself looming over a dramatic line-up of all seven cast members. This artwork seemed deliberately to recall the film's 1950s inspiration, *It! The Terror from Beyond Space*, and – being probably the only

international poster ever to feature both monster and full crew – was a much more obviously appealing commercial image. Nevertheless, it is still a less popular design than the original.

With the odd earlier exception, the practice of reissuing films began during the product shortage occasioned by the uncertainty of the 1938 Films Act, and continued under similar conditions of scarcity during the war. Reissues were pressed into service again after the war, when a serious dispute between Hollywood and the British government over dollar earnings leaving the UK led to a flat refusal by US studios to export any new American films into Britain between August 1947 and May 1948. Starved of new product, British cinemas were forced to survive for almost ten months on a diet of hastily cobbled-together reissues, and examples of the brief flood of hand-cut silkscreen quads that resulted still turn up from time to time today. Re-released films proved popular enough with filmgoers for the practice to be continued in times of plenty.

Most decent-sized box-office hits were re-released at least once, around two or three years after they first appeared. If the distributors could not be bothered to commission a new poster design, the original was simply reused, crudely printed as a one- or two-colour photographic silkscreen. Reissues sometimes followed recognisable patterns. From the early 1960s, for example, Disney re-released its classic back catalogue of animated features to coincide with the school holidays, on a rolling seven-year schedule. Thus *Dumbo*, for instance, was reissued in 1965, 1972 and 1979, each time with a different poster. On other occasions, reissues occurred in a block. Following the great success of Hammer's early gothic horrors, in 1962 Rank (who had a long-term distribution deal with Universal in America) decided to re-release many of the Universal originals. From *Son of Frankenstein* (1939) to *The Creature from the Black Lagoon* (1954), almost a dozen classics of the 1940s and 1950s did the rounds again, each sporting a new

Werewolf Woman (1976). No printer credited, but probably Bovince. Illustration by Sam Peffer, from a design by Graffiti. This quad has clearly seen service in Ireland, since some enterprising cinema manager has added the heroine's black-marker-pen bikini. (AC)

The Camp on Blood Island (1958). Printed by Stafford. Design and illustration by John Stockle. This sensitive and understated design was actually banned by London Transport. Also note Josh Kirby's paperback cover, reproduced in the corner. (BFI)

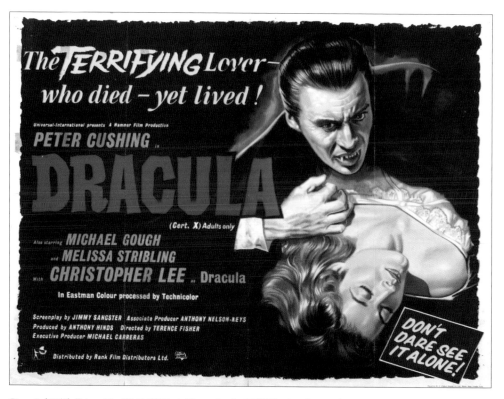

Dracula (1958). Printed by W. F. Clifford. Illustration by Bill Wiggins, from a design by Eddie Paul. A classic poster, with the illustration based on a famous publicity shot by Hammer's stills photographer Tom Edwards. (BFI)

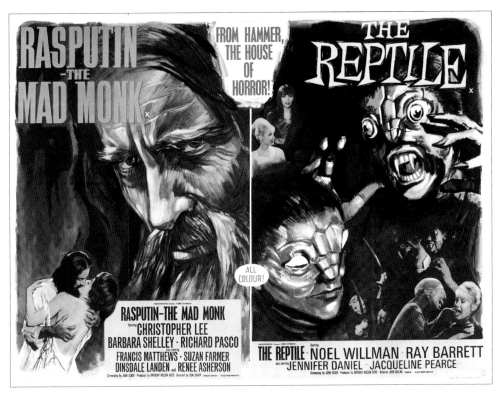

Rasputin the Mad Monk/The Reptile (1966). Printed by Stafford. Design and illustration by Tom Chantrell. 'From Hammer, the House of Horror', the most determined attempt at branding by a British production company since Ealing's heyday. (AC)

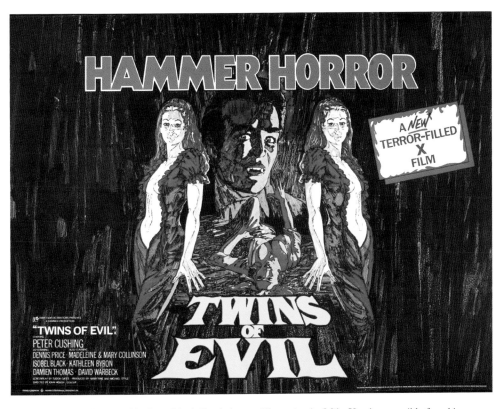

Twins of Evil (1971). Printed by Lonsdale & Bartholomew. Illustration by Mike Vaughan, possibly from his own design. The sexual elements are now being increasingly foregrounded in this brash pop-art design. (AC)

poster, to cash in on the horror fad. The quads were all cheap silkscreens printed in eye-watering Day-Glo primary colours, but, despite this, possess a certain clunky period charm, and (unlike the originals) are to some extent still available.

Most post-war British posters up to about 1960 featured just one design per film, per format, though Downton's quite regularly produced a 'sophisticated' version for the West End launch and a more basic layout for the general release.[26] As the 1960s progressed, though, an increasing trend was for bigger films to have two (or more) different styles of quad. However, British posters (unlike their American counterparts) have never featured any helpful code numbers to identify such alternative designs.[27] Alternative designs were sometimes forced by censorship issues – a famous example is the quad for *Goldfinger* (1964), where the UK version featured a risqué golden Shirley Eaton, and the more prudish Irish version a demure golden hand, both by American designer Robert Brownjohn. A more frequent source of variation was the 'advance' or 'teaser' poster. These

had been around in one form or another since before the war, but became particularly widespread during the 1970s as blockbusters began to employ marketing that created anticipation weeks, or even months, before the films' actual arrival. These 'coming soon' posters sometimes featured visual gimmicks, or employed an eye-catching minimalist focus on one particular unique element of the film – the so-called 'teaser'. On other occasions, straightforward alternative artwork was used: for example, the advance quad for *Clash of the Titans* (1981) features a lively action-packed design by the US artist Dan Gouzee, which is rather more effective than the slightly static alternative on the general release poster by Roger Huyssen. Another celebrated instance would be the pre-release British quad for *Star Wars*, which used the original US design by the Hildebrandt brothers. Gary Kurtz later selected Tom Chantrell's alternative artwork for the general release poster, and surviving copies of the Hildebrandt original are now fairly scarce and sought-after.

CHAPTER 7

Publicity Departments, Advertising Agencies and Design Studios

Prior to the war, the distributors' publicity departments had often employed in-house creative teams to help devise their promotional material, and many publicity managers (like Dudley Pout) would have had an art-school/design background. Full-time creative teams were expensive to maintain, however, and after the war UK distributors instead began to 'contract out' responsibility for their campaign work to a handful of advertising agencies. The publicity manager's role was now more that of a go-between, liaising with both the agencies' account executives and (subsequently) the print buyers at NSS.[28]

The amount of actual creative input these post-war publicity men had naturally depended upon temperament and ability. The chief print buyer at NSS during the 1970s was Ian Hedger, and taking a 'mental walk down Wardour Street', he recalls that the distributors' publicity reps he mainly dealt with were: Ron Shinn at Rank, George Skinner at Avco Embassy, Leslie Pound at Paramount, Charlie Berman at United Artists, Ted Collins at British

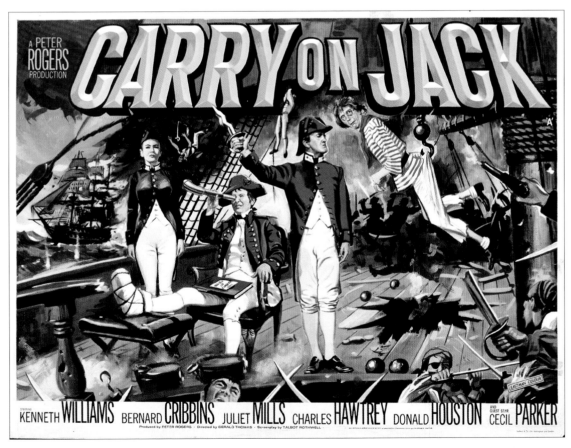

Carry On Jack (1963). Printed by Stafford. Design and illustration by Tom Chantrell. Everything but the kitchen sink is thrown into this hilariously epic Allardyce quad. (AC)

Lion, Jack Upfold at Cinerama, Trevor Green at Entertainment, Al Shute at Warners, Donald Murrey at Columbia, Graham Waugh at EMI, Eddie Patman at MGM, Arthur Allighan at Disney and John Fairbairn at Fox.[29] Some of these men were long-term fixtures, others came and went, and several worked for more than one company over the course of their careers. Some enjoyed a good reputation, others less so. Film publicity, then as now, was a relatively tight-knit and thus highly incestuous business. Wardour Street in those days was a 'rabbit warren', where everybody knew everybody else, and the latest industry gossip was endlessly exchanged over a pint in one of the trade's five pubs of choice: The George, The Ship, The King of Corsica, The Blue Posts or The Intrepid Fox.[30]

As we established in Part One, six advertising agencies were responsible for most of the poster campaigns and artwork that were not created by distributors' in-house teams. We can now return to those agencies to see how their work expanded in the post-war years.

By the early 1950s, Allardyce Palmer, which handled the Warners and Fox accounts, had moved to 109 Kingsway WC2. Now under the control of the founder's son, Peter Palmer, it had absorbed Bateman Artists as a fully owned creative arm. Bill Bateman himself retired a couple of years after this takeover – gratefully, according to Tom Beauvais, who described him as 'quite a cultured kind of chap, into classical music and anything arty, who never really meshed with the advertising people at all'.[31] In turn, Allardyce tended to look down on their film accounts as a 'necessary evil', to quote

Beauvais again. They were seen as 'the rubbishy, lower end of the market […] the agency actually much preferred the "quality accounts" like British Aluminum, Smith's Industrial Instruments, and so on …'. The main account executive on the film side was Stan Heudebourck (1926–2002), who first joined Allardyce in 1950, following eight years in Wardour Street reviewing shorts for the trade papers. In 1957, anticipating the formation of Warner-Pathé, a new Entertainments Publicity Division was set up at Screen House, 119–25 Wardour Street, headed by Heudebourck and creative director Tom Chantrell. (The other key 'creatives' on the film side were Tom Beauvais, John Chapman, Ray Youngs and Colin Leary.) The division thus also took on the responsibility for the publicity of part of Associated British, Hammer, Anglo-Amalgamated, Allied Artists and AIP, while continuing to design for Warners' three West End cinemas: the Warner Theatre on Leicester Square, the Carlton Haymarket and the Rialto, Coventry Street.[32] In 1965, the film division moved back in with head office, in their new premises at 213 Oxford Street, above Littlewoods.

In 1970, Allardyce was acquired by rival agency Kingsley, Manton & Palmer (KMP), and was immediately merged with another KMP-owned agency, Hampshire House, to make Allardyce Hampshire. Peter Palmer left, to be replaced by Donald Bailey. The merger brought in a new level of 'visualisers' and other creative staff, which, within two years, led Tom Chantrell to quit, though he continued to work for the agency on a freelance basis.[33] In 1973, the office moved again, to 10–12

Allardyce Palmer's Screen House offices, sometime in the mid-1960s, where a mock-execution by T-Squares appears to be taking place. Left to right: John Chapman, Tom Chantrell, Stan Burke, Mike Paterson and Ray Youngs. (Courtesy of Tom Beauvais)

The last law in a world gone out of control

Pray that he's out there somewhere.

Produced by BYRON KENNEDY
Directed by GEORGE MILLER
With MEL GIBSON
Music by BRIAN MAY
Written by JAMES McCAUSLAND
and GEORGE MILLER

MAD MAX

Mad Max (1979). Printed by Lonsdale & Bartholomew. Design and illustration by Tom Beauvais. One of the artist's best-known designs from the Chapman-Beauvais years, stripping the film down to its basic elements of the cop, the car and the road. (AC)

Carlisle Street, and things rapidly began to disintegrate. A management reshuffle at Warners resulted in Allardyce losing this historic account to Downton's, and when Fox in America had an almost-simultaneous change of heart, they also departed, going briefly to Doyle Dane Bernbach for a couple of years, then later UK Advertising.[34] Heudebourck followed Fox to DDB-UK, where he stayed on, working on the agency's Ladbrokes betting accounts, until his retirement in 1981. By the time of Heudebourck's departure, Allardyce was already on the ropes. In 1975, it was merged with three other loss-making KMP agencies, to make Allardyce PLN, but by this stage was 'haemorrhaging money'.[35] The final blow was the collapse of its biggest-spending client, Brentford Nylons, in 1977, which left Allardyce liable for their debts. The agency was effectively defunct by 1978, though not finally dissolved until October 1985.

The disintegration of Allardyce led to the establishment of a 'spin-off' design studio, Chapman-Beauvais, first set up in April 1975 by John Chapman and Tom Beauvais (who had left Allardyce in 1971 and 1973 respectively).[36] Their good long-term relationship with Julian Senior enabled them gradually to take over much of Warners' creative work, beginning with *Barry Lyndon* (1975), while also getting some assignments from Fox, during 1976 and 1977, including *Star Wars*. This early success soon allowed the firm to poach Ray Youngs and Colin Leary from the collapsing Allardyce and, although Tom Beauvais retired in 1992, the company is still handling most of Warners' British publicity (currently from offices on 27 John Street) over thirty years later.

After the war, Arthur S. Dixon, based in Kingsbourne House at 229–31 High Holborn, were handling three major film accounts – Columbia, Disney and Warwick (Cubby Broccoli's production company of the 1950s).[37] Two key poster designers joined Dixons in the mid-1950s: Vic Fair in 1954 and John Stockle in 1955, by which time the office had moved again, to 7–8 Savile Row. The chief account man on the film side was Tony Church,

A nice view of Allardyce's studio around the mid-50s. The two figures at their desks in the foreground are on the left, Tom Chantrell, and on the right, Tom Beauvais. (Courtesy of Tom Beauvais)

apparently (like his counterpart Stan Heudebourck at Allardyce) also a frequent contributor to the copywriting. Arthur 'Ben' Bennett was Dixon's principal art director of the period, and Rex Robinson the account executive handling Disney. At the end of 1965, Dixons was merged with two other agencies, in the very first three-way combination in British advertising. The smaller of the two new partners was Waddicor Clark Wilkinson, who quickly proved to have been less than honest about their true financial situation, collapsing altogether by mid-1967 and effectively dissolving their share of the partnership.[38] The other company involved in the merger was Downton Advertising Ltd, the third of our 'big six', and indeed perhaps the greatest name of all the UK's film agencies.

As we have seen, Downton's was set up in 1942 under the 'arm's-length' control of Rank. Designer and illustrator Eric Pulford had been invited down to London by Rank early in 1943 to work full time on their publicity, at the instigation of John Davis's Odeon deputy, Earl St John, and his publicity manager, John Dennett. Pulford, in collaboration with his brother Bert, who acted as company secretary, initially set up a design studio with Ron Hornsby, Tom Brownlow and Freddie Hibbs called Pulford Publicity, based above Express Dairies on Fleet Street (and later briefly on Glasshouse Street in Soho), via funding from Downton's.[39] At the end of the war, Pulford Publicity and Downton's jointly moved to new offices in Temple Bar House on Fleet Street, Pulford becoming a director of both companies. Finally, in 1963, Pulford's studio effectively took control of Downton's, he and Reg Hillier becoming joint managing directors. On the film side, Pulford's good long-term relationship with all the senior Rank executives meant that Downton's held the account for the entire Rank Organisation, including both its Odeon and Gaumont cinema chains, and also Universal Films (which Rank exclusively distributed up to 1969). The other film accounts it held during this period were RKO in the 1950s, British Lion and half of United Artists, specifically for those UA films launched at the Odeon, Leicester Square.[40]

Rank's main account executive at Downton's for many years was Pulford's co-director Reg Hillier, and the firm always had the reputation of being principally a film agency, though it did run various other commercial accounts, including Mercedes, Lufthansa, Imperial Smeltings and Fina Petrol.[41] On the film side, in addition to Pulford, the main creatives then included designers Eddie Paul and Fred Atkins, illustrators Bill Wiggins and Brian Bysouth, general assistant Colin Holloway and print buyer Les Silver. From the mid-1950s, Rank Overseas' involvement with the Italian Cinecittà studios meant that Downton's began employing artists from the Studio Favalli in Rome, most famously Renato Fratini and Arnaldo Putzu, who both moved to London for lengthy stays during the 1960s and 1970s. Downton's was thus a considerably bigger outfit than Allardyce Palmer, boasting a total staff of around eighty to ninety, including a studio of about forty creatives.

The film side of Downton's always made good money, and, early in 1964, the Inland Revenue began to take an active interest in alleged financial

Honkytonk Man (1982). No printer credited, but probably Broomhead Litho. Design and illustration by Tom Beauvais. A fine Clint Eastwood portrait on this late star Western. Kyle Eastwood's pose on the fence was actually modelled by the artist's own son. (AC)

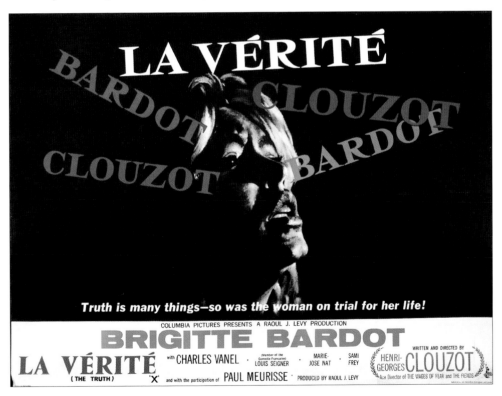

La Vérité (1960). Printed by Stafford. Illustration by Vic Fair, from (as the artist recalls) an original French publicity still. One of Fair's very earliest printed posters from his time with the Dixons agency, this later won a design award in America. (Courtesy of Vic Fair)

Doctor in the House/Genevieve (1954). Printed by Charles & Read. Design and illustration by Eric Pulford. A classic late 1950s Downton reissue, from a period when Pulford was still contributing a lot of finished art himself. (AC)

Silver Bullet (1986). Printed by Lonsdale & Bartholomew. Design and illustration by Vic Fair. A late-period Downton poster (with an agency credit on the left), the hand-lettering clearly shows this was only ever intended to be a preliminary rough, but it ended up printed anyway. (AC)

irregularities involving the agency.[42] Faced with what seemed a potentially devastating back-dated tax bill, Pulford arranged the Downton–Dixon–Waddicor Clark Wilkinson merger in 1965, selling the valuable lease on Temple Bar House, and moving to new premises in Metropolis House, 39–45 Tottenham Court Road. This sequence of events naturally added Dixons' designers to the creative staff, plus Columbia and Disney to the film accounts, though, ironically, the threatened tax case never materialised. However, the swift collapse of the WCW arm in mid-1967 seriously weakened Downton's' financial position, and at the end of the year the agency was taken over by Garland Compton UK. One of the directors of Compton was David Bernstein, originally a copywriter of some brilliance and a powerful personality, who quickly took an active interest in the film side of the operation. 'He tried to muscle in', as one of the old hands later put it, 'but it just didn't work – the clients wouldn't have it.'[43] Although not everyone at Downton's shared this antipathy to Bernstein, his controversial management style, together with a general long-term dissatisfaction

concerning pay, quickly led to a breakaway group forming, Feref Associates Ltd.

Feref was made up of five ex-Downton men: Fred Atkins, Eddie Paul, Ray Clay, Eddie Garlick and Frank Hillary.[44] In May 1968, each of these five put up one month's salary to finance the new company, with Eddie Paul as managing director.[45] Feref went on to employ a string of illustrators over the years, including Arnaldo Putzu, Brian Bysouth, Frank Langford, Josh Kirby, Dougie Post, Mike Bell and many others. The studio was originally based on Poland Street, above Bermans hat shop for six months, then 16 Little Portland Street and later 14–16 Great Pulteney Street, steadily building up its film work through the 1970s, as it competed directly with Downton's *et al.* for business.[46] As Britain's first specialist film-publicity design studio, it was able to undercut its rival agencies with cheaper quotes for high-quality work.[47] By the early 1980s, it was actually putting its name on some of its posters – Brian Bysouth's illustration for *Honky Tonk Freeway* (1981) was one of the first to carry their tag.[48]

Heat and Dust (1982). Printed by Broomhead Litho. Illustration by Brian Bysouth from a design by Fred Atkins.
A Feref poster for this impeccably respectable Merchant Ivory costume drama. (AC)

Meanwhile, following the Compton takeover and subsequent Feref defection, Downton's moved again, to 80–4 Charlotte Street. The agency was now called Downton-Pulford-Compton and replacement creative staff were taken on. The next major shake-up was the dramatic reverse takeover of Garland Compton itself by Saatchi & Saatchi in 1975, which immediately led to a brief partnership with Compton executive Graham Roe (as Roe-Downton), and another office move for the film side to 103–9 Wardour Street. The agency's chairmen were now Mike Hopkins and John Grundy, the principal film executives Peter Brunton (originally of Dixons) and Andrew Harrington, and the chief print buyer Dave Sands (previously with Allardyce).[49] Following the collapse of rivals Allardyce, and the big distributor mergers of the early 1970s, Downton's clients now included Columbia-Warner, Fox-Rank, United Artists, Walt Disney, plus the major independents Brent Walker and Avco-Embassy.[50] However, they were not immune the ceaseless wheeling and dealing

of Saatchi & Saatchi, the biggest advertising conglomerate of the time. In 1982, the Saatchis acquired the already-mentioned KMP agency, and made Downton's a KMP subsidiary. Then, in 1985, KMP itself hit difficulties, and was merged with an outside agency, Humphreys Bull & Barker, to make KHBB, with an associated office move to 82 Charing Cross Road.[51] By this stage, however, most of Downton's original creative staff (including Eric Pulford himself) had already left or retired. In 1992, another merger saw the company rebranded as CME-KHBB, but with heavy losses being sustained on the main agency's commercial business, Downton's was eventually moved into Saatchi HQ on Charlotte Street to retrench. In 1995, following Vic Fair's retirement and yet another reshuffle, the name was changed one last time to K Advertising, but Carlton's purchase of Rank Film Distributors in 1997 effectively marked the end of the historic agency.[52]

The fourth of our six agencies, Greenly's, continued to handle the Paramount account after

Funeral in Berlin (1967). Printed by W. E. Berry. Design and illustration by John Burningham (b. 1936). A typically stylish Lonsdales poster, from an artist now better known as a children's book illustrator on such modern classics as *Avocado Baby* and *Mr Gumpy's Outing*. (BFI)

The Front Page (1974). Printed by Lonsdale & Bartholomew. Illustration by Ann Meisel from a design by John Raymer. Meisel (b. 1947) was a contemporary of Richard Amsel at the Philadelphia School of Art in the late 1960s, and is now best known for her LP record covers. (AC)

the war, mainly adapting the company's American campaigns. In 1965, however, Greenly's was taken over by a new agency, Lonsdale Advertising, and the office moved to Commonwealth House, 1–19 New Oxford Street. The company's commercial accounts of the period included Abbey National, Pioneer, Toshiba and Great Mills, and in 1973 (by which time, following various mergers, the firm was known as Lonsdale Crowther Osborne), the office moved again to Hesketh House, 43–5 Portman Square.[53] Lonsdale's film accounts grew as the 1970s distribution mergers began, taking on MGM-EMI and CIC (Paramount-Universal) in 1970, then the major independent ITC in 1974 and United Artists (UIP) in 1981. The agency's creative director was Ian Crowther, with the account managers variously including Jack Foot and Roger Stokes for CIC, Tony Middleton for EMI and Philip Wimhurst for ITC. The two chief art directors were Ian Potter (EMI) and John Raymer (CIC), with the other key man on the poster side being Eddie Cobbett, responsible for finishing the proofs, and

later liaising with both the print buyers at NSS and the printers themselves.[54]

Lonsdale seems to have produced rather less original work overall than either Allardyce or Downton's. Two of its former executives, Ian Freeman and Mike Cohen, both estimate that 90 to 95 per cent of the agency's output was made up of simple adaptations of US campaigns, with some of the creative work being farmed out to Feref. Lonsdale also ran a smaller studio than its rivals, with 'perhaps half-a-dozen' creatives working on the film side.[55] As chief art director, John Raymer had responsibility for handing out the actual illustration work to the small group of freelances then specialising in such assignments: Fratini, Putzu and Bysouth, plus about four or five regular illustrators from the Artist Partners agency on Dover Street.[56] As Raymer explains:

> In line with the other large London agencies, the creative department concentrated on concepts, design and writing, and had no 'in house' illustrators. Of course, some of the art directors

Dr No (1962). Printed by Stafford. Illustration from the US campaign by Mitchell Hooks. An iconic quad from UK Advertising. Later Bond illustrator Robert McGinnis actually credits Hooks with kickstarting his commercial career, via an introduction to bookjacket work in the early 1950s. (BFI)

could do illustrative work, e.g. Bob Berkoff, but the golden rule was that any finished artwork was not done in the company's time, but had to be freelance. Lonsdales, like other major agencies, had an art buying department. This usually comprised two people, a head and an assistant, both of whom negotiated prices and timing, but more importantly saw work that was brought in speculatively by artists, photographers and representatives. The department kept a good comprehensive library of work which could be readily referred to, and there was a two-way liaison between art buyers and art directors on an almost daily basis, so that the latter were made aware of what was available in the world outside the agency. The buyers were also active in seeking out new talent and resources.[57]

Lonsdale's film accounts all disappeared during the mid-1980s. It briefly gained the ABC cinema circuit in 1984, but Cannon's takeover of Thorn-EMI abruptly ended the agency's association with

both this and the EMI account itself just two years later. Then, in summer 1988, UIP defected to Young & Rubicam, an agency much better placed to co-ordinate the major international campaigns now required.[58] That October, the company name was changed to The Capper-Granger Agency, and it was finally dissolved altogether in August 2000.

Our penultimate agency, UK Advertising, held the MGM account, and part of United Artists' business. As we noted earlier, Downton's held the United Artists business for films opening at the Odeon, Leicester Square; in contrast, the UK provided the advertising for UA films launched at the London Pavilion. The Pavilion was traditionally used to open films that United Artists were a little uncertain about.[59] This had no obvious impact on their later success, though – both *Dr No* (1962) and *A Fistful of Dollars* (1964), two of the biggest films of the 1960s, originally opened at the Pavilion (which itself eventually closed in 1981). During this period UK's managing director was John

Harvey, who in 1968 offered the newly formed Feref a lifeline one-year contract for creative work.[60] Otherwise, as at Lonsdale, much of UK's output comprised simple adaptations of American campaigns. In 1966, the firm moved to Chesham House, 132–54 Regent Street, and its film accounts began to pick up. It gained the Classic circuit in 1967 and Fox in 1976, plus various other independents in between, including Cinerama, Hemdale, Goodtimes and Entertainment. UK's owner was David Abrahams, and its account executives and creative staff variously included Tony Gregory, Dick Jeffs, Mike Wheeler and (from 1968) Ken Paul, Barry James, Russ Eglin and John Farley. All of these men also worked on the agency's numerous theatre accounts in addition to the film side.[61] However, when Abrahams sold the company to Bill McConnell in 1977 (moving to 25 Dover Street), the film accounts began to drop away. The last to go were Fox, United Artists and Classic during 1981–2. Following a brief name-change to McConnell Associates, the company's assets were quickly sold off, and the firm dissolved altogether in June 1988.

By the end of the war, our final agency of the six, Rex Publicity, were based at 149 Lupus Street, Victoria SW1, and were exclusively handling the ABC circuit's publicity.[62] They managed to hang onto the ABC account (apart from one short blip) for more than forty years, taking in further office relocations to 131–4 New Bond Street in 1954, and 5 Chesterfield Gardens, Curzon Street, in 1966. By this time, the firm was uniquely putting a 'Rex Publicity' credit on many of their quads. These were mainly double bills, carrying the ABC banner along the top, and featuring quite different artwork to their single-feature counterparts. The agency obviously had an arrangement with Allardyce, as the artist on several of these titles was Tom Chantrell.[63] In 1969, the agency changed its name to Rex Stewart Jeffries following an internal reorganisation, and three years later in 1972 it actually lost the historic ABC account briefly to KMP.[64] Rex regained it in 1974, by which time their offices had moved to Old Court Place, off Kensington High Street. For this final period the account was run by Graham Rowsell, who had arrived via KMP.[65] In 1984, ABC shifted briefly

A Fistful of Dollars (1964). Printed by Stafford. Illustration from the US campaign by Mitchell Hooks. Another key 1960s film, again featuring UK Advertising's habitual use of adapted American artwork. (AC)

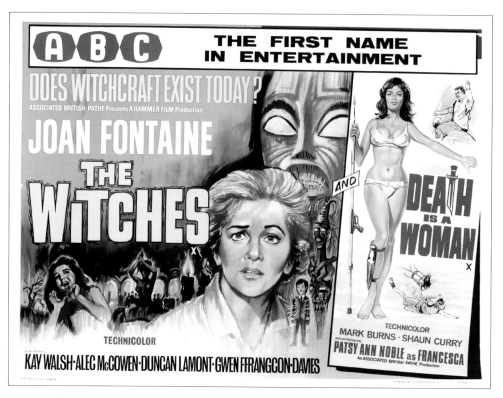

The Witches/Death is a Woman (1966). Printed by Leonard Ripley. Design and illustration by Tom Chantrell. A classic Rex Publicity double bill, for the strap-lined ABC circuit release. (AC)

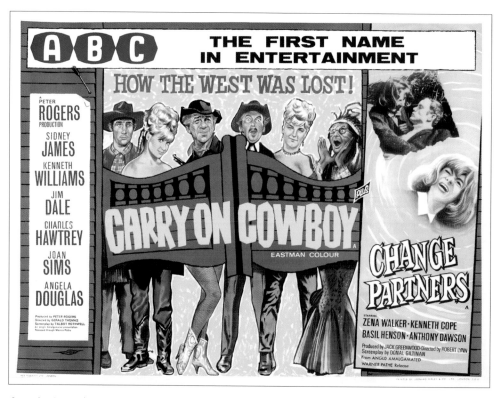

Carry On Cowboy/Change Partners (1965). Printed by Leonard Ripley. Design and illustration by Tom Chantrell. Another punchy Rex double bill: 'I tried to make peace with the Sioux once. Couldn't trust 'em. One minute it was peace on, the next, peace off.' (AC)

to Lonsdales, then in 1986 finally ended up with Cannon's agency, Haymarket Advertising. Rowsell went on to replace Ian Hedger as NSS's chief print buyer, while Rex briefly changed its name to Modern Marketing Ltd, before being finally dissolved in March 1989.

The 1970s and early 1980s were the era of the independent distributor in Britain, as a flood of foreign exploitation films – sex, horror, kung-fu and every genre in between – found a ready market on the small screens of Britain's newly 'tripled' cinemas. The publicity for most of these trash classics was principally supplied by just three small companies: the design studio Graffiti Productions Ltd, and two modest advertising outfits, Alan Wheatley Associates and Mike Wheeler Publicity. Each can be briefly discussed in turn.

Graffiti very much bridged the gap between the old-style commercial art studios and the new generation of graphic designers that gained ascendancy during the 1980s. The company was set up in June 1969 by two college friends, Paul Brown-Constable and Nimal Jayasekera, who had studied graphic design at the London College of Printing from 1965 to 1968. Their studio was at 69 Beak Street in Soho, and within a year or two the couple were producing material for the film business. Their initial contact was Ion Voyantzis at Ptolemy Films in Dean Street, and their work for Ptolemy soon came to the attention of Fred Hift, Fox's publicity director. When Hift left Fox in 1971 to form his own PR consultancy, he retained Brown-Constable and Jayasekera as 'his artists'. He kept the pair busy with graphics and advertising for a multitude of international film clients over the next thirteen years, at events including the annual Cannes film festival. However, Brown-Constable estimates that the company designed no more than thirty or forty quads, but the figure rises to a few hundred designs if video releases and international posters are taken into account: for example, their iconic one-sheet of a thuggish Ray Winstone in

Supersonic Man (1979). No printer credited. Illustration by Sam Peffer, from a design by Graffiti. Like a few other quads of the period, this hilariously tries to protect itself against accusations of mis-selling by including a *very* small corner-credit reading 'Artist's Representation'! (AC)

Scum (1979). The titles involved are mostly exploitationers of the period, though some more mainstream films crop up, such as *Hitler, the Last Ten Days* (1972 – their first poster), Burton and Taylor's *Divorce His, Divorce Hers* (1973), *The Eagle Has Landed* (1977), *The Buddy Holly Story* (1978), *Agatha* (1979) and *Priest of Love* (1981). None of these was illustrated as such, but rather used graphic and photographic elements. The firm's posters, like Feref's, are generally easy to identify, as they virtually all carry the italicised 'Graffiti' logo somewhere at the bottom of their design. In fact, much of the duo's best work ended up either unused, or (like *Buddy Holly*) almost immediately reprinted featuring a more straightforwardly commercial illustration.

Graffiti's other film business clients included Dennis Davidson Associates, Theo Cowan Associates, John Heyman's World Film Services, Lew Grade's ITC and various other independent producers. Graphics and logos were designed for films such as Ben Arbeid's *The Hireling* (1972),

Michael Klinger's *Gold* (1974) and *Shout at the Devil* (1976), and Fassbinder's *Despair* (1978). Graffiti were also responsible for a new British Lion logo. In addition, the firm were in at the very start of the video boom around 1980, working for Mike Tenner's Intervision, Adrian Munsey's Odyssey Video, MGM Video, Fox's Magnetic Video and many others. The illustrator that Graffiti most frequently used when required was Sam Peffer, though occasionally work would be farmed out to artists at other studios, including Colm Fitzgerald and Tony Kett at Stanwood Arts.[66]

Alan Wheatley's career in film publicity lasted more than forty years, taking in an 'early apprenticeship with the big boys' followed by a long freelance stretch, during which he became the chief supplier to Wardour Street's independent distributors, 'making a lot of smaller firms a great deal of money', as he now puts it.[67] Moving down to London from the Midlands in 1951 (aged twenty-one), he spent a few years engaged in general advertising work, before joining the staff

Graffiti Productions with their principal early client in 1973. Left to right: Nimal Jayasekera, Paul Brown-Constable and publicity man Fred Hift. (Courtesy of Graffiti)

of the Circuit Management Association (CMA) in 1955, working on their house magazine. CMA controlled the Gaumont and Odeon circuits for Rank, and Wheatley became progressively more involved in their central advertising department, until in 1958 he was eventually made deputy controller of Rank Publicity alongside John Fairbairn, working for manager Charlie Young and his assistant Don Murrey. Wheatley shifted briefly to United Artists in 1963, then returned to Rank for a few months, before trying his luck with Tony Tenser's Compton-Cameo in 1965.[68] Tenser was in the process of launching Roman Polanski's *Repulsion*, and commissioned Wheatley to produce a glossy promotional brochure on the film. Wheatley was happy with the result, but it did not please Tenser, and the subsequent row led to Wheatley leaving Compton to finally try his luck as a freelance. This was the beginning of Alan Wheatley Associates (AWA).

Pat Skinner at Rank generously kept him going with some work to begin with, and he also spent ten months helping to launch *Thunderball* (1965) for United Artists. Another early client was British Home Entertainment, who handled an interesting mix of films, including Laurence Olivier's *Othello* (1965) and a popular reissue of *Oklahoma!* (1955). The connections established during his first ten years in the business ensured that Wheatley was kept permanently busy for the remainder of his career, as he moved around a string of small offices in central London, keeping overheads low by paying cheap rents.[69] His two main illustrators were aquired within a year or so of each other: Sam Peffer from Geoff Wright Studios in 1971, and Tom Chantrell following his departure from Allardyce Hampshire in 1972. Other artists were occasionally employed, including Ted Baldwin, an illustrator from Reading who came via Mike Wheeler, and Brian Forbes, a cartoonist from Whitton, responsible for several comic sexploitation posters like *On the Game* (1974). Wheatley's only other assistant was a young designer, Nick Seaman, who worked on paste-ups and layout, but who 'took a couple of wrong turns' and died tragically early at just twenty-eight.

Most of Wheatley's quads were printed by either Broomhead Litho or Bovince (the latter for silkscreens), and are now quite often identifiable from the small 'AWA' logo that frequently appears on them. Another distinctive permanent feature was their $^3/_4$" white border. This was employed for two reasons: first, as Wheatley comments, it gave the image a 'frame', making it stand out when pasted up in a block of other quads, and second, it was simply cheaper. Posters featuring 'bleed' (i.e. with ink running to the very edges of the paper) had to be printed on larger than standard sheets, then later trimmed down on a guillotine to quad size. Posters featuring a border could be printed straight onto quad sheets, again keeping costs down. The scale of the release was the key determining factor for print runs. A 'mini-release' for a cheap exploitation effort might only have had 1,000 copies printed; in contrast, the average in the 1960s for a reasonably big film would have been between 5,000 and 10,000, with possible later reprintings if it developed 'legs' (i.e. began to take off by word of mouth). The biggest runs of all would have been reserved for blockbusters like the Bond films: Wheatley estimates that *Thunderball* would have had a print run of about 30,000.[70] Illustrated poster design rapidly died off in the

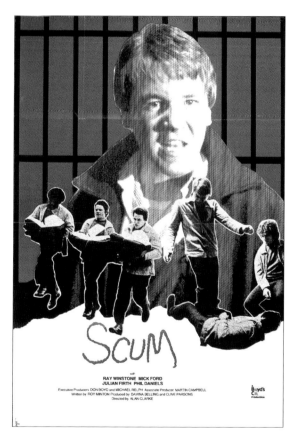

Scum (1979). Printed by Broomhead Litho. Designed by Graffiti Productions. '4737 Carlin Sir!' An iconic portrait of Ray Winstone in everybody's favourite thug melodrama. (AC)

Terror (1978). No printer credited, but probably Broomhead Litho. Design and illustration by Tom Chantrell with input by Alan Wheatley. A wonderfully garish illustration for this late-period British horror. (AC)

mid-1980s, Peffer and Chantrell's final commissions for Wheatley appearing over 1984–5. In the preceding fifteen years, AWA had worked for practically every single independent British distributor (with the sole exception of Miracle) then in operation. Wheatley continued to supply the last surviving indie, Michael Green's Entertainment, right up to his eventual retirement in 1998.

Mike Wheeler had a similarly long-term design career, which, like Wheatley's, included a lengthy stretch as a freelance working for Wardour Street's independent distributors. Born in 1940, he initially worked as a civil engineering draftsman for Reading Corporation, before moving into window display work with the Austin Reed group.[71] A couple of enjoyable years were spent playing string bass in his own jazz band, then in 1964, he joined Granada on the cinema management side, later discovering a flair for publicity at the company's HQ on Golden Square. Here, 'one floor below the great Sidney Bernstein', he handled the design and

printing of advertising material for live shows, films, wrestling and bingo for the Granada circuit. In 1970, he transferred to Rex Publicity for about a year, helping to handle the ABC account for Dennis Cave, then in 1971, he moved on again to UK Advertising, working on designs for the Classic circuit and other live theatre productions. By this time, he had amassed enough experience and industry contacts to try his luck as a freelance, and in 1972 set up Mike Wheeler Publicity, operating from offices on Montague Mews, off Baker Street, handling not only creative work and media placements but also various independent PR work. He took two other ex-UK men with him: Tony Gregory for the film side, and Dick Jeffs handling theatre productions.

Wheeler worked for most of the bigger indies of the time, including Miracle, Wardour Films, Variety (which later became Entertainment), Enterprise, Eagle, New Realm, Border, Goodtimes, Oppidan and many others. Perhaps his 'strongest and most successful relationship' was with

A gathering of Rank publicity men in the early 1960s. The three foreground figures are, left to right, Alan Wheatley, John Grundy and Frank Weintrop. The latter two were then regional press oOfficers, though Grundy actually ended up a director of Downton's. (Courtesy of Sam Peffer)

Adrienne Fancey's New Realm, launching both the popular Jackie Collins adaptation *The World Is Full of Married Men* (1979), and also the record-breaking *Emmanuelle* (1974), one of the biggest films of the decade. Wheeler himself negotiated the use of the infamous 'wicker chair' topless shot of Sylvia Krystel with London Transport and the national press for this blockbuster, the first and only occasion such a deliberately provocative image was allowed on the London Underground.[72] MWP often used flyposting, particularly for sexploitation titles that the established site-owners would not allow on their hoardings, and it was ironic that Wheeler was later invited to sit on the AVC, passing censorious judgment on other publicists' posters. The main illustrators MWP used were Tom Chantrell and Ted Baldwin, though others were occasionally employed for paste-ups ('lick'n'sticks' as they were known in the trade). Print runs were a fairly consistent 1,000 per quad, with the work usually going to Bovince, though Wheeler sometimes employed freelance print

buyer Steve Hems, or occasionally went through NSS. After about eight years of steady business, however, he hit difficulties in 1980 when one of his biggest accounts collapsed, effectively ending his freelance period. In 1981 he joined Rank as a press officer, gradually working his way up to become assistant publicity director under Ron Shinn, and then marketing and publicity director, handling the launch of many of their biggest films of the period. His responsibilities included both design and print buying, with the creative work naturally going out to Downton's, though Feref was occasionally also used, particularly for the firm's international product.[73]

In summary, then, the major advertising agencies and their principal film accounts were:
- **Allardyce Palmer:** Warners and Fox, c. 1936–74; Warner-Pathé, 1958–69, including Associated British, Allied Artists, Anglo-Amalgamated, AIP and Hammer
- **Arthur S. Dixon:** Columbia and Disney, c. 1945–65; Warwick in the 1950s
- **Downton's:** Rank, c. 1942–97, including the Odeon Circuit, plus Universal up to 1969; part of United Artists, c. 1945–81; British Lion, 1946–76;

Mike Wheeler in 1980. Along with Alan Wheatley, Wheeler dominated the independent side of British film publicity during the 1970s, before joining Rank around the time this photo was taken. (Courtesy of Mike Wheeler)

Prisoner of the Cannibal God (1980). Printed by Broomhead Litho. Design and illustration by Sam Peffer, with input from Alan Wheatley. Stacy Keach and Ursula Andress in an Italian cannibal melodrama temporarily banned in Britain for obscenity. You couldn't make it up. (AC)

Private Vices & Public Virtues (1977). No printer credited, but probably Bovince. Design and illustration by Tom Chantrell, with input from Mike Wheeler. The artfully scattered rose petals were added later, to cover up the naughty bits. (AC)

Columbia, 1966–97; Disney, 1966–83; Warners, 1974–82; RKO in the 1950s; Avco-Embassy, c. 1967–82; Brent Walker, c. 1974–86)

• **Lonsdales:** Paramount, c.1922–69; MGM-EMI and Paramount-Universal [CIC], 1970–88, including United Artists [UIP] from 1981; ITC, 1974–84

• **United Kingdom Advertising:** MGM, c. 1945–69; part of United Artists, c. 1945–81; Classic Circuit, c. 1967–82; Fox, 1976–81; Cinerama, Hemdale, Goodtimes and Entertainment in the 1970s

• **Rex Publicity:** ABC Circuit, c. 1942–84.

There were additionally two further 'spin-off' design companies involved: **Chapman-Beauvais** (ex-Allardyce) from 1975, who took on much of Warner's creative work; and **Feref** (ex-Downton's) from 1968, who gradually took on practically everybody else. From about 1970 onwards, the independent distributors were chiefly handled by **Graffiti Productions, Alan Wheatley Associates** and **Mike Wheeler Publicity**. Only Chapman-Beauvais and Feref are still actively involved in poster design work. In addition to these two 'originals', there are now also three other contemporary studios, established in the 1990s, which specialise in film publicity: The Creative Partnership (1990), Tomato Design Consultants (1991) and Empire Design Co. (1996). The (comparatively) recent appearance of this trio puts them outside our field of interest, however.

Now that we have clearly established who was working for whom, and over roughly what periods of time, we can turn our attention to the small group of agency employees whose design and illustration skills really lie at the heart of this book: the artists.

Dark Star (1974). No printer credited, but probably Bovince. Design and illustration by Tom Chantrell, with input from Mike Wheeler. 'Tell me Doolittle … how are the Dodgers doing?' Not released in the UK until 1978, hence the quoted review's reference to *Star Wars*. (AC)

CHAPTER 8

Artists (i): 'Real Ripsnorter' – Tom Chantrell and Allardyce Palmer

One of the legendary figures of British advertising was no-nonsense Scot David Ogilvy, whose books on the subject are now required reading for anyone interested in the theory and practice of the business. His introduction to *Ogilvy on Advertising* begins with the following characteristically blunt paragraph:

> I do not regard advertising as an entertainment or an art form, but as a medium of information. When I write an advert, I don't want you to tell me that you find it 'creative'. I want you to find it so interesting that you BUY THE PRODUCT. When Aeschines spoke they said 'How well he speaks'. But when Demosthenes spoke, they said 'Let us march against Philip'.[74]

We don't need the benefit of a classical education to appreciate the point Ogilvy is making here. For him, the best film posters would have been purely and simply the ones that *most made you want to go and see the film featured*. Employing this basic

Forever Amber (1947). Printed by Stafford. Design by Tom Chantrell. One of the earliest quads the artist recalled painting after the war, though as this is a hand-drawn litho, we are not seeing his actual illustration. (BFI)

criterion, it is not hard to single out the 'most successful' British film poster artist. No matter how dire the actual films they were publicising, Tom Chantrell's posters always made you feel you were going to see something really special, and that – in a nutshell – is surely what film publicity ought to be all about.

Chantrell had absolutely no pretensions about his job or his artistic abilities (though he could be very stubborn about taking advice). As his colleague Tom Beauvais recalls:

> To be a successful film poster artist you had to give them [the distributors] what they wanted. Chan never worried about being all clever … He would say, 'Well, they want a good portrait of this bloke with his gun' – or whatever – and he would do as dynamic a poster as he could. Sometimes we would all do a selection of layouts, different designs, and Chan would come along at the last minute and do one overnight in full colour … it would look really impressive, and invariably they would just go for that. Even though some of the other designs might

have been better in terms of their layout or whatnot, Chan just supplied what he knew they would like, and I learned very early on that that was the way to do it […] There's no room for understatement in advertising.[75]

Tom's father, James William Chantrell (1861–1943), was a musician and ex-trapeze artist who according to his son had 'travelled the world on different variety bills, and claimed to have done the triple'.[76] The act was known as 'The Fabulous Chantrells' and apparently once performed for the Tsar of Russia, receiving a silver snuffbox as an official memento of the occasion. James married Emily Louise Tew in June 1898 and over the next eighteen years the couple had nine children, of whom Tom was the last. According to the Tom's birth certificate, his father's profession at the time was 'Picture House Assistant'.

Thomas William Chantrell was born on 20 December 1916, at 14 Galloway Street, Ardwick, Manchester. In one of the eulogies delivered at his funeral, his daughters recalled that:

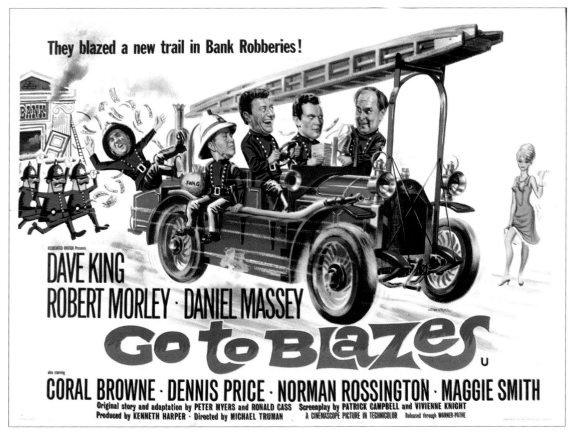

Go to Blazes (1961). Printed by Stafford. Design and illustration by Tom Chantrell. A typically energetic and well-composed comic illustration. Note a young Maggie Smith on the right, hitching a lift. (AC)

Tom Chantrell surrenders in front of his reissue quad for
East of Eden in 1961. The back of Sophia Loren in
The Millionairess is also just visible on the right.
(Courtesy of Ray Youngs)

His elder sisters Madeline, Phyllis and Dolly doted
on him, and his childhood was surrounded by
music and fun. His father had a partner named
Lewis, originally a slave who had bought his
freedom from the Deep South of America … both
men were musicians, and the Chantrells and
Lewises were apparently known for making a racket
playing jazz into the early hours of the morning.
The family were not rich, living in the cobble
streets and back alleys of Manchester, but the
dinner table was always set for a king.

Chantrell himself always claimed that his first
piece of commercial art was produced at age five,
when a teacher at school asked the class to paint
a picture of the character 'Tom' from Kingsley's
The Water Babies. She liked the young Chantrell's
contribution so much she paid him a penny for
it, and pinned it to the classroom wall. He later
received a lot of encouragement from his art
teacher, and at age thirteen won a national
competition to design a disarmament poster for
the League of Nations, gaining great prestige for
his recently opened grammar school. He very

briefly attended Manchester Art College, but
quickly decided this was a waste of time. As he
was by then fifteen years old, he had the option of
leaving, provided he could find a job straight away,
and so took some samples of his best work along to
Rydales, a local advertising agency, who told him
to start the following Monday.

After a few months, Rydales' top illustrator left
to form his own company, taking the best artists
with him, including Chantrell. However, Tom was
still young and hot-headed enough to allow his
temper to get him into trouble, and after about a
year or so, an argument about a substandard piece
of work (wrongly attributed to Tom) escalated into
a full-blown punch-up in the studio with his
foreman. Inevitably sacked on the spot, and unable
subsequently to find work in Manchester, the
seventeen-year-old moved down to London,
initially lodging with his sister Phyllis in
Hampstead. It was 1933. He quickly talked his way
into a job with a silkscreen printer, despite knowing
nothing whatsoever about the process. His first
attempt was such a disaster that he was forced to
own up, and the boss was sufficiently impressed
with his honesty to keep him on, and personally
train him up himself. Some time around 1935, he
ended up at Bateman Artists, a small studio of
about eight other designers/illustrators etc. As we
have seen, the studio was informally attached to
Allardyce Palmer, and produced occasional pieces
of poster artwork for Allardyce's Warners and Fox
accounts. Chantrell, however, was chiefly working
on architectural and engineering illustration at this
point, including Percival Provost aircraft,
Westminster dredgers and double decker buses.
In 1938, however, he designed a big six-sheet used
as part of the front-of-house display for the
Edward G. Robinson picture *The Amazing Doctor
Clitterhouse* (1938), one of the first films at the
newly opened Warners Cinema in Leicester
Square. There may well have been other posters
in the months leading up to war, but their titles
are not recorded.

In the early part of the conflict, Chantrell
married his girlfriend, Alice, and when called up in
1940, opted for the Royal Engineers and a career
in bomb disposal, as this seemed to offer the best
chance of spending time with her. The average life
expectancy for a squaddie working on UXBs was
then about ten days, but, based around Tunbridge
Wells, Chantrell nevertheless spent several years

The Bargee (1964). Printed by Stafford. Design and illustration by Tom Chantrell. Another effortlessly eye-catching quad, with a fantastic Harry H. Corbett portrait. (AC)

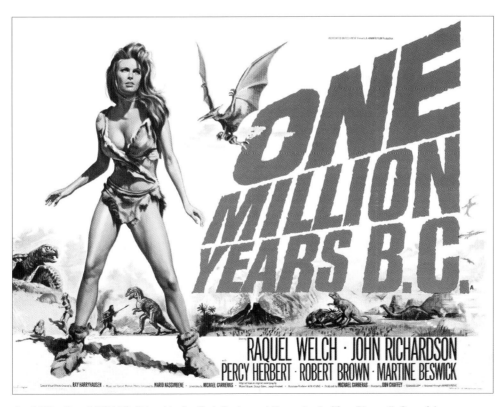

One Million Years BC (1966). Printed by Stafford. Design and illustration by Tom Chantrell. One of the most familiar images from any British film poster, with an unusual amount of white space for Chantrell, the better to make Raquel Welch stand out. (AC)

digging mines out of beaches along the Sussex and Kent coast. This period of his life also gave him an enduring contempt for authority in all its forms. After a while, Chantrell's artistic abilities were spotted by another officer, and he was transferred into a division producing signs and propaganda posters for the war effort. Demobbed in 1946, the 'returnees' policy of the time meant that he immediately went straight back to his old job at Bateman Artists, by now based in Corner Buildings, Kingsway WC2. From this point, his poster work seems to have gradually built up – one of the earliest post-war quads he recalled working on was *Forever Amber* (1947), with Linda Darnell, and another well-known title was *Brighton Rock* (1947), with a vivid image of gangster Richard Attenborough. Chantrell later painted a self-portrait featuring himself at work on this poster – a dapper figure with a pencil moustache, his trilby set at a jaunty angle.

When, having bought up Bateman Artists, Allardyce Palmer set up its Entertainments Publicity Division in Screen House on Wardour Street, Chantrell was given the job of running it with account executive Stan Heudebourck, although the two did not always get on particularly well. Heudebourck (who at the time had Anglicised his surname to 'Burke' – fittingly, as Tom felt) liked things to run as efficiently as possible, which tended to clash with Chantrell's more laid-back approach. Tom Beauvais remembers one argument that ended with Chantrell exploding '*Why does everything have to be so BLOODY URGENT all the time?*', to which Heudebourck could only patiently point out that this was the nature of the business they were in.[77] 'Chan was basically lazy,' Ray Youngs recalls, preferring to spend the day chatting and arguing, and doing most of his actual painting at night, an arrangement that did not prove popular with Heudebourck. 'He would argue about anything under the sun. Politics, religion, philosophy, psychology, you name it. He much preferred that to actually having to work.'

Chantrell's poster work in the 1950s was dictated by what Fox and Warners were releasing:

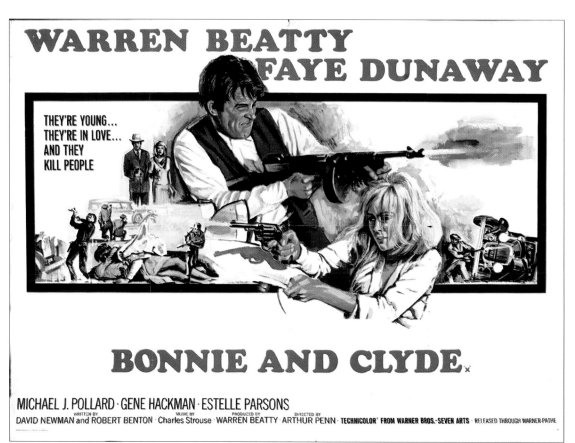

Bonnie and Clyde (1967). Printed by R. J. Wallman. Design and illustration by Tom Chantrell. Easily the best international poster for one of the key films of the 1960s. (AC)

Bullitt (1968). No printer credited but probably Lonsdale & Bartholomew. Design and illustration by Tom Chantrell. Another cult 1960s thriller, with a dynamic portrait of Steve McQueen. (BFI)

East of Eden (1955), *The King and I* (1956), *Anastasia* (1956), *Bus Stop* (1956), *An Affair to Remember* (1957), *South Pacific* (1958) and so on. As pop began to take off towards the end of the decade, he worked on several of the Elvis Presley musicals, beginning with *Love Me Tender* (1956), and their subsequent British imitations with Cliff Richard, starting with *The Young Ones* (1961). After the formation in 1958 of Warner-Pathé distributors, which had tie-ups with Anglo-Amalgamated, Associated British, Hammer, plus the US firms American International Pictures and Allied Artists, Chantrell's work became more eclectic. He worked on many of the bigger cult films of the 1960s, such as *Let's Make Love* (1960), *Bonnie and Clyde* (1967) and *Bullitt* (1968), AIP imports – generally adapting Reynold Brown's original designs – including *The Raven* (1963), *Comedy of Terrors* (1963) and *The Tomb of Ligeia* (1964), the six Anglo Carry On titles: *Cabby* (1963), *Jack* (1964), *Spying* (1964), *Cleo* (1965), *Cowboy* (1965) and *Screaming* (1966), and every

Hammer film between *The Nanny* (1965) and *Taste the Blood of Dracula* (1969).

Chantrell not only handled the Hammer quads but also turned out large amounts of pre-production artwork, used by James Carreras to sell the concepts to the distributors, and thus raise the production finance required to get the films made. Interestingly, these often reflect the films' gradual development – his numerous early layouts for *One Million Years BC* (1966) feature an anonymous chubby-cheeked blonde prior to the casting of Raquel Welch, while his preliminary quad design for *Quatermass and the Pit* (1967), though similar to the finished article, replaces the now-familiar Andrew Keir with a portrait that is unmistakably John Neville. Chantrell got on well with Carreras, the two men undoubtedly seeing in each other an appealing reflection of their own unerring commercial instincts. One of the few surviving bits of footage of Carreras, used in a 1970 BBC documentary, shows him in his office, brandishing a typically lurid piece of Chantrell artwork:

Carry On Cleo (1965). Printed by Leonard Ripley. Illustration by Tom Chantrell, from a design by Tom Beauvais. The original 'banned' version, withdrawn after the Fox/Warners copyright court battle. (BFI)

Carry On Cleo (1965). No printer credited. Designed by Ray Youngs. The rapidly put-together replacement, known at the time as 'Sid the Sphinx'. (AC)

A reference photo of Tom Chantrell posing as Dracula, taken when the required production stills from *Dracula Has Risen from the Grave* (1968) failed to turn up on time. (Courtesy of Shirley Chantrell)

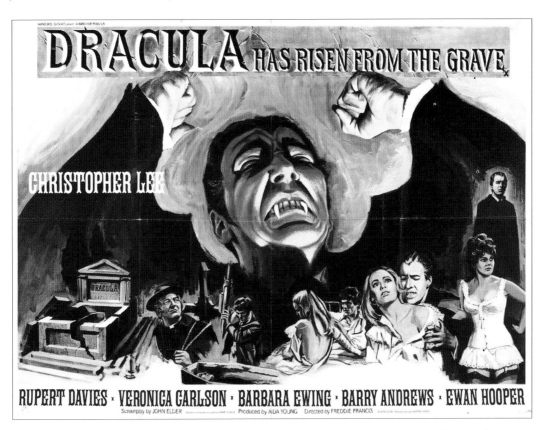

Dracula Has Risen from the Grave (1968). No printer credited, but probably Lonsdale & Bartholomew. Design and illustration by Tom Chantrell. The infamous resulting self-portrait, which has puzzled generations of Hammer fans by looking nothing like Christopher Lee. (AC)

I think it's all come about by the fact that we start with a title, and we think, now what's a good title? Well, how about 'To Love a Vampire' … And so then we make a poster, and we show it to the distributors and say, 'How would you like a film called To Love a Vampire?' and they say 'Wonderful, how soon can we have it?' And I say, 'Well I think we could deliver it in about six months … do you want to see a script or know who's in it?' And they say, 'No, this is a Hammer Film, and we know it'll be alright!'[78]

After Hammer's deal with Warner-Pathé ended in 1969, Chantrell's work for them became more intermittent, though he did paint the company's last two Dracula quads, *Dracula AD 1972* (1972) and *Satanic Rites of Dracula* (1973), along with continuing large amounts of speculative pre-production artwork: *Mistress of the Seas*, *The Reluctant Virgin*, *Kali*, *Devil Bride of Dracula* and many others. One of his later posters actually became part of the ongoing feud between James Carreras and his son Michael, who was then in the process of taking over the company: the shooting title of *Demons of the Mind* (1971) was

A reference photograph of Shirley Chantrell, posing as Princess Leia in *Star Wars* (1977), taken in the family back garden. (Courtesy of Shirley Chantrell)

Blood Will Have Blood, and Chantrell produced a striking pre-production design featuring Eric Porter (later replaced by Robert Hardy). Michael Carreras wanted to use an updated version of this for the quad poster, but EMI refused, preferring instead a rather bland photomontage. When Michael appealed to his father to intervene on his behalf, Sir James unexpectedly and humiliatingly sided with EMI, and the episode became just one more twist in the continuing long-term rift between the two men.

Chantrell's private life itself went through some major upheavals in the early 1960s. He had already raised two children with Alice (Stephen and Sue), when in September 1962, out of a desire to try something new, he began attending still-life classes at St Martin's School of Art with Ray Youngs.[79] Here he met a young eighteen-year-old Chinese student named Shirley How-Harlui and the two gradually became friends and fell in love. Eventually in 1965, they moved into Youngs old attic flat in south London, marrying nine years later, after Tom's divorce had finally come through.[80] Shirley's arrival changed Chantrell's approach to his work. In the early part of his career, he never felt anyone took much interest in his painting, and indeed did not even think of himself as a particularly good artist. But, with Shirley's enthusiastic support, he started to take himself more seriously, crucially beginning to save his artwork and proof copies of posters, while also becoming more confident about his own unique talents. He experimented with new techniques, going through a phase in which he created his backgrounds by screwing up a ball of paper, covering it in paint and then rolling it around the board to create an abstract pattern. *Mayerling* (1968) was done in pencil, and *Dreams of Thirteen* (1975) in pastels. Often, however, he had little interest in his assignments: Youngs remembers that *Billy Budd* (1962) was given to another artist (Tom Beauvais) simply because 'Chan couldn't be bothered – it was too difficult and there was no reference material available'. *Hello Dolly* (1969) and *How to Steal a Diamond in Four Uneasy Lessons* (1972) were 'just bashed out'.

When Allardyce Palmer merged with another agency to make Allardyce Hampshire in 1970, a new level of 'visualisers' and other creative staff were brought in. Their ideas about how the firm's posters should look increasingly grated on the

Star Wars (1977). Printed by W. E. Berry. Design and illustration by Tom Chantrell. Perhaps the most famous of all Chantrell's quads, this design in fact deliberately apes Frank McCarthy's *Dirty Dozen* US poster from ten years earlier. (AC)

stubborn Chantrell, who had grown used to doing things his own way. Eventually, in 1972, he resigned his art director post (and accompanying salary) to freelance for the agency on a fixed fee of £230 for three layouts and a finished artwork (his Hammer quads had mostly been painted for about £100 each).[81] Allardyce consequently lost both the Fox and Warners accounts less than two years later, though in Tom's opinion the agency was, in any case, already heavily overcharging most of its clients. As a freelance, Chantrell naturally began working from home for anyone who would employ him, and this period of his career (1972–86) is in many ways the most interesting, being crowded with offbeat posters for dozens of independent distributors, including Tigon, Oppidan and Entertainment. Commissions mostly came from agents like Alan Wheatley and Mike Wheeler, plus (from 1975) his old colleagues at Chapman-Beauvais.

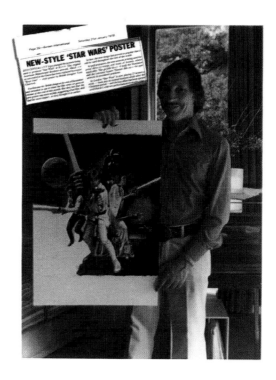

Tom Chantrell holding his original *Star Wars* artwork, taken for *Screen International* magazine in December 1977. (Courtesy of Shirley Chantrell)

Like any illustrator, Chantrell always liked to work from references – otherwise the artist cannot be certain he is capturing a particular feature accurately – and if the supplied stills did not include the desired image, a studio would have to be hired, along with the required number of models. The girls had to be prepared to pose nude if necessary.[82] Chantrell certainly had a well-developed appreciation of the female form, and without a doubt painted the best British sexploitation posters, including most of the Mary Millington titles. He had a habit of generously endowing all of his female stars with ample cleavage: when Joan Collins caught sight of his depiction of her on *The Wayward Bus* (1957), she complained that the film ought to be retitled *The Wayward Bust*! He saved on male models by painting himself or fellow artists. His quad for *Dracula Has Risen from the Grave* (1968) is a doctored self-portrait, and he pops up, minimally disguised, in various other posters, including *Private Nurse* (1977), where he stares disbelievingly from a sickbed as his curvaceous carer casually adjusts her thigh-boots, and *What's up Superdoc?* (1978), grinning unmistakably from a corner of the design in his battered trilby. Chantrell also regularly used family and friends as models. Shirley is the running figure in *Walkabout* (1970), a radar operator in *The Bermuda Triangle* (1977) and even Princess Leia in *Star Wars*. His twin daughters, Jaqui and Louise (born in 1968), feature in several of his early 1980s teen-comedy posters. Louise remembers precariously balancing on roller-skates for one of the later *Lemon Popsicle* sequels, staring back over her shoulder as her father, peering through his camera, instructed her to 'stick your bum out a bit more!'[83]

Chantrell was always a joker. He liked putting sly visual gags into his designs, a good example being *Emanuelle Meets the Wife Swappers* (1977), where the apparently random outlines of the illustration are, on closer inspection, not random at all.[84] He also had a great love of appallingly bad puns and gags, which he liked to include in his posters' copylines. *Au Pair Girls* (1972) was originally tagged the 'Au-What-A-Pair-Girls!', while *Crooks and Coronets* (1969), featuring Edith Evans and Telly Savalas in old biplanes, started out with speech bubbles declaring 'It's a Fokker–'/'–You're not kidding!' Tom Beauvais recalls:

We used to have this thing for renaming the films we were doing – *Demetrius and the Gladiators* [1957] became *Dermatitis and the Radiators*, *When Dinosaurs Ruled the Earth* [1969] became *When Diana Dors Ruled the Earth*, and *When the Legends Die* [1972] became *When the Leg Ends Die*! Chan was always very good at those, he enjoyed playing with words.

He also had a fund of outrageous stories about the difficulties that could later crop up during printing. One common problem, when using block capitals, was separation between the letters 'L' and 'I', which from a distance could often appear as a 'U'. According to Chantrell, the poster for Fox's 1943 family drama *My Friend Flicka* had to be hurriedly redone, while Clint Eastwood received a startling new first name on one of his 1970s quads.

In 1965, Chantrell's parodic poster for *Carry On Cleo* landed his client, Warner-Pathé, in hot water. Fox's *Cleopatra* (1963) has since become infamous as one of the most disastrously expensive flops in film history. Its original US poster by Howard Terpning showed Elizabeth Taylor reclining sensuously on a divan, while Richard Burton leans smoulderingly towards her. However, the film's third star, Rex Harrison, objected to his exclusion, and via contractual billing forced Fox and Terpning to add his portrait on the left of the design (despite the fact that, in the film's narrative, his character had died two years before the depicted scene). Such a ridiculous but iconic image was ripe for parody, and Chantrell's original *Carry On Cleo* quad simply substituted Kenneth Williams, Amanda Barrie and Sid James for Harrison/Taylor/Burton, adding Kenneth Connor and Charles Hawtrey peeping out from under the divan for good measure. Chantrell's classic tagline was 'The funniest film since 54 BC!'. Fox were not amused, however, and sued Warner-Pathé for copyright infringement. The *Daily Express* court report of 21 January 1965 carried a blow-by-blow account of the proceedings, which apparently saw everyone, including the legal teams, making the most of the farcical situation under review:

The *Carry On* poster was deliberately different said Mr Hogg [for the defence] – for instance Caesar was looking a bit ashamed of his laurel wreath. 'What we have done is to produce a poster, different in every detail, of three different actors

Come Play with Me (1977). No printer credited, but probably Bovince. Design and illustration by Tom Chantrell. One of the best known, and most financially successful, of all British sex comedies. (AC)

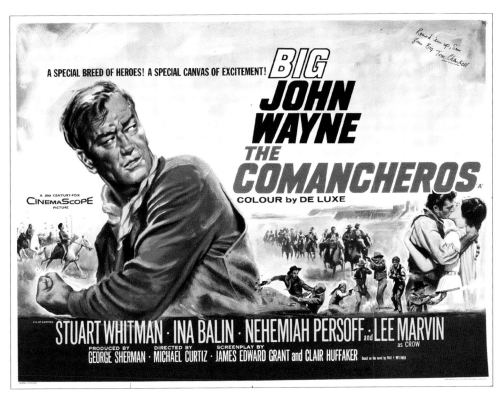

The Comancheros (1961). Printed by Stafford. Design and illustration by Tom Chantrell. A fantastic John Wayne portrait, against a typical all-action Chantrell montage. (AC)

Tom Chantrell towards the end of his career, sometime around 1990, working on an Oliver Reed video sleeve.
(Courtesy of Shirley Chantrell)

parodying the picture of the three artists appearing in the ludicrous scene in the plaintiff's poster'. Twentieth Century-Fox had brought no evidence of damage to the box office takings of *Cleopatra* – they were seeking to torpedo the whole publicity campaign of *Carry On Cleo* at the last possible moment. The artist, Thomas William Chantrell, art director of an advertising agency, said in written evidence 'I deny that my poster is a copy; it is a parody. I used my own talents to create a poster deliberately different.'

It was to no avail – Justice Plowman found for the plaintiffs, and the original *Carry On* poster was rapidly replaced by a silkscreened paste-up of Sid James's profile attached to a sphinx. Chantrell later maintained that the whole affair had been a 'put-up job', and both sides certainly benefited from all the attendant free publicity.

Chantrell's last really big poster was *Star Wars*. According to Fox's John Fairbairn:

Gary Kurtz had come to our London office, expressing a feeling that the time was right to develop some new ideas for the London release.

He specifically wanted to concentrate more on the personalities of the film instead of focusing on the hardware, to show the characters using the machinery instead of being dwarfed by it. He felt that *Star Wars* was about people, and he wanted the personalities developed more for all the characters. Tom Chantrell was given a brief of these requirements and developed the concept art.[85]

Chantrell's famous design, launched at Christmas 1977, was so popular Fox asked to buy the copyright for their merchandising. Tom asked five times his usual fee – £1,200 – and the artwork travelled across to America. The true monetary value of this now internationally known image can today only be guessed at.[86]

With the general decline in the use of illustration during the early 1980s, Chantrell, as one of the top freelances around, was beginning to price himself out of business. His last handful of quads from 1984–5 included the low-budget British sci-fi epic *Prisoners of the Lost Universe*, and sex films such as *The Devil in Miss Jones II* (both 1984). By then, he was already producing large quantities of video sleeve covers, which tended to

pay better than the quads – about £800 each by the end of the decade. But, by about 1993, even this market had finally dried up as clients increasingly called for photographic designs. His last theatrical poster, *The Punk and the Princess* (aka *Tough Love*, 1992) was apparently never paid for, and essentially marked the end of his sixty-year career. Thereafter, he restricted his painting to the occasional family portrait, and an annual valentine for Shirley.

Chantrell had suffered three accidents during his career. In 1965, a car reversed into him one morning, breaking his arm. When Shirley phoned the office to let them know what had happened, Stan Heudebourck could not resist immediately asking 'Which arm?'.[87] Fortunately, it healed perfectly. Later, in 1978, he severed an artery in his wrist trying to catch a falling glass in the kitchen. He had to see a Harley Street specialist, as the nerves had been damaged, and Louise, in particular, is adamant that his artwork was never quite the same afterwards. Finally, towards the end of his career in around 1992, a cyclist travelling

the wrong way down Brewer Street knocked him over. This shook him up quite badly, and his daughters agree that for the first time he 'began to show his age', becoming more anxious and quietly introspective.

His family provide a free-flowing string of adjectives and phrases to describe his character: 'jovial … peaceful … kind … hated confrontation, but didn't suffer fools gladly … quiet, but made a lot of sense … a night owl … a good raconteur … funny, with a dry sense of humour'. His favourite expression for a particularly exciting layout was a 'Real Ripsnorter!'. He liked working late into the night, till three or four in the morning, and painted to classical music, 'a glass of whiskey in one hand, and a cigarette in the other'. He stopped smoking when his daughters were born, but Shirley remembers him still instinctively patting away at his pockets for cigarettes long after he had given up. The latter years of his retirement were spent cautiously dipping his toes into the emerging market for film poster collecting. He anonymously

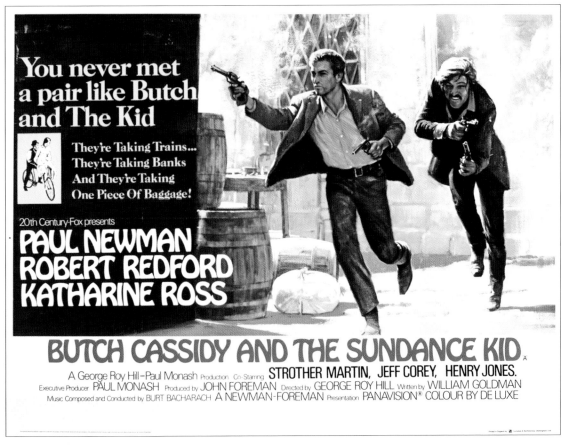

Butch Cassidy and the Sundance Kid (1969). Printed by Lonsdale & Bartholomew. Design and illustration by Tom Beauvais. Another classic 1960s poster, probably the best known by the artist. (BFI)

attended auctions and moviejumbles, selling a few of his more collectable pieces of original artwork to the handful of dealers and private collectors who bothered to track him down. In the late 1990s, he became diabetic and was forced onto a frustratingly restrictive diet. After suffering a minor heart attack in early summer 2001, he grudgingly allowed himself to be admitted to the local hospital, and died there on 15 July, aged eighty-four, much mourned by everyone who knew him.

What was Chantrell's overall output? It is difficult to be sure. For a start, he was certainly responsible for almost every major Warners and Fox film released in Britain between 1946 and 1974. Tom liked to quote a figure of 7,000 designs, though as Tom Beauvais has commented, to reach this he would have had to include 'every single scribbled idea, on every single scrap of paper'. A more accurate number, in terms of *finished art* is likely to be 600–800, though not all of these were eventually printed. A list he was compiling in 1996 reached well over 400 titles, and was nowhere near complete. Furthermore, these estimates do not take into account all of his other commercial work – record sleeves, book covers, even occasional commissioned portraits.

Why was his work so appealing? Like the man himself, it was utterly lacking in pretension, being purely concerned with communicating the essence of each film as powerfully as possible. His sexploitation designs are alive with a lascivious delight in the voluptuous female form. His horrors loom ghoulishly out of gothic castles, lit by flashes of fork lightning. His comedies directly invite you to laugh along with the characters larking about in them. His car crashes and detonations explode vividly out of their posters, and his fist-fights surge along with muscular aggression – John Wayne never swung a meaner punch than in the poster for *The Comancheros* (1961). Tom Chantrell never won any awards for his work (and would in any case have been embarrassed by the attention), but for many film fans his posters capture everything that is exciting and enjoyable about the best popular cinema.

It would be wrong, however, to give the impression that Chantrell worked in a vacuum. About twelve other talents were variously employed in Allardyce's studio over the years, perhaps six of whom specialised in the film side, and the most important of these 'supporting players' can now be briefly discussed. Two of the original characters with Bateman Artists after the war were John Canning and W. H. Pinyon. Canning specialised in publishing illustration work for women's magazines among others – he occasionally tried his hand at posters, but his efforts were 'hopeless', according to his colleagues. Pinyon (or 'Pinny', as he was known) did rather better, illustrating *Monte Walsh* (1970) and a few other titles when Chantrell was away, but he was slow, and his loose, watercolour style tended to make his posters look more like 'enlarged book illustrations'.

The most important artist on the film side (apart, of course, from Chantrell himself) was Tom Beauvais, whose father, Arnold, has already been discussed. Beauvais was born in Hampstead in 1932, spending two years studying engineering at Kingston Technical College before his father got him a job at Bateman Artists in 1949. Beauvais started out as an apprentice, running errands, making the tea and doing simple jobs like trimming artworks and putting a 'sneeze'

The name is Beauvais – Tom Beauvais. Exuding the kind of ruthless sex appeal most men can only dream of, the artist poses for a mid-1960s reference photo, taken for some long-forgotten Bond rip-off. The lucky ladies were a couple of hired models. (Courtesy of Tom Beauvais)

(i.e. 'a-tissue' protective paper cover) onto finished jobs. Bill Bateman recommended that the youngster concentrate on 'layout, lettering and design – and you'll never be out of work', which proved to be good advice. His responsibilities gradually increased until he was working alongside Chantrell helping to run the film side, doing lettering and designs for the latter's illustrations. His first lettering job was actually on his father's poster for *Treasure Island*, and he also worked on the classic *The Seven Year Itch* among others. In 1957, he moved over to Screen House on Wardour Street with another junior artist to create the press ads etc. This entailed working 'at a frantic pace – the line was "Do you want it good, or Tuesday?"!' At this point, he began illustrating his own posters: the first was *Hatful of Rain* (1957), an early drug melodrama with Eva Marie-Saint. Other titles include a late-1950s reissue of Hitchcock's *Strangers on a Train* (1951), *Third Secret* (1964), *Sweet Ride* (1967), *Hombre* (1967) and, perhaps most famously, *Butch Cassidy and the Sundance Kid* (1969).

After Beauvais began to rise in seniority, the next 'apprentice' to be taken on was John Chapman (born 1939), who was hired in 1955, taking over as 'Chan's Boy', and eventually going full time into lettering. In 1971, Chapman left to work for his cousin Derek Parnell, and two years later persuaded Beauvais to join him – the new agency's clients included property developers, and Beauvais began to work on architectural illustration, which later became his speciality. In April 1975, the pair jointly set up design studio Chapman-Beauvais, working for various distributors including Fox (Beauvais executed one of the early designs for *Star Wars*), Warners (both men had a good relationship with Stanley Kubrick and worked on all of his later films), plus independents like ITC, Tigon, Miracle and Hemdale.

Beauvais's 1970s quads are an eclectic mix of art, action, comedy and exploitation films: *Ludwig* (1972), *The Cassandra Crossing* (1976), *Julia* (1976 – Beauvais produced about six designs, none of them eventually used), *Shalimar* (1978), *Porridge*

Rising Damp (1980). Printed by W. E. Berry. Design and illustration by Tom Beauvais. One of the very last TV sitcom spin-offs, with a fine portrait of Leonard Rossiter. Ooh, Mr Rigsby. (AC)

Adult Fairy Tales (1978). No printer credited. Design and cartoons by Colin Leary, figure illustration by Tom Beauvais. A lively sexploitation design, this, as Beauvais recalls, was the sort of thing Chantrell tended to turn down simply because there was no decent reference available. (AC)

The Possession of Joel Delaney (1971). No printer credited. Design and illustration by Ray Youngs. A rare finished artwork by Youngs for this obscure Shirley MacLaine thriller. (AC)

(1979), *Mad Max* (1979), *Rising Damp* (1980), *George and Mildred* (1980), *Adult Fairy Tales* (1978 – with cartoons by Colin Leary), *Zombie Flesh Eaters* (1980 – a terrific design, successful enough to directly inspire *Blood Beach* [1980], a shameless imitation) and two of Clint Eastwood's later, more personal Westerns, *Bronco Billy* (1980) and *Honkytonk Man* (1982). Probably his last quad was a 1983 reissue of *Mad Max/Mad Max 2*, though he did a few later video covers and a handful of posters for foreign markets. Beauvais retired in 1992, and now works as a freelance architectural illustrator, many of his commissions being for proposed new supermarket developments like Tesco and Safeway.

Following Beauvais and Chapman, the next junior assistant to join the firm was Ray Youngs, 'the funniest man I ever met', according to his sometime colleague Dave Sands.[88] Born in Kilburn in 1942, Youngs is half Polish, half Irish (his surname actually being that of his later adoptive parents). His father worked in the fire service and was killed by a bomb shortly after Ray was born. By the late 1940s, he was running wild, shoplifting and hiding out in a derelict bombsite. He was then sent to a remand home for three months, followed by an orphanage in Essex, and eventually, aged fifteen, was 'farmed out' to a sympathetic family, working for a time as an agricultural labourer and doing some farm sketches for his employer. Then, towards the end of 1959, a friend, the commercial artist Dick Wilkinson (who produced many of the classic 1950s Guinness posters), mentioned that Allardyce Palmer's studio had a vacancy going for a studio boy. Youngs showed W. H. Pinyon some of his sketches of Croydon (where both men happened to be living at the time), was taken on and started out in Kingsway 'washing out waterpots' and running errands.

Like Chantrell before him, Youngs did not get on with studio manager 'Taffy' Parsons, an officious ex-army quartermaster sergeant, and after six months was sent over to Wardour Street, to work at Screen House instead: 'You can join all the other troublemakers and riff-raff there!' as Parsons put it.[89] Reporting first thing one Monday morning in March 1960, in the lobby Youngs encountered 'a bright, breezy character sauntering in, parcel of artwork under his arm, hair swept back, Ronald Colman moustache, looking like a 40s film star'. Explaining that he was there for a job interview with a 'Mr Chantrell', his new boss immediately gave him 4/- and told him to 'Nip across the road and get me twenty Churchmans and a buttered bath bun from Joe Lyons – I'm starving!' Returning to Allardyce's offices on the fifth floor, Youngs found Chantrell's room 'an Aladdin's Cave – the walls were completely covered with these fantastic film posters: Cary Grant, Marilyn Monroe, James Dean, John Wayne, Sophia Loren, Peter Sellers, Brigitte Bardot. It was amazing.' Introduced to Chapman and Beauvais – 'everyone wearing long white coats like doctors' – and with Chantrell, Chapman and Beauvais emitting a never-ending stream of puns and one-liners, 'the day flew by in a hectic whirl of banter and furious activity'. Youngs started out mixing paints, and gradually got involved in preparing layouts, like *Wild in the Country* (1961) and *The Young Ones*, which Chantrell would casually improve 'with a couple of deft brushstrokes'. His first film assignment was *Wake Me When It's Over* (1960), though his 'trade test' job was the title lettering on a reissue of *Oklahoma!* (1955).

Eventually, after the move to 213 Oxford Street (an open-plan office as opposed to Screen House's 'nest of rooms', which Chantrell had much preferred), Youngs was made studio manager in charge of producing the press ads. By this time, a fourth 'junior' had been taken on – Colin Leary (born 1944), who arrived in 1962 and eventually specialised in cartoons. Many of the posters that Youngs worked on were simple 'coloured-up sepia photographs' – for instance, *Hercules Unchained* (1960), the first film that had more spent on its publicity than on its actual production, and *Those Magnificent Men in their Flying Machines* (1965). He also vividly remembers doing posters for Hammer, 'with a title and a four-line synopsis – *Slave Girls of the White Rhino* [*Slave Girls*, 1967] that was one. Photograph a rhino in London Zoo, put some crumpet on it, and Bang, you're away!' Sometimes they were restricted by unlikely instructions from the client: for *The Great White Hope* (1970), a biopic of Jack Johnson, the brief was that 'it was a love story, and we couldn't actually show the black boxer!'.

Youngs joined Chapman-Beauvais on Percy Street in August 1976, effectively still working for Fox, Warners and various smaller independents (many of the latter via Dennis Davison Associates). By this stage, Chantrell was turning out 'a couple

Ray Youngs at his desk at Allardyce in 1967, working on designs for *Poor Cow*. (Courtesy of Ray Youngs)

A Shaftesbury Avenue bombsite hoarding in 1967, photographed by Ray Youngs as it prominently featured his advance *Poor Cow* poster! Quad-covered hoardings like this were once common sights all over Britain's towns and cities. (Courtesy of Ray Youngs)

of sex posters a month', and Youngs would do the accompanying press ads. During the 1980s, video sleeves took over, with photographic-style artwork 'as big as a desktop' being reduced down to video-box size, in contrast to the old quads, where an 18" x 24" artboard would be blown up to 30" x 40".[90] By the time of Chantrell's retirement around 1993, computers had completely taken over, and Youngs 'doesn't have to draw even a guideline any more', creating everything on an Apple Mac. One of Chapman-Beauvais's more recent big campaigns was *Harry Potter and the Philosopher's Stone* (2001), for which Youngs helped produce dozens of press ads. 'Long gone are the days of paint, brushes, pencils, magic markers, set squares, T-squares, cowgum and waterpots,' he comments wistfully.

Monte Walsh (1970) Printed by Lonsdale & Bartholomew. Design and illustration by WH Pinyon. A striking watercolour western design from Allardyce's old boy. 'Pinny' by this point apparently spent a lot of his day quietly snoozing at his desk. (AC)

CHAPTER 9

Artists (ii): 'Bloody Marvellous' – Eric Pulford and Downton Advertising

Though there may have been more brilliantly talented illustrators and designers working intermittently over the years, the most *important* artist in the history of British film posters was undoubtedly Eric Pulford. No one can match Pulford's depth of involvement, degree of influence, consistency of output or simple longevity of career. During his forty years running Downton Advertising, he had ultimate control over a studio that was essentially unique, not just in Britain, but throughout the world. This first section of a two-part history covering the talents working for Downton's will therefore discuss both Pulford and his three most significant associates: designers John Stockle and Vic Fair, plus illustrator Brian Bysouth. The second part outlines the other prominent characters involved, including the celebrated 'Italian Connection', and also tries to give a flavour of everyday life within the studio itself. First, though, we need to examine the career of the man who started it all.

Eric William Pulford was born in Beeston, a southern suburb of Leeds, in August 1915. His father owned a butcher's shop, and Eric was the eldest of the family's five children, with three brothers and a sister. He attended Cockburn High School on Gypsy Lane, where a teacher encouraged his drawing abilities. Leaving aged fourteen, his first job was with the Leeds branch of a London firm that manufactured electrical goods – the young Pulford designed light fittings there for a year or so, before taking up a five-year general apprenticeship at Gilchrists, a blockmakers in the city centre. His first piece of artwork was for a Brock's fireworks box, and at around this point one of his paintings – a still life of wine bottles and a flagon – was accepted as part of an exhibition at Leeds Art Gallery. During this formative period, he was also studying three nights a week at Leeds

Art College, and when he left Gilchrists in 1939, he briefly returned there to teach draughtsmanship for about a year. Pulford missed out on active service during the war due to a serious bout of pleurisy (contracted during a walking holiday in Strasbourg), which had put him in hospital for several months during 1938. In 1940, he married longtime fiancée, Alma, three years his senior, the two families having first met on a camping holiday some years before. By the time of his marriage, the seeds of his future career were already in place.

Pulford's work at Gilchrists had been spotted by Leslie Whitchurch and Eric Brown, two partners who jointly ran Format, a Leicester-based firm mainly producing engineering drawings. Whitchurch was also a part-time publicity manager for Rank, and initially employed Pulford on a freelance basis to produce finished artwork for film posters aimed solely at the local Leeds cinemas. Some of the earliest titles he recalls working on in this way include *Gaslight* (1940), *The Bluebird* (1940), with Shirley Temple, and *The Thief of Bagdad* with Sabu. Alma remembers posing for the latter at her mother's house in Leeds, and her parents 'not being very happy about it, as Eric and I were alone upstairs together!'.[91] In 1942, the couple moved to Leicester so that Eric could work for Format full time. The firm's main clients were Adcock & Shipley, and Pulford chiefly produced detailed drawings needed for the war effort, turning flat engineers' blueprints into 3-D illustrations, along with continuing his finished artwork for film posters. The big move, though, came early the following year, when in 1943, the Rank Organisation invited him down to London to set up his own permanent studio and work full time on their publicity.

The Pulfords at first lived in a furnished bungalow in Chingford, north London, then later

Oliver Twist (1948). No printer credited, but probably W. E. Berry. Design and illustration by Eric Pulford. A fine Alec Guinness portrait on this moody half-sheet for David Lean's classic adaptation. (BFI)

The Purple Plain (1954). Printed by Charles & Read. Design and illustration by Eric Pulford. One of Pulford's best-known posters within the business, this later won a major design award in America. (BFI)

Eric and Alma Pulford in a Rome restaurant sometime in the late 1950s, probably following a hard day's work at Studio Favalli. (Courtesy of Alma Pulford)

moved south to Ewell for a short period, but throughout most of his time at Downton's, Pulford's address was The Cottage, Punchbowl Lane, Dorking, a semi-rural lane running between Dorking and Betchworth Park golf courses. Here he converted the cottage's garage into a studio, where he did much of his painting in the evenings.[92] Most of the actual designing, however, was done at Temple Bar House, and Pulford remembered working on the poster for *Henry V* (1944) while bombs were exploding outside across central London. Notable titles from the immediate post-war years include *Odd Man Out* (1946), *Oliver Twist* (1948) and *Corridor of Mirrors* (1948), though there were dozens more. Key names that Pulford rated as having had a significant influence on the design of the advertising were Derek Coyte (the original head of publicity at Pinewood), Ealing's art director S. John Woods and the powerful husband-and-wife producers Peter Rogers and Betty Box. Other names closely involved included Charles Collins (Downton's original chairman), Reg Hillier (Rank's main account executive, and later co-director with Pulford of the agency itself), David Pursall (Derek Coyte's successor at Pinewood Publicity), Charlie Young (Rank's publicity director in the 1960s), and Donald Murrey and Pat Williamson, both of Columbia. A list of actual producers and directors Pulford worked for over the 1940s and 1950s reads like a *Who's Who* of British cinema: Carol Reed, David Lean, Ralph Thomas, Hugh Stewart,

Ronald Neame, Julian Wintle, John Bryan, Roy Baker, Michael Relph, Basil Dearden, Michael Powell, Emeric Pressburger and many others.

Rank's selection committee for posters was actually headed by the formidable Sir John Davis, the organisation's chairman, of whom even Pulford was apparently afraid.[93] Davis's short temper and open disapproval of his profligate film-makers were legendary. His deputy, the amiable Texan Earl St John (also a member of the poster committee), was more popular, but hard-drinking and a laid-back Southern attitude meant that he was often seen as little more than a yes-man for Davis. Pulford would submit about four or five 'concepts' in rough sketch form, which were then whittled down to two or three semi-finished designs. The committee members – including the distributor's publicity manager, plus the film's producer and perhaps director – would then choose which of these were to be developed as the final poster. As Downton's grew, other professional illustrators gradually joined the agency to share responsibility for producing the final artwork, but Pulford continued to do a large part of this himself until the late 1950s, often signing his work 'Eric W. Pulford' or, more occasionally, 'EWP'.[94] Pulford's own favourite from this period was *A Queen Is Crowned* (1953), featuring a majestic illustration of the Coronation parade down the Mall.

When Downton's expanded, Pulford's role became increasingly that of an executive, presenting work to clients and liaising with the distributors,

The Lady Vanishes (1978). Printed by W. E. Berry. Design and illustration by Eric Pulford. A rare late example of a finished Pulford artwork, for the middling remake that turned out to be the last-ever Hammer film. (AC)

A Queen Is Crowned (1953). No printer credited, but probably W. E. Berry. Design and illustration by Eric Pulford. A fine illustration of the Coronation procession, and one of the artist's personal favourites. (BFI)

Breathless (1983). Printed by W. E. Berry. Design and illustration by Eric Pulford. An unapologetically romantic design from late in Pulford's career. (AC)

Footsteps in the Fog (1955). Printed by Stafford. Design and illustration by John Stockle. Stockle's very first film poster, featuring one of his trademark black backgrounds. (BFI)

though he continued to contribute to design, and maintained a firm grip on the most important Rank series, in particular the *Carry On*s, *Doctor* films and Norman Wisdom comedies. As we have seen, he gained complete control of Downton's in 1963, and merged the firm with Dixons at the end of 1965, bringing in John Stockle and Vic Fair. Design work was then divided up fairly evenly within a competitive framework, each designer submitting their own ideas for each film, and Pulford later presenting the various results for selection by the client. According to Ken Paul, his stock phrase when advising his younger artists was 'you want bags of black – puts bags of black in it, lad!'. One of those younger artists, Brian Bysouth, remembers Pulford vividly:

> He was tall, slightly stooped, with a very terse way of expressing himself – always said exactly enough to get his ideas across, never any more. Very self-contained. He rarely offered us much encouragement. […] His favourite expression of approval was 'Bloody Marvellous'. I did a poster for him once, *Riddle of the Sands* [1978], which had this yacht on the sea in the centre, and he really liked it: [breaks into broad Yorkshire drawl] 'Look at that boat – it's really moving through that water, isn't it eh? Bloody Marvellous!'

During the early 1980s, with retirement on the horizon, Pulford began the gradual process of handing over the reins at the agency. He had continued to be responsible for the odd finished poster himself throughout the 1960s and 1970s, including titles like *Stranger in the House* (1967), and his last quad, *The Evil That Men Do*, appeared in 1984, the year he moved down to the south coast, and began a slow easing-away from Downton's. He commuted up to London initially two days a week, then one, eventually allowing even these occasional visits to trickle out – there was no big farewell ceremony. Vic Fair kept him busy with intermittent design work over this final period, including layouts on *The Bounty* (1984), *A View to a Kill* (1985) and *The Last Emperor* (1987), which fittingly proved to be his last assignment. He remained very active, sailing and playing golf, until a serious illness rather slowed him up in 2001. He and Alma then decided to move to a smaller bungalow, overlooking the marina where his yacht was moored, which he still occasionally sailed right

up to summer 2005, when in July he suffered a bad fall at home. He died a week later in hospital on 30 July, just one week short of his ninetieth birthday. Responsible for at least 500 individual designs over almost half a century (Colin Holloway thinks the final figure may be nearer 1,000), including work for some of the best films ever made in this country, his contribution to the field of British film posters cannot be overestimated.

As we have previously noted, two other designers arrived at Downton's in 1965 as part of the Dixons merger. The elder of the pair was John Stockle, who was born in Stoke Newington in December 1928. His father, a florist in the local high street, died when his son was only eight. In 1934, the family moved to a new semi-detached house in a leafy part of Enfield, and Stockle spent the rest of his life there, eventually converting an outhouse at the bottom of the garden into his studio.[95] In July 1997, almost ten years after his retirement, the annual Enfield Festival mounted an exhibition of his work called 'Designing for the Movies', at Forty Hall Museum. In addition to displaying dozens of his artworks and posters, it also included a brief biographical account of the artist's career written by Stockle himself. The following material is drawn from the artist's original handwritten notes:

> When I left school in 1944, after being evacuated for five years to Great Yarmouth, I was heading for a scientific career – being better at maths and science than art! My mother got me a job in the lab at Belling & Lee, taking a day-release BSc course at Enfield Tech. A neighbour who worked as a compositor at the Samson Clark advertising agency in Mortimer Street heard of an opening for a Junior in their Art Studio. So I chucked away a budding scientific career for the unknown hazards of Commercial Art. The interview went reasonably well, and they took me on at £1.14s. a week. I emptied waterpots and got sandwiches and cigarettes (mostly under the counter then!). This continued in a frustrating way until I was called up to do my National Service.
>
> Still dubious as to whether I was cut out for a career in Commercial Art, I opted to be an Engine Fitter – at least I could work in a garage if all else failed [Stockle serviced Meteor jets, and was actually in Berlin during the famous airlift]. I did spend time drawing and painting (and attended art

Further up the Creek (1958). Printed by Stafford. Design and illustration by John Stockle. A typical example of a comic poster of the era, from Stockle's time with the Dixons agency. (AC)

John Stockle in January 1990, just over a year after his retirement from Downton's. (Courtesy of Marjorie Stockle and the *Enfield Gazette*)

classes in Chichester and Lubeck in Germany), sending cartoons to various magazines, and had quite a few accepted – enough to hope I could be an artist on my demob, two and a half years later. Firms were then obliged to take back returnees, and sadly I was back to waterpots and cigs at the ripe old age of twenty! Then, however, I had the opportunity to become a lettering artist, also producing simple line illustrations, and I got better – at this point I also started evening classes at Hornsey Art School, taking figure costume. After a total of nine years I applied to join the studio of a Commercial Photographers, and my first job was to hand-letter six lines of Russian ½" high – I managed, and started designing bits and pieces, beginning to put a portfolio together.[96]

In 1955, Stockle landed a job as a general artist with the Dixons agency and designed his first film poster for the thriller *Footsteps in the Fog*. However, comedy was more to his taste, and he continued to submit cartoons for publication, 'but the editors didn't seem to share my sense of humour!'. He also

designed greetings cards as a freelance. His greatest acknowledged influence was the caricaturist Robert Sherriff, who worked for *Punch* and other magazines, and Stockle managed to get himself taken on by Sherriff's agent, and occasionally did some of his busy hero's work for him, up to Sherriff's death in 1960. 'His style lives on through me,' Stockle believes, 'and the posters for *The Mouse That Roared* [1959] and *Rock around the Clock* [1956] reflect this.' His other chief influence was the great war artist Frank Wootton, who was himself later commissioned by Dixons to design posters for *The Guns of Navarone* in 1961. Like Wootton, Stockle liked painting aircraft, especially Spitfires, and in his spare time he also produced watercolours of local Enfield scenes, including the area's cricket grounds.

Stockle's wife, Marjorie, whom he married in June 1957, remembers him as an 'outrageous introvert'. His dress was always carefully colour-co-ordinated, and he had a dry sense of humour, but sometimes was not a particularly easy character to live with. He retired at sixty in December 1988,

Watch It Sailor (1961). Printed by Stafford. Design and illustration by John Stockle. Another of Stockle's comic posters, this was an unsuccessful adaptation of a popular West End farce, and Hammer's last attempt at comedy until *On the Buses* ten years later. (AC)

but within six months of this was diagnosed with Non-Hodgkin's lymphoma, and spent the remaining ten years of his life in and out of chemotherapy. He nevertheless continued to live life to the full, travelling widely with Marjorie, painting prolifically and generally refusing to give up. Three years after his moment of glory with the Forty Hall exhibition, he died in May 2000, aged seventy-one. He also wrote an account of the creative process at Dixons/Downton's for the 'Designing for the Movies' exhibition in 1997, and the following is again taken from his original notes:

> I was involved with 3–4 other designers, and we were very competitive. We all attended a private screening, usually in the bowels of Wardour Street. Unless the client had any specific points to make, we were free to design what we thought would bring the patrons to the cinema. The job really was to condense roughly two hours of film into one frozen frame, and a first class design. One film we had was *The Cardinal* (1963), a Roman Catholic story of a young man's rise to Cardinal, and our brief was not to include anything religious! Fortunately, that sort of brief was rare.
>
> We also suffered from client 'suggestions', which sometimes involved taking a piece from one or two designs and adding them to a third, resulting in a 'dog's dinner'. On a few occasions we were only given a film script to design a poster from. Some we designed were nothing like the film when we finally saw it! During my time designing posters, 95% of them were painted artwork. The reason for this was the lack of reference stills. We were dependent on the material supplied by the client to produce the poster, so if all we had were star portraits, we had to photograph models and paint the star's head on!
>
> I had several posters banned by the-then London Transport. […] 'LT' had a strict set of rules. One film was *The Camp on Blood Island* (1957) – too gruesome! – and another was *Heaven Fell That Night* (1958) – too sexy! – though we managed to get around the latter by silkscreening a black one-piece costume over Bardot's bikini. We did have some fun with my design for *The Virgin Soldiers* (1968). I persuaded a lad in our art studio to run across our photographic studio naked and holding a rifle! We placed a small Union Jack on his bottom as a tattoo. LT objected to both the tattoo on the 'offending buttocks', and the white background (an invitation

> to graffiti), and it finally ended up with a dark green background, and Union Jack underpants! All of us designers have a collection of designs which are far better than the accepted one.' […] I produced a lot of 'potboilers' too numerous to mention, but along the way I did design some I was pleased with, notably *Rock Around the Clock* (1956), *The Hellions* (1961), *The Finest Hours* (1964), *The Thomas Crown Affair* (1968), *Play Misty for Me* (1971), *Eyes of Laura Mars* (1978), *Comfort and Joy* (1984), *Prizzi's Honour* (1985), and *House of Games* (1987).[97]

Stockle's time with Dixons, working on the Columbia and Disney accounts, meant that he often tended to handle these distributors' posters following the Downton's merger. These included almost all the regular Disney cartoon reissues. He also did several of the earlier Hammer posters, including *The Snorkel* (1957), *The Revenge of Frankenstein* (1958), *Further up the Creek* (1958), *I Only Arsked!* (1959) and *The Damned* (1962) – for the latter, he actually went out to Bray Studios to supervise the stills photography for the poster. His 'mini-trademark' was the black background, first used on *Footsteps in the Fog* (1955), and – with a pleasing symmetry – his last ever film design, *White Mischief* (1987).[98] He remains, rather unfairly, very much the 'forgotten man' of British film publicity.

To some extent, Stockle later fell under the shadow of his junior colleague from Dixons. Vic Fair is generally recognised today as probably the most brilliant designer to have worked on British film posters since the war, though with his characteristically unassuming demeanour, he would be the last person to make such a grandiose claim. Fair was born in Chadwell Heath, Essex, in March 1938. His father was an industrial draughtsman, designing tractors for Ferguson and Ford. Fair attended the local secondary modern, leaving at fifteen to join a small advertising agency – Hector Hughes on Southampton Row – as a junior, while also studying in the evenings at St Martin's College of Art. In early 1954, three of Hector Hughes's staff defected to Arthur S. Dixon, and took the young Fair with them. Very soon after arriving, though, Vic was forced to leave again to do his eighteen months' National Service in Cyprus, and during his absence John Stockle also joined the agency. When Fair returned, he was still only at the end of his teens, and gradually became more and more involved in design work.

House of Games (1987). No printer credited. Design by John Stockle. A stylish photographic design for David Mamet's clever comedy thriller, this was one of Stockle's last printed quads. (AC)

Here We Go Round the Mulberry Bush (1967). Printed by Lonsdale & Bartholomew. Design and illustration by Vic Fair. One of Fair's most celebrated 1960s designs, with reflective silver mirror-paper glued over Barry Evans's face. (BFI)

A straight-faced Vic Fair in the mid-1970s, refusing to say cheese. (Courtesy of Vic Fair)

Possibly Fair's first film poster was *La Vérité* (1962), with Brigitte Bardot, a design for which he later won an award. He also remembers painting Dirk Bogarde in *HMS Defiant* (1962), and various other titles during the early 1960s. His career really began to take off after the 1965 Downton-Dixon merger, however, as Eric Pulford gradually came to realise what an outstanding designer he had happened to inherit. Memorable Fair layouts from this period include *Isadora* (1968), *Here We Go Round the Mulberry Bush* (1967), with its revolutionary use of silver mirror-paper glued over Barry Evans's face, and a psychedelic design for *I'll Never Forget Whatsisname* (1967).

Following the Garland-Compton takeover, Fair found himself less than impressed with David Bernstein's management ethos, and although he did not ultimately follow Eddie Paul and co. into Feref, he loaned them his pick-up truck to help the defectors with their office move. At this point he was involved in a particularly rewarding professional relationship with the Italian illustrator

The Man Who Fell to Earth (1976). No printer credited, but probably Leonard Ripley. Design and illustration by Vic Fair. Probably the best known of Fair's posters, and the only one regularly credited to him, since he liked it so much at the time he actually signed it. (BFI)

Renato Fratini, a collaboration that will be discussed in the next section. In the 1970s, a lot of Fair's designs were illustrated by Brian Bysouth, though equally often, the original layouts themselves ended up as the final artwork, simply because it would have been hard for anyone else to improve on them.[99] Many of his best-known and most popular posters date from this era, including his classic *The Man Who Fell to Earth* (1976) – the first of a series of memorable collaborations with director Nicolas Roeg, which also included *Bad Timing* (1980) – *Lisztomania* (1975), several vivid designs for Hammer, such as *Countess Dracula* (1971) and *Vampire Circus* (1972), *Carry On Behind* (1975) and the infamous *Confessions* films, done in the style of saucy seaside postcards. Like Stockle, Fair also intermittently had trouble with London Transport's censorship, particularly over *Death Line* (1972), one of the great British horror films of the period. His original ingenious design featured an oncoming tube train, cleverly worked to look like a skull, but LT objected to the macabre imagery,

which might have alarmed passengers, and a literal skull was disappointingly substituted.[100]

Fair liked to produce very big roughs – 35" x 45", larger than a quad – and felt free to add bits of paper onto them if additional ideas came to mind. John Stockle once jokingly complained that the distributors were always choosing Fair's designs simply because they were so huge. He used magic markers sprayed with fixative, and then pastels, or sometimes watercolours, or an airbrush, depending on what he felt the design required. This sort of experimentation helped to keep the job interesting, as he often felt constrained by the conventional demands of the clients, who frequently rejected his better designs. For the James Bond film *A View to a Kill*, he put Roger Moore in a white tuxedo: 'Not very exciting are they, the Bond posters … always the same thing. So I had this idea of putting him in a white jacket, but they just threw their arms up in horror – "Ooh no, we can't have that". It was ridiculous really.' Regardless of his occasional frustrations, the executives at the agency certainly

Vampire Circus (1972). Printed by W. E. Berry. Design and illustration by Vic Fair. The big cats were taken from a children's storybook, but the hidden phallics at bottom left and right are all the artist's own work, and reflect his disgraceful sense of humour. (AC)

Confessions of a Driving Instructor (1976). Printed by W. E. Berry. Design and illustration by Vic Fair. A classic smutty-postcard image, banned outright in one Welsh town. If you want to know what 1970s British cinema was all about, I'm afraid you're looking at it. (AC)

knew what a valuable asset they were employing: once, following the Roe-Downton merger in 1975, Fair and Colin Holloway jointly handed in their resignations. Returning home from work the same evening, Fair found he had been beaten to his front door by a motorcycle dispatch rider, carrying a new blank contract from Downton's management, on which he was invited to write his own terms for staying on.

By the late 1980s, however, Fair was, in his own words, 'becoming very, very bored … there was nothing really for me to do in the office, and I used to go home early all the time'. He found the video work – 'which was practically all there was left at the end' – particularly unstimulating, and eventually retired in 1995 to live quietly in north London. He still works regularly on new design projects, including charity assignments and children's books, while also playing snooker and badminton in his spare time. What made him stand out as a designer was his uniquely freewheeling *creativity*. He cheerfully admits that he often enjoyed working on horror film posters like the Hammer titles, because 'there were no particular conventions to follow – you could just let your imagination run wild'. The last word can go to his sometime colleague John Raymer: 'to my mind there was no one in the same league as Vic Fair. Vic's design sense, his draughtsmanship, and his colour sense were equally brilliant, and seemed to flow from him without apparent effort. All the hallmarks of a genius.'[101]

Stockle and Fair were principally designers, though both were responsible for many finished posters over the course of their careers. Often, however, their approved layouts would be given to an illustrator to produce the finished artwork. Downton's employed several such men over the years, but one name in particular stands out from the rest, in terms of both regularity of output and longevity of career, not to mention the sheer quality of most of his painting: Brian Bysouth.

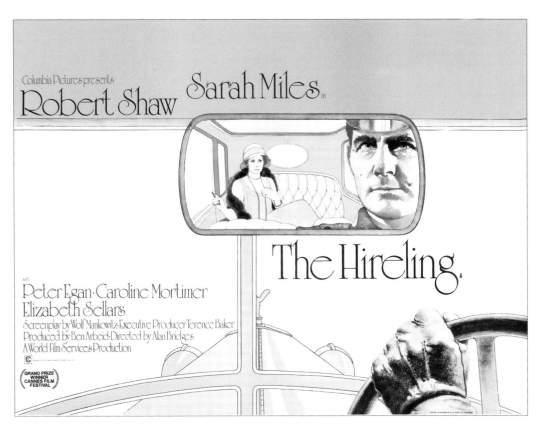

The Hireling (1974). Printed by W. E. Berry. Design and illustration by Vic Fair. Another strikingly imaginative design, and one of the artist's own favourites. (AC)

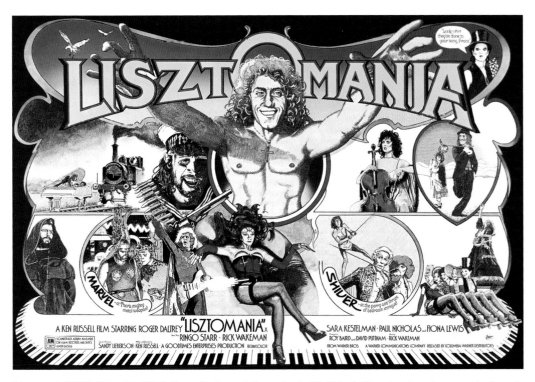

Lisztomania (1975). Printed by W. E. Berry. Design and illustration by Vic Fair. A vibrantly coloured pop-art classic, again showcasing its designer's sly sense of humour. (Courtesy of Vic Fair)

Bysouth was born in Cricklewood in October 1936. His father was a captain in the Royal Army Supply Corps, and later the general manager of a Vauxhall dealership, while his mother had originally been a fashion artist. By his own account, the young Bysouth was heading for a career as a tearaway, until he managed to win an art scholarship. Aged twelve, he accordingly entered Willesden Art School, where he studied for an Intermediate, then subsequently National, Diploma in Design and Illustration.

Having completed his National Service between 1955 and 1957, Bysouth returned briefly to art school, before touting his work around likely agencies, looking for a job. He was taken on by Ron Hornsby at Downton's as a junior artist, working in a studio with eight other letterers. He was initially paid £6 a week, rising after a while to £9, and enjoyed early success when two of his poster designs were approved by Pulford – *Tiger Bay* and *Ferry to Hong Kong*, both from 1958. However, he was unhappy with the low wages,

and left after only eighteen months to work at Rapier Arts for John Ind, who immediately doubled his young artist's pay. Bysouth stayed on at Rapier for two years, but then at the end of 1960 rejoined Downton's, this time lured back by the princely offer of £27 a week. He remained at Downton's for the next thirteen years, and though the agency's film work over this period was chiefly dominated by Italian artists, he still illustrated plenty of quads, including *Cromwell* (1970), painted to Vic Fair's design (an alternative style to Putzu's portrait version), *Hannibal Brooks* (1968) and *Two Mules for Sister Sara* (1969). In 1971, he bought and renovated a dilapidated cottage out in the wilds of the Hertfordshire countryside (where he still lives today), and in November 1973 finally left Downton's to freelance.[102]

Bysouth moved on to David Judd Associates, who had a stable of artists based in an office on Euston Street, and were employing four reps, including studio director Ken Hayter. One of his first freelance posters was *The Golden Voyage of*

Tiger Bay (1958). Printed by Charles & Read. Design and illustration by Brian Bysouth. Bysouth's first film poster, painted soon after joining Downton's aged 21, which immediately caught Pulford's eye. (Courtesy of Brian Bysouth)

Ferry to Hong Kong (1958). Printed by Charles & Read. Design and illustration by Brian Bysouth. The artist's second poster, for Rank's original attempt at a big international blockbuster. (Courtesy of Brian Bysouth)

Brian Bysouth in early 1981, at work painting the quad for *Fort Apache the Bronx* in his Great Portland Street studio. Note the references pinned up on the left of his board. This was actually from a Vic Fair design. (Courtesy of Brian Bysouth)

The Island at the Top of the World (1974). Printed by W. E. Berry. Illustration by Brian Bysouth, from a design by Eric Pulford. A colourful live-action Disney epic, this later won a design award in America. Watch out for those killer whales! Look out for that volcano! Mind those Vikings! (AC)

The Riddle of the Sands (1978). Printed by W. E. Berry. Illustration by Brian Bysouth, from a design by Eric Pulford. The vivid image of the racing yacht particularly impressed the normally taciturn Pulford. (AC)

When Eight Bells Toll (1972). Printed by Leonard Ripley. Illustration by Brian Bysouth from a design by Eric Pulford. A dynamic design showcasing Bysouth's trademark attention to detail, giving a genuine sense of scale to the mayhem. (AC)

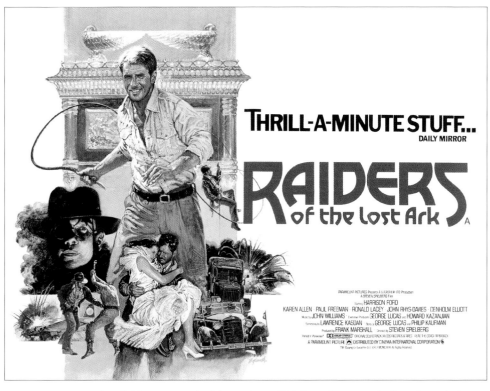

Raiders of the Lost Ark (1981). No printer credited, but probably W. E. Berry. Illustration by Brian Bysouth, from a design by an anonymous Lonsdales Art Director. One of Bysouth's best-known posters, this was commissioned when the original US design was felt to be rather too subdued. (AC)

Sinbad (1973), from a layout by Pulford, for which he was paid £300. A pattern thus developed where Bysouth was regularly hired to produce finished art for both Downton's and Lonsdales, though he also got plenty of less glamorous work via David Judd, including box tops for Ideal Toys. As a freelance, Bysouth was now earning £7,000 a year (more than double his leaving salary from Downton's). Most of his classic posters were painted with gouache on 24" x 19" artboard, and, like Vic Fair, he generally produced his roughs in magic marker on tracing paper sprayed with fixative. It took him about a week to paint the average quad, often changing the design around if he felt the original layout did not work very well in practice. His style changed over time, but many of his 1970s posters feature a distinctive technique (previously employed by Lowry), in which the paint has been applied over an initial layer of ground, giving the appearance of a fine 'toothbrush' effect to the brushstrokes.

In 1978, he set up a new company with Judd's ex-studio director, as Bysouth Hayter, but the partnership did not prosper in the long term. However, this period did produce one of his most famous posters, *Raiders of the Lost Ark* (1981), when Paramount decided Richard Amsel's US original was not an exciting enough design. Finally, in 1983, Bysouth was offered a job at Feref, and with Peter Andrews then beginning to get a firm grip on the company's wayward accounts, he accepted. From the mid-1980s, his work, by necessity, became increasingly photorealist. He illustrated *A View to a Kill* for Vic Fair, and subsequently produced the last of the old-style James Bond posters, *The Living Daylights* in 1987. His final quad to actually feature any painted illustration may well have been *The Shadow* (1994), though, by then, he was increasingly using computers. In 1995, Feref gained an important contract to produce the sleeve artwork for the *Star Trek–TNG* series of DVDs, and Bysouth spent his last years in the office turning out a sequence of these intricate pieces of work. When another illustrator let them down, he actually stayed on for an extra twelve months to complete the series, finally retiring in December 2002. He now claims not to care 'if I never have to pick up another paintbrush again'.

CHAPTER 10

Artists (iii): The Sausage Factory and the Italian Connection – Life at Downton's

'Downton's was a bit of a sausage factory really,' comments Fred Atkins, 'you were just turning stuff out constantly. I can't remember half the posters I worked on … it was never-ending.'[103] Atkins, a genial giant with a droll sense of humour, was the younger of Downton's two principal designers on the film side prior to the Dixons merger. We shall return to his contribution in a moment, but first need to consider his elder partner – the prolific Eddie Paul. Born in Hackney in 1920, Paul attended Southend School of Art.

He began his career at Temple Art Studios, before moving on to Star Illustrations on Shoe Lane, where he gained a considerable reputation as a scraperboard artist.[104] During the war, he worked as a fitter on Spitfires, apparently joining Pulford Publicity shortly after his demob in 1946. He used crayons and coloured pencils to produce his roughs, long before magic markers were introduced, and working alongside Pulford designed many of the agency's more successful posters of the 1960s, including *El Cid* (1961),

From Russia with Love (1963). Printed by Charles & Read. Illustration by Renato Fratini, from a design by Eddie Paul. By some way the best of the Bond posters, with a top-drawer combination of stylish design and casually brilliant execution. (BFI)

Eddie Paul meets fellow megastar Miss Piggy on the set of *The Muppet Movie* at Elstree in 1979. (Courtesy of Ken Paul)

55 Days at Peking (1963), *The Fall of the Roman Empire* (1964) and, most famously, *From Russia with Love* (1963), the latter usually incorrectly attributed to Pulford himself.

Eddie Paul's son Ken (born Hackney, 1949) remembers 'sitting on dad's knee' while his father designed Downton posters for the latest blockbuster, and being inspired to draw himself.[105] His father later became the unlikely leader of the five ex-Downton men who formed the breakaway studio Feref in 1968 ('The last person you would have imagined doing something like that,' according to Alan Wheatley).[106] He was well liked and respected within the business as 'a gentleman'. He died suddenly of a heart attack while on his way to work one morning in 1984, only a few months short of his retirement.

Paul's younger sidekick, Fred Atkins, was born in Swanley, Kent, in February 1928. His father was a stationmaster, and Atkins attended Beckenham Art School for two years, before joining the FHK Henrion agency on Sloane Street as a junior. After six months, he moved on to Stevens Advertising Service for about a year, and then, aged eighteen, to General Film Distributors on 127 Wardour Street. He was with GFD for eighteen months, designing press ads and the odd cheap poster for £15 a week. Finally, in 1951, he arrived at Pulford Publicity on Fleet Street, more or less simultaneously with illustrator Bill Wiggins. Early posters he recalls

Fred Atkins at his desk in Feref's offices on his sixtieth birthday, February 1988. His real first name is actually Michael – during his first job, the older men in the office thought he worried so much they nicknamed him 'Fret', which inevitably became 'Fred', and stuck. (Courtesy of Fred Atkins)

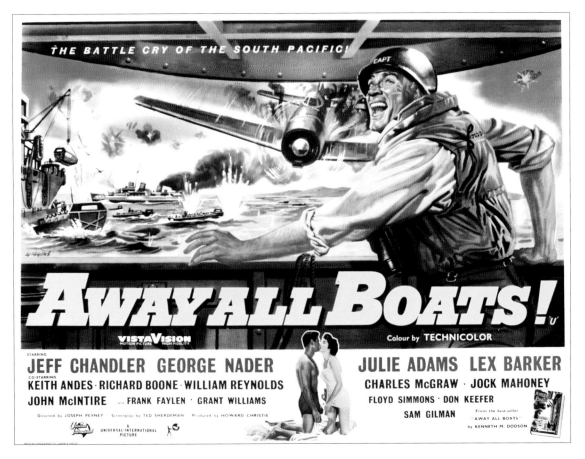

Away All Boats (1956). Printed by Charles & Read. Illustration by Bill Wiggins, from a design by Fred Atkins. All-action war heroics from dynamic duo Wiggins and Atkins, who both joined Pulford in 1951. (BFI)

designing include *Magnificent Obsession* (1954) and *Away All Boats* (1956), plus various other now-forgotten titles of the period featuring Rock Hudson, Jane Wyman and Doris Day. He formed Feref with Eddie Paul in 1968, and continued designing quads and press ads up to his eventual retirement in 1993. We will hear of them both again in the section on Feref.

The third key name from Downton's early period at Temple Bar House is studio director Colin Holloway. Born in Croydon in 1936, Holloway initially trained as an architect, studying design at Croydon Art School and briefly joining Lonsdale Hands in 1953, before almost immediately moving on to Pulford Publicity. He quickly made an impression when Pulford admired one of his roughs for *Jacqueline* (1956) and appointed him as his personal assistant. But Holloway actually plays down his creative contribution (though he did design the finished poster for *The Landlord* in 1970, and a few others over the years), preferring to describe himself

instead as a good organiser and collaborator with the other talents on the firm. He was Pulford's assistant up to the Garland Compton takeover, and eventually became studio director, co-ordinating the day-to-day output of the agency's thirty to forty artists, while also helping the imported Italian illustrators settle in London during the 1960s. Shortly after arriving in Wardour Street, he and Vic Fair tendered their resignations (with the intention of joining Feref), and were persuaded to stay on with the offer of directorships of the agency. Holloway eventually left the ailing Downton's in 1993, continuing to work for his own freelance company, Owl Graphics, producing video covers and record sleeves for RCA/Columbia up to his retirement in 1996.[107]

One of the earliest major illustrators Pulford Publicity employed after the war was someone we have already encountered, the cinema display artist Roger Hall, who joined the firm soon after his demob at the end of 1946.[108] Eric Pulford was on the lookout for film artists to work for him at

Jacqueline (1956). Printed by Charles & Read. Design by Eric Pulford, probably with input from Cliff Hirstle. Colin Holloway was involved with early designs for this Rank melodrama, but the finished poster looks a lot like the work of graphic designer Hirstle. (AC)

Fame Is the Spur (1947). No printer credited. Illustration by Roger Hall, from a design by Eric Pulford. This was Hall's first film poster for Downton's, following almost fifteen years painting cinema front-of-house displays. (BFI)

Ladies Who Do (1963). No printer credited. Design and illustration by Harry Stevens. A terrific cartoon by Stevens for this very British farce. (BFI)

Mask of Fury (1945). Printed by Stafford. Illustration by John Kaye, from a design by Eric Pulford. Not released in Britain until 1953, the original US title of this gung-ho nonsense was *First Yank into Tokyo*. (AC)

Fleet Street, and offered Hall – by now a fast-working and technically versatile painter with years of relevant experience – a whopping £16 a week. Hall recalls: 'All sorts of rumours were flying around about Eric and the future. There seemed no question big things were happening with his firm, and it looked like a good opportunity.' He and Pulford soon shared 'a good rapport':

> Eric was sort of self-effacing about his own talents, but I thought he was a terrific painter. His posters for *Oliver Twist* were marvellous pieces of work. Mind you, I did show him how to add tone and colour into shadows and that sort of thing – Eric had started out in a printing house, and of course, there, black was just black! He wanted me to teach him how to paint in oils and so on … we got on very well.[109]

Ironically, despite turning out 200–300 posters over the seven years he was at Temple Bar House, Hall can now recall only three titles – *Circle of Danger* (1951), with Ray Milland, *The Adventurers* (1952), with Dennis Price, and his first quad, 'a big Michael Redgrave portrait', for *Fame Is the Spur* (1947). Hall (based in Potters Bar from 1951) was working 'at a terrific pace' throughout this period, rarely spending more than two days creating the finished artwork, and was often turning out three posters a week. However, Pulford's complete monopolisation of all the design work – 'even when he was ill, he'd still be sitting up in bed working on his layouts – no one else got a look in' – became so frustrating that, in 1953, Hall tendered his resignation: 'Eric didn't want me to go, but I was ready for something new.'

Hall quickly moved into the field for which he is latterly best known, bookjacket illustration, working for Hutchinson (hardback dustcovers) and, later, paperback companies like Corgi, Pan, Panther, Four Square, Mayflower and Mills & Boon. In the 1960s, he also painted about a dozen film posters for Geoff Wright, before handing this particular contact over to Sam Peffer in 1971: 'Sam went on to do all those sexy posters for Geoff, but I just wasn't interested in that side of things at all.' Instead, he moved on to film and television production work, also illustrating fourteen Ladybird children's books from their 'Famous People' series, among many others. Between 1986 and 2003, he lived in Spain,

travelling widely and holding three separate exhibitions, before finally returning to a quiet retirement in Gloucestershire, where he still paints landscapes and local scenes.

By the mid-1950s, Downton's was employing three senior illustrators – Bill Wiggins (an old colleague of Hall's), Derek Stowe and John Kaye. Pulford also used various freelances like Henry Fox, (now better known for his bookjacket work on Badger paperbacks), whose occasional quads included *Portrait from Life* and *The Weaker Sex* (both 1948), and later Hammer's *The Steel Bayonet* (1957). Another regular contributor was Harry Stevens, whose distinctively lively cartoon style became a familiar sight on most of the Norman Wisdom comedies, along with such titles as *Battle of the Sexes* (1960), *Double Bunk* (1961), *Only Two Can Play* (1962) and *Ladies Who Do* (1963).[110] Stevens was born in Manchester in 1919, and joined the Society of Industrial Artists in 1955, winning the Council of Industrial Poster Design Award in 1963. His best-known posters are now probably the eleven striking travel designs he created for London Transport between 1960 and 1974.

John Kaye did quite a bit of film work in the 1940s, particularly the agency's RKO titles, like *Mask of Fury* (1945), *A Song Is Born* (1948) and *Bride for Sale* (1949). Another occasional contributor to the film side was Dougie Post, who chiefly worked on the agency's commercial accounts like Lufthansa. He illustrated *The Card*, *It Started in Paradise*, *Something Money Can't Buy* and *The Venetian Bird* (all 1952), and later intermittently worked for Feref, particularly on their war titles. With such a big stable of artists on the payroll, practically everyone on the firm had a go at designing or illustrating a quad at some point. Mike Greenslade designed some of the *Carry On* titles, including *Don't Lose Your Head* (1967), while the graphic design team of Cliff Hirstle and Don Piper also produced a few, such as *Violent Playground* (1958) and *The Big Money* (1956). However, the main illustrator (aside from Pulford himself) prior to the arrival of the Italians was Bill Wiggins.[111]

Wiggins (1915–88) had worked in cinema display in the 1930s, and was a special constable during the war, arriving at Downton's with Fred Atkins in 1951. Over the next twenty-five years or so, he painted scores of posters, mainly 'potboilers

Something Money Can't Buy (1952). No printer credited. Illustration by Dougie Post, probably from a design by Eric Pulford. Of course, escort agencies were a bit different in those days. (BFI)

Violent Playground (1958). Printed by Charles & Read. Designed by Cliff Hirstle. The figure with the machine gun is actually Colin Holloway. This is a good example of Hirstle's vivid graphic design work. (AC)

and double bills' according to his colleagues, including classics like *Love Slaves of the Amazons* (1957). He later shared an office with youngsters Brian Bysouth and Vic Fair, who both remember him 'painting away with a Senior Service permanently glued to his mouth'. His output actually features some fairly choice titles, including early Hammers like *Dracula*, *The Mummy* and *Curse of the Werewolf/Shadow of the Cat*, plus the sci-fi shocker *The Day of the Triffids* (1962) and Ray Harryhausen epic *Three Worlds of Gulliver* (1959). He initially retired in 1975, but rapidly found himself so bored that he returned within a couple of months and continued full time for another three years, eventually leaving to paint commissioned oil portraits for an art/photographic business in Bromley.

Other designers who subsequently joined the firm included Arthur 'Ben' Bennett, who arrived in 1965 from Dixons – 'A clever designer with a lot of good ideas', according to Colin Holloway, who was responsible for several striking posters, including

Anne of the Thousand Days (1969), *Three into Two Won't Go* (1969) and *Young Winston* (1972) – and Michael Bennallack-Hart, who joined in 1972. Bennallack-Hart was born in Kent in 1948 and studied at Ravensbourne College of Art and Design. Leaving in 1970, he spent two years as a freelance for United Artists, chiefly designing record sleeves. At Downton's, he was responsible for some stylish posters, including *The Night Porter* (1973) and *Thunderbolt and Lightfoot* (1974). In 1974, he left to work as an art director, initially for Ted Bates, then later McCann-Erickson, but briefly rejoined Pulford in 1979–80. He left again to begin painting full time, specialising in landscapes nostalgically recalling his childhood in the Weald of Kent. He has exhibited in galleries in London, San Francisco and New York, and is now internationally successful.[112]

Other creatives involved on the film side variously included Brian O'Hanlon, a hand-drawn litho artist who according to Colin Holloway originally worked for printers W. E. Berry in

The Day of the Triffids (1962). Printed by Tintern Press. Illustration by Bill Wiggins, from a design by Eric Pulford. (AC)

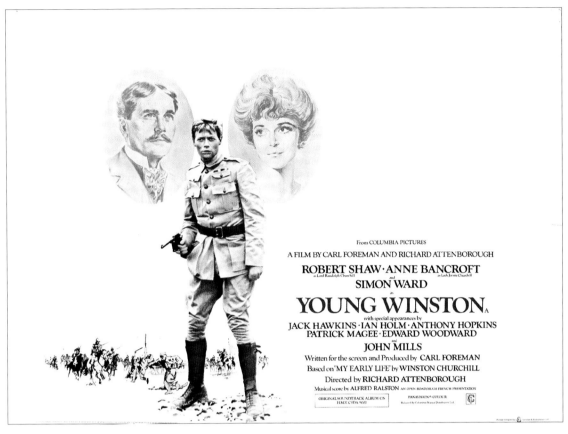

Young Winston (1972). Printed by Lonsdale & Bartholomew. Designed by Arthur Bennett. A fine photographic design by Bennett, who joined Pulford following the Dixons merger in 1965. (AC)

Bradford; Freda Reasor, an American copywriter who later returned to the USA to write novels as 'Freda Bright'; George Hulme, an Irish-Canadian playwright-turned-copywriter, responsible for taglines such as 'A Great Guy with His Chopper' for *Carry On Henry* (1971); Bernard Canavan, an Irish author who worked as a visualiser; David Kimpton, an illustrator with a distinctively tight style who later left for America; paste-up men Stan Judd, Ray Clay and Eddie Garlick; and Frank Hillary, the chief retoucher. Hillary originally arrived at Pulford Publicity after winning a national competition organised by Rank to design a Saturday Morning Cinema Club poster for the Odeon chain. According to Colin Holloway, 'Frank was by far the best colour retoucher in London, his copying of artwork by the Italian artists being almost as good as the originals.'

As with any male environment, there was a lot of practical joking and laddish camaraderie, which operated as a healthy release from the strain of working in a frequently high-pressure environment. For example, almost everyone was assigned a nickname: Colin Holloway was 'Hollow Legs', Brian Bysouth was 'Bubbly', because of his curly hair, and so on. The chief office joker was Stan Judd, whose favourite trick was to smear cowgum on Fred Atkins's telephone whenever the latter was out of the office, though he was once caught out himself with the old 'bucket of water propped up on a broom-handle' trick.[113] Everybody gathered in the basement of the local Joe Lyons restaurant first thing in the morning before heading into the office, and this usually led to a huge bun-fight. 'There would be food all over the walls,' recalls Colin Holloway. Lunch for some of this crowd was generally taken at the Blue Anchor on Chancery Lane, where there was also an old dartboard, which eventually ended up in Colin Holloway's office. There also seems to have been a second dartboard, downstairs in the basement. According to Fred Atkins, 'You could hear it going Thump Thump Thump. It used to really wind up Ted Aylward [the old studio manager] – "When are you bastards going to get down to some work?"!'

Thunderbolt and Lightfoot (1974). Printed by Lonsdale & Bartholomew. Illustration by Arnaldo Putzu, from a design by Michael Bennallack-Hart. 'Ben', as he was known around the office, contributed several such smart designs over the mid-1970s. (AC)

Such tomfoolery aside, the most significant event at Downton's during the late 1950s was the gradual employment of Italian artists to do illustration work on the firm's film publicity. They would eventually dominate the agency's output during the 1960s, revolutionising the look of British posters in the process.

In the early 1950s, Eric and Alma Pulford began holidaying in Terracina, to the south of Rome. By this stage, the workload at Downton's was becoming too much for Pulford to handle on his own, and he was not particularly impressed with the quality of a lot of the artwork from freelance British illustrators. Rank Overseas then had a distribution office in Rome, connected with the Italian government-funded Cinecittà Studios, and John Davis personally asked Pulford to go to Rome and, in his own words, 'Enlist the best Italian artists to produce publicity material for Rank, initially to be used mainly in Italy.'[114] In Rome, Pulford was introduced to Augusto Favalli, who had been part of the Italian Futurist

movement before moving into commercial work and setting up a studio employing a stable of artists to supply Cinecittà's film publicity. 'A brilliant designer, and crucially, a very good organiser too,' as Colin Holloway recalls, Favalli continued to dominate Italian film publicity up to his death from a stroke in 1971.[115] Initially, Pulford just used a handful of Studio Favalli artists to create advance publicity (principally for brochures detailing Rank films then in production), but the Italian involvement steadily grew.

In the first place, the Italian artwork was startlingly beautiful, showcasing an irresistible mix of a nationally passionate temperament, the unique Mediterranean light and the artists' mostly classical training. It thus looked quite unlike anything coming out of England at that time. Second, it was cheap. The overall quality was so good that Downton's were frequently able to use 'visuals' – simple rough layouts – as finished art in Britain, thereby technically paying considerably less than the going rate for what

Above Us the Waves (1955). Printed by Charles & Read. Illustration by Nicola Simbari, from a design by Eric Pulford. One of the very first British posters to carry an Italian illustration, this is a good example of Simbari's bold style. (BFI)

they were getting. The Italians only ever did illustration, however – all the creative work and necessary reference material were supplied by Pulford, who began making several trips a year to Rome, toing and froing with suitcases full of layouts, stills and artwork.

Around 1955, Italian artwork began to appear on British posters: one of the first examples was possibly Nicola Simbari's painting for *Above Us the Waves*, released that April. By the end of the decade, the trickle had become a flood, and the artists themselves were beginning to be brought over to England to work. As Brian Bysouth recalls:

> It made a tremendous impression. Suddenly there was all this fantastic work about, which was really exciting, but at the same time the English artists were thinking 'How can we possibly compete with this?' I was only just starting out myself then, so really had no choice but to try and develop my own style and stick with it.[116]

Compiling a complete list of Italian artists who worked on British posters is difficult, as many only contributed one or two titles each. Overall, though, there are at least a dozen major names, and limited biographical information on most of these is available via the internet, as Italy takes its poster artists far more seriously than Britain, and can boast several comprehensive websites to prove it. Pulford himself remembers using Giorgio Olivetti (1908–?), Dante Manno (1911–66), Manfredo Acerbo (1913–89), Averado Ciriello (1918–), Silvano 'Nano' Campeggi (1923–), brothers Giuliano and Enzo Nistri (1926–), Alessandro Biffignandi (1935–) and several others, some of whom (like Ciriello) visited Britain occasionally.[117] However, the two main 'early' names were Nicola Simbari and Angelo Cesselon.

Nicola Simbari is now generally considered to be one of Italy's most important living artists. He was born in 1927 in San Lucido, but grew up in Rome, where his father was an architect at the

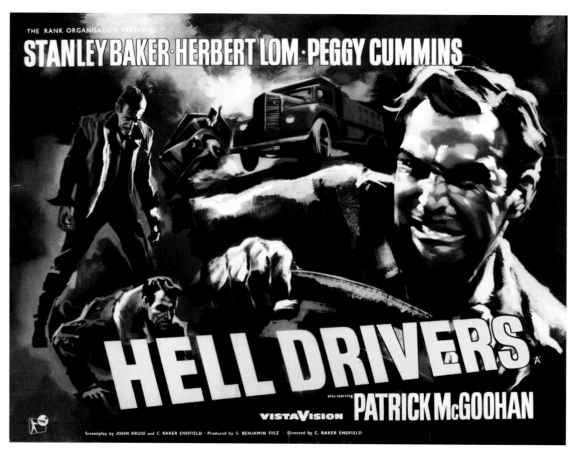

Hell Drivers (1957). Printed by Charles & Read. Illustration by Angelo Cesselon, from a design by Eric Pulford. A terrific, muscular piece of illustration for this classic British thick-ear, featuring one of the greatest hard-man casts ever assembled. (BFI)

Vatican. At sixteen he ran away to join the circus, returning after a few years to study architecture at the Academia di Belle Arti. After a brief period teaching, he set up his own studio in Via del Babuino, first exhibiting in Rome in 1953, then London in 1957, but it was his one-man 1959 show in New York that really made his name. Thereafter, he mixed painting with sculpture (creating some monumental steel constructions), and his powerful and energetic style, reflecting what his biographies like to describe as a 'passionate thirst for life', has made his work extremely collectable. He worked on many quads for Rank over the late 1950s and early 1960s, including *Dangerous Exile* (1957), *The Horse's Mouth* (1958) and *The Royal Ballet* (1960). Simbari was one of the first of the Italians to make working visits to England. Colin Holloway remembers that he

came to work in my office one day to paint posters for *Windom's Way* [1957]. On being shown how our artists used the various mechanical devices and aids

to project the original photos onto board for painting, Nicola simply pushed them to one side, saying 'I haven't the time to waste using these', and just painted the images direct onto the board, no initial drawing. He painted three posters that afternoon. He also told me that he wouldn't put pencil to paper unless he knew he could sell it first. A very commercial artist![118]

Angelo Cesselon, probably the most prolific of the early Italian illustrators, was born in Venice in 1922, and studied under Ercole Brini (1913–80), himself a distinguished poster artist. From the end of his twenties, Cesselon began working as a freelance for Augusto Favalli, in 1955 winning the Cambellotti prize, and in 1958 being voted 'Cinema-Painter of the Year'. In the 1960s, he gained great acclaim as a portraitist, his sitters including President Giovanni Gronchi and Pope John XXIII. Abandoning film work in 1969, Cesselon devoted himself entirely to religious painting, dying in Velletri in 1992, aged seventy.

He painted numerous Rank posters up to the mid-1960s, two of his best-known designs being *A Town Like Alice* (1956) and *Hell Drivers* (1957). For the latter film, he also produced a series of international one-sheets, featuring ravishing action portraits of stars Stanley Baker and Peggy Cummins, which seem to encapsulate the explosive colour, excitement and vitality of the whole Italian school. He also later painted a stunning series of general star portraits, 'fine-art printed by Stafford in anything up to ten colours', according to Holloway, which were subsequently hung in cinema foyers for permanent display.[119]

Only three of the Italians came over to London for long stays. Pino Dell'Orco lived in Britain for about seven years from the late 1960s to the early 1970s, freelancing for Downton's, and also, for a time, doing bookjacket work via Artists Partners. One of his earlier quads had been *North West Frontier* (1959), which included an iconic image of Kenneth More as a British Army officer.

Dell'Orco actually had a brief and unsuccessful marriage to an English girl, but he eventually returned to Rome after painting quite a few quads of the period.[120] The two major names of the 'Italian Connection', however, between them notched up a total of thirty years living and working in Britain, and thus effectively came to dominate the poster scene in this country: Renato Fratini and Arnaldo Putzu.

Although Fratini has been dead now for over thirty years, his is still the name that practically everyone in the business immediately volunteers when asked to nominate their own personal 'greatest artist'. His technical ability was unsurpassed – Ken Paul describes him as 'the only man I ever saw who could actually draw with a paintbrush'.[121] Vic Fair marvels at his speed – 'He was incredible. He was like a machine – he could just bash things out overnight' – and his 'amazing draughtsmanship'.[122] Colin Holloway cannot help but admire the sheer feeling he

North West Frontier (1959). Printed by Charles & Read. Illustration by Pino Dell'Orco, from a design by Eric Pulford. Colin Holloway recalls: 'Pino was a strange character … he once casually handed in a finished artwork done entirely in black and brown, and claimed he had forgotten to paint it in colour!' (BFI)

The Chalk Garden (1964). Printed by Charles & Read. Illustration by Renato Fratini, from a design by Eric Pulford. A fantastic portrait of Hayley Mills, demonstrating exactly why Fratini was so much in demand through the 1960s. (AC)

Maroc 7 (1966). Printed by Charles & Read. Illustration by Renato Fratini from a design by Eric Pulford. A good example of Fratini's dramatic and unpredictable colouring of his portraits. He employed a similar technique on several of the *Carry Ons*. (AC)

effortlessly injected into his work: 'He had amazing graphic sense and colour sense, like no one else I've ever known – he seemed to paint with a sort of uninhibited expressionism.' He also recognises that Fratini and Fair was a unique collaboration: 'There was a very special synergy between Renato and Vic – outstandingly original designs interpreted as truly great artwork … a unique partnership of two geniuses, never to be repeated.'[123]

Renato Fratini was born in Rome in October 1932. His father was a railwayman, and Renato initially studied at the city's famous Academy, as had Simbari before him. He apparently always had a supreme confidence in his own ability that would have bordered on arrogance but for his immense charm. According to Colin Holloway, he went into Studio Favalli one day 'and walked up to Favalli – who at that time was basically God – and simply said "I am Renato Fratini and I've come to work with you" – as though Favalli himself should have felt privileged!'[124] Fratini came to

England at the end of 1958. Colin Holloway was initially put in charge of looking after him, as at that stage he still spoke no English, though he quickly picked up the basics. The real landmark for the artist, however, was a party he attended in 1959, where he met and fell in love with a young fashion designer named Georgina Somerset-Butler, now better known as Gina Fratini. She remembers him with undiminished affection: 'He was incredibly good looking, with wonderful eyes … very attractive and funny, with tremendous enthusiasms – he just seemed to be interested in everything.'[125]

Fratini's first studio was at 38 Harrington Gardens, Kensington, and he later moved to a Victorian sculptor's studio on Princes Gate. When he and Gina married in 1961, they lived at 12 Kensington Court Place, about two minutes' walk away. As his wife recalls:

He really pulled me together, and taught me so much about art. You can always see the honesty in

Khartoum (1966). Printed by Lonsdale & Bartholomew. Illustration by Renato Fratini, from a design by Eric Pulford. Another good example of Fratini's abilities, this time his skill at economically *suggesting* detail, rather than laboriously recreating it. (AC)

his painting – I think he passed some of that on to me, the need for attention to detail, which is particularly important in clothes design.

Everyone who knew Fratini agrees that he lived life to the full, indulging every possible taste to the maximum. According to Gina:

He loved food, loved drink, loved cigars, loved dancing … he just liked to generally live it up. He adored jazz, and we were always out at Ronnie Scott's. He had great presence and tremendous passions. But really, we were very young, and in a lot of ways rather immature.

The marriage broke up before the end of the 1960s.[126]

Colin Holloway describes Fratini's technique and approach to poster design as follows:

He used to say that it was as much to do with what you left out as what you put in. Simplicity was the key to get the message across, and the essential starting point was always good reference material. […] He had this incredible delicacy of

Renato Fratini in about 1970, around the time he left England for Mexico City. This photo suggests something of his powerful physical presence. (Courtesy of Colin Holloway)

touch – could do the most finely detailed artwork imaginable. Mind you, he treated his brushes appallingly. He was always stealing mine, and then I'd find them lying around days later, completely ruined.

However, Fratini was generous in offering advice when asked: 'Renato was the most generous artist with his "secret techniques" – most keep them jealously to themselves.'[127] Fratini was on a retainer from Downton's, plus individual payments for work. Holloway recalls that the first 'big' poster he did was for *The Fall of the Roman Empire*, in vivid red acrylics. He demanded (and got) £100 for this, and from this point his prices rose steadily. Many of his early posters are even better remembered, though, including *Whistle Down the Wind* (1961), *Phantom of the Opera* (1962), *This Sporting Life* (1963) and, probably the most famous of all, the second James Bond film, *From Russia with Love*, in which he captures Sean Connery's sardonic smirk to perfection.[128]

James Bond apart, Fratini's most famous series of posters is almost never credited to him: the *Carry On*s. He illustrated all of these, mostly from designs by Pulford, from *Don't Lose Your Head* (1967) up to *Carry On at Your Convenience* (1971) – the latter, released that November, may well actually be his final quad. By this point, he was earning an unprecedented £1,000 a poster, making him easily Britain's highest-paid film artist ever. For *Waterloo* (1970), a dazzlingly detailed battle scene, he was actually paid £2,000. There is an amusing sidelight, though, for anyone who has ever carefully studied this poster, or any of his similar epic landscapes. As Gina recalls, 'His trademark was always to put someone in the background weeing. He'd be working away at his board, going "I must get my wee-wee in somewhere!"' Sharp-eyed enthusiasts can have fun trying to spot these renegade figures.

By 1969, with a broken marriage behind him, and a lot of his money being lost through tax, Fratini felt he had seen enough of England, and early the following year left for Mexico. He did plenty of commercial work for America, including ads for Pepsi Cola, while still contributing the odd assignment for Downton's (including the titles above). Colin Holloway recalls how they had difficulty getting any money out to him, as cheques had a habit of disappearing in the post. He got

Carry On at Your Convenience (1971). Printed by W. E. Berry. Illustration by Renato Fratini, from a design by Eric Pulford. Possibly Fratini's last British poster, with more idiosyncratic colouring of the portraits. (AC)

Waterloo (1970). Printed by Lonsdale & Bartholomew. Illustration by Renato Fratini, from a design by Eric Pulford. Vic Fair comments: 'All that detail … Fratini could just knock it in. Look closely, and there's actually nothing there! Genius, really.' (BFI)

married again, to a young Jewish student, but continued to see Gina occasionally. Then, in the summer of 1973, he was at a beach party when he suddenly collapsed from an enormous heart attack. Years of excess had finally taken their toll, and he was dead at just forty years old, a tragic waste of a brilliant talent. Fratini's story thus perfectly fits the traditional art-world stereotype of the doomed young bohemian genius. As the most gifted, richly rewarded and ultimately famous artist to have ever worked in the field in England, his shadow continues to fall heavily across the world of British film posters.

Fratini's successor at Downton's was a somewhat less high-profile, but similarly talented artist, himself responsible for a string of classic quads. More important, he is still around to tell his own story. The last of the Italian illustrators to work full time in England – and still manage to return home in one piece – is the great Arnaldo Putzu. Born in Rome in August 1927, Putzu began painting when he was around ten years old. His

classical studies, including a focus on architecture, occupied him until he was eighteen, by which time his favourite subject had become portraiture, initially of his relatives. He got involved in film publicity in 1948 doing poster illustration in Milan, and while there met the famous Enrico De Seta (1906–), who took him back to Rome to work at the heart of the film business in collaboration with many other artists, some of whom we have already mentioned. After four years with De Seta, he felt confident enough to set up his own studio.

Putzu began producing work for Rank in the late 1950s. His first quad was a powerfully atmospheric portrait of Belinda Lee (the tragic Rank starlet who died a few years later in a car crash in Italy), in *The Secret Place*, released in February 1957. This poster impressed Pulford (though Putzu did not rate it particularly), and Downton's began commissioning a steadily increasing amount of work from him. With Fratini proving a great success in England, and

Kidnapped (1973). Printed by W. E. Berry. Illustration by Arnaldo Putzu, from a design by Eric Pulford. A colourful swashbuckler, with a fine portrait of Michael Caine. This can be usefully compared with Jock Hinchliffe's Disney version, illustrated in a previous chapter. (AC)

Putzu eager to follow in his footsteps, the decision was made to bring Arnaldo across too. He arrived in London in February 1967, six months short of his fortieth birthday. The first poster that he painted in England was *The Magnificent Two* (1967) with Morecambe and Wise. His initial contract at Downton's ensured that he was paid a retainer, plus fees for work produced. He never earned as much as superstar Fratini – Fred Atkins thinks about £500 a poster would have been his maximum – but quickly took on an equally punishing workload, handling not only film work but also large amounts of publishing illustration.[129] Just as Fratini pursued a lucrative sideline in bookjackets, painting dozens of Fontana paperback covers, Putzu also worked widely in magazines, including the covers of practically every issue of *Look-In* comic (the 'Junior *TV Times*'), between its launch in 1972 and change of format in 1981. Indeed, a two-page profile of his work appeared in the 1975 *Look-In* annual:

He works on fairly large sizes of board (generally about 30" x 20") and uses a variety of paints and pens, pencils etc. Acrylic colours that enable him to use them very thin in washes or thicker in dabs are his favourites for most work, as they dry quickly, and the colours don't run into each other accidentally … Those large, swishing brush strokes that form the background of so many of his pictures are put on first, covering the rough composition that he's drawn in pencil. He then paints from his palette on top of this, composing the illustration, putting in more and more detail, starting with the darkest colours, and leaving the highlights till the end.[130]

As far as his quads go, apart from this instantly recognisable style – his broad brushstrokes and characteristically loose illustrations are more or less unique in British posters – his work is easy to identify, as (unlike Fratini) he generally signed it.

When Feref moved into 16 Little Portland Street at the end of the 1960s, Putzu was assigned

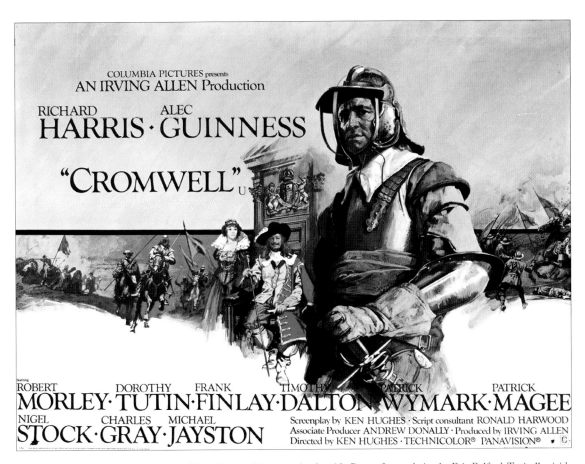

Cromwell (1970). Printed by Lonsdale & Bartholomew. Illustration by Arnaldo Putzu, from a design by Eric Pulford. Typically vivid portraits in one of the artist's personal favourites amongst his British posters. (AC)

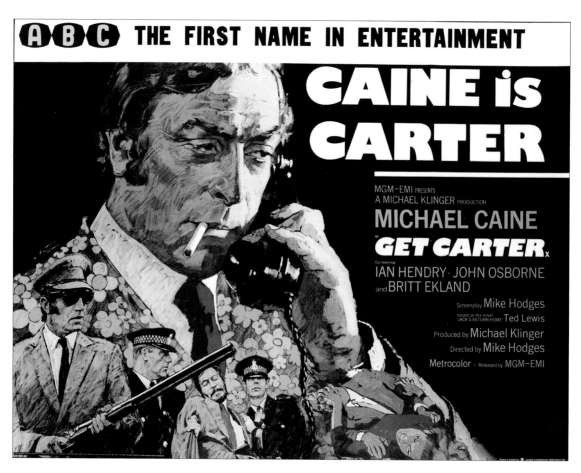

Get Carter (1971). Printed by Lonsdale & Bartholomew. Illustration by Arnaldo Putzu, from a design by Eddie Paul. One of the most iconic of all British film posters, from one of our most uncompromising thrillers. (AC)

an office on their floor as his studio. A photograph from 1973 shows him at work here on the quad for *Bless This House* (released that June), with posters for *Raging Moon* (1970), *Cromwell*, *Run Wild, Run Free* (1969) and *Carry On Abroad* (1972) pinned up on the wall behind his easel. Putzu himself smiles easily over his shoulder at the camera, a trim, muscular, good-looking figure in a plain shirt, his elbow casually propped on a corner of the board, every inch the stylish continental artist. He took over the *Carry On* series from Fratini in 1972, and also worked regularly for Hammer, principally on their spin-off comedies like the *On the Buses* series, though

he additionally (like Tom Chantrell) produced a lot of pre-production artwork for the company's later gothic horrors. His best-known poster is probably *Get Carter* (1971), in which he rather whimsically puts ruthless gangster Michael Caine in a psychedelic floral dressing gown – possibly an ironic comment on the film's unremittingly

bleak violence, or possibly just a quick way of adding a bit of colour to offset the flat black background. His own personal favourites among his British posters include *Cromwell* and *Romance of a Horse Thief* (1971), with Yul Brynner, though he is nowadays understandably vague about many of the films he actually worked on – along with most of the other artists in this book, the sheer volume of work involved has blunted his recollection of individual titles. In 1975, he won the *Hollywood Reporter*'s 'Key Art Award' for best European poster, given to his design for the blockbusting kung-fu epic *The Man from Hong Kong*.

The fashionable *Image* art magazine profiled Putzu in its summer 1973 issue, and the article offers a revealing glimpse into the British film publicity scene of the time. Putzu is forthright in his dissatisfaction with the restrictions he was sometimes forced to work under, compared with his heyday in Italy during the 1950s:

They were different times, and it was a different business. You didn't have so many middlemen asking you to put down 'their' ideas. I would go and see the film and work out my ideas and produce some roughs. Then I would take them to my client and finalise the poster we wanted. Even now in England I always insist on seeing the film, but often I don't get a chance to put down my own feelings [...] Often the publicity has been handed over to an advertising agency, and so they have their plans, or to take a recent example I did a rough for a film, and the company in America liked it, but it was vetoed at this end by the English company. Very occasionally it's different.

Describing his philosophy of illustration, Putzu comments:

Your first aim when working on the poster is to sell the film. Therefore you've got to make it as striking as possible. It doesn't matter if it doesn't say what the film's about. Remember, most people are only going to take it in at a glance. ... Using references [i.e. stills and photographs], nine times out of ten you've never got exactly what you need, unless you get a model to pose for you. Once you've worked the pose out you're halfway there, because you can always add the correct face later, which for me isn't difficult as I was trained as a portrait painter.

The article comments that he usually turns out three roughs per film, the client choosing one for the final artwork, and that most of his posters were then produced over two days, with an average payment of £200, though the *Carry On*s paid more. Putzu is bullish about the money side: 'You must know what your work is worth. I have never undersold myself, and if someone started asking half my price I still wouldn't be underselling.' He also seems unconcerned that photographic posters were becoming a potential threat:

I'm convinced it's much more difficult to produce a good photographic poster. It's easier to create an atmosphere using paint [gouache and acrylic] and behind a very good photographic poster there must be a painter's eye, or a good art director [...] I like my work very much. It is very varied, and occasionally you can put down what you really feel.[131]

Putzu now thinks his last British poster was the 1979 re-release of Peckinpah's *The Getaway* (1972) – a good example of a reissue that is actually far superior to the original – though Colin Holloway feels there are likely to be a few additional later titles.[132] In any event, the final straw for the artist occurred in the early 1980s, when he spotted a pirate video in a Wardour Street shop window that had a piece of his previously unused artwork on the cover. Enquiring about this at Rank, he was told that all of the publicity material on the film, plus a print of the actual negative itself, had been stolen from their offices some weeks earlier, and there was nothing they could do. With his commissions now in decline, and his wife keen for them to return home, he finally flew back to Italy in October 1985, his commercial career at an end. Before he left, he went to see Pulford to say goodbye, and was dismayed to find the latter still rhapsodising over *The Secret Place* – 'Ah, I remember that first poster you ever did for us! A masterpiece!' Putzu was too polite to argue: 'I just thought, Oh God, not that old thing again!'[133] Now settled permanently

Arnaldo Putzu at work in Feref's offices in summer 1973, painting the quad for *Bless This House*. (Courtesy of Arnaldo Putzu)

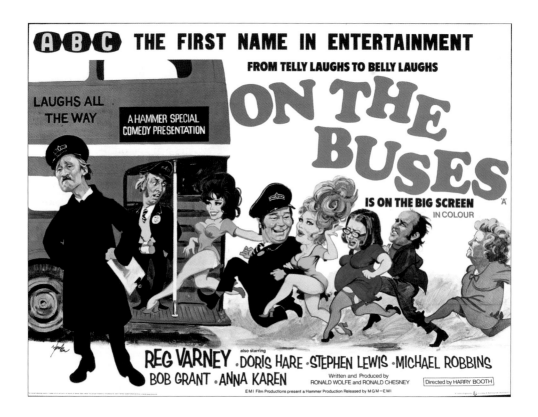

On the Buses (1971). Printed by Lonsdale & Bartholomew. Illustration by Arnaldo Putzu, from a design by Eddie Paul. A lively comic poster for the biggest UK box-office success of its year. (AC)

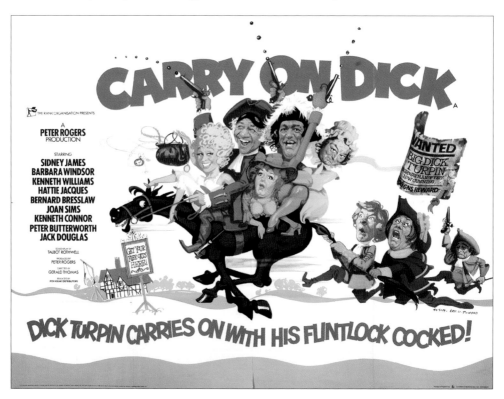

Carry On Dick (1974). Printed by Lonsdale & Bartholomew. Illustration by Arnaldo Putzu, from a design by Eric Pulford. Last of the classic *Carry Ons*, both film and poster-wise, being the swan-song of James, Jacques, Windso, and original scriptwriter Talbot Rothwell. (AC)

in Rome, Putzu continues to paint today, working on commissions for portraits and meticulous still lifes.

The departure of Putzu marks the symbolic end of the 'Italian Connection', and, by extension, the great days of British film posters. Never again would a humble domestic quad carry work of such effortless energy, freedom and sheer vivacious appeal, even when the subject matter happened to be the lowest of low-grade exploitation cinema. Putzu is the last link in a chain of men who actually changed the entire look of British posters, and for a brief period made them seem as exciting as anything else in Europe. For the final part of this survey of leading artists, we shall look at the freelances – the various independents who worked for agencies like Lonsdales and UK Advertising on an occasional, individual basis – and also the handful of art school graduates arriving on the scene at the end of the 1970s, who, ironically, began to establish themselves just at the point when the whole illustrated tradition in British posters was coming to an end.

CHAPTER 11

Artists (iv): Feref and the Freelances – The End of a Tradition

As we have already noted, the 1967 Garland Compton takeover of Downton's did not prove very popular with several of the talents there, as new boss David Bernstein had a management style that tended to alienate some of his workforce. Apparently, you could tell how far out of favour you were by the position of your desk in the morning, as an ex-employee recalls:

> Bernstein had an assistant who did his dirty work, and this chap used to move the furniture around in the studio at night. Anyone who was for the chop would find their desk getting nearer and nearer to the lifts, until they'd eventually be working more or less out in the corridor! It sounds ridiculous now, but it wasn't funny at the time.[134]

By early 1968, this situation, coupled with a long-term dissatisfaction concerning pay, had reached crisis point, and in May five key creatives left and set up on their own as Feref: designers Fred Atkins and Eddie Paul, paste-up and layout artists Ray Clay and Eddie Garlick, plus retoucher Frank Hillary. The new company was quickly set on its feet by John Harvey of UK Advertising (at that time chasing Allardyce's Fox account), who offered Feref a £1,000 contract for one year's creative work. This covered not only UK's film side, but various other commercial accounts as well, including Burton's Menswear.[135]

Both Colin Holloway at Downton's and Peter Brunton at Columbia helped keep the fledgling company going with bits of work, as did Mike Wheeler. By 1970, Feref was starting to prosper, with offices at 16 Little Portland Street. Fred Atkins designed a number of quads (though he tended to work more on press ads). Two posters he admits responsibility for are *Virgin Witch* (1972), a hilariously tacky British exploitation picture,

and *Heat and Dust* (1982), one of Merchant Ivory's prestigious literary adaptations. But the chief designer was Eddie Paul, responsible for quads like *The Railway Children* (1970), *Raging Moon*, *Swallows and Amazons* (1974), *Stardust* (1974) and *Cross of Iron* (1977). By the time Eddie Paul turned his attention to the last of the original *Star Wars* trilogy, *Return of the Jedi* (1983), he had been joined at Feref by his son Ken, by then a successful advertising executive in his own right.

After leaving school, Ken Paul joined Hawke Studios as a messenger boy. From there he briefly went to the publicity department at MGM-British in Borehamwood, then in 1965 moved on to Geoff Wright studios in Soho for two years, employed as a junior artist on campaigns such as *Dr Zhivago* (1965), *The Dirty Dozen* (1967) and several of the *Man from Uncle* films. In 1967, he struck out on his own, joining up with Russ Eglin (previously of Moss Empires), Barry James (from Windsor Artists) and later John Farley (a designer who had worked for Downton's), to form a small studio. They were quickly bought out the following year by David Abrahams, who wanted them for his agency, UK Advertising. Paul was initially employed as a designer at UK, mostly on the film side. He was made a board director in 1969, aged just twenty, apparently the youngest man in British advertising to have achieved such a senior position, though this breakthrough also effectively ended his involvement in actual creative work. Barry James left in 1972 to set up Haymarket Advertising (later Cannon's agency), and Russ Eglin departed shortly afterwards for DeWynters, which designed and printed a few quads over the late 1970s and early 1980s. When Abrahams finally sold UK on in 1977, Ken Paul left to freelance for a couple of years, and eventually joined his father at Feref in 1979.

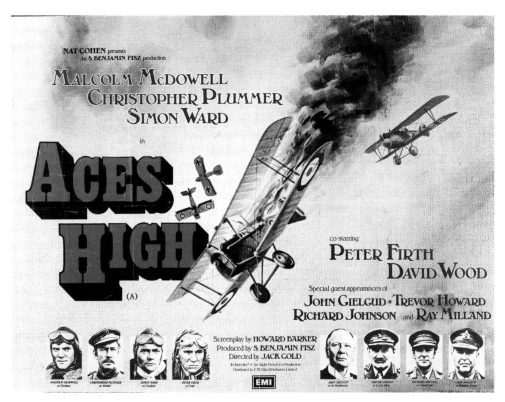

Aces High (1976). Printed by Broomhead Litho. Design and illustration by Eddie Paul. Paul worked on Spitfires during the war, and insisted on illustrating this quad himself: 'He wouldn't let anyone else touch it,' Fred Atkins recalls. (AC)

The Feref management team in 1983. Left to right: Frank Hillary, Ray Clay, Barry James, Eddie Paul, Ken Paul and Paul Ratcliffe. Two notable absentees: Eddie Garlick had retired by about 1970 and Fred Atkins never got into the office early enough to appear. (Courtesy of Ken Paul)

Virgin Witch (1972). No printer credited, but probably Bovince. Illustration by Arnaldo Putzu, from a design by Fred Atkins. Truly one of the forgotten classics of British art cinema, the sensitive and poignant drama of a beautiful young occultist whose clothes keep falling off. (AC)

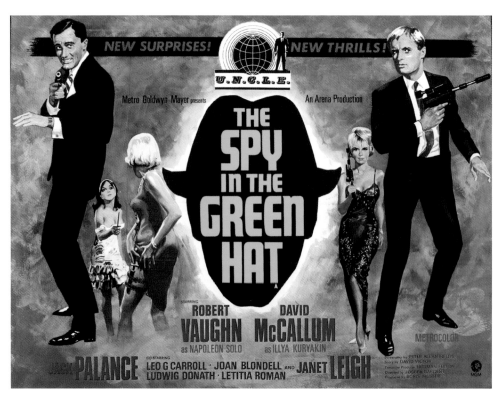

The Spy in the Green Hat (1967). No printer credited. Ken Paul worked on designs for all the *Man from Uncle* spin-offs; the illustrator here is uncertain, though Barry James is a possibility. (AC)

Thanks to his efforts, Fox, EMI and Rank Overseas were soon added to the firm's film accounts, but the unexpected death of his father in 1984 came as a bitter blow. Ken Paul finally retired from Feref in November 1999, moving up to Scotland where his wife's family are based. Looking back on his thirty-five years in the business, the campaigns he remembers most fondly include several of the Bonds, the *Superman* series, the original *Star Wars* and *The Texas Chainsaw Massacre* (1974), which he actually defended on the radio, when the BBFC refused it a certificate.

Feref employed a range of illustrators, some of whom were old hands from Downton's (for example, Dougie Post, who contributed occasional titles like *The Jerusalem File*, 1971), and some of whom were simply young artists who walked into the studio touting for work, carrying a portfolio that happened to impress Fred Atkins (for example, Frank Moses from Leeds, who did a few quads for them, including *Mad Dogs and Englishmen*, 1971).[136] Arnaldo Putzu, with his own studio in

their offices, obviously did an enormous amount of work, and another regular contributor was Frank Langford (1926–98), who seems particularly to have illustrated EMI's posters. Langford had been a popular comic artist in the 1950s and 1960s, working on *Eagle*, *Boy's World* and *Countdown*, plus the two Gerry Anderson titles, *TV21* and *Lady Penelope*, while also drawing the adult 'Jack and Jill' strip in the early days of *The Sun* newspaper. His best-known poster is probably the iconic quad for *Sweeney!* (1976), with tough guys John Thaw and Dennis Waterman, but he worked on dozens of other titles, from television spin-offs like *Are You Being Served?* (1977) to *Keep It up Downstairs* (1976), EMI's sole contribution to the murky but lucrative world of British soft-core porn. His last poster for Feref seems to have been *Hot Dog – The Movie!* (1984).

Another ex-Downton artist who worked regularly for Feref was Josh Kirby. Born Ronald William Kirby in Waterloo, Lancashire, in November 1928, the son of a grocer, the nickname

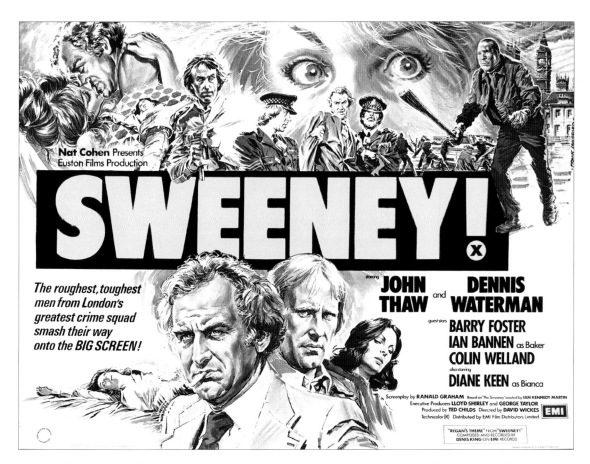

Sweeney! (1976). Printed by W. E. Berry. Illustration by Frank Langford, probably from a design by Eddie Paul. Perhaps the strongest of the 1970s TV spin-offs, and a terrific illustration by comic artist Langford, showcasing his exceptional draughtsmanship. (AC)

'Josh' was acquired while studying at Liverpool City School of Art from 1943 to 1949, where a fellow student joked that he painted in the style of Sir Joshua Reynolds.[137] After graduating in 1950, he was commissioned by Liverpool City Council to paint their mayor but, reluctant to get drawn into the staid world of professional portraiture, he soon moved down to London and began working for Pulford Publicity. His mother, worried that he might be conscripted, had not included him in the National Registration of September 1939, and Kirby thus initially lived without a ration book, National Insurance or official identification. He briefly worked above a cobbler's on Marylebone Lane, but soon moved to an old pickle shop in Battersea, letting the flat above to Nell Dunn, where she wrote the now-classic social-realist novel *Up the Junction* (1963).

Kirby turned out a lot of quads between 1951 and 1957, including the colourful *The Beachcomber* (1954) with Robert Newton, while intermittently painting posters for a film company in Paris. In the mid-1950s, he also started producing bookjacket work, including the first Pan paperback edition of Ian Fleming's *Moonraker* (1956), and was eventually responsible for over 400 covers, though he disliked doing anything except sci-fi/fantasy. Despite this, his painting for the novelisation of *The Camp on Blood Island* was striking enough to be actually included on John Stockle's quad for the film itself. Kirby began freelancing for Feref in the early 1970s, turning out a sumptuous illustration of Keith Michell in *Henry VIII and His Six Wives* (1972), and an unused one-sheet for *Monty Python's Life of Brian* (1979) based on Bruegel's *Tower of Babel*, but his predilection for sci-fi meant that his most memorable later quads included titles like *The Beastmaster*, *Krull*, *Starflight One* and *Return of the Jedi* (all 1983), mostly from designs by Eddie Paul. However, just as he seemed to be getting into his stride with film work (aided by the short-lived boom in 'Sword and Sorcery' subjects), the market for poster illustration abruptly dried up. Luckily, by this time, he had begun producing the covers for the immensely popular 'Discworld' series of fantasy novels by Terry Pratchett. Despite his

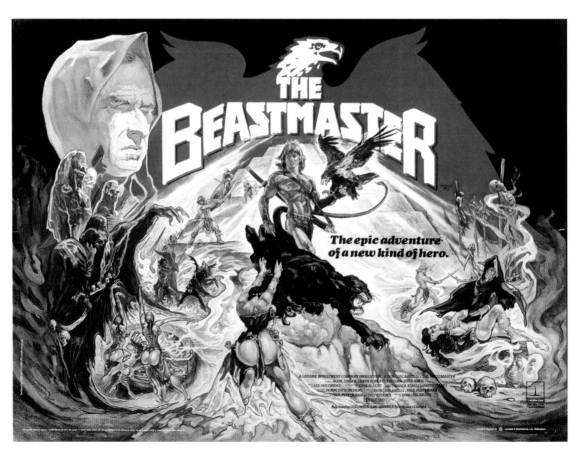

The Beastmaster (1983). Printed by Lonsdale & Bartholomew. Illustration by Josh Kirby, probably from a design by Eddie Paul. An impressively garish illustration by Kirby, highlighting his fondness for big bottoms. (AC)

fondness for science fiction, Kirby was determinedly old-fashioned, always painting in slow-drying oils, and from 1965 living and working in an old Tudor rectory in Shelfanger, Norfolk. He died there in October 2001, one of the most fondly regarded of British genre artists.

Another occasional Feref contributor was Harry Gordon, now best known for his psychedelic quad for *Wonderwall* (1969). This was designed for the Cinecenta (now Odeon) on Panton Street, off Leicester Square, Britain's first purpose-built four-screen cinema, which opened with a blaze of Feref-produced publicity in January 1969. Ken Paul remembers the initial scepticism that greeted the launch – 'a multi-screen cinema? What an idea – it'll never catch on!' – but Fred Atkins nevertheless spent much of the 1970s designing endless cheap double-bill quads for the place, principally foreign sexploitationers.[138]

The last of the major illustrators at Feref (apart, of course, from Brian Bysouth) was Mike Bell. He was born in Hull in 1932, and studied at Birmingham College of Art before joining local design studio Charles Hurlston in the early 1950s. He was taken on at Feref in 1972, and began illustrating quads on a regular basis. Some of the earlier titles he recalls include *Lady Caroline Lamb* (1972), *Hammersmith Is Out* (1972), *Hitler, the Last Ten Days* and Bertolucci's *1900* (1976). He was put on a retainer by the firm in the early 1980s, and continued to design as well as illustrate many posters, including *Brass Target* (1978), *Love and Bullets* (1978) and the unforgettable *Zoltan, Hound of Dracula* (1977). We can get a good idea of the sheer volume of work Bell turned out from his job book for the six-month period from October 1986 to April 1987: over twenty titles are listed, roughs and finished art on films as diverse as *Eldorado*, *Switching Channels* and *Three Amigos*. By this point, though, his film work was already beginning to 'peter out', one of the last major posters he recalls working on being *Jacknife* (1989) with Robert De Niro.[139] He still paints today, and at the end of 2002 created a series of three amusing ads for independent radio station Kiss 100 FM, done in the style of pastiche 1960s

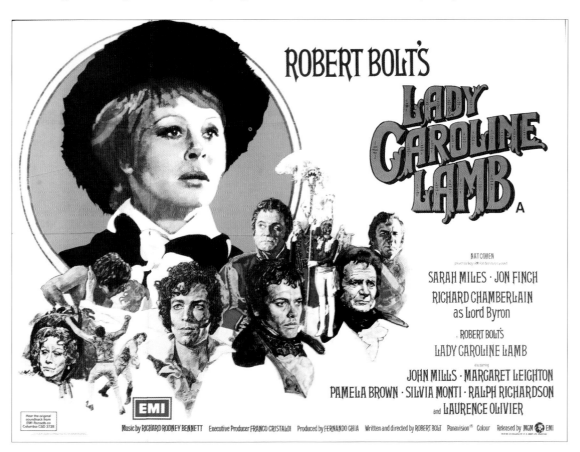

Lady Caroline Lamb (1972). Printed by W. E. Berry. Illustration by Mike Bell, from a design by Eddie Paul. A fine series of portraits for this popular costume drama (AC)

Mike Bell at his desk at home in 1990, towards the end of his film career. His pet parrot is visible in the background. (Courtesy of Mike Bell)

Romancing the Stone (1984). No printer credited, but probably Broomhead Litho. Design and illustration by Mike Bell. A lively design for this sub-Indiana Jones adventure. (AC)

film posters, with more than a hint of Renato Fratini about them.

Agencies like Lonsdales and UK Advertising did not run large enough creative departments to employ their own illustrators; rather, they had perhaps two or three art directors on the payroll, who each had responsibility for commissioning finished work from the pool of available freelances. One of the most significant of these art directors/designers/commissioners was Lonsdales' John Raymer. He was born in 1933 in South Norwood, and (like Colin Holloway) attended Croydon School of Art, gaining his National Diploma by specialising in book illustration.[140] Following two years' National Service in the Canal Zone, Egypt, he returned home in August 1955 to be taken on as a junior visualiser at Greenly's on Berkeley Square:

My job was to develop the ideas of a creative person, and draw up a 'visual' for presentation to a client. It was not long before I began to wonder

about the permanence of the job I had come into. Members of the creative staff would just disappear and not come back; in fact within my first six months of employment, half the staff around me had been sacked! I discovered that if you didn't pull your weight, or show some flair, then out you went.[141]

Greenly's had held the account for Paramount Pictures from 1922, but Raymer did not work on it until 1967, a year or so before the retirement of Frank Pickford, the man who had handled the account from the beginning. By this time, things were rapidly changing: Richard Lonsdale-Hands had taken over the agency (which then, of course, became Lonsdales) and a perceived gap between US and UK publicity requirements meant that, almost for the first time, original campaigns were being devised in Britain, as the 'Swinging Sixties' got into gear. As Raymer explains:

Part of my task as 'anchor man' on the Paramount account was to produce designs for each film, and

Barbarella (1968). Printed by Lonsdale & Bartholomew. Illustration by Renato Fratini, from a design by Robin Ray. A classic 1960s pop-art design for one of the decade's daftest and most entertaining films. (BFI)

initially I would be competing with designers from other groups in the agency. These other groups would be invited to involve themselves in working on a film if their workload permitted. Thus, publicity for *Smashing Time* (1967), *Half a Sixpence* (1967), and *Oh! What a Lovely War* (1969) was designed by John Billingham, *Funeral in Berlin* (1967) by John Burningham, and *Barbarella* (1968) by the creative director Robin Ray [the latter with memorable artwork by Renato Fratini]. None of the designers at Lonsdales, including myself, had any previous experience with film publicity, we were by no means specialists. Thus I tend to think that the work produced there had a difference, and the difference showed itself in a greater variety of graphics and appeal [...] There was less dependency on the use of montages, and more emphasis on finding a single image.

There was always a balancing act by the film companies when launching a product in the UK (or for that matter worldwide). Are the distributors in the UK to change the original publicity for local markets? A decision had to be made. If the film had opened successfully in the USA, then its publicity would be considered to have probably contributed to that success, and should therefore be left unchanged. If not a success, but believed to have potential, then the agency would be asked to create a new design. Films actually made in the UK would frequently, though not always, have publicity originated in this country. Low budget films would not merit a change, simply because there was little money to invest in a new image. The latter could have its risks. I recall the scramble to revamp *Duel* (1971), a film made by the then-unknown Steven Spielberg, and having no great actors or actresses to draw the crowds. It was launched quietly, away from the West End, without a premiere. Critics hailed the film, so there was a hasty rescheduling, and a West End launch laid on. I had to come up with something that could be printed as a poster and be in the newspapers in a matter of days, and we didn't have the luxury of using colour. ...

The Shootist (1976). Printed by W. E. Berry. Illustration by Roger Coleman, from a design by John Raymer. A really great portrait of John Wayne by Coleman, commissioned after Richard Amsel's original US campaign had flopped badly. (AC)

At Lonsdales, work was structured in a very different way to Downton's. Because the designers at the latter had many more films to deal with a year, they were freed from all other detail work, such as adapting to press ads, Front of House displays etc. The adaptation work was carried out by the in-house studio; Front of House display was put out to contractors by the client. The designers were required to submit many more designs for each film to the client, and all those designs were to a high degree of finish. Downton's clients were thoroughly spoilt. In contrast Jerry Lewis and Leslie Pound at Paramount would see fewer designs, but more importantly could understand an idea sometimes from a rough scribble.[142] Jerry Lewis was keen that the artwork for each film was done by a different artist, so as to create variety and individual identity. He would therefore ask to see specimens of the artist's work that we had in mind to commission. At Downton's the artwork was given to just a few artists. [...] In addition to designing the film publicity, at Lonsdales I was also responsible for designing the Front of House displays, and had scale plans of many West End cinemas to hand in my room, not to mention press-ad adaptations, premiere invitations, and so on.[143]

After twenty years at Greenly's/Lonsdales, Raymer felt ready for a change, and in 1975 accordingly shifted across to the competition:

Moving to Downton's, or Roe-Downton as it was then, proved to be something of a culture-shock for me. The pace of work in trying to produce highly finished designs for a greater number of films, and not having the relief of working on other types of account, was difficult at first [...] As film work lessened in the 1980s, so the work on video covers came about, though here there was less creative input, and rather more adaptation from designs originated for the film publicity. Colin Holloway came into his own at this point. He not only became an account executive dealing with Columbia and Fox, but was a past-master at organising an economic workflow of video covers through the agency. He also had the ability to design those covers at great speed – I could do 2¼ per hour, but he could regularly produce 3 in the same time!

John Raymer at his desk at Lonsdales in 1965, a couple of years before he began working on the Paramount account. (Courtesy of John Raymer)

Some examples of Raymer's poster designs while at Downton's include *Game for Vultures* (1979), *The Far Pavilions* (1984) and *Nothing in Common* (1986), all with artwork by Brian Bysouth. He retired in 1993 (the same year that Colin Holloway left to set up his own company) and now paints local scenes, which are often later exhibited and sold in galleries around his native Surrey.

The list of illustrators Raymer used while at Lonsdales would be lengthy and varied, containing several one-offs, but there is a connecting thread that joins the four main contributors: the Artist Partners agency. Artist Partners was formed in 1950 by Donovan Candler, in collaboration with Denis Rix, Betty Luton White, John Barker and the designer Reg Mount. Candler had previously worked for Tudor Arts, another popular London artists' agency, and when he initially opened AP's offices on Lower John Street in Soho, he took many of his old contacts with him. Within three years the agency had about fifty artists, designers and photographers on its books, including names like Tom Eckersley and Hans Unger, and had moved to occupy three floors of an office block

on Dover Street. Throughout the 1960s, other major international figures joined up including Saul Bass and Feliks Topolski. During the property boom at the end of the decade, the Dover Street building was sold, and AP relocated to 14–18 Ham Yard, where they are still based today, now managed by Christine Isteed. The four main artists at AP who freelanced for Lonsdales were Roger Coleman, Brian Sanders, Cecil Vieweg and Michael Leonard, and each can be briefly discussed in turn.

Roger Coleman, now one of this country's most distinguished portraitists, was born in South Wigston, Leicestershire, in 1930. He studied painting at Leicester College of Art between 1948 and 1951, and in 1952 (while doing his National Service with the Royal Marines) won a national portrait painting competition. He then spent four years studying at the Royal College of Art, editing the college journal *Ark*, and later joined the editorial staff of *Design* magazine, writing and broadcasting about art while also organising various exhibitions. In 1959, he returned to painting, while also starting to do illustrations (principally for news magazines). The following year, John Barker of Artist Partners took him on after seeing one of his specimen illustrations. Coleman thinks his first film poster was *Is Paris Burning?* (1965), which he followed up with about a dozen or so others over the next fifteen years, including *Catch 22* (1970) and *Bad News Bears* (1976). He also did some designs for Kubrick's *2001* (as did another AP designer Tom Adams, a backdrop artist who actually worked on the production), and was later put on a retainer by Corgi, illustrating their bookjackets. His most famous poster is undoubtedly Don Siegel's *The Shootist* (1976), commissioned because the original American campaign, using an art nouveau design by Richard Amsel, had failed to prevent the film flopping in the USA. Coleman's enormous and brilliantly executed portrait of John Wayne's dying gunfighter was an immediate hit. He took six days to complete the artwork for the poster, and

Oh! What a Lovely War (1969). Printed by Lonsdale & Bartholomew. Illustration by Brian Sanders, from a design by John Billingham. A clever and appealing spoof of the classic Kitchener call-up poster. (AC)

It's hilarious when Woody Allen tries to play it like Bogart!

"Dames are simple. I never did see one that didn't understand a slap in the mouth."

Paramount Pictures presents
An Arthur P. Jacobs Production
in association with Rollins–Joffe Productions
PLAY IT AGAIN, SAM AA
A Herbert Ross Film
Starring
WOODY ALLEN DIANE KEATON TONY ROBERTS
JERRY LACY and SUSAN ANSPACH Co-starring JENNIFER SALT and VIVA as Jennifer
Screenplay by WOODY ALLEN Produced by ARTHUR P.JACOBS Directed by HERBERT ROSS Executive Producer CHARLES H.JOFFE
Based on the play by WOODY ALLEN Produced on the New York Stage by David Merrick Music scored by Billy Goldenberg An APJAC Production
TECHNICOLOR A Paramount Picture

Play It Again Sam (1972). Printed by Lonsdale & Bartholomew. Illustration by Cecil Vieweg, from a design by John Raymer. Vieweg's monochrome pencil work is here ideally suited to Woody Allen's affectionate homage to Bogart. (AC)

the result is one of the most powerful and iconic quads of the decade.[144]

Brian Sanders shared studio space at Ham Yard with Coleman in the 1970s. Born in London in 1937, Sanders studied at Sir John Cass College of Art, and did his National Service in the Royal Marines touring the Mediterranean and Middle East, which provided plenty of opportunity for interesting scenic painting. In 1960, he began his career as a freelance illustrator, initially working with Adrian Flowers, a photographer with Artist Partners. He received plenty of magazine work as well as book covers for Penguin and others. His first film poster was possibly *Oh! What a Lovely War* in acrylics (at the time he was mostly working in watercolours), followed by around fifteen other titles, including *Paint Your Wagon* (1969), *Darling Lili* (1969), *Lady Sings the Blues* (1972) and *Yanks* (1979). The latter was not used in the end, and, in common with a lot of the other freelance artists, Sanders is sometimes uncertain which of his designs were actually printed. He also worked on

2001 (1968), officially recording the shooting rather in the manner of a courtroom sketch artist, as Kubrick would not allow any photographers on the set. This led to the director offering him the opportunity to do the quad. Kubrick had the idea of an illustration depicting 'an audience looking at the Crab Nebula on a screen', presumably to reinforce the notion of his epic as a family film. When Sanders suggested that there were dozens of better images that could be taken from the film itself, Kubrick curtly withdrew the offer. Sanders's last two posters seem to have been *The Whales of August* (1987) and *A Month in the Country* (1987). He is now probably best known for his postage stamp designs.[145]

Cecil Vieweg thinks he probably completed fewer posters than either Coleman or Sanders – no more than six or seven of his works were printed. Born in 1941 in Johannesburg, Vieweg initially worked for a South African agency as a creative director, but wanted to get into illustration. This meant leaving and trying his luck elsewhere. He

The Day of the Jackal (1973). Printed by Lonsdale & Bartholomew. Illustration by Michael Leonard from a design by Graham Walking. A particularly powerful design for this suspenseful hitman thriller. (AC)

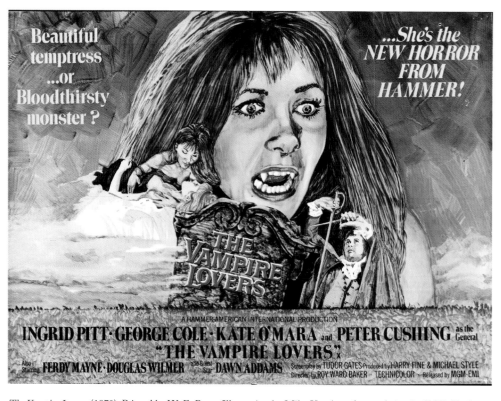

The Vampire Lovers (1970). Printed by W. E. Berry. Illustration by Mike Vaughan, from a design by Eddie Paul. Nude lesbian vampires on the rampage. Every fourteen-year-old boy's favourite film. (AC)

arrived in London in 1968, where he was immediately taken on by Artist Partners. Vieweg moved quickly into film work, though a lot of his output seems to have been visualising only. He worked with Lindsay Anderson, producing designs for *If …* (1968) and its sequel, *Oh, Lucky Man!* (1973), and produced a finished illustration for *The Molly Maguires* (1970), with Richard Harris and Sean Connery (though he thinks Brian Sanders's painting may have been used instead). Illustrations of his that were definitely printed, all from designs by John Raymer, include *The Legend of Nigger Charlie* (1972), a black Western starring Fred Williamson; *Play It Again Sam* (1972), possibly the best-ever Woody Allen poster, with terrific monochrome portraits of Allen and Diane Keaton; and *The Eagle Has Landed*, which he thinks was probably his last piece of film work.[146]

Michael Leonard, the last of the four AP illustrators to have worked regularly on film posters, has had perhaps the most distinguished career of all. Born in Bangalore, India, in 1933, Leonard studied at St Martin's School of Art between 1954 and 1957, then worked as an illustrator, joining Artist Partners at the end of the 1950s. He first exhibited as a painter in 1972, and has had one-man shows in London and New York, receiving a commission to paint a portrait of the Queen in 1986 for her sixtieth birthday. Examples of his work are in both the Victoria and Albert Museum and the National Portrait Gallery, and several monographs have been written about him by critics Lincoln Kirstein and Edward Lucie-Smith. However, he was not above taking on film poster work. His quads include: *On a Clear Day You Can See Forever* (1970) with Barbra Streisand, and a powerful design for *The Day of the Jackal* (1973), featuring a portrait of De Gaulle reflected in assassin Edward Fox's pupil. Other AP artists who worked on film posters include Ann Meisel (*The Front Page*, 1974), Stuart Bodek (*The Incredible Sarah*, 1976), Brian Froud (*The Dark Crystal*, 1982) and Alan Lee (*The Company of Wolves*, 1984).[147]

Another popular freelance illustrator of the 1970s, responsible for several well-known quads of the period, is Mike Vaughan. Born in Weston-super-Marc in 1940, his father was apparently an engineer manufacturing dental appliances, and his son never attended art school, being completely self-taught. Vaughan joined a London agency when he was about sixteen as a teaboy, and slowly

worked his way up through the ranks, learning his trade by constantly observing the other artists around him. In the 1960s, he worked on some prestigious accounts like British Airways, British Steel and American Express, and also did plenty of bookjacket illustration, including children's annual covers.[148]

Vaughan had a distinctive style, quite loose and often employing big splashy backgrounds similar to Arnaldo Putzu's work, but with a much heavier use of outline – his original pencil marks underneath the paint are occasionally still visible. His poster work seems to have begun at the end of the 1960s, mostly for EMI, and includes several late Hammer Horrors: *The Vampire Lovers*, *Lust for a Vampire*, *Scars of Dracula/Horror of Frankenstein* (1971) and *Blood from the Mummy's Tomb*. He also painted *The Deserter* (1970) for Paramount and a few others. One of his last posters seems to have been the *Thief of Bagdad* clone *Arabian Adventure* (1979) – it was a sign of the times that the best tagline review EMI could provide was *Variety*'s 'Star Wars with flying carpets!'. Vaughan abandoned commercial work at the end of the 1980s to move into highly finished fine art subjects, sold through prestigious London galleries, including Nancy Attwood's Essential Art in Harefield. He specialised in dramatic scenes of racing yachts, but also painted other sporting events like golf and motor racing, plus wildlife portraits. These included some powerful studies of big cats, several of which became very popular as prints. Attwood recalls him as 'a thoroughly nice guy, very easy to work with and with a terrific sense of humour', but extremely outspoken: 'he always said exactly what he thought about things – definitely shot straight from the hip'. Sadly, Mike Vaughan died suddenly in July 2003 from a blood clot on the brain, a cruelly premature end to a versatile talent that was clearly still evolving.

Another freelance whose career followed a strikingly similar path is no-nonsense illustrator Mike Francis. Born in Mitcham, Surrey, in May 1938, son of a proofreader, Francis was already showing some promise as an artist by the time he left school at fifteen. An art teacher suggested a scholarship at Sutton, but with his father reluctant to contribute to the fees, Francis instead became a porter at Covent Garden for a few months. However, when a friend landed a job as a studio junior, Francis felt encouraged to try to do the

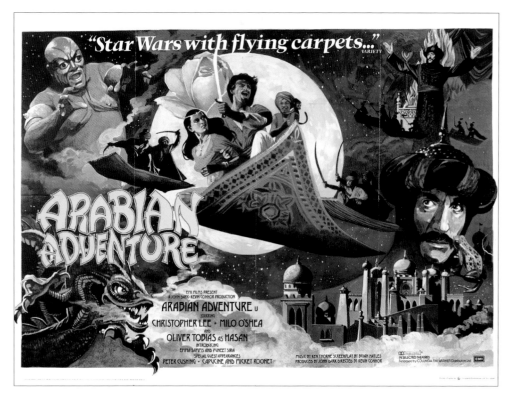

Arabian Adventure (1979). Printed by Lonsdale & Bartholomew. Illustration by Mike Vaughan, from a design by Eddie Paul. Another interesting example of what might be described as Vaughan's deliberately naive style, on this rather half-baked British fantasy. (AC)

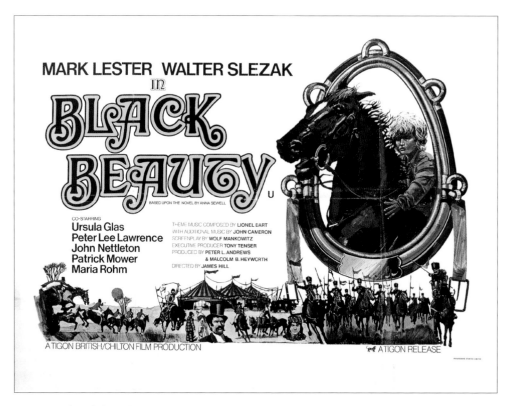

Black Beauty (1971). Printed by Progressive Publicity. Design and illustration by Mike Francis. Francis's first film poster, for Tony Tenser's lively children's adaptation. (AC)

same, and was taken on by Rome Studios in Soho, one of the four big London commercial art outfits (the others were Hawke, Gilchrists and Fleet Advertising). The studio was run by 'Miss Rome' (actually Romanovsky), 'a Russian naturalised-American lady with famously individual dress-sense, who used to wear this incredible ginger wig and a Robin Hood hat complete with a feather – a real character!'[149] It employed about thirty artists, perhaps a quarter of whom were women, including specialists in figure work, still life, car illustration, lettering and so on. The major long-term contracts were car manufacturers like Morris and Ford, plus washing powders brands like Persil and Daz.

Francis started out as a messenger boy on £2.50 a week, and, after a while, was given small illustration jobs. Just as he was beginning to find his feet, however, he was called up for National Service in the Royal Army Ordnance Corps at Blackdown, spending part of his time there in the glasshouse: 'Well I was quite a drinker in those days …'. Eventually, in 1958, he was discharged and went straight back to Rome Studios, to a welcome raise of £4 a week. Francis stayed with Rome for the next twelve years, soon getting his own desk and beginning to do car advertising and still-life work for products like Rowntree's Kit-Kat. However, following the death of Miss Rome, the studio set-up began to deteriorate. Finally, in 1970, Francis left to join Illustrators of London on Great Marlborough Street, a group run by Ivan Rose, an artist with some earlier experience in film work, 'who taught me a hell of a lot'. At the same point, Francis was introduced to Tony Tenser, who began to supply him with regular film work for Tigon, beginning with the quad for *Black Beauty* in April 1971. He also recalls producing posters for Hammer and other independent companies, often painting two-colour double crowns for the Underground. He rarely signed his work – 'we were told not to' – though his signature is on *King Elephant* (1971), a wildlife documentary that was quite a success. He and Rose left Illustrators of London in 1973 to help set up a commercial studio/illustration unit for a photographic company called Hatton, while still turning out various film work for Warners ('very finicky') and MGM, via their art buyer Elizabeth Hesketh. This period lasted for about eighteen months, until in 1974 Francis won the National Gallery's 150th Anniversary Award, and with the

Mike Francis in 1973, a couple of years into his film career. (Courtesy of Mike Francis)

prize money under his belt decided to go freelance and work from home.

He estimates that he averaged a couple of film posters a year, less than 15 per cent of his overall output, though he also did a lot of video covers in the 1980s, principally for CIC.[150] Some of Francis's later quads came via Downton's – Colin Holloway, John Raymer, Vic Fair and Brian Bysouth all gave him work at one time or another. Many of his better-known titles date from late in his film career, including *The Terminator* (1984 – a famously iconic design), *American Dreamers* (1984), *The Karate Kid* (1984), *Not Quite Jerusalem* (1985) and *The Holcroft Covenant* (1985). There were a few later quads and video covers, but, by about 1990, film illustration work had dried up completely. Since the mid-1960s, Francis has also been painting highly finished photorealist work in the American style for exhibition around various high-profile London galleries, and recently this side of his career has taken off properly, with his work being bought by celebrities including Jerry Hall, Bob Monkhouse and Robbie Williams.

Ivan Rose, Francis's acknowledged mentor, was born in Wembley in September 1935, the son of a hairdresser. He attended Ealing Art

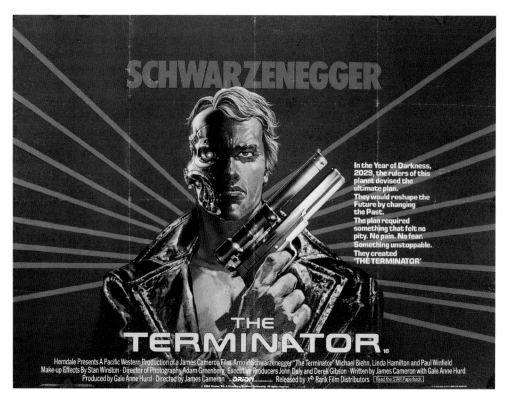

The Terminator (1984). Printed by W. E. Berry. Design and illustration by Mike Francis. One of the artist's last poster assignments and easily his best remembered, with an iconic portrait of Schwarzenegger's robotic assassin. (AC)

Goldengirl (1979). No printer credited. Design and illustration by Ivan Rose. A really excellent series of portraits on this now long-forgotten sporting melodrama. (AC)

School, leaving at fifteen to work briefly for a model-makers in Hammersmith, then later a photographic studio. He gained an apprenticeship with Rank Screen Services in 1951, doing photorealist illustration for subjects like restaurant interiors, and, at one point, even got involved with one of Rank's occasional flings with cartoon animation. However, he was sacked at the age of twenty-two for being 'a disturbing influence on the other working staff', an irreverent anti-authoritarianism that meant he gained and lost various other studio jobs over the next four years. He eventually went freelance in 1962 to specialise in magazine illustration.[151] Rose's film work began in the 1970s following the formation of Illustrators of London, though his output was only intermittent, perhaps only ten quads in total. Titles he recalls date from the end of the decade: *The Wanderers* (1979), *The Onion Field* (1979) and *Goldengirl* (1979). Since the 1980s, he has worked mainly in storyboarding and animatics, with the odd commercial poster.

One mysterious freelance who has resisted all attempts to track him down is John Payne. His unique jagged monogram appears on dozens of quads from the 1960s, principally for the independent distributors Gala and Compton. Gala was set up in 1958 by Kenneth Rive (1918–2002) to distribute mostly erotic foreign-language films to the arthouses, and Payne was the company's 'house artist'. His distinctive, almost Italian-style illustrations featured on titles as diverse as *Adolescents* (1960), *Vice and Virtue* (1962), *Four Kinds of Love* (1965) and *Night Games* (1966), as well as fantasy epics like *Goliath and the Vampires* (1964). Rive also ventured into production in the mid-1960s, with offbeat horror items like Lindsay Schonteff's *Devil Doll* (1964), a reworking of the 'haunted ventriloquist's dummy' theme, for which Payne contributed a strikingly nightmarish surrealist design. The artist also seems to have worked for even smaller distributors, for example Archway Films' *Death Comes from Outer Space* (1961).

Goliath and the Vampires (1964). No printer credited, but probably Broomhead Litho. Illustration by John Payne, adapting US campaign artwork by Reynold Brown. A madcap Italian peplum/horror, Payne still obviously liked this enough to sign it. (AC)

Payne's other principal employer was Tony Tenser (b. 1920). Tenser recalls Payne as being several years older than himself, a quiet man who lived in Northampton, about an hour's commute from London. Tenser joined Miracle Films as a publicist in 1955. Like Gala, Miracle specialised in importing 'continental' films. They handled the early Bardot titles – Tenser came up with the infamous 'Sex Kitten' tag – and he thinks Payne did the quads for *Light across the Street* (1955) as well as *And God Created Woman* (1956), the first two released in this country. Tenser went on to set up Compton distributors with Michael Klinger at the end of the 1950s, and soon got into production himself, beginning with nudist quickies like *Naked as Nature Intended* (1961). He continued to use Payne for many of his posters, meeting the artist regularly in Soho to discuss design ideas, until he broke with Klinger in 1966 to set up his own company, Tigon Films.[152] Payne seems to have dropped out of sight in the 1970s, though he may have simply given up signing his

work. He remains one of the more frustratingly elusive figures in this book.

The last of our illustrators from the classic period of poster design is much more of a known quantity: Sam Peffer. Sam has frequently spoken about his work, and has also written a full (as yet unpublished) autobiography. Though he only rarely signed his own posters, along with Tom Chantrell he dominated the exploitation side of film publicity in this country over the 1970s, painting at least 200 quads. Samuel John Peffer (he acquired the nickname 'Peff' in the Navy, and afterwards signed his better work with it) was born in Islington in November 1921. He left school at thirteen, already showing clear artistic ability. His father was an interior decorator, and, via a friend, got Sam a job with Leon Goodman Displays on Fonthill Road, Finsbury Park. Goodmans built cinema front-of-house displays, and Peffer initially painted their previously used artboards in flat colours to prepare them for the next display by the firm's artists, in between being a 'teaboy,

Devil Doll (1964). No printer credited. Design and illustration by John Payne. A really striking surreal illustration for this offbeat British fantasy. (AC)

messenger, and general runabout'. He worked six days a week for 7/- take-home pay. After six months, an opportunity came up at Weddell Brothers on Upper Hornsey Road, paying 12/6 a week. Weddells was a poster writers and silkscreen printers, working for the film business, and Peffer was initially employed there as a letterer, alongside one solitary artist named Doug Brigdall. When Brigdall left for military service in 1940, Sam replaced him and started painting Hollywood stars for a living, instead of merely as a hobby.[153]

In 1942, Peffer was called up and joined the Navy, taking part in the Malta Convoys and the famous 'Operation Pedestal', later surviving the sinking of his ship. Following demob in January 1946, he worked for a short while in an office on Chancery Lane designing press ads, then moved on to Hope Advertising on Charing Cross Road, another firm designing film posters. Here, however, he was forced back into lettering, as illustration was the sole preserve of the company's only artist,

a man in his late fifties called Richardson. So Peffer applied for a job with another cinema displays firm, De Frene Advertising, based in Burleigh Mews, off Riding House Street. John De Frene told him to paint a portrait of Deanna Durbin on a large board, liked the result and hired him. The panel became one of four displayed outside the Tivoli cinema on the Strand, advertising Durbin's latest film, and Peffer recalls De Frenes as a 'very happy, free and easy company' to work for. He married his longtime sweetheart, Kitty, in January 1949, and for a while things went well, as he painted display panels for cinemas like the Warner West End, Carlton Haymarket, Rialto on Coventry Street and the London Pavilion. However, De Frenes suddenly lost a vital contract, and the boss suggested cuts in salary to tide the company over. Newly married, Peffer simply could not afford this and moved on again, this time to Theatre Publicity, a company on Finchley Road that produced advertising slides for cinema projection, mostly requiring stock illustrations. This lasted

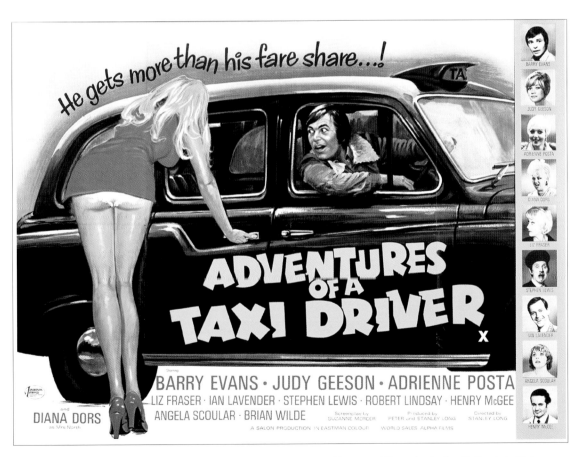

Adventures of a Taxi Driver (1976). No printer credited, but probably Bovince. Design and illustration by Sam Peffer. A sizable box-office hit at the time, this spawned two equally dire sequels, the quads for which were both illustrated by cartoonist Brian Forbes. (AC)

for a couple of years, and Peffer was successful enough to later join new firm Pearl & Dean in the same capacity.

After two years with Pearl & Dean, Peffer went freelance, signing up with Don Candler at Artist Partners, and moving into paperback cover illustration. Between 1955 and 1967, he worked for all the main publishing houses – Arrow, Pan, Panther, Corgi, Digit, Compact and others – painting hundreds of covers, famously including early editions of the Bond paperbacks *Casino Royale*, *Moonraker*, *From Russia with Love* and *Dr No*, for about £40 each. By the end of the 1960s, though, this illustration market had effectively dried up, thanks to the prevalence of photography and the overuse of cheap imported artwork from Italy and America.[154] Luckily, in September 1971, Peffer received a phone call from Roger Hall, with whom he worked at Design Bureau, illustrating all-colour paperbacks for Hamlyn. Hall was too busy to do a quad poster for Geoff Wright, who ran a film publicity studio in Soho, and had instead put

Sam's name forward for the job – a horror double bill for continental shockers *Creatures of Evil/Blood Devils*, released that October. So began a busy thirteen-year period in which Peffer illustrated around 200 posters, and a similar number of later video sleeves. In September 1972, Wright proposed that Sam should become his full-time studio manager, and, after almost eighteen years freelancing, he accepted, working alongside Wright's associate Alan Wheatley from various offices around W1. The studio employed several junior artists on and off, including (briefly) Ken Paul and the cartoonist Tommy Knox, who was apparently only sixteen when he provided the Mexican caricatures on Sam's *Eskimo Nell* (1974). Wright eventually retired towards the end of 1976, and Peffer was freelance once again, still working principally for Wheatley, plus Graffiti Productions as video began to take off.

A list of Peffer's poster artwork 1971 to 1984 takes in every possible exploitation genre of the period: kung fu, horror, sci-fi, war, action thrillers,

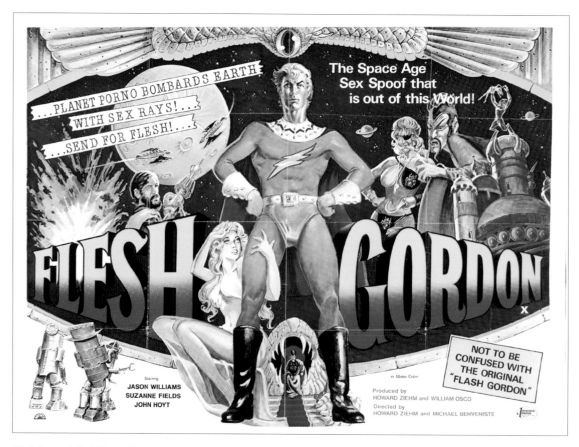

Flesh Gordon (1974). Printed by Broomhead Litho. Design and illustration by Sam Peffer. A hilarious over-the-top montage for this witless sci-fi spoof, a big hit of the period that featured the unlikely pairing of fine stop-motion effects work with hastily cut-down hardcore sex scenes. (AC)

teen romantic comedies and even a few children's films. However, sex predominates, and Sam readily admits that he 'became noted as a painter for the raincoat brigade'. Titles include: *Adventures of a Taxi Driver* (1976), *The Amorous Milkman* (1974), *Flesh Gordon* (1974), *Hussy* (1979), *Jungle Burger* (1980), *Lemon Popsicle* (1977), *Let's Get Laid* (1977), *The Legend of Bruce Lee* (1976), *The Other Cinderella* (1977), *Roar* (1982), *Shogun Assassin* (1981), *Smurfs and the Magic Flute* (1979) and *Ups and Downs of a Handyman* (1975). For most of these he was paid around £60. In contrast, simple paste-ups were about £15 each. He did layouts in magic marker, and his finished art in gouache on 15" x 20" artboard, turning out about two posters a month. By the early 1980s, his fees had risen, and quads were paying about £100–120 each, but work was rapidly thinning out. In his own words:

A change in my world of art was starting, and I was not getting so many commissions for posters. Just as illustrated paperbacks back in the late 1960s had been replaced by colour photography, a similar pattern was emerging, and the illustrated film poster was being replaced with photographic stills. Distributors were cutting costs – it was cheaper to produce a film poster using the stills than pay an artist to design one … inevitably, within a short space of time, my supply of work from Alan [Wheatley] dried up completely. Additionally, as the months progressed, I began to get less work from Graffiti until, as with Alan, there was no further artwork being supplied by them either. They had my final invoice, written on October 31st 1985, and probably received it on my sixty-fourth birthday, November 3rd. I then concluded my career as a freelance artist and retired – I had no regrets, and had achieved my boyhood dreams.

Peffer's last quad, according to his old job book, was *Desires of a Nymphomaniac*, from October 1984, which paid £105. He now lives quietly with Kitty in the north London house that they bought together in 1964, the front bedroom/studio where he painted all his posters still much as it was in the 1970s.

The only formal training Sam Peffer ever received were a few evening classes at Hornsey School of Art following his demob in 1946, when he was forced to choose between illustration and boxing for a career. Other than that, he is

Roger Hall (in the hat) and Sam Peffer take a break at a London Book fair in 2005. Between them they painted well over five hundred separate film posters and countless cinema display boards. (Courtesy of Sam Peffer)

the classic example of the old-style commercial artist who learned his trade on the job, having to develop his skills through continuous practice at work. However, the final two artists we shall consider in this section are part of an entirely different post-war generation of art-school graduates who actually *studied* illustration and graphic design academically, before using their skills in British film publicity just as the field was being finally taken over by computers: Marcus Silversides and Graham Humphreys.

Marcus Silversides was born in Hertford in 1957, and studied graphic design and illustration at Leicester Polytechnic from 1977 to 1978. Arriving in London in 1980, he was taken on by Downton's on Wardour Street, and trained by Vic Fair – he had no particular ambition to work in film publicity, it was simply the best job/salary he was offered at the time. Early posters he designed for the agency include *Back Roads* (1981) with Tommy Lee Jones, the submarine saga *Das Boot* (1981) and *Cutter's Way* (1981) with Jeff Bridges. In 1983, he moved over to Lonsdales for

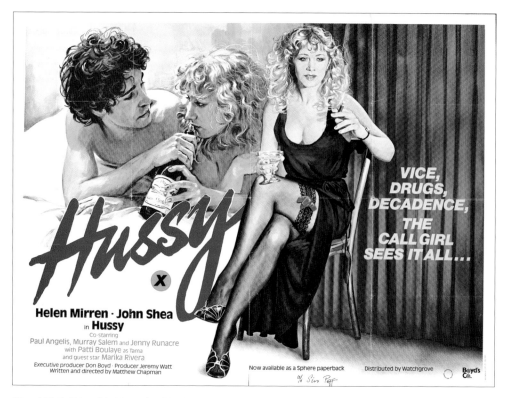

Hussy (1979). Printed by Broomhead Litho. Design and illustration by Sam Peffer. One of Peffer's best posters, with a fine portrait of call-girl Helen Mirren mixed up in Soho's gangland. (AC)

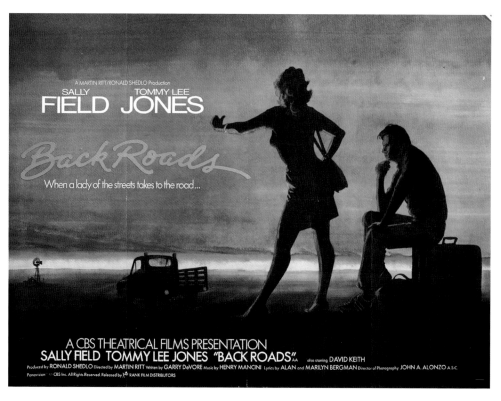

Back Roads (1981). No printer credited. Design and illustration by Marcus Silversides. An effectively moody illustration by Silversides, the first poster he 'got through' after joining Downton's about a year earlier. (AC)

Marcus Silversides in about 1990, in front of a couple of his earlier designs. He still works on film posters today, from a converted mill in Essex. (Courtesy of Marcus Silversides)

The Monster Club (1980). Printed by W. E. Berry. Design and illustration by Graham Humphreys. The artist's first film poster, painted quickly in just a day and a half, after his original version was rejected as 'too ghoulish'. (AC)

A very fresh-faced Graham Humphreys in 1982, just a couple of years into his commercial career. Like Silversides, he still works in film publicity today, and is perhaps the last great name in a long line of British poster artists. (Courtesy of Graham Humphreys)

three years, the period that really saw the end of illustration on a large scale. In 1986, he moved to Latimer Advertising, still doing film work, including Entertainment Distributors from 1987. He returned briefly to Downton's in 1993, by which time 'computers had completely taken over', then from 1995 went freelance as Redwire (basically himself plus an old colleague from Latimer), based in Harlow and working for Columbia and Entertainment. Silversides has thus employed various illustrators over the years, including Ralph Steadman, Graham Humphreys and Peter Mennim. Mennim (b. 1955) studied fine art at Reading University in the early 1970s, and produced about ten quads between c. 1988 and 1995, including *The Wolves of Willoughby Chase* (1988), *Slipstream* (1989), *Highlander II* (1990) and *The Crow* (1994); he now works as

a portraitist. Silversides's last big campaign at the time of writing was the *Lord of the Rings* sequel, *The Two Towers*, in 2002 – almost all straight adaptations of American designs, with the sole exception of one bus-side poster he designed himself on an Apple Mac.[155]

Illustrator Graham Humphreys was born in Gloucester in July 1960, and studied graphic design at Salisbury College of Art. He was keen to try his luck designing film posters, having spent his teenage years admiring disaster movie quads like *The Poseidon Adventure* (1972), *The Towering Inferno* (1974) and *The Hindenburg* (1975) outside his local cinema. Like Silversides, he arrived in London in 1980, but always worked as a freelance. His first quad was *The Monster Club* (1980), Milton Subotsky's attempt to do an Amicus compendium-horror for the family audience. Humphreys's initial (and preferred) attempt, a bluey-green design he spent two weeks on, was rejected as 'too ghoulish', and he was forced to quickly repaint it in a day and a half.[156] He tended to specialise in fantasy subjects, like Josh Kirby, reflecting his own personal taste. Perhaps his most famous design is a nightmarish green and red quad for *The Evil Dead* (1982), a very strong contender for the last truly classic British horror film poster.

Humphreys also produced an excellent midnight-blue illustration for the original *A Nightmare on Elm Street* (1984), and other early quads of his include: *The Funhouse/My Bloody Valentine* (1981), *Baby It's You* (1982), *Brother from Another Planet* (1984), *Creepers* (1984 – a double crown only, for the film's extremely limited London release), *Death Warmed Up* (1985) and *Kindred* (1987). His last hand-illustrated poster was Mike Leigh's *Life Is Sweet* (1990), and he now mostly works on a computer like everyone else – for instance, he 'put the blood-splats on *Reservoir Dogs* [1992]!'. In addition to his poster work, he has done storyboarding for the films *Hardware* (1990) and *Dust Devil* (1992), toy packaging for the BBC (for Dalek models), various record sleeves and some book illustration work. He is now with the Creative Partnership on Bateman Street, and has some claim to be the last great name among Britain's film poster artists.

Before leaving the artists, however, it will be instructive to consider one final name, as a cautionary tale that demonstrates just how difficult

it became for freelances to make a success of film work in the 1980s. Chris Achilleos is now widely recognised as one of the most talented and distinctive illustrators of his generation, but his adventures in the film side, nevertheless, mostly ended in frustration and disappointment. Achilleos was born in Famagusta, Cyprus, in 1947, but moved to England following the death of his father in 1960. He studied scientific and technical illustration at Hornsey School of Art during the late 1960s before leaving in 1970 to freelance. He quickly built up a reputation for bookjacket work, including his popular series of *Doctor Who* Target paperback covers from the mid-1970s, and then fantasy illustration. His film work really began to take off following a call from Julian Senior at Warners, who invited him to supply some conceptual layouts for *Greystoke* (1984). These were painted, but then quickly dropped in favour of a more urgent assignment – *Supergirl* (1984). Achilleos was commissioned to produce three big finished poster illustrations, but at the last minute the film's distribution changed hands, and the work went to Feref.

A proposed new design for *Bladerunner* (1982) similarly proved to be a dead end – Senior provided a very complex brief (don't emphasise the sci-fi angle, play down the film noir …), and Achilleos came up with three imaginative and highly finished layouts that both he and Senior were pleased with. However, these were all immediately rejected by the client, who quoted some previously undisclosed contractual requirements, and instead requested a standard star-portrait montage that made a nonsense of the original instructions. Ray Harryhausen personally commissioned an early poster artwork for *Clash of the Titans*, but this also sank without trace, as did a later design for *Twilight Zone* (1983). *Batman* (1989) was yet another high-profile job that ended in a legal wrangle, this time following a mix-up over more contractual agreements between the star, studio and commercial poster printers Athena, who had acquired an abortive licence on the artwork's reproduction.

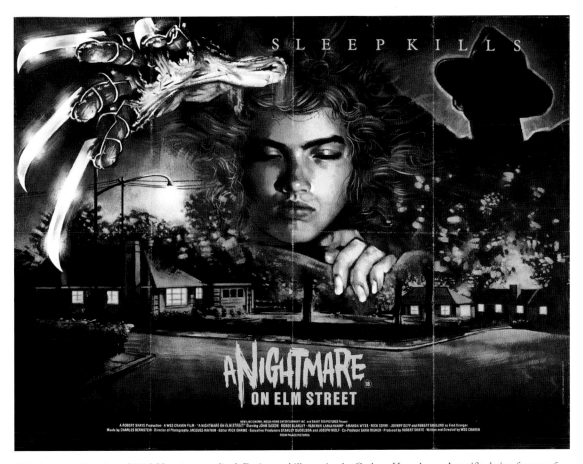

A Nightmare on Elm Street (1984) No printer credited. Design and illustration by Graham Humphreys. A terrific design for one of the more imaginative horror films of the 1980s. (AC)

However, some poster designs that Achilleos worked on did actually see the light of day. His paintings for the Eddie Kidd motorbike adventure *Riding High* (1979), animated sci-fi epic *Heavy Metal* (1981) and Jackie Chan actioner *The Protector* (1986) were all successfully printed as quads. If there are any further titles, though, Achilleos himself cannot recall them, and he instead emphasises the difficulties film work of the period presented, comparing it with another popular market – 12" LP record covers – that also vanished at much the same point. He is also dryly downbeat about the future of commercial artwork in general:

When my generation – the sixties art-school graduates – disappears, that'll be it for illustration. The youngsters coming out of the colleges these days can't even draw, let alone paint; they just spend hours playing on computers ruining their eyesight. They'll all need glasses by the time they're thirty!

We can examine some of the other factors that led to the decline of the illustrated tradition in more detail in the later section on DTP. Before that, though, we must return to the printing companies, beginning with a firm that practically became synonymous with the phrase 'British film poster': Stafford & Co. Ltd, of Netherfield, Nottingham.

Heavy Metal (1981). No printer credited. Design and illustration by Chris Achilleos. A typically stylish illustration for this popular animated fantasy, from an artist who unfortunately saw few of his designs finally printed. (AC)

CHAPTER 12

Printers (i): Stafford & Co. and W. E. Berry – A Virtual Duopoly

As we have seen, Stafford/Lonsdale of Nottingham were the biggest of Britain's film poster printers, being responsible for around 25 per cent of all the posters printed between 1910 and 1985. With the introduction of the landscape quad as the standard British size, Stafford and a handful of other printers, notably W. E. Berry of Bradford, effectively operated a monopoly in the field. By this time, the company had passed into the hands of its founders' sons, J. Stanley Stafford and Claude Stevenson, and the firm continued to be run as a family business.[157] In addition to the Forester Street works, Stafford also ran a London office, from various addresses in W1: Newman Street, Berners Street and Soho Square (the latter adjacent to the NSS office at No. 27). In November 1961, however, the company was acquired by another long-established northern printer/publisher, Lonsdale & Bartholomew, originally of Chapel Street, Bradford, who themselves dated from 1904.[158] For the sake of continuity, the 'Stafford' name was retained by the firm for the next five years until the last London office at 62 Oxford Street was closed. One of the very last posters to carry the familiar credit was Bill Wiggins's blockbusting quad for *Thunderbirds Are Go* in December 1966. From January 1967, 'Lonsdale & Bartholomew' began appearing in the posters' bottom right-hand corner. One of the earliest such quads was for the James Bond spoof *Casino Royale*, in February, featuring Robert McGinnis's psychedelic female figure on a plain white background. Such (comparative) minimalism would have seemed unthinkable on one of Stafford's bold quads with their radiant full-colour landscapes, and while the standard of printing remained excellent, the new printing technology of photo-offset was never really able to re-create the lush warmth of tone that characterised the older posters.

A major change occurred in litho printing not long after the war that transformed the way poster images were created. As we have seen, the vast majority of early British film posters employed the traditional technique of chromolithography ('hand-drawn litho'), in which craftsmen at the printing works simply copied an interpretation of the original design directly onto the printing plates, using a highly trained eye only to make the necessary colour separations. The development of so-called 'photo-mechanics' gradually revolutionised lithographic printing, however, allowing the unmediated work of the poster artist to be seen for the first time. Photolithography actually has its origins in the 19th century, while the first machine for offset-litho printing was developed as early as 1906. But problems with large scale production, and the unstable chemical coatings needed for the printing plates, meant that its widespread adoption for cinema posters had to wait until the introduction of diazonium-resin coatings in the early 1950s.[159] The first photolithographed British film posters began to appear around 1954, and, by the end of the decade, basic 'four-colour photo-offset' had become the accepted industry standard. No major lithographer's shop was complete without a custom-built, rail-mounted process camera, fitted with the necessary halftone screens and colour filters to produce large-format films.

Two later developments speeded up production still further. The first four-colour 'drum scanners' began to appear around 1968, electronically creating the colour separations without the need for a process camera, while at about the same point (following the advent of quick-drying inks), large four-colour presses were developed that could apply all the colours in a single 'pass' through one machine.[160] With 'direct', each of the inks had to

Painted Boats (1945). Printed by Stafford. Design and illustration by John Piper. A typically subdued but memorable Ealing poster. (BFI)

The Chinese Cat (1944). Printed by Stafford. Design and illustration by Clifford Rowe (1904–89). Another of Ealing's Charlie Chan imports. Rowe, along with James Fitton and James Boswell, was a founder member of the left-wing Artists International Association in 1933. (BFI)

bc applied separately, on four different machines, and time had to be allowed for each poster to dry before going on to the next press in the sequence. The production time of a typical run of several thousand posters using a four-colour offset press was thus cut from a couple of days to about three or four hours.[161]

The gains in efficiency ensured by offset-litho technology helped to keep Lonsdale & Bartholomew (under managing director Harry Downing and his works manager Henry Binch) profitable through the remainder of the 1960s and early 1970s.[162] With the arrival of NSS, and corresponding demise of many of their smaller competitors, a virtual duopoly with W. E. Berry was soon established. However, the continual closure of cinemas across Britain gradually reduced print runs, until profit margins were minimised and business became very slow. By the early 1980s, L&B had practically abandoned film posters altogether. Two of their later old-style quads were

for the medieval fantasies *Sword and the Sorcerer* (1982) and *The Beastmaster*, both featuring outrageously camp artwork in delirious swirling colours by Brian Bysouth and Josh Kirby, respectively. One of the firm's very last posters was for the Stephen King werewolf thriller, *Silver Bullet*, released in September 1986, with a memorable Vic Fair layout. By this stage, though, the company was in serious financial difficulty. In May 1987, a management buyout saw the ailing firm change hands for a nominal £3. With a name change to the snappier Lonsdales Ltd, the new managing director, Keith Townsend, attempted to diversify into the greetings-card market, investing in new equipment and increasing the workforce. This expansion was partly financed by the sale of the Netherfield site to Gedling Council for redevelopment. In Autumn 1989, the company relocated to Poulton Drive in Sneinton, Nottingham.

The disastrous consequences of this over-expansion, in an already overcrowded industry,

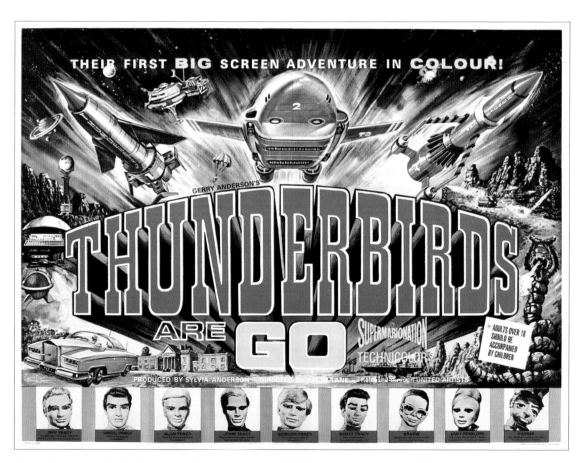

Thunderbirds Are Go (1966). Printed by Stafford. Illustration by Bill Wiggins, from a design by Eddie Paul. One of the last quads to feature the original Stafford credit. From 1967 they began to carry the name of the takeover firm's original partners, Havelock Lonsdale and Walter Bartholomew. (AC)

Eagles Wing (1979). Printed by Lonsdale & Bartholomew. Design and illustration by Vic Fair. A haunting design by Fair for this rather obscure British/American Western. (AC)

became apparent a year later, when the receivers were called in to Poulton Drive. Lonsdales was quickly picked up by the Scottish stationery chain John Menzies, who sold off the company's remaining assets before finally dissolving the firm altogether in January 1995, on the 150th anniversary of Stafford's original founding. A retired senior manager of Menzies purchased the entire contents of Forester Street's stockrooms on the eve of the original works' demolition in 1991. This included theatre, pantomime and opera posters dating back to the turn of the century. The majority of this unique collection was sold on, piecemeal, to America, over the remainder of the decade. The Forester Street works was finally demolished in 1992, and replaced with a couple of small housing developments. The only indication left today of the site's colourful history is hidden in the names of the new cul-de-sac and modest block of flats that now stand on the plot: 'Caxton Close' and 'Staffords Court'.

The other big name in post-war poster printing, W. E. Berry Ltd, was ultimately no luckier than Lonsdales, despite a cannier attempt to move with the times when posters became unprofitable. We saw in Part One that Berrys printed most, and distributed all, of Paramount's posters, and they continued to do this up until the involvement of NSS in the 1960s. By the end of the war, the firm had passed on to William Edward's son, William Albert. Unfortunately, William Albert's stewardship of the company was not a very successful period – according to Peter Lee, the new boss did not inherit his father's expansive business acumen, and was more interested in becoming a 'local figure' than being a forward-looking manager.[163] William Albert accordingly purchased no new printing equipment for almost twenty years, and by the early 1960s the firm was beginning to struggle.

Luckily, in addition to his son, William Edward had also had a daughter, Violet, who later married a local boy named Fred Lee. Fred and Violet had

The Sword and the Sorcerer (1982). Printed by Lonsdale & Bartholomew. Design and illustration by Brian Bysouth. A poster so camp you can practically pitch a tent on it. The hero's exploding underpants are a particular delight. (AC)

a son themselves, Edward Lee, who eventually worked alongside William Albert at Berrys in the 1950s, becoming increasingly frustrated at the chronic under-investment and indifferent leadership. Finally, in an effort to save the ailing family business, Edward stepped in with an offer to buy the company outright in 1964. In order to do this, he had to remortgage his house to raise the necessary cash, and the stresses involved in this probably contributed to his death only eighteen months later in 1966. The newly purchased company, therefore, passed down to Edward's son, Peter Lee, then aged only twenty-three, who immediately took up the reins, and remained Berry's managing director for the rest of the firm's life.

Like their rival, Stafford, W. E. Berry had gone over to offset printing in the late 1950s, though direct was still used for a while on the big 24-sheet hoarding posters, which were produced up to the late 1970s. For the old direct process, the poster artwork would be sent up by train from London

to Bradford, and the key craftsmen at Nesfield Street would then hand-draw an interpretation of this directly onto the zinc printing plate, as Peter Lee has explained:

> They had what you'd call the 'black man', he was the key craftsman, he drew the key plate for the black printer, and again pulled an impression from that, and the 'colour men' rubbed the impression down onto the old plates and drew the colours to the black. The apprentices always started on yellows, as that was the least important colour, yellows and flesh colours.[164]

The next vital stage was to get the first impression safely off the black plate:

> Some of the artists had different tricks with this – one chap used to hold lighted rolls of paper just under the metal, as he reckoned the heat melted the crayon into the grain just that little bit more. Mind you, if it didn't fix it was heart-attacks

Wild Beauty (1946). Printed by W. E. Berry. Designer unknown, but possibly Eric Pulford. A really gorgeous hand-drawn litho, which actually carries a credit for its 'Nesfield Printing Works'. (AC)

It's Not Cricket (1949). Printed by W. E. Berry. Designed by Eric Pulford. You can't get much more English than this hand-drawn litho of an archetypal village cricket match. (AC)

all round, because sometimes the entire design could be worn off the plate in the first two revolutions, and that was a couple of days' work down the drain![165]

Solid tones, including letters, were painted directly onto the plate with a waxy ink. A greasy crayon was then used to draw on the halftones, their strength controlled by the density of the crayon. Acid mixed with gum arabic was afterwards applied to the plate and then rinsed off, to leave the parts treated with ink and crayon standing out in isolation, forming the printing plate onto which the printing ink would be rolled by the machines. The posters were then printed in a colour sequence on four ancient (pre-1914) Furnival 60" x 40" machines placed in a line, which survived into the 1960s. The quads were printed on a pair of old George Mann two-colour presses, which remained in use until the end of the 1970s. The change to photolithography was quite gradual during the late 1950s:

> We had a sort of 'halfway house' for quite a while, where the black plate would be photographic, but the colours still hand-drawn from that. The litho-artist craftsman side I suppose ended altogether sometime around the early sixties, but it was a long time before photolitho could really match the smoothness of the old chalk-work.[166]

Offset printing naturally speeded up this whole process, particularly when electronic scanning was introduced in 1977:

> We used to scan down on very small sizes and very fine dots, and project as you would for the big hoarding posters. Quads were originally always done at same size. The only thing was, we were now printing on a four colour press, all in one pass. […] The tragedy was we'd never been more capable of churning the things out fast, and there was hardly any business left.[167]

At the time that Peter Lee took over at W. E. Berry, the NSS was consolidating its hold over the country's film publicity production and distribution. This actually operated to the firm's advantage, as NSS favoured using the bigger printers for speed and efficiency, and much of the work was shared out between Lonsdales and Berrys over the 1970s. Prior to NSS's involvement, the

Carry On Up the Khyber (1968) Printed by W. E. Berry. Illustration by Renato Fratini, from a design by Eric Pulford. This international one-sheet plays down the caricatures, which may have been less familiar overseas, in favour of all-purpose comic action. (AC)

agency Berrys had most contact with was Downton's, which naturally influenced the studios for which the company printed. W. E. Berry printed most of Rank's overseas posters, as well as those for Paramount, Disney and Columbia. Peter Lee also enjoyed good working relationships with the key men at NSS – the old managing director, Russ Cradick, and the later heads of its print buying department, Ian Hedger and Brian McIlmail, all of whom eventually became friends rather than mere business acquaintances.

However, the long-term problem with the film poster market, as Lee quickly recognised, was that there was fundamentally no prospect for growth. As early as 1972, he had bought Berry's first small four-colour sheet-printer, reasoning that commercial printing, for leaflets and brochures etc., was the long-term way forward. The firm's commercial work increased steadily through the 1970s, until by the end of the decade Lee was ready

The Way of the Dragon (1972). Printed by W. E. Berry. Design and illustration by Sam Peffer. Perhaps the best film of Bruce Lee's short but influential career, and his last to be released in the UK, in March 1974, some months after his untimely death. (AC)

The Emerald Forest (1985). Printed by W. E. Berry. Illustration by Brian Bysouth, from a design by Vic Fair. One of Berry's final quads, and one of the last classic Fair/Bysouth collaborations, a stylish design impeccably executed. (AC)

for a dramatic expansion. In August 1980, the firm moved to a new £600,000 purpose-built works on Otley Road in Baildon, and Lee additionally purchased a £500,000 Harris web-offset press, a formidable commitment at the time, but one that soon paid off handsomely.[168] Unfortunately, a lot of original archive material was lost on Nesfield Street's closure, as its stockrooms on the top floor were cleared out prior to the move. By 1984, poster printing had declined to around 8 per cent of Berry's business, and its days were clearly numbered. A year later, Lee bought another big web-offset press, which required additional space at Otley Road, and the decision was taken to have it finally replace the last MAN-Roland quad printer. Early 1986 accordingly saw the very last film posters printed by the firm – one of the final quads was for Sam Raimi's black comedy *Crimewave*, released in April.

Ironically, as the poster side of its business was in terminal decline, Berrys flourished as a company. After the war, the firm had employed between fifty and sixty staff, but by the 1970s this had dropped to around forty. However, as the new commercial work took off at Otley Road, the staff numbers steadily increased up to a late-1990s level of about 140 employees. But, in 1999, the company made its first serious miscalculation, investing £7 million in another huge new press and bindery extension: as part of this deal, Yorkshire Bank took a charge on Otley Road's freehold, which had previously been entirely held by the family. During 2000 and 2003, the company suffered heavy losses (due to a squeeze in their key direct mail and financial printing markets), and on 2 December 2003, W. E. Berry was placed in the hands of administrators KPMG.[169] For all Peter Lee's best efforts, then, W. E. Berry has finally become part of Britain's printing history along with rivals Stafford, though the firm at least survived the tumultuous decades of the 1980s and 1990s, a period that saw the end of most of their immediate contemporaries.

CHAPTER 13

Printers (ii): Ripley to Broomhead – The Supporting Players

The three big printing firms we have so far examined in detail – Allens, Stafford and Berrys – have each left us good documentary evidence relating to their respective company histories. Allens produced a commemorative book to celebrate their centenary, Stafford's activities were well reported in the local press and Berrys, as we have seen, was until very recently still in existence, run by the great-grandson of its founder. With many other printers, though – often long-vanished small family firms – building up a coherent picture of their involvement is not so easy. Nevertheless,

using various available resources, this section will attempt a broad overview of the fifteen or so further companies who made a significant contribution to British film posters after the war. The evidence involved includes street directory listings, Companies House data and interview material. Making the best of this sometimes sparse detail, however, we can follow a chronological sequence to begin with the firm that was essentially 'Number Three' after Stafford and Berry, in terms of both output and long-term importance: Leonard Ripley & Co. Ltd.

The Heiress (1949). Printed by Leonard Ripley. Designer unknown. A fine hand-drawn litho for this popular 1940s melodrama. (AC)

The Intelligence Men (1965). Printed by Haycock Press. Illustration by Renato Fratini, from a design by Eric Pulford. The first of Eric and Ernie's three attempts to crack the big screen, none of which unfortunately quite worked. (AC)

Ripley & Co. Printers were established in 1910 at 16–17 Silk Street EC2. By 1923, the name had changed to Leonard Ripley & Co., and the company had moved to 200a Upper Kennington Lane, Vauxhall SE11. Leonard's son, Sidney William Ripley (1909–91), was involved with the firm from the late 1920s, and by the time of his arrival the company's chief business was in railway and film poster printing.[170] By 1939, the firm had settled at 350 Kennington Lane, and it gradually grew until it filled the entire block between 350 and 362. After the war, it also ran a works at Hampton Hill, and later (in the 1970s) premises at 152–6 Brixton Hill SW2. From the end of the war, Ripleys was busy turning out a steady stream of quads for domestic fare like *No Room at the Inn* (1948), alongside more glamorous Hollywood imports such as *Bride for Sale* (1949) with Claudette Colbert. The Ripley name continued to be a commonly seen credit on posters throughout the 1950s and 1960s, in particular on most of Rex Publicity's ABC double

bills. However, in 1972, Sidney Ripley sold the company to John Bentley, the now-infamous 'asset-stripper'. Bentley had already controversially bought British Lion (including its subsidiaries, Shepperton Studios, Pearl & Dean and Mills & Allen) and several other major companies, making his money by deliberately disposing of the property holdings that came with them for big profits.

Bentley was himself taken over in February 1973 by financial services group J. H. Vavasseur, who quickly merged their two new printers, so that Ripleys became a subsidiary of the Mills & Allen Printing Group. However, the firm stayed on at Kennington Lane (two of its later print managers were Stan Matthews and Jim Holmwood), and was still turning out film posters at the end of the 1970s. One of the later quads to carry the Ripley credit was for Pete Walker's melodrama *Home before Midnight* (1979), with artwork by Sam Peffer. The company was last listed in Kelly's in 1982, and the Vauxhall works were

Kings of the Coral Sea (1956). Printed by Electric Modern. Designer unknown. A marvellously dramatic hand-drawn litho for this picturesque Aussie adventure. (AC)

closed down the following year and demolished to make way for a new development, Druce House.[171]

A similar company to Ripleys was the Haycock Press, first listed in Kelly's in 1910 as Haycock, W. J. & Co. Ltd, General Printers, at 69–70 Dean Street in Soho. By 1917, the name had changed – presumably via an amalgamation – to Haycock-Cadle Co. Ltd, and the works had moved to Neate Street, Camberwell SE5, a road running through Burgess Park. By the end of the war, the firm was renamed Haycock Press, and had a new sales office at 25 Catherine Street in the Aldwych, while the Neate Street premises were now known as the Hacaprint Works, and had begun printing film posters. Typical quads of the period are *Once upon a Dream* (1947) and *Warning to Wantons* (1948), both for Rank, the latter featuring a portrait of Anne Vernon in a languorous pin-up pose. Indeed, Haycock seems to have worked mainly for Rank, producing a pleasing mix of posters ranging from Hammer's *Brides of Dracula* (1960) to Morecambe and Wise's *The Intelligence Men* (1965). One of

the final quads to carry the Haycock credit seems to be *Sky West and Crooked*, released in September 1965. The company was last listed in Kelly's in 1967, by which time the Hacaprint Works had presumably closed down, as the only address given is 2 Exmoor Street W10.

The next printer is a name remembered with some affection by several of its contemporary competitors. Electric (Modern) Printing was founded in 1927, with a major works on Allison Street, off Waterloo Road, Cheetham, Manchester. Like most of the other companies under discussion, it specialised in railway and film poster work, being one of the bigger firms of the late 1940s/early 1950s, producing dramatic one-sheets for domestic efforts like *Bond Street* (1948) and *No Love for Jennifer* (1949), plus American imports such as *C-Man* (1949). By the late 1950s, it was tending to specialise in cheap reissue posters, often for Grand National and other second-run distributors, and many of its 1960s quads are interesting examples of what Peter Lee has called

The Cure for Love (1949). Printed by Frederick Kahn. Designer unknown. An interesting minimalist design, like several other Kahn posters of the period, for this amiable Lancashire-set farce. (AC)

'halfway house' printing – a photographic black plate, with garishly hand-drawn colours. Alan Broomhead (who will appear in his own right in due course) now admits that his firm probably had quite a bit to do with Electric Modern's demise, as by the end of the 1960s Broomhead Litho were poaching much of Electric's business.[172] One of the very last quads to carry the EM credit was a typically slapdash double bill for *Nightmare in Wax/Blood of Dracula's Castle* from 1969; the firm was eventually dissolved in October 1993.

Returning to London, another printer who seems to have been briefly busy after the war was Frederick W. Kahn. The firm is first listed in 1929, at 56–7 St John's Square EC1. By the end of the war, their works had moved to 144 Clerkenwell Road, with a sales office a couple of minutes away, in Empire House, St Martins Le Grand, just north of St Paul's Cathedral. Kahn produced a whole glut of posters between the end of the war and the early 1950s, mostly for domestic producers – for example, Rank's *One Night with You* (1948)

and London Films' *The Cure for Love* (1949), with Robert Donat. One distinctive feature of many of these quads is their strikingly contemporary style: *Madness of the Heart* (1949), with its two photorealist portraits of Margaret Lockwood flanking a central plain-white credits panel, has an almost 1980s look. The firm seems to have left the market after about 1952, however, and is last listed in 1967 at 334–6 Goswell Road EC1, suggesting that it was possibly taken over by Lonsdale & Bartholomew (the following year, the same address is given as Lonsdale's London office).

Another London printer whose contribution was brief but significant was Graphic Reproductions of 225 Southwark Bridge Road SE1, just north of the Elephant and Castle tube. Although not listed in Kelly's until 1954, they were certainly in operation well before then, as their credit is on the quad for the Powell and Pressburger production *The End of the River* (1947). Their main claim to fame, however, is taking over from Waterlows at the end of the 1940s as the chief printer for Ealing Studios'

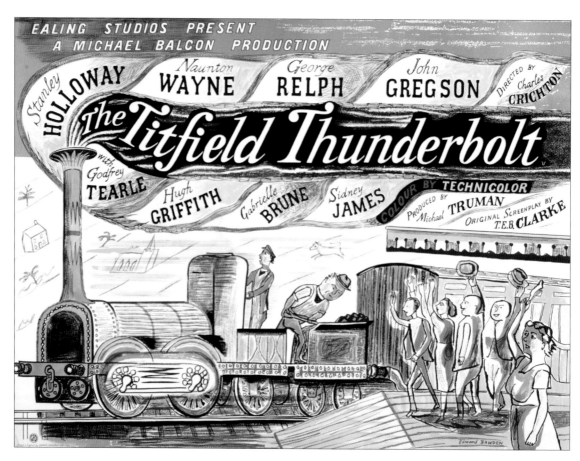

The Titfield Thunderbolt (1952). Printed by Graphic Reproductions. Design and illustration by Edward Bawden. A whimsical illustration for Ealing's ultimate train-enthusiast film. (BFI)

posters. The Graphic Reproductions credit thus appears on some of the most celebrated post-war British quads, including titles like *Passport to Pimlico*, *The Titfield Thunderbolt* and *The Cruel Sea*. When Ealing ended, so apparently did Graphic's involvement with the film business, as *The Divided Heart* (1954) appears to be one of their final posters. They are last listed in Kelly's (still at Southwark Bridge Road) in 1976.

A more prolific contribution was made by Charles & Read, particularly in the late 1950s/early 1960s. Another firm with Victorian origins, they are listed in Kelly's in 1910 as a 'Law Stationers, Lithographers & Printers', suggesting that they had already been in existence for some time. Their works were at 3 Great Winchester Street EC2, with a sales office at 7 Quality Court, Chancery Lane WC2. By 1925, they were described simply as a 'Photolithographers', and had moved to 27 Chancery Lane, opening a second printshop after the war, the Clayton Works on the Pinnacles Industrial Estate west of Harlow in Essex. Charles

& Read began printing film posters around 1954, and probably introduced photo-offset for British quads. One of their first posters seems to be Ealing's *The Love Lottery*, with artwork by Brian Robb, and they worked a good deal for Rank.[173] But as the number of domestic releases declined over the late 1960s, so did Charles & Read's output. One of their final posters was for the children's film *Run Wild, Run Free*, released in June 1969, and they were last listed in Kelly's the following year.

Display Productions were long-lived London silkscreen printer, based at 155a Marlborough Road in Holloway N19. They were established in 1942, but their film poster printing seems to have covered the period 1957–62 only. They worked mostly for Anglo-Amalgamated, taking in the majority of Anglo's AIP imports of the period, featuring punchy double bills like *I Was a Teenage Frankenstein*/*Blood Is My Heritage* and *Screaming Skull*/*Cage of Doom* (both 1958). They also printed all the early *Carry On*s up to *Regardless* for Anglo.

Another Peter Rogers comedy, *Watch Your Stern* (1962), seems to have been one of their last posters, but the firm stayed on at the Marlborough Road works up until 1989, finally going into receivership in 2000.

The next two printers seem to be linked to W. E. Berry via Harry Price, Berry's London-based salesman. The first is Tintern Press, the majority of whose posters carry the simple credit 'T. P. Ltd'. They were established in 1952, with an office at 19 Beak Street, Soho (an address associated with Price throughout the 1960s).[174] One of their earliest quads seems to have been Reginald Mount's classic 1955 poster for Ealing's *The Ladykillers*, and they printed an intriguing mix of titles over the next twenty-five years or so. The lack of consistency in the company's output suggests a firm who were used when no one else was available, printing odd entries in series otherwise dominated by bigger names. Examples include their solitary Ealing poster just mentioned, *Carry On Doctor* (1968) and *Kiss of the Vampire* for Hammer. By the early 1970s,

they were apparently specialising in EMI's international one-sheets, and after 1974 these carried the full 'Tintern Press' credit at the bottom. One of the last examples is the television spin-off *Sweeney 2* one-sheet from 1978; the firm was finally dissolved in September 1987.

The other printers linked to Harry Price were Sales & Display Services, whose posters carried the mysterious acronym 'S&DS Ltd'. They seem to have been established around 1960, and are first listed in Kelly's in 1962, with a sales office at 4 Blenheim Street W1 and a works in Shoreditch at 13 Batemans Row EC2. S&DS mainly printed for Disney, one of their earliest quads being a lush portrait of Patrick McGoohan as *Dr Syn* (1962). They also worked intermittently for Paramount: for example, producing a striking sci-fi design for *Robinson Crusoe on Mars* (1964). In 1968, their sales office moved to the first floor of Roxburghe House, 273 Regent Street, where they continued up to the mid-1970s, one of their final quads apparently being Arnaldo Putzu's design for the 1972 reissue

The Lost World (1960). Printed by Charles & Read. Illustration by Bill Wiggins, probably from a design by Eddie Paul. Michael Rennie is menaced by some magnified iguanas. (AC)

of *The Story of Robin Hood* (1951). They are last listed in Kelly's in 1976, though 13 Batemans Row is still a printing works today, currently home to RA Press Ltd. Peter Lee of W. E. Berry maintains that almost all the litho printing for both Sales & Display Services and Tintern Press was actually carried out at Nesfield Street, though, for political reasons (i.e. to appease NSS), the quads had to carry the TP or S&DS credit.[175]

Of the five firms left to discuss that began printing film posters in the 1960s, three are still in existence today, and the other two only quite recently folded. They generally obtained their work by having it 'contracted out' to them by NSS, as it rapidly began to centralise poster supply. The first of these printers is R. J. Wallman, described by Ian Hedger as 'the best silkscreen printer in the business'.[176] Ron Wallman formed his company (apparently initially in partnership with an H. Malyon) in 1957, and their first premises were at 18 Noel Street, off Wardour Street in Soho.

In 1963, the firm moved to a new works at 1–9 Rosina Street, Homerton, Hackney E9. One of their earliest credited posters seems to have been Tom Chantrell's controversial one-sheet for *Carry On Cleo*, and the firm thereafter produced a wide range of quads across the late 1960s and early 1970s, including quite a few of the later Hammer films. *The Lady Sings the Blues*, with Diana Ross as Billie Holiday, seems to be one of their final posters. At the end of the 1970s, the company moved a couple of miles west to Acme Works on Rendlesham Road E5, and Ron Wallman finally retired and wound the business up in early 2002.

The next printer was definitely a 'major player' in film publicity from the end of the war onwards, according to both Ian Hedger and Brian McIlmail of NSS. Progressive Publicity was formed in the mid-1920s by brothers Harry and Sid Moore, well-known figures in the business who were apparently born 'in a flat above the Admiral Duncan pub in Soho'. Ian Hedger recalls that their first works were supposedly on the site of what is

The Unearthly (1957). Printed by Tintern Press. Designer unknown. A moody design for this obscure shocker, featuring Allison Hayes shortly before she starred in *Attack of the 50 Ft. Woman*. (AC)

now the Warners office, 'back in the days when it was originally a stable block'. In 1929, the firm was listed at 4 Denmark Street (as H&S Advertising), and by 1941 had moved to 134–46 Curtain Road, Shoreditch. Progressive began as suppliers of front-of-house displays, but, from the end of the war, the firm apparently stored and mailed out all of the Odeon circuit's publicity, including posters, stills, pressbooks and so on. As a silkscreen printer, Progressive also produced a lot of quads itself, chiefly for second features and reissues, though it only occasionally attached an identifying credit to its output. One vivid quad that does carry their byline is the 1958 reissue of the Boris Karloff *Frankenstein*. In 1968, the company moved again, to 2–8 Anton Road, Hackney Downs E8, and appears to have simultaneously geared up its poster printing, producing quite a run of quads in the late 1960s/early 1970s, principally for Tony Tenser's Tigon films. One of their last credited posters is for another Karloff horror, *Cauldron of Blood* (1971), a superior example of a very basic green

and red hand-cut screenprint, a type of poster even then rapidly disappearing. Progressive Publicity was listed at Anton Road right up until 1989, being finally dissolved in February 1998. The old works on Curtain Road (supposedly originally built as a button factory, and with a history traceable back to Shakespeare's day) now house the Brick Lane Music Hall.

The last three companies in this survey are all still in operation. Kent Art Printers was established in 1934 by Albert 'Andy' Anderson, who bought out and merged two separate Chatham printing firms – Donald Shave, a poster-writer and silkscreen printer, and Wood & Co., a letterpress firm based on The Brook. Following various moves, in 1959, the firm finally settled in a new works straddling Rochester's High Street and New Road. At this stage, Kent Art had separate litho, silkscreen, letterpress and signwriting departments all under one roof.[177] However, all of the firm's film posters appear to have been straightforward screenprints – one of the earliest

Dr. Syn (1962). Printed by Sales & Display Services. Illustration by Jock Hinchliffe, possibly from his own design. A fine Patrick McGoohan portrait for this lively Disney romp. (AC)

credited examples is a quad for the 1964 Russian version of *Hamlet*, printed for London's Academy Cinema and featuring a typically distinctive Peter Strausfeld artwork. Quad printing seems to have properly got into gear around 1967, presumably following NSS's farming-out of the available work, and there was a steady run of posters – mostly second-features for Paramount, Columbia and MGM – up to the mid-1970s.

The firm's current works and technical manager, Dave Witherden, started out with the company as an apprentice in the pre-press department in 1971, and reckons that at the time, Kent Art was turning out 'around one film poster a month' among its other work.[178] Two of the later quads Witherden recalls working on were *Man of La Mancha* and *Lady Caroline Lamb*, both from 1972, but even then the low print runs, measured against the very labour-intensive production process, meant there was a question mark over the long-term economic viability of the work. In any event, a combination of unfortunate factors led to Kent Art abandoning

film posters in 1977. The silkscreen department itself was a small unit, only employing four or five men, its two key craftsmen being Sam Saunders and Wilf Twyman. Saunders died suddenly, and Twyman retired shortly afterwards, followed only a few months later by a devastating fire that completely destroyed the entire department. Inevitably, the decision was taken to focus on litho printing and finishing. In 1990, the firm moved again, to Hopewell Drive in Chatham, and is now run by Paul Anderson, grandson of the founder.

The penultimate company in this survey also built its success on silkscreen printing. Jack Rosen (b. 1916) served his five-year apprenticeship in the 1930s. After war service as a cartographer, he was demobbed and became part of a seven-man partnership creating hand-drawn posters for cinemas and dance halls in central London, based in a signwriting shop above a Chinese restaurant in Soho. The firm grew steadily, as, one by one, Rosen bought out his partners and gained full control. Eventually, in 1951, his solicitor offered

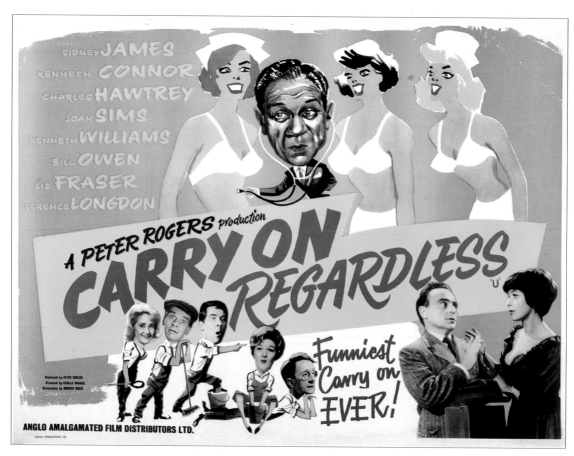

Carry On Regardless (1961). Printed by Display Productions. Designer unknown. A terrific early *Carry On* poster, pre-dating the Chantrell and Fratini eras, but featuring a rather slapdash Sid James portrait. (AC)

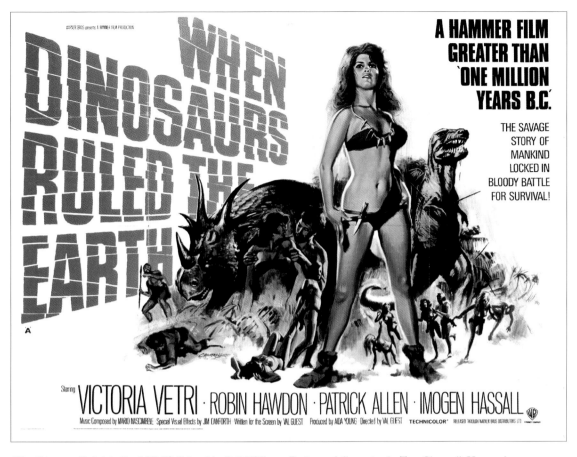

When Dinosaurs Ruled the Earth (1969). Printed by R. J. Wallman. Design and illustration by Tom Chantrell. Hammer's attempt to follow up *One Million Years BC* featured some fine effects work, but Victoria Vetri was unfortunately no Raquel Welch. (AC)

him an available company name – 'Bovince Ltd'. By this point, with signwriting in decline, Rosen was already moving into screenprinting. Bovince's first works were at 126 Elthorne Road N19, and the company was involved in cinema work right from the outset, putting together window displays and other exhibition assignments. Some of their most memorable jobs were collaborations with Warners' longtime publicity rep Ron Lawrence, including the creation of a giant ant mounted on a flatbed truck (*Them!*, 1954), and a similarly mobile enormous wooden horse (*Helen of Troy*, 1955).[179] Bovince soon began building the front-of-house displays for the Warner West End in Leicester Square and other prestigious clients. 'The design of each cinema front was left very much up to us,' comments Rosen. 'It was often a challenge to finish on time ready for each new release – these changed on a weekly basis, and this often meant working all night …'[180]

There were two crucial developments for Bovince in the mid-1960s. One was its ambitious expansion in 1967 to new premises at 276 Chase Road, Southgate, while the other was a chance meeting between Rosen and NSS's Russ Cradick at a Variety Club event. As a result of this key contact, Bovince started gaining regular work printing quads for NSS, one of the earlier examples being Tom Chantrell's design for *Puppet on a Chain* (1970). Jack Rosen's sons, Peter, Leigh and Terry, all started with the firm at this point, Peter becoming commercial director in 1974, after completing a Business Studies course at the London College of Printing. He recalls that, around this time, NSS asked Bovince to stop putting their name on the quads they were printing. It is not clear exactly why the request was made, and bigger suppliers like W. E. Berry and Lonsdale & Bartholomew do not seem to have been subject to any similar restriction. Nevertheless, the Bovince name certainly vanishes off posters at this point, even though the firm was still printing large amounts of material. Peter Rosen recollects Tom Chantrell's *Food of the Gods* (1976), with its

infamous giant cockerel, and Brian Bysouth's rather more restrained *Picnic at Hanging Rock* (1975), as two of their later uncredited quads, and it is tempting to speculate about other companies who might perhaps have been printing in the same anonymous manner at the time.[181] In 1981, Bovince moved again, to Uplands Business Park on Blackhorse Lane, Walthamstow. The connection with the cinema continues, though the company now tends to specialise in printing the big 48-sheet hoarding posters rather than quads. Under Peter Rosen's leadership, the firm now employs about sixty-five staff.[182]

Finally, we can turn to perhaps the last great name in British film poster printing: Broomhead Litho. Derek Broomhead was born in Salford, Manchester, in 1926 and spent the war serving in a Field Survey Unit printing maps in Palestine, later gaining further experience in the trade by working for Leonard Ripley & Co. in Vauxhall. Together with his brother Alfred, he formed D&A Broomhead Litho Ltd in November 1963, initially taking over an older firm, Studio Torron, on 57 Gee Street EC1. Studio Torron themselves dated back to the end of the war, and were originally based on 190 Haverstock Hill NW3. They printed quite a few quads for Compton Cameo, and Broomhead inherited this business, salesman Peter dealing direct with Compton's print buyer, Elizabeth Hesketh (later to work for MGM). One of the first posters to carry the Broomhead credit was Compton's *Black Torment* (1964), Tony Tenser's attempt to duplicate Hammer's successful 'period costume gothic' formula. The real leap forward for the firm took place in 1966, however, when Broomhead moved to larger premises at 20–2 York Way N1, directly behind King's Cross station, into what had originally been the *Times* laundry building. The founders' sons, David, Alan and Kim, also started working for the firm, and with Derek's wife, Joan, handling receptionist/secretarial duties, the company was very much a family affair, the total staff never exceeding about seven or eight people.[183]

Broomhead stepped up its cinema work at this point, printing for Compton, Gala, Miracle and other smaller distributors, plus agencies such as Downton-Dixon (via print buyer Les Silver), and later Alan Wheatley, Graffiti and Feref. The artist most often seen on Broomhead's earlier quads was John Payne, who Alan Broomhead recalls once sent the firm a letter congratulating them on 'the best colour reproduction of his artwork' on a poster he had ever seen. Another job the firm drew acclaim for was Jan Lenica's *Repulsion*, which received an industry award for 'best four-colour poster' – a particular irony, as Alan remembers that he had actually 'put about twelve colours onto it!'.[184] This sort of attention to detail was possible in a small family firm, particularly during stretches when there was less work coming in.[185] Around 1970, Broomheads introduced another minor innovation, which has since made all of their later posters instantly recognisable. British quads were traditionally always printed on machine-glazed (MG) paper, which is polished on one side to give a better printing surface for retaining the ink, while the reverse is left rougher to absorb billposters' paste. Broomhead, however, began using blade coated cartridge paper instead – in this process the freshly milled sheets of paper are coated on both sides with a mix of china clay and latex, smoothed by a metal blade, giving a distinctively glossy finish that dramatically improves the print quality. This type of paper allowed the firm to put 'a lot more ink on the posters' resulting in remarkably vivid colours. This was particularly important for the exploitation quads Broomhead mostly printed, which needed to be as eye-catching as possible. This initiative had a couple of minor drawbacks, though – not only did the glossy backs not absorb paste so well, the sharp poster edges often left the billposters complaining of excessive papercuts![186]

It was not all plain sailing for the company, however. The general financial crisis of the mid-1970s saw the rent on its York Way premises practically double over a single year, and it was decided that maintaining a central London works was too expensive a proposition. In 1976, Alan Broomhead moved to an industrial estate in Lytham, Lancashire, initially to set up a subsidiary repro business ('repro' is pre-press camera work, i.e. scanning and film preparation). Two years later, York Way was finally closed down, and Broomhead Litho's presses were moved up to Lytham as well. Quad printing declined steadily during the 1980s, and by 1990 accounted for 'probably less than 10 per cent of our overall business'. By this stage, the firm was running a big MAN-Roland four-colour press and, as Alan Broomhead comments, employing this to turn

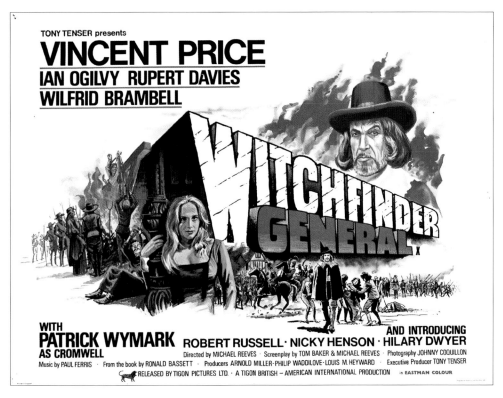

Witchfinder General (1968). Printed by Progressive Publicity. The illustrators for this classic costume drama are frustratingly still unidentified – there are clearly two involved, one for the portraits and one for the montage, though the latter does look a little like the work of Frank Langford. (AC)

Psycho/The War of the Worlds (1960/1953). Printed by Kent Art. Designer unknown, though both films employ adapted US campaign art. A cheap photographic silkscreen for this Paramount double-bill reissue of about 1967. Hitchcock, quite uniquely, rather often appeared on his own posters. (AC)

Puppet on a Chain (1970). Printed by Bovince. Design and illustration by Tom Chantrell. Bovince's posters only rarely featured a printer's credit. The celebrated boat-chase sequence illustrated was directed separately by action-specialist Don Sharp. (AC)

Flesh Gordon 2 (1990). Printed by Broomhead Litho. Illustrator unknown, though the initials 'AW' have been added. A very late exploitation poster, one of the last printed by Broomhead, with a design spoofing Sam Peffer's original quad of 1974. (AC)

out the 2,000-copy quad print runs was like 'using a sledgehammer to crack a walnut'. The end of the line for the old set-up was Derek's retirement in 1993, and the original Broomhead Litho was dissolved that October. The offshoot company continued to work for the film business, though, principally for Entertainment distributors, via Alan Wheatley. The Lytham repro outfit (from 1983 named Laserscan Studios) handled the pre-press work, while Kim Broomhead moved to Watford, to oversee the actual printing at a separate company called Parvester Ltd. However, even this limited involvement ended in 1998 on Alan Wheatley's retirement, Parvester itself being dissolved that May.[187] One of the very last artwork quads to carry the old Broomhead credit was the outrageously tacky sci-fi spoof *Flesh Gordon 2* (1990), featuring a lascivious octopus-monster, alongside various rudely shaped spacecraft. Broomhead quads like this perfectly capture the robustly downmarket exuberance of Lytham's near-neighbour Blackpool, and British posters are the poorer for their disappearance.

Having surveyed all the major printing companies, we can now turn our attention to the process by which the posters were actually distributed to the cinemas (or local billposting firms) in time for the appearance of the films they were publicising. As we have already noted, from the end of the 1950s this aspect of the business was effectively controlled by just one company: National Screen Service Ltd.

CHAPTER 14

'New York, London, Perivale': National Screen Service Ltd

Remember, it's National Screen Service

Whether you're distributor, producer, director, film editor, exhibitor, advertising agency executive, television advertiser or just shopping . . . this N.S.S. manpower is at your service all the time.
Ed Smith, Managing Director
Esther Harris, Production Director F.B.K.S.
Bill Land, Technical Director
George White, Art Director
Sid Tutt, Sales Director
Russ Cradick, Accessories Director
Chris Brunel, London Head Office Contact (TV and special productions)

''If one of us can't solve your problem, nobody can.''

National Screen's management team, from a promotional brochure of about 1960. Left to right: Russ Cradick, Ed Smith, Sid Tutt, Chris Brunel, Esther Harris, Bill Land and George White. Cradick had first set up their accessories division around two years earlier. (Courtesy of Ian Hedger)

By the 1920s, Wardour Street was packed with projection theatres and editing rooms, and by the 1930s, all the big distributors, both British and American, had established their HQs within its towering office blocks. Most of the street's offices had ample cellarage, and it was in these gloomy basements that the film companies stockpiled their promotional material, including posters, for shipping out to the cinemas. All of the UK's big distributors controlled their own paper publicity from these West End headquarters, right up to the 1960s. Smaller independent distributors used local publicity firms for the same purpose. Some of the better-known companies of the 1940s and 1950s were Girosigns at 86–8 Wardour Street, Lim Publicity on Montague Mews North, near Paddington, and Coltmans Displays off Fairfield Road in Hounslow.

The only publicity tool not directly handled by the distributors themselves were trailers. These were specially made and distributed by a company called National Screen Service, established in Britain in May 1926, but actually an offshoot from an American parent company of the same name that had been set up in New York seven years earlier. The American NSS was launched by the Robbins and Gruen families in 1919, at first solely to produce and distribute trailers, and moved into the 'accessories' side in 1940, initially with Paramount and RKO.[188] By 1947, all the big Hollywood studios had contracted out their paper advertising to NSS, distributed via about thirty 'exchanges' (i.e. storage warehouses) located in all the major cities. This system declined over the 1970s as the US multiplex invasion gradually rendered the old variety of poster sizes obsolete (with up to ten films now sharing foyer display space, only one-sheets were still practical). The studios reacted by once again taking control of

their now manageable accessories operations. By 1984, less than 20 per cent of the business was still being supplied by NSS, though they continued to operate on this much-reduced basis until 2000, when the remaining three offices were finally bought out by Technicolor Inc.

The British branch of the NSS was initially situated at 25 Denmark Street, Soho, though the trailers themselves were manufactured in Broadwick House on nearby Broadwick Street.[189] By 1930, the office had moved to 113–17 Wardour Street, which became known as Nascreno House, and although this block's freehold was later purchased by impresario William Hinds (better known as Will Hammer), NSS stayed on as tenants for several years. The building was later renamed Hammer House and became one of Wardour Street's most famous landmarks.[190] By the end of the war, NSS had finally settled into the new Nascreno House, at 27 Soho Square, in a top-floor suite of offices that had once been a flat belonging to Gracie Fields.[191] It was not the office location that was the real problem, however, but the site of the plant. On the outbreak of war in September 1939, the Government passed an emergency law that nitrate film (which was potentially explosive) could not be stored within eight miles of central London, and the 'Trailer Factory' urgently needed a new home.[192]

The chosen location was Perivale, a quiet western suburb of London, about one mile north of Ealing on the Central Line. In the heart of its industrial district, at 15 Wadsworth Road, was an anonymous factory unit built in 1934, which had spent the first five years of its life as an Italian laundry. On the outbreak of war, its Italian tenants were interned, and NSS quickly moved in. The relocation would have been expedited by the fact that the company did a lot of work for the Ministry of Information during the conflict, turning out propaganda, which at the time was classed as a Reserved Occupation.[193] For the next twenty odd years, Wadsworth Road solely produced and distributed trailers. The building was divided up into offices, which included a dispatch department, an art department, an editing room, camera rooms, a viewing theatre, a mini-studio with rostrum camera, a scriptwriting department, a black-and-white lab right at the back of the building and various clerical and secretarial staff offices. Together with the Soho Square office, at its peak NSS

employed a large team of about 120 people. Its most distinguished employee was undoubtedly Esther Harris, Britain's premier trailer producer, who made some of the most celebrated 'Coming Soon' features of the 1960s, and remains a great unsung heroine of the industry.[194] Another regular visitor was Maurice Binder, who found considerable fame producing the now-classic title sequences of the James Bond films.

By the mid-1950s, the serious decline in cinema audiences was beginning to bite, and the big firms were forced to cast around for obvious economy measures. One of the most needlessly expensive practices identified was the cost of storing huge amounts of paper publicity in prime-site West End basements, and, following the example of their American counterparts, the British 'majors' started to gradually subcontract out this side of the business to NSS. The architect of NSS's move into accessories was Russ Cradick, who had previously

The Legend of Young Dick Turpin (1965). No printer credited. Illustration by Jock Hinchliffe, possibly from his own design. The posters featured in this section are examples of the principal UK formats in use up to the end of the 1970s. This is a 30" x 20" double crown. (AC)

worked with his father at MGM, and had already gained plenty of experience in the publicity side of the industry. Cradick set up a system whereby NSS charged a flat 17.5 per cent commission to produce and distribute other companies' paper publicity, paying half the pressbook price per poster (for their own stock), with the balance – along with the 17.5 per cent – being charged to the renter.[195] This basic system remained in place for forty years. Wadsworth Road began handling film posters in 1958, and, one by one, the big distributors signed up over the following decade. It is difficult to confirm the exact dates, as most of the records of the period were destroyed when the office finally closed in 1998, but the approximate sequence was as follows: MGM 1958, Paramount 1961, Fox 1962, Columbia 1963, EMI and Warners 1969, and Disney, Rank, Universal and United Artists all 1971. Sometime during the late 1960s, as the accessories side really started to take off, NSS apparently bought out Coltmans Displays wholesale.

In addition to the 'majors', many of the smaller independents also moved over to NSS, though some stubbornly preferred to manage their own publicity throughout: Miracle Films, for instance, continued to distribute their posters from an office on Lewisham High Street up to the early 1970s. One minor distribution rival was ad-sales company Rebel Films of Carshalton, Surrey, a 'mini NSS', which handled material for some of the smaller independents like Target, Miracle and Entertainment during the 1970s.[196]

Following Russ Cradick's later promotion to managing director, the man who oversaw NSS's poster operations was Brian McIlmail, who first joined the company in 1965, initially looking after the dispatch side at Wadsworth Road. In 1968, he was offered a promotion into the print buying department in the Soho office, liaising with the distributors and printers in organising poster production and distribution. As he explains, this sometimes involved some canny political manoeuvring with film publicists, who

Home at Seven (1952). Printed by Stafford. Design and illustration by Brian Robb (1913–79). This is a 22" x 28" half-sheet. Robb worked as a cartoonist for *Punch*, and during the war was a Lieutenant in the Camouflage Unit, building dummy tanks for the Alamein deception of October 1942. (AC)

habitually gave an inflated impression of their picture's importance. The process began when a distributor initially approached NSS with an advertising campaign and a budget. Depending on the budget and the number of prints for release, NSS would then work out the number of posters required. The total had to cover the West End launch (handled directly by the distributor) and ensuing circuit release, any promotional tie-ups with local shops etc., a set amount for the London Transport Authority (LTA) to paste up in the city's Underground stations and a percentage for the large number of independent cinemas. NSS also supplied Malta, Gibraltar and the Republic of Ireland. Irish material was handled by Cinema & General Publicity Ltd from their Dublin office at 35 Upper Abbey Street, though Ireland actually took only about 100–200 quads per film. The overall number of posters, therefore, varied from film to film, but McIlmail suggests print runs of about 3,000 to 4,000 would have been average to high.

Carry On Screaming (1966). No printer credited, but probably Stafford. Design and illustration by Tom Chantrell. This is a 40" x 27" international one-sheet. (AC)

Driver (1978). Printed by Lonsdale & Bartholomew. Illustration by Brian Bysouth, from a design by Eddie Paul. This is an 81" x 40" three-sheet, printed in two sections. A punchy design for Walter Hill's brilliantly pared-down thriller. (AC)

For some minor films, such as second features, much smaller runs of 300–400, usually silkscreened, quads were ordered.[197]

NSS was also careful in the way it used printers. It was not considered a good idea to acquire a printing company of its own, as this would have been merely 'buying up a load of extra problems'. Additionally, as McIlmail needed to be seen to be getting the best value for money, constantly having jobs done in-house would not have looked good to the distributors. Therefore, NSS developed a policy of alternating between the two biggest speciality printers in the country, Stafford & Co.

and W. E. Berry, McIlmail dealing directly with their respective print managers, Henry Binch and Peter Lee. Other printers, such as Kent Art and Bovince, were occasionally used, but the advantage of dealing with Stafford and Berry was that the amount of money involved in the deals gave NSS 'clout' in getting instant access to the printer's machines, in a business where speed and cost were always of the essence. The company was equally shrewd on the question of storage. Wadsworth Road was not especially big, so the usual arrangement was that the bulk of the run would be held at the printers, with NSS taking a thousand or so at a time – that way 'our storage problem

becomes their storage problem!'. On top of the practical conveniences of using Stafford and Berry, McIlmail also credits them with employing the best craftsmen: 'They had guys there, artisans, who really understood the "personality of the poster", and could make the best of each one.'[198]

One instantly identifiable feature of every NSS poster was the 'copyright' warning strip printed along the bottom, which insisted that all posters had to be returned to NSS once the cinemas had finished with them. This was put there for two reasons. First, since NSS only leased the advertising copyright from the distributors, the posters could not be sold outright, as they were not NSS's

The Chiltern Hundreds (1949). Printed by W. E. Berry. Design by Eric Pulford. This is a huge 81" x 80" six-sheet, printed in four sections. Unsurprisingly, very few posters of this size have survived. (AC)

property in the first place. Second, the warning was intended as a broad self-protection. After the 'tripling' boom of 1973, one new feature many of the buildings carried was lightbox poster cases. An unexpected side-effect of their introduction was that loose (un-pasted) 'lightbox' copies of posters slowly began to feed a small but growing collectors' black market. When this phenomenon first came to Wadsworth Road's attention, the company felt obliged to protect itself against potential action from the distributors.

The basic range of paper materials that NSS supplied for each film included a poster, a pressbook, a synopsis (including cast and credits) and a set of eight front-of-house stills. Some bigger films also had a set of eight 14" x 11" photogravure lobbycards. The ordering process was handled by NSS's administration department, via forms sent in from each cinema's 'booking diary'. Delivery was sometimes by post, but more usually by Film Transport Services. FTS was a specialised haulage firm operating on behalf of the film industry. It was based on the North Circular Road, in Fairfield House NW10 (only about half a mile from Wadsworth Road), but had various other depots around the country. Independent couriers would visit these depots twice a week, each van delivering both publicity material and film prints to perhaps thirteen or fourteen regional cinemas. FTS's direct deliveries into independent cinemas were taken over by Courier Express in the late 1970s.

The major film distributors and cinema chains also had their own storage depots dotted around the country: for instance, Rank had a major depot in Lowton, midway between Manchester and Liverpool, and other depots in Glasgow, Birmingham, Cardiff, Belfast and Dublin. Odeon's posters were stored and mailed out by Progressive Publicity. ABC's posters were handled by two different firms – Art Display Services (ADS) in Limehouse sent material out to individual cinemas, while Joseph Wones of West Bromwich dealt with 'away from theatre' sites such as bus stops or shops involved in tie-up promotions.

One convenient side-effect of the multiplex invasion of the late 1980s for NSS was that it finally ended a long-running dispute that had cropped up 'about every five or six years' since McIlmail had first joined the firm. Of all the major territories in the world, Britain is historically the only one to use a horizontal poster format, which

A Letter to Three Wives (1949). Printed by Stafford. Designer unknown. This is a 60" x 20" door panel. An attractive hand-drawn litho on a rarely-seen format. Unusually for the craftsmen at Stafford, the plates on this poster have actually been printed slightly out of alignment. (AC)

The Night My Number Came Up (1954). No printer credited. Design and illustration by Eric Pulford. This is a 22" x 16?" lift bill, the smallest standard British format. As the name suggests, these posters were intended mainly for Underground lifts and escalators. Few of this format now survive. (AC)

The Sea Wolves (1980). No printer credited, but probably W. E. Berry. Illustration by Arnaldo Putzu, from a design by Vic Fair. This is a 60" x 40" double quad crown, sometimes referred to as a 'bus stop' poster. They gradually replaced the slightly larger three-sheet format over the 1970s. (AC)

meant that artwork always had to be customised by the UK distributors from the vertical American one-sheet designs. US criticism of this 'wasteful' practice reached a peak in the mid-1980s, when the British industry was in its weakest state, leading to transatlantic accusations of 'the tail wagging the dog'. However, the UK exhibitors commissioned a report in 1985 that estimated that it would cost them about £250,000 to change all their displays over to the one-sheet format, and pointed out that this was money they could ill-afford to spend. Shortly afterwards, the UK market revived dramatically, putting British interests in a stronger bargaining position, and the challenge was fought off once and for all. The irony is that, nowadays, one-sheet posters are quite often used in the bigger multiplexes, and digital technology has made changing formats for poster designs not much more than a matter of merely hitting a few computer keys.

McIlmail also claims the credit for first suggesting the idea of double-sided posters in Britain. Visiting the opening of the new Cannon multiplex at Salford Quays in late 1986, he noticed that a poster he had spent a lot of time on with the printers, getting the colour registration just right, was being bleached out by the lightbox glare. He suggested adopting a recent innovation whereby posters could be back-printed with a paler negative image on the reverse side. When illuminated from behind, in new backlit lightboxes, the translucent posters then 'glowed' with a very high-definition image. This important development revolutionised poster printing in the UK, and had become the industry standard by 1990.

Throughout the period 1958–86 when NSS in Britain had been handling posters, the American parent company was run by twin brothers Burton and Norman Robbins, and Bob Gruen, sons of the original founders. By the mid-1980s, the twins were approaching retirement age, and the industry was undergoing huge and not always congenial changes. An offer was put to the Robbins brothers for their main office on Times Square, by now an extremely valuable piece of real estate, and they decided that it was as good a time as any to call it a day. One consequence of this was that the British NSS was put up for sale. Several potential buyers showed an interest, but none of them held much appeal for the management team (including McIlmail) that was then in place. The only option

left to avoid takeover was a management buyout, and the then managing director, John Mahony, brokered this directly with the Robbins brothers. In order to raise the cash, the production side was sold off, as almost all trailers were by now imported from America in any case. This reduced the number of staff to a more manageable twenty-five or so, and at much the same point the original lease on 27 Soho Square expired, so head office moved to smaller premises on nearby Wedgwood Mews, off Greek Street. Following these manoeuvres, in December 1986, McIlmail, Mahony and company secretary Norman Darkins purchased the company outright.

By the late 1990s, however, the new owners were themselves approaching retirement, and had become 'old men in a young man's industry', to quote McIlmail. After some negotiation, media giant Carlton eventually acquired the firm in June 1998, and the trio finally took their leave. One of Carlton's first moves was to close down Wadsworth Road, and the company has moved several times since, though it is still based in Perivale. McIlmail is now philosophical about the radical changes of the mid-1980s onwards. A generation gap had opened up – 'You had twenty-two-year-olds running the big multiplexes, for God's sake!' – and these 'young firebrands', in general, had no time for the traditional methods and attitudes of their elders. This, more than anything else in his view, accounts for the sudden disappearance of original artwork in film posters after about 1986. It looked old-fashioned and anachronistic, a reminder of a type of cinema promotion now long gone, that needed to be replaced by more contemporary design strategies. This process was only speeded up by the encroaching technological revolution: both Stafford and Berry, NSS's traditional printers, had themselves abandoned film posters as unprofitable in 1986, the year of the NSS management buyout.

Perhaps the most appealing aspect of the old NSS set-up at Wadsworth Road was a peculiarly British parochiality, compared with its meticulously organised American counterpart. McIlmail claims that the firm had a smart white van, whose side bore the legend 'NATIONAL SCREEN SERVICE LTD – NEW YORK, LONDON, PERIVALE'. Everyone who ever saw this vehicle had only one inevitable response: 'Exactly where the hell is Perivale?'

CHAPTER 15

Fragmentation: Video Boxes, Multiplexes and Desktop Publishing

The mid-1980s were a time of profound change in the British film industry. The Conservative government's 1985 Film Act effectively ended almost sixty years of continuous state support (of one form or another), and overnight cast British cinema into the stormy waters of the free market. As audiences reached their lowest ebb in 1984, the meteoric rise of home video seemed to presage the end of filmgoing as a form of mass popular entertainment. The first domestic video cassette recorders had been launched in Britain during the summer of 1978. The earliest UK distributors of prerecorded videocassettes were originally home-movie firms like Derann, Iver and Mountain, who had established themselves in the 1970s supplying the Super-8mm cine-projector market. Derann and the other pioneers started out by copying their Super-8 stock onto video, then began shopping around for cheap older feature films, often very obscure or poor-quality

Zombie Flesh Eaters (1980). Printed by Broomhead Litho. Design and illustration by Tom Beauvais. One of the most infamous of the video nasties, this is actually a rather old-fashioned horror film, though it did bring new meaning to the phrase 'eye-popping entertainment'. (AC)

B-features, the rights to which could be acquired relatively inexpensively.[199]

The major theatrical distributors were themselves rather wary of video to begin with, seeing it as both vulnerable to piracy and a potential threat to their dwindling cinema audiences, and for sometime refused to get involved with the new medium. This quickly created an interesting environment in which hundreds of offbeat films previously unavailable in Britain began circulating largely unregulated, in a suddenly exploding market over which legal controls were still very hazy.[200] One of the major early successes with the public was the gory horror film. The packaging for such tapes quickly became increasingly lurid, as independent companies struggled to get their product noticed on video store shelves. Early video sleeve artwork sometimes drew on the original cinema poster, where one was available, but many of the films had never actually had a British cinema release (or enjoyed the associated attention of the BBFC's scissors)

and, in these cases, distributors commissioned their own artwork. As one later commentator put it: 'Blood-dripping monsters, Flesh-chewing cannibals, Nazi torturers, Knife-wielding maniacs, and Gore-choked power tools were common sights.' James Ferman, of the BBFC, later admitted that 'the covers of the Nasties were terribly important to their image'.[201]

The first hint of trouble were several letters published in *Television and Video Retailer* in February 1982, complaining about a trade advertisement that had appeared on the previous issue's back cover. This was promoting new release *SS Experiment Camp* on the Go Video label, and contained a full-colour reproduction of its cover artwork. This remarkable composition features a background of concentration camp fences and a sinister SS officer's portrait, in front of which is artwork of a bloodied and almost naked female, suspended upside down from a pole with a swastika medallion chained to her wrist. When challenged about this picture, Go's managing director, Des

Flesh for Frankenstein (1975). Printed by W. E. Berry. Illustration by Arnaldo Putzu, probably from a design by Eddie Paul. Blurry intestines wobbled in audiences' faces, thanks to the magic of 3D. (AC)

Dolan, offered the novel defence that his company had actually toned down the original artwork, by painting a black G-string on the previously naked woman. In their monthly case report for May 1982, the Advertising Standards Authority upheld complaints about three separate video covers (*SS Experiment Camp*, *Cannibal Holocaust* and *Driller Killer*) and condemned the magazine editors who had printed press advertisements containing them.[202] So began what became a full-blown media hysteria around 'video nasties', in which the illustrated box covers became evidence of the depravity they contained.

At the end of June 1983, the first 'banned' list of titles was published by the DPP, fifty-two films either already successfully prosecuted or with prosecutions pending, and circulated to dealers. This list began to be issued monthly from July the following year, at just the point that the new Video Recordings Act (1984) became law, enforcing BBFC certification of *all* prerecorded videocassettes released in the UK. A compilation of all the titles

appearing in the eighteen or so different DPP lists gives a grand total of seventy-four films, of which a perhaps surprising thirty-one had previously received a British cinema release and BBFC 'X' certificate, though often only in a substantially cut form.[203] Many of the video boxes that caused such controversy in the first place were simple variations of the artwork featured on the original quad posters, such as Tom Beauvais's *Zombie Flesh Eaters* (1980 – an iconic horror film poster if ever there was one), Tom Chantrell's *Possession* (1982), Graham Humphreys's *The Evil Dead*, Ted Baldwin's *Death Trap* (1978), Sam Peffer's *Exposé* (1976), Graffiti's *Bloody Moon* (1982), Enzo Sciotti's *Tenebrae* (1983), Dario Campanile's *Dead and Buried* (1981) and Arnaldo Putzu's *Flesh for Frankenstein* (1975), all of which had, of course, been approved at the time by the AVC.

To avoid any future difficulties, a companion committee to the AVC was set up in the wake of the 1984 Video Recordings Act, to monitor the sleeve artwork of videos. The Video Packaging

The Evil Dead (1982). No printer credited. Design and illustration by Graham Humphreys. Released almost simultaneously on video (hence the promotional tagline at bottom right) and subsequently regularly seized, though never successfully prosecuted. (AC)

The House by the Cemetery (1981). No printer credited. Design and illustration by Enzo Sciotti (b. 1944). Another banned Italian *giallo*. As with his contemporary Renato Casaro, Sciotti's work featured regularly on British exploitation posters in the 1980s. (AC)

Prisoners of the Lost Universe (1984). Printed by Broomhead Litho. Design and illustration by Tom Chantrell. Chantrell's last widely seen quad, following which he worked almost exclusively on video sleeves. (AC)

Review Committee operated in tandem with the BBFC, and took a notably strong line following the excitement stirred up by the nasties scandal. For example, a heavily cut video re-release of *The House by the Cemetery* (1981), originally one of the banned titles, featured Enzo Sciotti's quad poster artwork of a knife-wielding ghoul looming over a graveyard. However, the illustration had to be amended to remove a smear of blood on the monster's knife before the VPRC would approve it.[204]

Twenty years down the line, the nasties have acquired a certain renegade cachet, and it is probably only a matter of time before some of the better titles acquire the 'classic' status already assigned to their previously disreputable counterparts from the 1930s and 1950s. The video nasty scandal itself represents the tail-end of the whole illustrated tradition in British film publicity. Many of the top poster artists – Chantrell, Beauvais, Peffer and others – spent the last years of their professional careers turning out video sleeves, as the market for original quad designs dried up.

As the lurid boxes of video nasties were being swept from the rental shelves in 1985, two separate but hugely important developments occurred: the launch that March of desktop publishing (DTP) computer graphic-design technology, and the opening in October of the UK's first purpose-built multiplex cinema in Milton Keynes. Both led to individual revolutions within their respective fields, but one side-effect of their combined impact was the swift disappearance of the British illustrated film poster. Historical perspective is clearly important here: the first poster books appearing during the early 1970s all lament the late 1950s as the end of a supposed 'Golden Age'.[205] More recently, the tail-end of the 1960s has been vaguely identified as a turning point in the slow slide from heady creativity to commercial cliché.[206] But, in Britain, the real dividing-line – if we are talking about the demise of an identifiable and coherent tradition involving long-established participants – is unmistakably the mid-1980s.

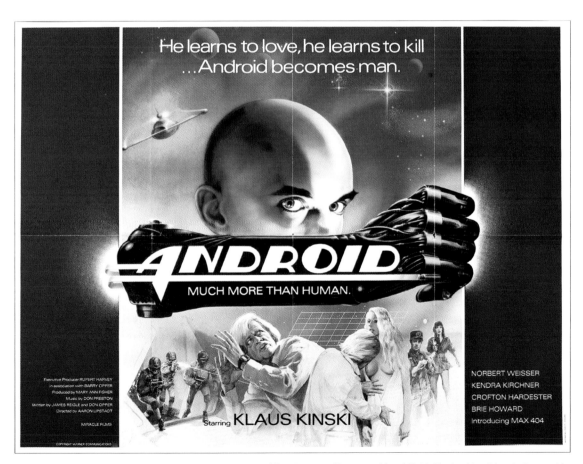

Android (1983). Printed by Broomhead Litho. Illustration by Tom Beauvais (figure work) and Keith Fowles (the airbrushed portrait), from a design by Colin Leary. A good example of a team effort, and one of Beauvais's last posters. (AC)

Looking first at the design side, DTP was the result of the emergence of a series of interlinked computer technologies within a few months of each other. There were four American companies involved – Apple, Adobe, Aldus and (to a lesser extent) a traditional printing-equipment manufacturer named Linotype.[207] Apple launched its revolutionary Macintosh in January 1984, the first personal computer to operate via the now-familiar 'point and click' mouse, and followed this up twelve months later with the equally significant Laserwriter printer, producing text and graphics at a respectable 300 dots per inch. The Laserwriter was powered by Postscript, a 'page description language' code first developed by Adobe, a new software company originally set up by a couple of ex-Xerox engineers. The third firm of this trio was Aldus, run by Paul Brainerd, previously a newspaper editor with a background in the computer side. In 1984, he had conceived the idea of Pagemaker, a program that would enable users to prepare page layouts on a computer screen rather than physically with paste and scissors. At about the same point, Linotype launched the Linotronic 300, the first commercial laser image-setter (i.e. colour scanner)

able to interpret Adobe's Postscript code. This was an important element in the overall package, as it provided the means to convert computer design work into the high-resolution films required in professional photo-offset printing.[208]

The press event announcing 'The Birth of Desktop Publishing' (a phrase apparently coined by Brainerd) took place at New York's International Typeface Corporation HQ the following March. All the key players were present, but even the most ambitious of these men could scarcely have foreseen the speed with which DTP conquered the entire publishing industry, swiftly replacing the old 'proprietary' system of discrete specialist stages with one unified production process. The major graphic design programmes arrived a few years later: Photoshop (launched February 1990) allowed image processing in the form of sophisticated manipulation of photographs/artwork, while other relevant packages include Painter, Illustrator and Freehand, all self-explanatory in their ability to allow the creation of digital artwork directly onto a computer screen. Each of these later innovations, however, can be directly linked back to the launch of DTP in March 1985, by

Tom Beauvais's retirement in 1992. Left to right: Rob Mepham, John Chapman, Ray Youngs, Tom Beauvais, Tim Canadine, Penny Tidd, Colin Leary (partially obscured) and Keith Fowles. (Courtesy of Tom Beauvais)

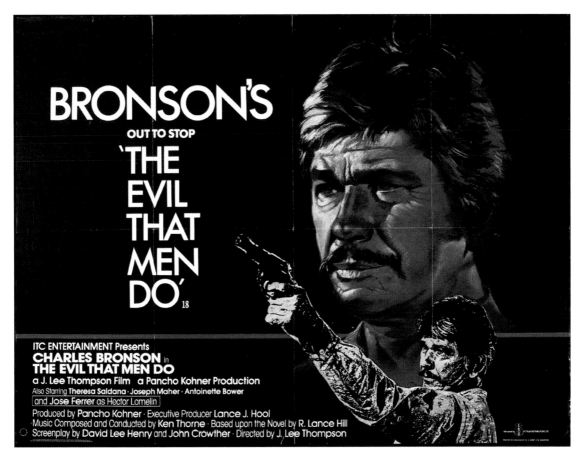

The Evil That Men Do (1984). Printed by W. E. Berry. Design and illustration by Eric Pulford. Charles Bronson shoots some more baddies. Pulford's last printed poster, following which he retired to the south coast to sail his yacht. (AC)

default a key date in the development of film posters as pieces of graphic design.

The second crucial factor affecting British film posters was the rapidly changing face of cinema distribution and exhibition. As the home industry hit its lowest ebb in the mid-1980s, most of the older independent distributors finally folded, and the steady supply of international exploitation movies they had handled quickly dried up (generally shifting over to the emerging video market). Double bills and popular reissues also vanished during the same period, for exactly the same reasons. However, in October 1985, the UK's first purpose-built multiplex, the Point complex at Milton Keynes, opened with ten screens and was an immediate huge success, attracting one million admissions in its first year alone. This began the so-called 'multiplex revolution', in which a rush of competitive building across the country completely revitalised British exhibition, re-attracting the vital teenage audience and rapidly making cinemagoing fashionable once more.

By 2000, when Rank finally sold its historic Odeon chain as a going concern, admissions nationally had returned to 142 million (back to the level of 1972), with the number of screens up to 2,560 (a return to the levels of 1961), multiplexes accounting for almost 75 per cent of this new market on both fronts. This 'fresh blood' came with a price, though – a new generation of film executives, who tended to see illustrated posters as part of an anachronistic promotional style in urgent need of modernisation. Old-style showmen like Al Shute of Warners, John Fairbairn of Fox and Don Murrey of Columbia retired en masse from Wardour Street's publicity departments at the end of the 1970s. Their replacements tended to have few romantic or nostalgic attachments to the artist-rendered quad, and, with audiences plummeting, the US parent companies became understandably reluctant to spend additional money on separate UK campaigns. The inevitable result was that one-sheet designs were simply recycled directly onto the quads, often regardless of their suitability for

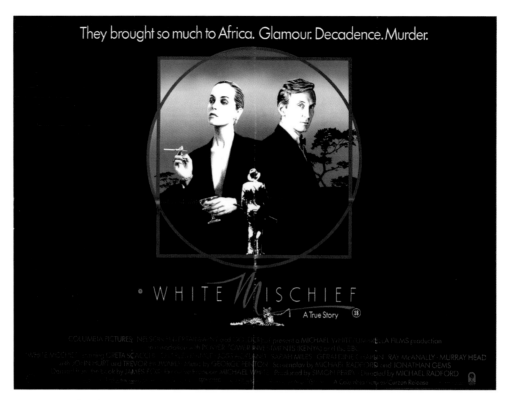

White Mischief (1987). No printer credited. Design and illustration by John Stockle. Stockle's last poster, featuring another of his trademark black backgrounds. He retired from Downton's at the end of the following year. (AC)

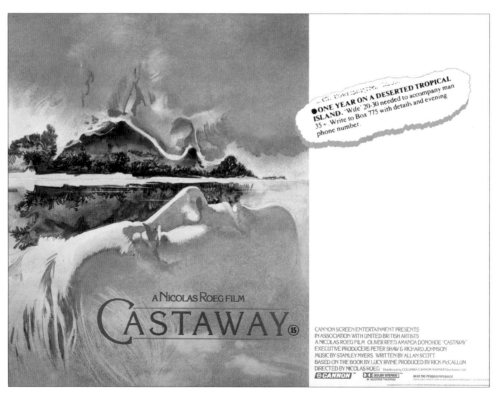

Castaway (1986). No printer credited. Design and illustration by Vic Fair. Brian Bysouth was originally commissioned to paint the finished art from this rough, but when he couldn't seem to catch the required ambience, the original was eventually simply printed instead. (AC)

the different format.[209] Typically, the illustration would take up a 65 per cent block on the left of the poster, with the right-hand 35 per cent devoted to title and credits, thereby rendering the quad's unique landscape format visually ineffective. The landscape quad was soon used much less in any case, with one-sheet displays, banners and cardboard 'standees' becoming the publicity tools of choice in cavernous multiplex foyers.[210] Hollywood's historical dominance of British distribution thus inexorably extended into exhibition, and from there inevitably into publicity and promotion itself.

As we have seen, another side-effect of the early 1980s exhibition crisis was the disappearance of most of the industry's traditional printers: shrinking print runs and rapidly changing technology effectively removed what little profit-potential was left in the market. Similarly, NSS's sixty-year association with its American parent company was severed in 1986 and its role in the accessories market gradually withered away. As for the industry's six traditional agencies, all but one had ceased involvement by the end of 1988, as the major distributors gradually shifted their business to powerful multinational firms.[211] Dixons had been absorbed by Downton's in 1965, Allardyce lost both Fox and Warners in 1974, UK lost United Artists in 1981, Rex lost the ABC circuit in 1984 and Lonsdales lost UIP in 1988. Only the biggest of the six, Downton's, survived beyond this point, despite losing both Warners and Disney during 1982–3. It nevertheless held on to Columbia and Rank up to 1997, when the sale of the latter to Carlton effectively ended the historic agency along with its principal client.

Despite the undeniable impact of all this technological innovation and business restructuring, however, it must be pointed out that traditional painted artwork had been in gradual decline for several years prior to the arrival of multiplexes and DTP, and by 1986 most of the illustrators were already in retirement. Sam Peffer's final year in the business, 1984–5, was 'terrible – there was no work at all'. Like his fellow artists, he had effectively priced himself out of a contracting market: 'What happened on film posters was that they were getting more and more expensive, and they [the distributors] wouldn't pay the money for them.'[212] As the youngest of the major names, Vic Fair lasted longer than most, but his work became almost

exclusively photographic and, thoroughly bored, he retired gratefully in 1995. Brian Bysouth worked steadily through the 1980s and 1990s, but after *The Living Daylights* in 1987, his output necessarily became more and more photorealist. He was the last to formally retire from film work, in 2002.

The artists offer differing explanations for the disappearance of the illustrated poster. Brian Bysouth cites the lack of trained illustrators coming out of the country's art schools at the time, and points to work being given to young artists who were often simply not sufficiently skilled to do the job properly.[213] Additionally, Bysouth recalls that the quality of the resources provided for the artists declined noticeably around this point. Traditional illustrators always worked from reference stills sent by the distributor who was commissioning the poster. With the decline of the unit photographer, the quality of the reference material offered became very poor, forcing the illustrators to occasionally

The Beast of War (1988). Printed in America. Design and illustration by Vic Fair. Possibly Fair's last-ever printed illustration, this ironically wasn't even used in Britain in the end. This is actually an American one-sheet, and for obvious reasons is the only one included in this book. (Courtesy of Vic Fair)

Return of the Jedi (1983). Printed by Lonsdale & Bartholomew. Illustration by Josh Kirby, from a design by Eddie Paul. This is a slightly trimmed London Transport copy – LT unbelievably had a brief policy in the early 1980s of actually guillotining quads down to fit their new-size poster sites. (AC)

second-guess some of their images, producing unsatisfactory results. Then there was the problem of video. Artwork for video sleeves before 1984 was often of ridiculously poor quality, done on the cheap for small independent distributors by anonymous and minimally skilled artists. As the video boom properly kicked in, more money for packaging became available, and the better-known illustrators got involved, often producing 'top-quality artwork for some truly crappy films', as Bysouth recalls. This quickly created a problem of its own, though: the public soon grew wise to being cheated by misleading sleeves on unwatchable films, and the distributors reacted by beginning to package their videos with photographic paste-up work instead. This inevitably had a knock-on effect in theatrical film publicity.

Marcus Silversides, who was at Lonsdales over the early 1980s, recalls a lot of problems with *Brainstorm* (1983), Natalie Wood's last film. The distributor repeatedly rejected the initial illustrated quad designs as 'too painterly', and eventually settled for a retouched image that was actually based on a distorted photograph of Silversides's

own head. Shortly after this acrimonious episode, Silversides remembers UIP – the most powerful of the international distributors, and Lonsdales' main film client – issuing a memo that specifically stated that from that point on, painted artwork was not to be used, 'as the public no longer believes in it': photographic paste-ups were instead to be employed as standard, unless already approved US artwork was being adapted.[214] The only exceptions to this rule were rare instances where a deliberately retro look happened to be required: one obvious example would be Brian Bysouth's cheerful quad for *Carry On Columbus* in 1992, when the unlikely revival of a fourteen-year-old film series seemed to call for a traditional comic-caricature style on the accompanying poster.

Vic Fair remembers that increasing 'star power' was also a factor: many stars were getting poster approval by the 1980s, and generally preferred photographs of themselves to artwork, which – being usually based on a still – did not always 'capture the essence of the photo', in their critical opinion. Fair acknowledges that 'of course film posters have always featured big star portraits', but

Hot Dog ... the Movie! (1984). No printer credited. Illustration by Frank Langford, probably from a design by Eddie Paul. A truly witless American comedy, this was almost certainly Langford's last poster for Feref. (AC)

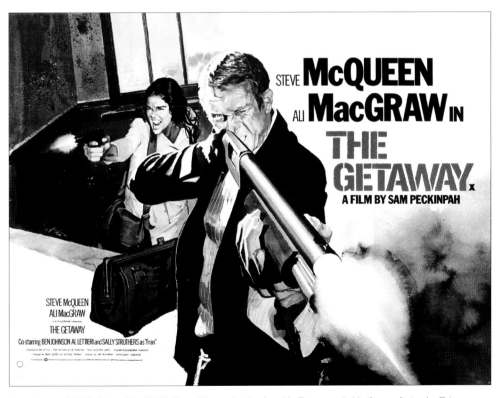

The Getaway (1972). Printed by W. E. Berry. Illustration by Arnaldo Putzu, probably from a design by Eric Pulford. This is the 1979 reissue, and one of Putzu's last British posters, with a striking use of watercolour in place of his usual acrylics. (AC)

The name is Holloway – Colin Holloway. This iconic reference photo was actually taken at Pinewood for *Deadlier Than the Male* in 1966, but was later used by Brian Bysouth on three Bond posters: *For Your Eyes Only*, *View to a Kill* and *The Living Daylights*. (Courtesy of Colin Holloway)

complains that by the end of the decade, the enforced monotony of 'two large photographic heads, which was all they ever seemed to want', had become so restrictive that there was little challenge or creative satisfaction left in the job.[215]

Along with the demise of illustration, something else had changed in poster design. Most movies had traditionally been sold with 'hype', the more shameless, the better. 'There's no room for understatement in advertising' was the credo designers like Tom Beauvais and Tom Chantrell were brought up on.[216] However, from the mid-1980s, understatement actually seemed to become a promotional style in itself. Copywriting took on a new minimalist form, hinting at a film's content with spare, snappy taglines that often deliberately

The Living Daylights (1987). No printer credited. Illustration by Brian Bysouth, from a design by himself and Mike Bell. The last major British poster to feature a painted illustration, and one commanding a record fee – Bysouth was paid £3,000 for this assignment. (AC)

Carry On Columbus (1992). No printer credited. Design and illustration by Brian Bysouth. A curious throwback to a lost era in several ways. The fact that Bysouth has uniquely dated as well as signed the illustration only adds to the feel of an irreverent historical document. (AC)

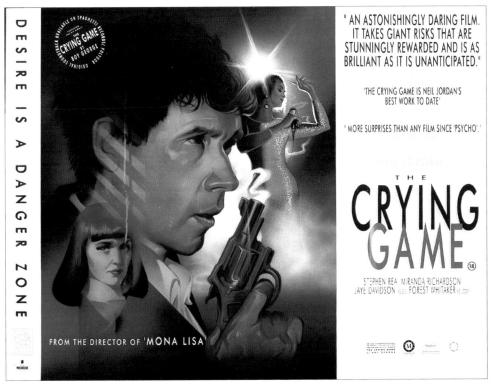

The Crying Game (1992). No printer credited. Design and illustration by David Scutt. A wonderfully stylish poster for a terrific film, but very much the end of the road. By the time this appeared in 1992, illustration on British posters was effectively dead. (AC)

used irony, in line with a perception of audiences as more sophisticated and media literate. This often took the shape of a punchy three-sentence construction – 'It is Evil. It is Real. It is Awakening.' (*Prince of Darkness*, 1988) – that quickly became a cliché. Copywriting minimalism was often also mirrored in poster design imagery, which now tended towards a single key marketing 'logo' repeated in every piece of advertising: for example, *Jurassic Park*'s black-on-red T-Rex skeleton, or *Ghostbusters*' spoof 'No Ghosts' red and white cartoon. At the same time, digital technology meant that illustrations could be electronically adapted to suit any country's poster format, so there was no need for the previous variety of international designs, and posters from around the world quickly became more or less identical.

For a classic illustration of the sea change in poster promotion style, it is worth considering an example like *The Blair Witch Project*, the surprise indie-horror hit of 1999. An ultra-low budget teenage exploitation movie of the sort AIP used to churn out in the 1950s, had this actually been a 1950s film, the posters would have gone into overdrive selling its supremely exploitable mix of unseen terrors and teenagers-in-peril. Quite possibly featuring a trashy full-colour illustration of the Blair witch her/itself looming over a dramatic montage of screaming teen faces, the taglines would have undoubtedly been something

along the lines of: 'SEE the deadly secret of the Haunted Woods! SEE teenagers menaced by the Curse of the Blair Witch! SEE a beautiful girl in peril in the Witch's Lair! WE DARE YOU to sit through 80 minutes of sheer heart-stopping terror!' And so on. Instead, the 1999 poster is a masterpiece of cool understatement. A stark black and white design, it features two photographs, the uppermost a bleak view of an autumnal pine forest, and below that a close-up of the top half of star Heather Donaghue's tearful face staring directly into camera (actually a key image from near the climax of the film). The only taglines are two flat sentences of background information – 'In October of 1994 three student filmmakers disappeared in the woods near Burkittsville, Maryland, while shooting a documentary. A year later their footage was found.'[217]

The change is clearly towards ad campaigns that operate on a more sophisticated level, enticing audiences in with minimalist imagery and low-key copywriting styles, in an effort to market the entertainments in a more ironic, detached, (post)modern manner. Whether this constitutes a positive or negative change is, of course, a matter of personal taste, but it is often hard for fans not to feel a certain nostalgia for the old Hollywood ballyhoo. Even if the films themselves were frequently terrible, at least their posters offered full value for money.

POSTSCRIPT

Film Poster Collecting – From a Hobby to a Business

Paradoxically, if the film poster is in decline, its interest for collectors is undoubtedly on the increase, and has been for the past thirty years. In the 1950s and 1960s, the only way a keen film fan in Britain could obtain original posters was either through a friendly local cinema manager, who might occasionally have been prepared to hand over his old displays to an enthusiastic regular (despite NSS's specific instructions to the contrary), or, on an even more basic level, by discreetly tearing a particular example off a local hoarding. The 'Collectors Corner' back-page

This small Wimbledon fair effectively marked the beginnings of an organised film collecting scene in Britain. However, despite Stan's cheerful optimism, only seven dealers actually turned up on the day, one of whom was a confused antique-watch seller. (Courtesy of Marilyn O'Neons)

feature of *Film Review* magazine (published by Associated British, and sold in their ABC cinema foyers) is a useful record of the development of interest in film posters. Throughout the early 1960s, all the classified advertisements ask for 'articles', 'cuttings', 'photos' or, more occasionally, 'stills' and 'souvenir brochures', generally on specific stars. Appeals for posters, in comparison, are conspicuous by their absence. By October 1966, however, things had started to move. Mr R. Flay of Brighton has 'hundreds of posters for sale, sae for list'. Even more specifically, Miss P. Todd of Morden, Surrey, 'has film posters e.g. *Lord Jim*, *Dr No*, *Thunderball*, *Cleopatra* etc. for sale at 1/6 each'. Mr D. Taylor of Newcastle-on-Tyne offers various Western posters that he wants to exchange for those of *Dr No*, *Goldfinger* and *Where the Spies Are*. In contast Mr A. Temple of Huddersfield wants posters from *Dracula Prince of Darkness*, *Phantom of the Opera*, *Monster of Terror* and *The Mummy*, and offers a 1946–7 *Junior Film Annual* (among other things) in exchange.

Sometimes demand follows distribution, and this sudden interest in posters may well have been stimulated by the contents of stockrooms coming into circulation as a result of the increasing number of cinema closures in the early 1960s. The NSS's centralisation of accessories distribution at Perivale over the same period also undoubtedly helped to open up potential lines of supply. Taking a wider cultural view, new tastes in interior design made the display of cinema posters in the home acceptable for the first time. Ole Christiansen's first Athena poster shop had opened in Hampstead in July 1964, selling an eclectic mix of fine-art reproductions, populist Tretchikoff-type prints and photographic blow-ups of the decade's coolest icons. Riding the Pop Art zeitgeist of the time, the shop was an immediate success, and by the

close of the 1970s a chain of well over 150 Athena stores were open in high streets and shopping centres across the UK, supplying a freshly affluent and vaguely aspirational generation of British teenagers with cheap and fashionable bedroom decoration.[1] All kinds of nostalgic commercial art became an obvious target for reproduction, and, by the mid-1970s, vintage American movie poster reprints were starting to appear. US market-leader printers Portal Publications of California (founded in 1954 by Terence Flynn, initially to import Spanish bullfight posters) began licensing the first scaled-down reproductions of cultish original *The Black Cat* and *King Kong* one-sheets in 1976, quickly followed by more mainstream classics, including *Gone with the Wind*, *The Wizard of Oz* and *Casablanca*. Film posters, slowly but surely, were becoming hip.

Meanwhile, back in the classified ads of *Film Review*, a parallel demand for the real thing was continuing to develop. By the February 1973 issue, Mr C. Carter of Halstead offers 'for sale: quads 30p each – *Big Jake*, *Carry On Cowboy*, *House That Dripped Blood*, *Bridge at Remagen*, *Magnificent Seven* etc.', while Mr P. Thomas of Somerton offers 'posters for *Get Carter*, *Butch Cassidy* and *Battle of Britain* plus others'. Mr A. Taylor of Lincoln has 'For Sale 30" x 40" posters *OHMSS*, *Patton*, *Airport*, *Murphy's War* etc.', which he wants to exchange for 'anything on Italian Westerns'. Alternatively Mr C. Maclean of Hamilton, Lanarkshire, has posters from *Soldier Blue*, *Love Story* and *Madame X*, which he wants to 'swap for *Carry On* and *James Bond* posters'. Even at this early stage, the demand for James Bond material, along with horror (particularly Hammer) titles, demonstrates that the current fad for these posters is nothing new. By the middle of 1973, about 50 per cent of the classifieds in *Film Review* were concerned with posters, either selling in bulk or demanding specific

Primitive London (1964). No printer credited, but probably Broomhead Litho. Designer unknown, but possibly John Payne. To reflect the inevitable hub of the UK collecting scene, the posters in this section are all London-themed. (AC)

London in the Raw (1964). No printer credited, but probably Broomhead Litho. Illustrator unknown, but possibly John Payne. Hands up all those who have thrilled to its gay excitement. (AC)

titles, and from this point onwards they appear to have been top of most collectors' lists. The obvious problem with obtaining posters (or any other form of memorabilia) by post was that it was impossible to see what was actually being purchased until it arrived. What was clearly needed was a forum where collectors and dealers could meet face to face.

Marilyn O'Neons was a graphic designer from Epsom in Surrey who collected film reference books and other material for her work, obtaining it (just like everyone else at the time) mostly via classified advertisements in the movie magazines. Together with her husband, Doug, she also attended Autojumbles at the weekends, and it was his suggestion that she organise a similar event for film collectors.[2] The first 'Moviejumble', as she dubbed the event, was held in September 1973, in Marlborough Hall, Compton Road, Wimbledon. Twenty tables were booked, but only six movie memorabilia dealers turned up to this first fair. Despite this, the fair was a modest success, and

O'Neons began organising two a year, in March and September. The first seven were held at Marlborough Hall, then from 1977 at progressively larger central London venues, including Bloomsbury's Central Hotel and the Royal Horticultural Society's Old Hall, before arriving at Westminster's Central Hall in 1979. O'Neons naturally designed all the advertising for these fairs, featuring her trademark 'Stan & Ollie' caricatures, and the name Moviejumbles still sticks today with some of the older collectors. However, after her twenty-fifth fair, in September 1985 at Kensington Town Hall, she called it a day. Later organisers of the Westminster fairs (based permanently at Central Hall from 1987) include Don Walker, originally of the Chelsea Cine Club, and latterly Ed Mason, a dealer who started out professionally in 1980 with a memorabilia shop in Chelsea Antique Market. The events have now been renamed Collectors' Film Conventions, and at their peak, in the late 1990s, the big fairs featured up to 160 tables.

Soho Incident (1956). Printed by Stafford. Designer unknown, but possibly John Stockle. A moody design for this gangster melodrama, from the days before Soho was associated solely with commercial sex. (AC)

The pioneer in the north of England was Philip Nevitsky, another film fan and collector, who started out organising antique fairs in Rochdale in 1974. He set up the first Movie Mania film fair, with thirty stalls, in Manchester's Houldsworth Hall, Deansgate, in April 1976, following it with other venues at Milton Hall, Deansgate and Methodist Central Hall, Oldham Street, before settling in the Piccadilly Plaza Exhibition Hall in 1978. The Manchester fairs stayed at Piccadilly for fourteen years, at a steady rate of four a year, until 1992, when the venue shifted to Sacha's Hotel, reaching a peak of seven fairs annually. Nevitsky also experimented with other locations, like Birmingham's Central Hall on Corporation Street (five fairs only, between October 1979 and May 1981, the second of which introduced the author to film poster collecting), and Liverpool and Leeds in the early 1990s. However, alongside Manchester, his long-term successful venue has been London's Electric Ballroom in Camden, which began in April 1989, and was still hosting seven fairs a year in 2006.[3]

The third significant promoter from the early days was Teddy Green. He had visited one of the Wimbledon fairs in the mid-1970s, and gradually started buying and selling material, initially just for his personal collection. He launched his own series of fairs, Movie Cons, at the Ivanhoe Hotel on Bloomsbury Street WC1 in January 1979 (shifting to the New Ambassadors Hotel, Euston, in 1986), and in the early 1980s bought out John Thomas's Cine-Search postal memorabilia business, renaming it Movie Finds and later The Movie Guild Archive Club. However, at the end of 1989, Green retired to the south coast to open a small shop in Hastings, and both the Euston fairs and postal business were wound up a year or so later.[4]

From around the end of the 1970s onwards, many other mail-order businesses were set up selling old posters, stills and pressbooks to collectors. Some of the bigger names were the already-noted Cine-Search based on Cranbourn Street WC2, Film Magic in Watford and Movie Boulevard in Leeds, though there were plenty of

Emmanuelle in Soho (1981). Printed by Lonsdale & Bartholomew. Illustrator uncertain, but (according to Fred Atkins) possibly the late Barry James. Twenty-two years down the line from *Nudist Paradise*, this was Britain's last home-grown theatrical sex comedy. (AC)

others that came and went. These generally sold quads at a flat price of around £3 each. Specialist shops also started opening, initially in London. The pioneer had been Fred Zentner, who began selling memorabilia and books in 1967 'from two shelves in an Occult bookshop on Museum Street'.[5] In November 1969, he opened the now famous Cinema Bookshop at 13 Great Russell Street, off Tottenham Court Road, and was there right up to his retirement in July 2005, probably the UK's longest serving dealer. London's first film poster *gallery*, The Chelsea Gallery, was opened in 1974 by Pida Ripley, on the King's Road. Pida's husband, Sydney, had previously run Leonard Ripley & Co., the poster printers in Vauxhall, although much of the gallery's stock actually came via Fred Zentner. A big media launch, with celebrities like Joan Collins and David Hemmings in attendance, ensured maximum initial publicity, but stress and overwork quickly led to a serious illness for its owner, and the gallery closed less than two years later.[6]

Comic collector Danny Posner opened the first Vintage Magazine Shop on London's Cambridge Circus in 1975, selling mostly old comics and magazines, with a small amount of film memorabilia. The film side rapidly grew, particularly after 1980, when the premises moved to what is now the flagship store at 39–43 Brewer Street, Soho. By 2006, there were several branches in London and elsewhere, including an archive in Hackney.[7] One of Posner's earliest customers was Greg Edwards, now Britain's leading poster expert. Originally involved with the Hertford Film Society, and with a background in formal art training (as a designer and illustrator), in 1975, he bought his first film poster (a quad for Kubrick's *The Killing*) from 'a shoebox in the original Vintage Magazine Shop'. The following year, he began a postal business dealing from home, obtaining some of his early stock through classified advertisements in *Exchange & Mart*, in which collections were frequently offered for sale.[8]

In 1978, Edwards, in partnership with Richard Dacre, opened Flashbacks, Britain's first dedicated memorabilia shop, in the foyer of the old Scala Cinema on Tottenham Street. Over the next five years, Flashbacks moved out to Wapping, then back to Soho's Dean Street. In 1985, Edwards split from Dacre, and opened The Cinema Shop on Summer Row in Birmingham, followed by another shop in Edinburgh. In 1995, he returned to London, and started a new gallery, Cinegrafix, just south of the river, in a precinct near Tower Bridge. Cinegrafix closed four years later, and Edwards now continues to sell material over the internet, on his own 'rarefilmposters' website. He wrote and published two books on film posters between 1984 and 1985, and remains more or less the only dealer in Britain to have engaged in any serious research on the subject. Flashbacks, meanwhile, is under Dacre's management, at Silver Place, Soho.

From the early 1980s, many comic and science fiction bookshops began selling small amounts of posters and other memorabilia, as prices were still cheap, and the casual supply of material fairly plentiful. Forbidden Planet had opened on Soho's Denmark Street in 1978, and within two years had added a dedicated 'Film and TV Collectables' department. This was originally run by Phil Edwards, an Australian dealer who also dabbled in freelance cinema journalism for *Starburst* magazine and others. His connections with the film distributors allowed him to obtain large quantities of popular contemporary quads, often by the simple expedient of buying directly into their print runs. The arrangement came to a natural end on Edwards return to Australia in 1983, though, by then, several of his rivals were already being supplied by a handful of London Transport's more entrepreneurial billposters.

The network of supply had previously been heavily dependent on the initiatives of one individual – a kind of low-key 'Godfather' of British film poster collecting and dealing – who, although quite a well-known figure on the scene to this day, is reluctant to appear in this account. Suffice it to say that he had a professional connection with all the major film distributors, buying and selling his first posters in 1965. By the early 1970s, he was discreetly involved with NSS at Perivale, and maintained this key relationship right up to the end of the decade. It is important to understand, though – as our man himself points out – that film poster collecting during this early period was not remotely fashionable, and posters themselves were considered no more desirable or interesting than old fan magazines, for example. Throughout the 1980s, 'new' quads (i.e. those from around 1970 onwards) sold for about £3-5 each, with older titles rising to perhaps £20, depending upon the featured star. Pre-1950s material was very rarely seen. A detectable shift began during the late 1980s, as the crowds attending the fairs became noticeably younger, and prices started slowly rising, particularly on the more hip 1960s titles.

The real sea change for poster collecting in Britain can be precisely dated to 1995, when three separate significant events occurred within a few months of each other. In March, Christie's in South Kensington held its first auction devoted solely to film posters; then in September, the internet online-auction website eBay was launched; and finally, in October, London's first big film poster gallery, The Reel Poster Gallery, opened

Bond Street (1948). Printed by Electric Modern. Designer unknown, but possibly Eric Pulford. (AC)

on Great Marlborough Street W1. Each of these developments can be briefly discussed in turn.

Christie's in London had actually been auctioning film posters since 1985 (and Sotheby's had started a few years earlier still), but these had only been as part of more general memorabilia sales, where posters had not made much overall impact. However, the American branch of Christie's in New York held a dedicated poster auction in 1990 that 'canonized the poster as a collectable', as one US magazine article later put it, and when these auctions quickly became popular annual events, it was only a matter of time before a similar sale was organised in Britain. The 1995 London auction was an enormous success, with its catalogue's iconic cover image of Audrey Hepburn in *Breakfast at Tiffanys* seeming to encapsulate the new stylish ambience the subject had suddenly acquired. On the day, many veteran collectors who attended were bemused at the amounts being paid for material often still available at the fairs for a fraction of the price, but an unmistakable shift in the market was clearly

occurring. Christie's were not slow to capitalise on the buzz that this show initiated, immediately organising two auctions a year (in March and September, to tie in with the big Westminster fairs) from 1996 onwards.

The appearance in September of the internet auction-site eBay was initially a much lower-profile event. The 'internet explosion' arguably dates from the launch of the graphics-based Mosaic browser in February 1993, which allowed even computer novices to 'surf the web' for the first time, and the internet's overall impact in popularising film poster collecting (along with innumerable other previously obscure hobbies and interests) hardly needs stating. eBay was originally put together by an American programmer for his girlfriend, as an online forum enabling her to swap collectable 'Pez' candy dispensers with other enthusiasts across the USA. Catching the public's imagination, it quickly became one of the most popular sites on the internet, and within a year or two featured a dedicated subdivision of 'Entertainment Memorabilia', including lengthy

Piccadilly Third Stop (1960). Printed by Tintern Press. Illustration by Nicola Simbari, from a design by Eric Pulford. (AC)

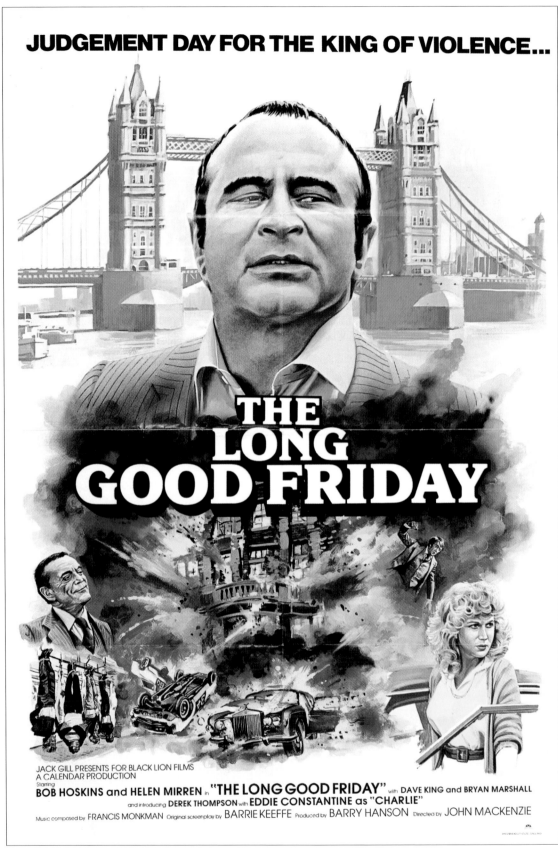

Long Good Friday (1980). Printed by Broomhead Litho. Design and illustration by Tom Chantrell. Bob Hoskins loses his rag in this classic London thriller. (AC)

Pleasure Girls (1966). No printer credited, but probably Broomhead Litho. Illustrator uncertain, but possibly John Payne. Tired of London's bittersweet bedsitterland, and you're probably tired of life. (AC)

Passport to Shame (1959). Printed by Stafford. Designer unknown. London vice exposed, again. (BFI)

film poster listings. These rather resembled the old classified adverts in *Film Review*, except that:

1. The seller could 'post' a photograph of their item on the site, so that everyone could see what was on offer.
2. Potential buyers could then bid against each other online within a set time period, so that the seller got the best possible price.
3. This whole process was far faster and more streamlined than the previous postal or telephone negotiations had ever been.

eBay offered dealers and collectors alike a 'level playing field' without the physical inconvenience of having to lug heavy boxes of posters around the fairs, and the effect on dealer attendance at film fairs is already apparent, as more and more people opt to buy and sell material from the comfort of their own homes. It seems that the days of the specialist shop may also be numbered. In recent years, eBay has also begun to have an interesting democratic effect on prices, bringing middle-range material back down to an easily affordable level and thus keeping the hobby open to everyone.

Finally, in October 1995, the Reel Poster Gallery opened in London, in Great Marlborough Street W1, opposite the fashionable Liberty's department store. Run by Tony Nourmand (who started collecting in 1979) and his associate, Bruce Marchant, Reel Poster was a new way of selling posters in Britain, a stylish gallery environment offering a relatively limited range of material, with modish selection criteria based on aesthetic appreciation of individual designs. This had the dual effect of suddenly repositioning film posters as important works of popular art, while

simultaneously allowing them to be sold at vastly inflated prices. Other top-end dealers quickly followed suit, opening their own swish galleries in expensive central London locations, but Reel Poster has remained the market leader, due in large part to Nourmand's shrewd PR skills and his early links with the organisation of the Christie's auctions. Reel Poster has since published a series of poster books (organised by decade or genre), and its symbiotic relationship with Christie's has ensured that it is the business most usually featured in newspaper and magazine articles hyping the subject.

In summary, then, 1995 represented a watershed in the transition of poster collecting in Britain, from a small-scale hobby into a fashionable money-driven business. Escalating prices, fuelled by a relentless media obsession with the 'lucrative investment' angle, have been accompanied by rumours of price-fixing, rigged auctions and other financial skulduggery.[9] Any suddenly 'hot' new commodity almost inevitably attracts this sort of aggressive speculation, however, and current trends in top-end material have recently tended to focus on 1960s icons like Audrey Hepburn, Steve McQueen and Michael Caine, with James Bond and Hammer posters maintaining their positions as post-war market leaders. Collectors with less mainstream tastes (and more modest budgets) can still pick up offbeat but interesting older quads quite cheaply from the handful of remaining original moviejumble dealers. However, as many of these veterans themselves gradually shift their business onto the internet, or even opt for outright retirement, future 'hands-on' sources for affordable vintage posters will inevitably become increasingly scarce.

CONCLUSION

'Man, If You Have to Ask ... '

The landmark first edition of Leslie Halliwell's *Film Guide* appeared in 1977, containing 8,000 titles catalogued, evaluated and rated with a system of between one and four stars for merit: at the time, an undeniably impressive achievement. Earlier editions of the book (up to its editor's death in 1989) also contained an essay at the end of the volume, encouragingly titled 'Decline and Fall of the Movie'. This was an astonishingly curmudgeonly seven-page rant in which Halliwell explained why he felt almost nothing made after

the end of the 1950s was actually any good. Only four post-1960 films ever gained his maximum four-star 'milestone in cinema history' rating: *Saturday Night and Sunday Morning* (1960), *A Hard Day's Night* (1964), *A Man for All Seasons* (1966) and *Bonnie and Clyde* and you can still sense his rather grudging inclusion of the latter, 'which even made extreme violence quite fashionable', so as not to appear too blimpish. This illustrates the perennial difficulty writers face in maintaining objectivity about their pet subjects. Halliwell, one

Brannigan! (1975). Printed by Lonsdale & Bartholomew. Illustration by Brian Bysouth, from a design by John Stockle. (AC)

of the cinema's foremost historians, quite explicitly thought that the collapse of the studio system at the end of the 1950s had led to an irreversible decline in the cinema as a whole, and this book argues along similar lines that the mid-1980s saw a decline in the genuinely memorable film poster. Can this stance be justified as anything other than personal prejudice?

In a 1991 interview, the artists Sam Peffer and Pat Owen reminisced together about the decline in bookjacket illustration during the 1960s, and its replacement with cheaper photographic paste-ups:

Peffer: '[the publishers had the opportunity to spend less money] … which was what they started doing. Eventually all covers were photographs.'

Owen: 'But for some strange reason it never worked, and they could never figure out why it was. It was like the old film posters. There was an element of drama in the painted film poster

that wasn't there in the film still. So something got put into it in the process of doing the drawing that wasn't there in the first place.'[10]

This succinctly sums up the appeal of the illustrated tradition in film posters. There is a powerful dramatic and romantic quality to painted artwork that is not present in photographs, and this is true even for the lowliest examples of the form. Nobody would seriously argue that Sam Peffer's sexploitation titles of the 1970s are great art, but they are still infinitely more appealing than today's identikit computer-generated tedium. An analogy can be made here with recent advances in special-effects techniques. It is claimed that CGI effects, which sprung up in the wake of *Jurassic Park*, have a limitless potential, but as the images created never actually exist in the real world, they tend to appear flat, lifeless and uninvolving on the cinema screen. This is in contrast to the frequently ropey yet vivid effects work of the 1950s and 1960s, in which craftsmen actually physically constructed

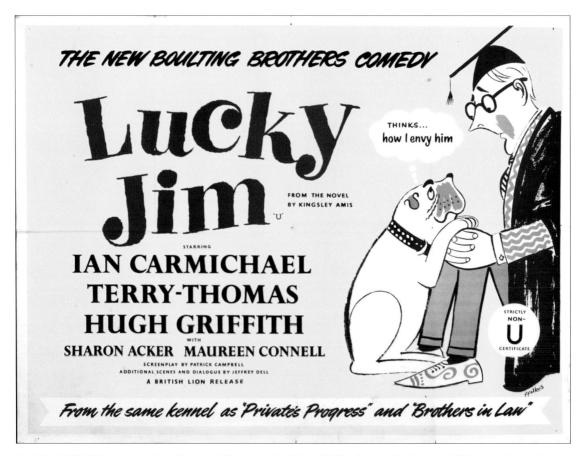

Lucky Jim (1957). No printer credited. Design and illustration by Michael Ffolkes (1925–88). Cartoonist Ffolkes also designed several of the Boulting Brothers' comic title sequences. (BFI)

things on the studio floor – think of Ray Harryhausen's mythological stop-motion creatures, or Les Bowie's regular disintegrations of Christopher Lee for Hammer, or Eiji Tsuburaya's rubber-suited monsters trampling across yet another miniature Japanese city. Computers can now create all of these sequences far more easily and quickly, yet the old magic is somehow lost.

Posters, I would argue, also fit into this 'hand-crafted' tradition. Painted artwork uniquely creates a sense of *anticipation*, the promise of thrills and excitement to come, too exotic to be captured in any mere photograph. The spontaneity of the great designers like Vic Fair cannot be reproduced by a machine, no matter how sophisticated. Some readers – particularly younger ones, perhaps – may well feel bemused by this Halliwell-style tirade, and wonder what is really so different about the film posters of today, compared with those of just twenty or thirty years ago; to which I can only quote Louis Armstrong's reply to the journalist who once enquired what jazz was all about: 'Man, if you have to ask, you'll never know!'[11]

Film posters up to the mid-1980s seem to me to fit into a long and rich tradition of popular folk art, taking in elements like circus and pantomime advertising, the music hall, funfair sideshow hoardings and even old pub and inn signs. The film artists, themselves, were typically from working-class backgrounds – Pulford's father was a butcher, and Chantrell's a variety performer/travelling musician – and these men intuitively *knew* how to capture the popular imagination with exciting and dramatic designs, just as the original printers like Stafford and Berry were hard-headed northern industrialists, cannily servicing the mass-entertainment industries of their time with brashly colourful advertising. This whole powerful and resonant tradition, stretching back in one form or another to the mid-19th century or earlier, has only comparatively recently drawn to a close.

To finish on a personal note, one interesting side-effect of writing a book like this is that it provides a potent sense of history. It seems strange to me now to think that when I bought my first film poster back in 1980, the industry was still operating much as it had done since the end of the war: Lonsdales and Berrys were still printing quads, Eric Pulford was still running Downton Advertising and my later artistic heroes, Tom Chantrell and Arnaldo Putzu, were still designing and painting their own freelance posters. In hindsight, then, I feel that I have been doubly fortunate – not only because the utterly unfashionable status of the hobby in those halcyon days allowed me to quickly build up a collection of my favourite posters on a now-unthinkable 50p a week pocket money, but also because, in the process of writing this book, I have had the opportunity twenty years later of meeting and talking to almost all of the veterans who contributed to making that youthful adventure so exciting. Future generations of fans, still to discover these wonderful images for themselves, will not be so lucky on either count.

BIBLIOGRAPHY

Adler, Alan, *Science Fiction and Horror Movie Posters*, New York: Dover, 1977

Allen, W. E. D., *David Allens, the History of a Family Firm 1857–1957*, London: John Murray, 1957

Barr, Charles, *Ealing Studios*, London: David & Charles, 1980

Bryce, Allan, *Video Nasties*, London: Stray Cat, 1998

Castell, David (ed.), *Cinema 78*, London: Independent Magazines, 1977

Chaneles, Sol, *Collecting Movie Memorabilia*, New York: Arco, 1977

Chibnall, Steve, 'Blood, Toil, Sweat – and Gouache!', in *Paperback, Pulp and Comic Collector* no. 8, Westbury: Zeon Publishing, 1991

Chibnall, Steve, *Quota Quickies*, London: BFI, 2006

Docherty, David, Morrison, David and Tracey, Michael, *The Last Picture Show?: Britain's Changing Film Audience*, London: BFI, 1987

Eccles, J. D. *et al.*, *Films* (Monopoly Commission Report), London: HMSO, 1983

Edwards, Greg, *Book of the International Film Poster*, London: Columbus, 1985

Exton, John (ed.), *British Circus Posters 1930–1960*, Lincoln: CFA, 1994

Eyles, Allen, 'Exhibition and the Cinemagoing Experience', in Robert Murphy (ed.), *The British Cinema Book*, London: BFI, 1997

Feather, John, *History of British Publishing*, London: Routledge, 1988

Gifford, Denis, *The British Film Catalogue 1895–1985*, London: David & Charles, 1986

Haill, Catherine, *Theatre Posters*, London: Victoria and Albert Theatre Museum, 1983

Haill, Catherine, *Fun without Vulgarity*, London: Stationery Office, 1996

Halliwell, Leslie, *Filmgoer's Companion*, London: McGibbon & Kee, 1965

Halliwell, Leslie, *Film Guide*, London: Granada, 1977

Hearn, Marcus *et al.*, *The Hammer Story*, London: Titan, 1997

Hillier, Bevis, *Posters*, London: Weidenfeld & Nicolson, 1969

Horne, Alan, *Dictionary of 20th Century British Book Illustrators*, Woodbridge: Antique Collectors' Club, 1994

Hudson, Graham, *The Victorian Printer*, Princes Risborough: Shire, 1996

Jay, Michael, *Great Movie Posters*, London: Orbis, 1982

Johnson, Tom, *Censored Screams*, New York: McFarland, 1998

Kerekes, David *et al.*, *See No Evil*, London: Headpress, 2000

Kobal, John *et al.*, *50 Years of Movie Posters*, London: Hamlyn, 1973

Kobal, John *et al.*, *Foyer Pleasure*, London: Aurum, 1982

Livingstone, Alan, *Thames and Hudson Encyclopaedia of Graphic Design and Designers*, London: Thames and Hudson, 1992

Lumgair, Christopher, *Desktop Publishing*, London: Hodder, 2000

MacNab, Geoffrey, *J. Arthur Rank and the British Film Industry*, London: Routledge, 1993

McGillivray, David, *Doing Rude Things*, London: Sun Tavern Fields, 1992

Morella, Joe *et al.*, *Those Great Movie Ads*, New York: Galahad, 1972

Noah, Emil, *Movie Gallery*, Fort Lauderdale: Noah Communications, 1980

Ogilvy, David, *Ogilvy on Advertising*, London: Pan, 1983

Perry, George, *The Great British Picture Show*, London: Pavilion, 1974

Perry, George, *Forever Ealing*, London: Pavilion, 1981

Pout, Dudley, *The Life and Art of One Man of Kent*, Rainham: Meresborough, 1982

Presbury, Frank, *The History and Development of Advertising*, New York: Doubleday, 1929

Printing Trades Directory (Annual), London: Benn Brothers, 1969

Rebello, Stephen and Allen, Richard, *Reel Art: Great Posters from the Golden Age of the Silver Screen*, New York: Artabras, 1988

Schapiro, Steve and Chierichetti, David, *The Movie Poster Book*, New York: E. P. Dutton, 1979

Simmons, Rosemary, *Collecting Original Prints*, London: Studio Vista, 1980

Strevens, Peter (ed.), *Selling Dreams* (Exhibition Catalogue), Cardiff: Welsh Arts Council, 1977

Sweeney, Russell, *Coming Next Week*, New York: A. S. Barnes, 1973

Timmers, Margaret (ed.), *The Power of the Poster*, London: Victoria and Albert Museum, 1998

Treasure, John, *The History of British Advertising Agencies 1875–1939*, Edinburgh: Scottish Academic Press, 1977

Vance, Malcolm, *The Movie Ad Book*, Minneapolis: Control Data Publishing, 1981.

Weill, Alain, *The Poster: A Worldwide Survey and History*, London: Sotheby's, 1985

Wilson, David (ed.), *Projecting Britain*, London: BFI, 1982

NOTES

Preface and Introduction

1 Wilson (1982) and Edwards (1985).

2 Quoted in Halliwell (1965).

3 Historically, American posters have conformed to the more obviously restrictive one-sheet portrait format.

4 Both roughs are reproduced in Strevens (1977).

5 Interview with Ian Hedger, October 2002.

6 Interview with Brian McIlmail, May 2002.

7 Interview with Peter Lee, October 2002. The plates themselves would have been stored for a time afterwards, in case the film turned out to be an unexpected success and a quick reprint was required to cover additional bookings.

Part One

1 Perry (1974).

2 Eyles (1997).

3 Perry (1974).

4 The films of Disney, the ninth important Hollywood name, were distributed by RKO between 1936 and 1954. Smaller studios such as Monogram and Republic, both specialising in B-movies, Westerns and serials, also had distribution deals in the UK.

5 Eyles (1997).

6 Ibid.

7 Ibid.

8 Ibid.

9 Quoted in Allen (1957).

10 The history of printing techniques and the theatre poster are described in Weill (1985) and Haill (1983).

11 Czech lawyer Alois Senefelder discovered lithography in Prague in 1798. It was based on the simple premise that oil and water will not mix: a design was drawn onto a flat slab of absorbent limestone with a greasy crayon, then the stone wettened and a coat of ink applied with a hand-roller. The oily printing ink was thus *attracted* to the greasy crayoned outlines, but *repelled* by the thin film of water on the blank areas, and when a fresh sheet of paper was pressed onto the treated stone, it came away with a clean impression of the original drawing printed onto it. The technique reached England in 1824 via the printer Charles Hullmandel, who opened premises at 51 Great Marlborough Street W1, the first professional business to be set up outside Germany.

12 Quoted in Weill (1985).

13 See Hillier (1969).

14 See Weill (1985). Victorian and Edwardian theatre posters actually have a far better survival rate than pre-1940 film posters, due to legislation in force between 1842 and 1912 that allowed designers, printers or theatrical proprietors to register the copyright for their publicity at Stationers' Hall on Ludgate Hill. In addition to the payment of a small fee, an actual copy of the poster itself had to be filed with the application, and a unique collection of these items has thus survived at the Public Record Office in Kew. However, with painful irony, just as illustrated *film* posters were beginning to appear in Britain, in April 1912 the regulations were amended and it was deemed no longer necessary to deposit a copy of the poster – brief written details instead became sufficient.

15 Chromolithography was first patented in 1837 by Godefroy Engleman. It used the superimposition of the three subtractive primary colours – cyan blue, magenta red and yellow – via separate printing of each on individual, carefully aligned stones. Intermediate tones were thus created by skilful overprinting of the translucent inks, their relative strength and density controlled by the amount of crayon used when drawing the initial images on the stone. A fourth colour, black, was sometimes also added to improve overall definition, which eventually led to the standard four-colour 'CMYK' process still in use today. The actual process of producing a correctly registered multicolour print employed a further new highly skilled technique known as transfer lithography. The master lithographer, using

his piece of supplied artwork as a reference, first drew the so-called keystone in black, in effect a 'painting-by-numbers' guide, in which every outline corresponded to a colour difference in the original, no matter how slight. Three (or more) separate impressions of this keystone were made on special sheets of coated 'transfer paper', which were then dusted with a water-soluble blue dye that adhered only to the inked outline image. These sheets were then fixed to new freshly dampened stones and run through the press again, resulting in the transfer of the *non-ink-accepting* image onto each colour stone itself – a perfect facsimile of the original. The colour artists would then crayon in the required areas of colour onto their respective 'proving stones', using this transferred outline image as a guide.

Hard Boiled Mahoney (1947). No printer credited. The posters in this final section have all been selected as representative examples of the various printing techniques. This is a basic two-colour hand-drawn litho. (AC)

16 Automation was really the key event ushering in the 'era of the poster', however, following Georg Sigl's invention of a steam-driven flatbed litho press in Vienna in 1851. This utilised automatic rollers to moisten and ink the stone, while the paper was pressed into contact by a revolving cylinder encased in a rubber blanket. British engineers Hughes & Kimber perfected this design in London in 1865, but just three years later, more efficient rotary presses first started to appear. These replaced the stone blocks with a zinc plate curved round a cylinder, speeding up production. Stone and zinc-plate processes (collectively known as 'direct' lithography) then competed for about sixty years, until the more cumbersome stone litho died out in the late 1920s.

17 Allen (1957).

18 *Nottingham Illustrated*, Summer 1887.

19 Ibid. One enormous poster in production was a 56-sheet double crown – 'one of the largest ever produced' – for 'Buffalo Bill's Wild West', requiring 224 double crown stones to complete. Buffalo Bill's show appeared, to great excitement, at London's Earls Court in May 1887, during its three-year tour of Europe.

20 Ibid. Historically, the two principal UK engineering firms building large-scale litho presses were both based in Leeds: George Mann & Co. (est. 1871) and R. W. Crabtree & Sons (est. 1895). The pair actually merged in 1965, then six years later, on Mann's centenary, were further amalgamated with another two local press manufacturers to make the conglomerate Crabtree Vickers, which survived until 1992. The names might not mean much nowadays, but nevertheless the vast majority of posters discussed in this book will have been printed on either Mann or Crabtree presses. <www.companies-house.gov.uk>

21 Quoted in Haill (1996). By this time, the works had expanded onto adjoining land, and, by 1914, would cover a very sizable plot bordered by Forester Street, Bailey Street and Victoria Road.

22 The names of the various sizes are taken from their original watermark images, and are frequently archaic – Foolscap, for example, originally showed a jester's cap and bells, and was supposedly first introduced by Cromwell on Commonwealth state papers as a joke at the expense of the recently executed Charles I. Post featured a bugle, Copy a fleur-de-lys and Pott the English Arms. See Feather (1988).

23 This original system gradually fell into disuse after the Second World War, as the modern German 'Metric' series was adopted across Europe, finally becoming the official International Standard in 1975.

24 Double crowns were also called 'single sheets', and often referred to as 'bus fronts' or 'bus backs' as this was where they were principally displayed. Interview with Ian Hedger, October 2002.

24 Shapiro (1979).

26 Happily, copies of the accompanying catalogue (Strevens, 1977) are still quite easily found.

27 Edwards (1985).

28 Perry (1974).

29 *The Fairy Bottle* was printed by the short-lived Barway Press, responsible for several of the earliest illustrated posters in the 'Selling Dreams' exhibition. Kelly's London Street Directory lists them at 11 Duke Street, Adelphi WC in 1913, and four years later gives an additional works at Wharf Road, Notting Hill. However, they seem not to be listed after the end of the war.

30 In common with other UK three sheets of the period, it is in fact 90" x 40" (i.e. three quad crowns), printed in two separate sections, a double quad crown, together with a single quad. The later shorter size of 81" x 40" (based on the US format) did not appear in Britain until after the war.

31 *Daily Express*, 18 January 1916.

32 The decision was taken after considering 200 other rival sites, and so was an indirect tribute to the company's main facility. Allens were eventually paid £315,000 compensation, universally agreed as a fair sum for an extremely valuable asset. The works were eventually closed in 1980, and later demolished to make way for the new Harrow Crown Court and Hailsham Drive access road.

33 Straightforward sentiment kept the antiquated works on Corporation St, Belfast, in operation long after their profitability had demonstrably ended. In 1928, a recommendation was made that they be closed, but instead a new company was formed to run them, in a brave but ultimately futile attempt to finally make them pay. The stocks that were part of this deal included 'some millions of old theatrical posters for which there was still a demand in 1928', but when defeat was acknowledged, and the works finally shut down in 1940, 'what remained were sold as wastepaper to the Ballyclare Paper Mills'. Allen (1957).

Love's a Luxury (1952). Printed by Electric Modern. Two-colour hand-litho. (AC)

34 A door panel for Chaplin's *The Gold Rush*, although correctly dated in terms of *production* to 1925, is in fact a 1940s reissue.

35 Allen (1957).

36 Strevens (1977).

37 After the Second World War, Allens gradually expanded their billposting territories in Ireland, Scotland and the north of England. In 1965, the company merged with Mills & Rockley, the second largest billposting firm then in operation in Britain. (The other significant name in the trade was the Hill group, which controlled London and much of the south.) In 1928, Mills of Coventry had joined with Rockley of Nottingham to form a new alliance, which soon expanded out of the Midlands into the south-west, via company acquisition. The merger of Allens and M&R, which led to the formation of a fresh company, Mills & Allen, therefore put the new partners in a position to carve up much of the country (outside of the capital) between them. Although ownership of the firm has changed hands several times, Mills & Allen is still the biggest name in 'poster contracting' – as it is now known – in Britain.

38 According to the founder's great-grandson, Peter Lee, William Edward was really more of a salesman than a printer, an entrepreneur who enjoyed mixing with his clients and travelling around the country chasing business. He had a fixed weekly routine of commuting down to London first class every Monday and installing himself in a Piccadilly hotel suite with his name on the door. He spent the week getting work for Nesfield Street and travelled back to Bradford on the Friday, arriving home at 11 Apsley Crescent quite late in the evening. In fact, it was rumoured that he was actually back in the city by about lunchtime, and discreetly spent the remainder of the afternoon with a lady friend, at her house behind Bradford Cathedral. Interviews with Peter Lee, April 2002–March 2005.

39 Fred Martin of Paramount was also responsible, in 1923, for introducing W. E. Berry to his friend Bertram Mills, who was then in the process of starting up a circus. According to Peter Lee, the circus was at the time so disreputable that William Edward initially swore that he would rather pack the business in altogether than produce posters for something so 'non-U'. But he was eventually persuaded, and discovered a highly profitable new source of revenue. Thanks to the outstanding talents of their designer, Leon Crossley, Berry's posters for Bertram Mills are now world famous.

40 Presbury (1929).

41 Treasure (1977).

42 Livingstone (1992). An important distinction here is between a 'full service' agency, which offers the space-buying facilities noted above, and a 'design studio', which produces creative work only.

43 The first American agency to be established specifically for the movie industry was Diener Hauser Greenthal,

set up in the early 1950s by 'noted film buff' Monroe Greenthal, while the two other specialist US film agencies of the 1960s were Charles Schlaifer and W. H. Schneider Inc. Morella (1972).

44 Interview with John Raymer, May 2003.

45 *The Times*, 14 November 1923.

46 Interview with Peter Brunton, March 2003.

47 Interview with Colin Holloway, May 2003.

48 Interview with Stan Heudebourck, September 2001.

49 Interview with Peter Brunton, March 2003.

50 Jordison & Co. formed in July 1887 with a major works on Cargo Fleet Lane, Ormesby, Middlesborough. By 1910, they had also opened a London office at 26 Litchfield Street, off Charing Cross Road. According to Peter Lee of W. E. Berry (interviewed October 2002), they were involved 'on the fringes of the business' in film material right up to the 1960s, though if this is the case they do not seem to have put their name on any posters after the war. The firm was dissolved in 2000. Another northern printer apparently briefly involved around the same period was Chorley & Pickersgill of Leeds, who seem to have printed a few early posters for Cecil Hepworth. Timmers (1998).

51 The insert is illustrated in Rebello and Allen (1988).

52 Jay (1982).

53 Johnson (1998).

54 *The Times*, 3 August 1932.

55 Johnson (1998).

56 Reporting on the LCC's Entertainments (Licensing) Committee, *The Times* of 20 June 1933 discussed the new measures under the heading '"Horrific" Films – LCC and Admission of Children', and concluded, 'Every poster, advertisement, sketch or synopsis of any film passed by the BBFC which is displayed, sold, or supplied either inside or outside the premises, shall indicate in a clear and legible manner the category A or U in which the film has been placed by the Board. Except with the express consent of the Council in writing, no poster [etc.] shall be displayed [etc.] which depicts any scene or incident not included in the version of the film passed by the Board.'

57 There were eighteen 'Horrific Advisories' and thirty-seven 'H Certificates' awarded in total.

58 Illustrated in the catalogue *Vintage Film Posters*, Christie's, South Kensington, 19 May 1997.

59 Some campaigns offered alternative logos. GFD's campaign for Anthony Asquith's prestigious *Moscow Nights* (1936) used the double crown to supply an alternative to its preferred stylised typography. In fact, the double crown was frequently used in this way – see, for example, Wardour's campaign for the Clifford Mollison comedy *Almost a Honeymoon* (1930).

60 British Lion's pressbook for the rather less ambitious comedy *Mr Stringfellow Says No!* (1937) also insisted that its full-colour lithographed posters would 'attract attention far better than an uninspired hand-lettered job'.

61 *Picturegoer*, 25 April 1936.

62 The artwork was a significant improvement on the Gaumont-British designs for Jessie's earlier film, *It's Love Again* (1936), in which her face was barely recognisable.

63 *Dark Eyes of London* pressbook.

64 Interview with Eric Pulford, May 2003.

65 American poster artists are rather better documented than their British counterparts. Some of the more well-known names operating since the war would include: Saul Bass (1920–96), Reynold Brown (1917–91), Jack Davis (b. 1924), Frank Frazetta (b. 1928), Al Hirschfeld (1903–2003), Albert Kallis (b. 1929), Frank McCarthy (1924–2002), Robert McGinnis (b. 1926), Bob Peak (1927–92), Joseph Smith (1912–92) and Howard Terpning (b. 1927). Three important younger contributors are Richard Amsel (1947–85), John Alvin (b. 1948), and Drew Struzan (b. 1946), all of whom began poster illustration in the 1970s and now enjoy something approaching celebrity status on the basis of their work. (Amsel, probably the most talented of all, was unfortunately an early victim of AIDS.) Their work is unquestionably familiar to generations of British cinemagoers thanks to its widespread reproduction on dozens of domestic quads.

66 Feather (1988).

67 Quoted in Chibnall (1991).

68 Haill (1996).

69 Ibid.

No Place for Jennifer (1949). Printed by Electric Modern. Two-colour hand-litho. (AC)

70 Livingstone (1992).

71 Interview with Roger Hall, December 2003.

72 Group interview with Fred Atkins, Brian Bysouth and Colin Holloway, May 2003.

73 Bevis Hillier (1969) does include a few snippets about Morrow in his invaluable 'England to 1914' chapter of *Posters*, which otherwise deals chiefly with Hardy, Hassall and the Beggarstaffs.

74 Interview with Greg Edwards, January 2003.

75 Interview with Stan Heudebourck, September 2001.

76 Information about the family was supplied by Tom Beauvais in a series of interviews between July 2001 and June 2003.

77 His father, also Charles Henri, was not an artist, however – a document in the family's possession gives his profession as either 'horse contractor' or 'house contractor', depending on the interpretation of the handwriting.

78 This only happened by a fluke of timing: being a Fox film, it automatically went to Allardyce Palmer, but their art director, Tom Chantrell, was away on holiday. Arnold's son, Tom Beauvais, was by then working at Allardyce, and it was suggested that his father could perhaps do the required illustration instead. The design and lettering was therefore prepared in the studio by his son and Alan Oldershaw, but the actual painting itself was given to the seventy-year-old Arnold.

79 Pout (1982).

80 Silkscreen printing (now generally known as 'screenprinting') employs a simple stencil and ink method of reproduction whose roots can ultimately be traced back to ancient China and Egypt. To be properly effective, however, most stencils need to be supported on some kind of mesh, and the first modern patents for the process were taken out in 1907 by Samuel Simon, a fabric printer from Manchester. In 1914, John Pilsworth, a signwriter from San Francisco, extended its application to mass-produced advertising boards and posters. Pilsworth used a sequence of hand-cut paper stencils mounted on bolting cloth stretched over a frame and inked, to progressively build up a *multicoloured* design. The director of a British milling firm, Lt. Col. Mayhew, obtained the UK patents for this process in 1918 and set up a company named Selecticin in London. By the mid-1930s, the Scottish firm McCormack began manufacturing a machine to screenprint posters in which ink was forced through the mesh of the screen by a 'squeegee'. Finally, in the early 1940s, Colin Sharp, a chemist at the Autotype company in Ealing, developed the photographic stencil. The screen mesh is coated with a light-sensitive gelatin emulsion that, when dry, blocks the holes in the mesh. The image to be printed is developed in a camera, then the positive film and screen mesh are sandwiched together and exposed to ultraviolet light in a contact frame. A jet of water washes away all the emulsion not hardened by the UV light, leaving an open stencil corresponding exactly to the original image on the film. Different coloured overlays on the original design can be used to create separate stencils for multicolour printing. See Simmons (1980).

Silkscreen posters are easy to distinguish from lithographs, as they feature only solid blocks of colour, with no true variation of tone and little detail. Photographic reproduction is comparatively crude, and uses tell-tale large black dots. As a process, silkscreening was much slower and more laborious than lithography (although cheaper) and its print runs were considerably smaller – in the low hundreds, compared to lithography's low thousands. Screenprinting was generally reserved for supporting-feature posters, though when employed with imagination, its vivid blocks of colour could sometimes create genuinely arresting images.

Berlin Correspondent (1942). Printed by Stafford. Three-colour (yellow, red and blue) hand-litho, which, due to wartime paper rationing, also features part of an older billboard 24-sheet printed on the back. (AC)

81 Pout had married Vida, the daughter of a neighbouring farmer, in 1932.

82 On Ealing Studios, see Perry (1981) and Barr (1980).

83 Wilson (1982). The title, *Projecting Britain*, is taken from the first chapter of Charles Barr's seminal book on Ealing.

84 Edwards (1985).

85 Early posters included *So Near Yet So Far* and *Lieutenant Daring and the Photographing Pigeon* (both 1912).

86 The Ealing connection ended in 1950, and Waterlows were bought out by De La Rue & Co. Ltd ten years later.

87 Quoted in Wilson (1982).

88 As the majority of these men have previously achieved critical recognition as key figures in post-war British commercial art, fuller biographies of each can already be found in Alan Horne's *Dictionary of 20th Century British Book Illustrators* (1994), and only the briefest introduction to their respective careers is given here.

89 Quoted in Wilson (1982).

90 Ibid.

91 Ibid.

92 Ibid.

93 Ibid.

94 The *Dead of Night* quad was printed by the prestigious fine-art printers Chromoworks Ltd. First established in 1917 at 416–424 High Road, Willesden Green NW10, they briefly dabbled in film posters – notably *Brief Encounter* (1945) – for Rank in the mid-1940s.

95 Door panels 60" x 20", and generally printed in two double crown sections) seem to have appeared principally in the 1940s. They were used by Ealing, on films like *Dead of Night* and *San Demetrio, London* (1943), and also for Rank's later Gainsborough melodramas, such as *Dear Murderer* and *When the Bough Breaks* (both 1947). The size was rather awkward to design for effectively, being even taller and thinner than a three-sheet, and seems to have been little used after about 1950, though later examples do intermittently crop up – for example, *My Beautiful Laundrette* (1985).

96 On his death in 1978, Hurry left many of his designs and posters, including *Dead of Night*, to his nephew, the film-maker John Armstrong.

97 Medley was certainly responsible for the baroque *Saraband for Dead Lovers* (1948), Ealing's first colour costume drama, an expensive project suggested to the studio by Rank, and not a commercial success.

98 Wilson (1982).

Part Two

1 Eyles (1997).

2 Ibid.

3 The Monopolies and Mergers Commission did investigate this set up in both 1966 and 1983, but found the system too deeply entrenched to recommend any effective changes. Eccles (1983).

4 Interviews with Alan Wheatley, October 2002–March 2005.

5 The standard arrangement with the police, when caught red-handed, was apparently that any posters left in the van were seized, while those already pasted up on the hoardings were discreetly ignored.

6 Eyles (1997).

7 Perry (1974).

8 Interview with Peter Lee, March 2005. The standard double quad was confusingly referred to as a 'four-sheet' in the advertising trade, as it is four double crowns in size. Throughout the 1950s, a standard quad cost 3/- (15p) according to the pressbooks. In 1963, the price rose to 3/6 (17½p), which lasted until decimalisation in 1971, when the price went up to 20p. The decade's spiralling inflation rates had pushed this right up to 75p by 1980. In 1986, the final year we need consider, new quads cost cinema managers £1 apiece. However, the contemporary inflation-adjusted equivalent of *all* these different prices is actually a consistent £2 each. How much profit this represented for the ad-sales departments of the time depended entirely on the size of the print run. This is illustrated by a note in one of Alan Wheatley's old job books, listing Broomhead Litho's quad prices as of July 1979 – for an *original* run, 500 copies cost £695, 750 cost £710, 1,000 cost £725 and 2,000 cost £915. Later reprints from the original plates were cheaper, as the plates had already been made. Very occasionally the print buyers could be caught out with this: another of Wheatley's account books notes that he made a rare overall loss on the campaign for *House of the Long Shadows* (1983), for example. Larger sizes were an expensive luxury: a three-sheet cost almost four times as much as a quad, and a six-sheet was more than five times the quad price.

Blonde from Brooklyn (1945). Printed by Stafford. Standard four-colour hand-litho, including a black plate for definition. Three-colour cannot recreate pure black, and has to make do with a distinctive muddy brown. (AC)

9 Interview with Brian McIlmail, May 2002.

10 Docherty *et al.* (1987).

11 Interview with Peter Lee, March 2005.

12 Francis Marshall took up drawing after five years of sea-faring. He spent eight years on the staff of *Vogue*, sketching fashion and social events, before leaving, in his own words, 'to get some of the fashion out of my system'. *A Matter of Life and Death* pressbook, Steve Chibnall Archive.

13 Edwards (1985).

14 The latter prompted C. A. Lejeune to write in the *Observer* (17 May 1953) that 'The most interesting contribution to the week's cinema has been not a picture, but a picture about a picture: Ronald Searle's delightful poster for *The Oracle*.'

15 Apicella was born in Naples in 1922 but moved to England in 1954, designing many posters, particularly for Schweppes, and later the interiors of dozens of Pizza Express restaurants. Timmers (1998).

16 Interview with Tony Tenser, May 2003.

17 Interview with Greg Edwards, January 2003.

18 McGillivray (1992).

19 Chibnall (2006).

20 Hearn (1997).

21 Ibid.

22 Derek Hill, 'The Face of Horror', *Sight & Sound*, winter 1958–9.

23 Carreras never missed a trick for self-promotion: Hammer's 1967 fantasy *Quatermass and the Pit* is partially set in a London tube station, and Chantrell's posters for the previous year's releases, *Dracula Prince of Darkness* and *The Witches*, are clearly visible on the walls behind the actors.

24 Interview with Mike Wheeler, April 2003.

25 Interviews with Tom Chantrell, May 1996–July 2001. Ireland has traditionally had the toughest censorship for poster advertising, and right up to the early 1980s even relatively bland designs were doctored, sometimes by individual cinema managers. Immodest displays of leg or cleavage were painted out, so that, for example, the originally nude heroine of Graffiti's *Werewolf Woman* (1980) suddenly acquired a fetching black bikini-top and matching briefs. Sometimes the posters would go back to the printers, to have the required alterations silkscreened over the top of the original artwork. Interview with Brian McIlmail, May 2002.

26 Interview with Colin Holloway, May 2003.

27 Stafford's earlier quads usually show individual stock numbers in their bottom right-hand corner, which can be a useful chronological indicator of their printing, but do not refer to differing styles. There were two different sequences in operation during the 1940s: a 'C' prefixed series for Columbia, and an 'A' suffixed series for everyone else. In January 1950, a new digit-only sequence began for all distributors, which continued up to December 1955, when the practice was finally discontinued altogether.

28 Interview with Colin Holloway, May 2003.

29 Interview with Ian Hedger, October 2002.

30 Interviews with Alan Wheatley (December 2002) and Peter Brunton (March 2003).

31 Interview with Tom Beauvais, June 2003.

32 Interview with Stan Heudebourck, September 2001.

33 Interview with Dave Sands, October 2002.

34 Interview with Stan Heudebourck, September 2001.

35 Interview with Dave Sands, October 2002.

36 Interview with Tom Beauvais. The pair were initially based on Charterhouse Street, followed by offices on Percy Street and Chancery Lane, with Chapman very much the business head, and Beauvais in charge of the creative side.

37 The majority of Dixon's business, however, was commercial – the major accounts were New Zealand Butter, L'Oreal Hair Colour and Metal Box. Interview with Peter Brunton, March 2003.

38 Ibid.

39 Interview with Eric Pulford, May 2003.

40 Interview with Colin Holloway, May 2003.

41 Ibid.

42 Ibid.

43 Interview with several ex-Downton staff, May 2003.

44 The name Feref – in case the reader has not already spotted it – was a simple acronym of their first initials, though it also happens to be an old Malay term for 'artist's paint'.

45 Interview with Fred Atkins, May 2003.

46 Ibid.

47 Interview with David Kemp, January 2003.

48 Copying Feref's lead, Downton's also gave itself belated credit on a few of its mid-1980s quads, including Vic Fair's design for *Silver Bullet*, at the artist's own suggestion. Following Eddie Paul's death in 1984, his son Ken took over, and ran Feref until his own retirement in 1999. By that time, operating from new offices at 14–17 Wells Mews, Feref was handling work for almost all the major UK distributors, and has since enjoyed continuing success. Having changed hands a couple of times in the last few years, however, there are now no real connections left at all with the original 'gang of five'. Interview with Ken Paul, June 2003.

49 Interview with Peter Brunton, March 2003.

50 Interview with Colin Holloway, May 2003.

51 Interview with Dave Sands, October 2002.

Gigantis the Fire Monster (1960). No printer credited. 'Halfway House' litho printing – a photographic black plate, with hand-drawn colours. (AC)

52 Interview with Peter Brunton, March 2003. The original 'Downton Advertising Ltd' had been quietly dissolved in February 1994, and its final incarnation as K Advertising similarly bit the dust in January 1998.

53 Interview with Ian Freeman, March 2003.

54 Interview with James Halfhyde, February 2003.

55 Interview with Mike Cohen, March 2003.

56 Interview with John Raymer, May 2003.

57 Correspondence with John Raymer, June 2003.

58 Interview with Mike Cohen, March 2003.

59 Interview with Ray Norton, February 2003.

60 Interview with Fred Atkins, May 2003.

61 Interview with Ken Paul, who eventually became the company's managing director, June 2003.

62 Interview with Peter Brunton, March 2003.

63 For example, *Carry On Cowboy/Change Partners* (1965), a 70/30 split with an Edgar Wallace thriller, was illustrated by Chantrell, and carried the 'Rex Publicity' credit in the bottom left border, opposite Leonard Ripley's traditional printer byline.

64 Interview with Peter Brunton, March 2004.

65 Interview with Graham Rowsell, February 2003.

66 Interviews and correspondence with Paul Brown-Constable, February 2003. With the advent of DTP design packages Graffiti changed direction, abandoning advertising work for publishing. A new company, Graffiti Editions Ltd, was established in 1991, producing showbiz magazines and periodicals that have most recently included titles like *Exposure* for Fuji, *Academy* for BAFTA and *Foyer*, an independent film-festival guide. Now based in a new studio at 4 Margaret Street W1, as Brown-Constable comments, Graffiti 'started out as a two-man outfit', and successfully remain so, well over thirty years later.

67 Interviews with Alan Wheatley, October 2002–March 2005.

68 Compton's previous publicity head, Graham Whitworth, had just left to set up his own firm Arrow Publicity Associates, which lasted for about five years and produced a handful of quads, including 1968's *An Idiot in Paris*.

69 They included premises on Wardour Street, Bateman Street, Ham Yard, Great Windmill Street, Lexington Street, Carlisle Street, Percy Street and Poland Street.

70 NSS's print buyer Ian Hedger suggests that 3,000 would have been average for a typical mid-1970s quad, broken down into 150 for London Transport, 100 for British Transport, 1,100 for 'away from theatre' sites and 1,500 for the circuit release.

71 His real ambition was to be a set designer for film and television. Interviews and correspondence with Mike Wheeler, April 2003.

72 MWP also produced theatre posters for London Management (often touring productions showcasing stars such as Sid James, Hylda Baker and Roy Castle) and handled PR for various artists, including Kenny Ball and his Jazzmen. Ibid.

73 However, in 1995, during the run up to Rank's sale to Carlton, his job effectively ceased to exist, and Wheeler now works as a freelance unit driver for the film studios, ferrying stars to and from Shepperton and Pinewood's sound stages. As he notes, 'It is interesting now to sit on this side and observe the change in poster design, some of which is terrific, but some of which is downright awful … particularly when driving around, you realise that the designers often fail to consider legibility, or the old motto that I was brought up on: WHO, WHAT, WHERE, & WHEN!' Ibid.

74 Ogilvy (1983).

75 Interview with Tom Beauvais, March 2002.

76 Various interviews with Tom Chantrell, May 1996–July 2001.

77 Beauvais is cynical about this side of things, though: 'You'd work frantically to get a piece of artwork finished for a client who was insisting they needed it ASAP, then when Stan or whoever rushed it around to their office for approval, they'd be out having a haircut – you know – and the secretary would promise to show it to them later.' Interview with Tom Beauvais, March 2002.

78 The footage is included in *Hammer: The Studio That Dripped Blood*, BBC Television, 1987. Carreras's producer-partner, Anthony Hinds, has also reminisced about this: 'A week or two before going on one of his regular trips to the States to try and drum up some business [Carreras] would ask me what ideas I had for

future productions. I would come up with about a dozen titles – some of books submitted, rarely of scripts – mainly just titles I thought would make good pictures. [...] He would then choose the ones he fancied most, and have colourful posters made – which sort of gave the impression the thing had already been shot. [...] He would then produce these posters at his meetings with the American majors, saying "How would you fancy this for $200,000?"!' *Dark Terrors*, no. 16, November 1998.

Konga (1961). No printer credited. Four-colour hand-cut silkscreen. Judging by the fine detail on Konga's body, the black screen appears to have been hand-painted directly onto the mesh. (AC)

79 Youngs was actually in the *life*-drawing class: 'When Chan saw my paintings of naked ladies, he liked the look of this so came along to join, but as the life class was full he had to enrol in the still-life class instead, painting Greek busts and urns!'

80 Interviews with Shirley Chantrell, July 2001 – June 2003.

81 An insight into his growing frustration a few months prior to his departure is provided by a letter dated 10 February 1972, which he wrote in reply to one of the directors of Allardyce who had complained that both Chantrell and Youngs (then sharing a cramped office) were not always at their desks by 9 a.m. Chantrell opens

by itemising his and Ray's joint output over the preceding two months. Taking December 1971 alone, this comprises: '16½ days – 70 jobs. 8 quad poster layouts/7 quad poster finished drawings/7 quad poster revised finished drawings/16 double crown poster layouts/1 trade ad finished drawing/7 trade ad layouts/15 press ad layouts/3 press ad finished drawings/1 bus side poster layout/1 location sketching job at Warner Brothers/2 screenings/3 meetings/+ various miscellaneous jobs (displays etc.).'

January 1972 provides a similar list, and Chantrell then gives the thirty film titles involved, which include *The French Connection*, *Le Mans*, *Clockwork Orange*, *Klute*, *Dirty Harry*, *Butch Cassidy and the Sundance Kid/Mash*, *The Cowboys*, *The Devils*, *Crucible of Terror* and *Horror Express*: 'I include the titles to show you that they were not lots of tries at the same job, but separate creative concepts.' The remainder of the letter is a terse explanation of the way he and Youngs were then working: 'As you know, a quad poster comprises Finished Colour Artwork – usually multiple figures – and between fifty and one hundred words letraset (cheaper and quicker than photosetting) [...] All these jobs met their almost impossible deadlines: we have had no complaints about timing, and as you know, film ads have to be both right, and on time. [...] Many jobs are given to us after 5.30 p.m. Ray is available lunchtime and between 5.30 and 7.00 p.m. – sometimes later for the last minute briefs [...] we both regularly work till about three in the morning. I think our good performance over the last two months has been largely due to our temporary room, which though cramped, is quiet, and the natural light adequate – our previous room was noisy. [...] Ray and I make up any time necessary by under-booking overtime, and charging low rates for freelance.'

82 Ray Youngs's comment was: 'We used to joke that if Chan wanted a reference of a hand or foot he would get two girls to strip naked'.

83 Interviews with Jaqui and Louise Chantrell, July 2001–June 2003.

84 Vic Fair at Downton's was simultaneously engaged in a similar private joke between himself and Eric Pulford on titles like *Vampire Circus* from 1972. However, the similarity between the two men ends there. Chantrell was notoriously reluctant to watch any of the films he was paid to illustrate, considering this a complete waste of time, whereas Fair expresses bemusement at the very idea of a poster designer who would not want to see the film first. Interview with Vic Fair, May 2003.

85 *Starlog*, no. 18, December 1978.

86 The quad for the sequel, *The Empire Strikes Back* (1980), adapted US artwork by Tom Jung; while *Return of the Jedi* (1983) again employed an original British design, courtesy of Eddie Paul and Josh Kirby.

87 Interview with Stan Heudebourck, September 2001.

88 Interview with Dave Sands, October 2002.

89 Beauvais recalls the disdain Allardyce's managers had for the reprobates at Screen House: 'One of the top men was showing some commercial clients around the offices one day, and he sort of gingerly poked his head round our studio door, and said, "This is what we like to think of as the – ahem – engine room of the operation", and the implication was very much, "You'd better not go in there – they haven't been fed yet."'

90 In addition to Chantrell and Beauvais's work, many of the firm's later video sleeves were done by airbrush artist Keith Fowles.

91 Interview with Eric Pulford, Alma Pulford and Jan Styles, May 2003.

92 Pulford's daughter, Jan, recalls that he 'never changed his waterpots, and was constantly licking his brushes – it's a wonder he never poisoned himself!' Ibid.

93 Colin Holloway remembers that the 'finished illustrations, which were presented as they would be printed with the title and main stars' names in full colour, were always covered with a thick clear-acetate sheet as protection against Sir John, who had the bad habit of scribbling corrections directly onto the artwork!' Interview with Colin Holloway, May 2003.

94 Posters by other illustrators sometimes carry a generic credit for 'Pulford Publicity'.

95 Interview with Marjorie Stockle, May 2003.

96 Notes dated June 1997, in the possession of Marjorie Stockle.

97 Ibid.

98 Stockle kept few of his artworks and posters: his Disney quads were given away over the years to family friends, and when a short magazine article about his work was written in 1989, he gave 'about 90 per cent' of his remaining collection to its writer, eventually receiving less than half back several years later for the Forty Hall exhibition.

99 Occasions where his roughs were used as finished artwork include *Castaway* (1986) – at first given to Brian Bysouth, who eventually admitted defeat when he failed to recapture the original layout's delicate ambivalence of an island that is also a woman's face – *The Last Emperor* and *Silver Bullet*, an obscure werewolf thriller that happened to be one of the very last posters printed by Lonsdale & Bartholomew in Nottingham.

100 Fair also has the distinction of having one of his designs rejected by a Watch Committee in Wales – *Confessions of a Driving Instructor* (1976), in which the heroine has inadvertently grabbed Robin Askwith's personal gear stick. Castell (1977).

101 He added: 'But as any genius will tell you, it is in fact not without effort. I would sometimes see the newspaper that Vic had brought with him on the train while commuting to work [from Buckhurst Hill, where Fair lived throughout his time at Downton's], and it would frequently have design ideas drawn down the margins, and in any blank spaces available.' Interview with John Raymer, May 2003.

102 At this stage, he was also running an entrepreneurial sideline dealing antique furniture from a Saturday stall on Camden Passage, inherited from Vic Fair's wife Kate. Interview with Brian Bysouth, May 2003.

103 Interview with Fred Atkins, May 2003.

104 He was later commissioned to produce a portrait of Churchill using the technique, for the credits of the television series *The Valiant Years* (1960).

105 Interview with Ken Paul, June 2003.

106 Interview with Alan Wheatley, December 2002.

107 Interview with Colin Holloway, May 2003.

108 As a conscientious objector (like Tom Chantrell), Hall had been assigned to the Non-Combatant Corps, spending much of the conflict 'humping Nissen hut parts around' for the Royal Engineers. Demobbed in 1946, he returned briefly to ADS (now on Lupus Street in Pimlico) before spending a couple of months with a recently formed company on Wardour Street producing magazine covers and other commercial assignments. Although more rewarding work, this was not as well paid, and after a couple of months Hall was beginning

Sea Devils (1953). No printer credited. Five-colour hand-cut silkscreen, including a flesh tone for the figures. (AC)

to worry about his bank balance, when out of the blue, he was head-hunted.

109 Interview with Roger Hall, December 2003.

110 Interview with Colin Holloway, May 2003.

111 Group interview with Fred Atkins, Brian Bysouth and Colin Holloway, May 2003.

112 Interview with Michael Bennallack-Hart, May 2003.

113 John Stockle once unwisely confessed to feeling guilty about his time as a fitter during National Service, since one plane he had worked on later crashed with engine failure, killing the pilot. Judd subsequently acquired a pair of airman's flying boots, and got into the habit of dangling them outside Stockle's window from the floor above.

114 Interview with Eric Pulford, Alma Pulford and Jan Styles, May 2003. An alternative version of this story, courtesy of Peter Lee of W. E. Berry, maintains that Rank's publicity head, Charlie Young, had a girlfriend in Milan at the time, and was simply on the lookout for an excuse to go and visit her regularly.

115 Interview with Colin Holloway, May 2003. Favalli's main domestic rival was the BCM agency, formed in 1945 by the great triumvirate of illustrators Anselmo Ballester, Alfredo Capitani and Luigi Martinati, all of whom were active until the mid-1960s, though not on British posters.

116 Interview with Brian Bysouth, May 2003.

117 Interview with Eric Pulford, May 2003.

118 Correspondence with Colin Holloway, June 2003.

119 Ibid.

120 Two younger Italian artists whose work was still occasionally appearing on British quads in the early 1980s are Renato Casaro (b. 1935) and Enzo Sciotti, particularly on imported exploitation films of the period.

121 Interview with Ken Paul, June 2003.

122 Interview with Vic Fair, May 2003.

123 Interview with Colin Holloway, May 2003.

124 Ibid.

125 Interview with Gina Fratini, June 2003. Colin Holloway's description is less flattering: 'Short and stocky, with thick, tight, curly black hair, a Puckish face, and hands like bunches of bananas.' Interview with Colin Holloway, May 2003.

126 Gina tells an anecdote that gives a clear insight into his artistic philosophy: 'When he was studying at the Academy, one of the exercises the students all had to do was draw an egg, from life, first thing every morning, then later show it to the tutor. Well, one morning Renato really couldn't be bothered with this, and just drew an egg from memory on the train, thinking it looked perfect anyway. But when he tried to show it in class he was immediately pounced on – the teacher simply said, "That isn't a real egg – you've just made it up." And Renato always maintained this taught him that you can't cheat at art – it has to be honest, or it doesn't work properly.'

The Colossus of New York (1958). No printer credited. Four-colour hand-cut silkscreen. (AC)

127 Interview with Colin Holloway, May 2003.

128 The first Bond film, *Dr No*, opened at the London Pavilion, and its publicity was therefore handled by UK Advertising, who used a simple adaptation of the US one-sheet design by Mitchell Hooks for the quad. Following this smash hit, *From Russia with Love* transferred to the Odeon, Leicester Square, and responsibility for its campaign thus went to Downton's, and their star illustrator Fratini. With *Goldfinger*, things moved up another gear, and the quad was created by Robert Brownjohn (1925–70), the fashionable American graphic designer, who had been in England from 1960 (with the London office of J. Walter Thompson), and had also produced the film's title sequence. From *Thunderball*, up to *The Man with the Golden Gun* (1974), the campaigns were created in America by US artists Frank McCarthy and Robert McGinnis, McCarthy tending to handle the action, and McGinnis the glamour. Over the 1970s, as the films descended into bloated self-parody, the posters became increasingly witless and formulaic, perhaps a low point being reached with Bill Gold's design on *For Your Eyes Only* (1981), which featured a distant Roger Moore framed between the tanned thighs of a crossbow-wielding villainness. When this quad first appeared on London's Underground, enraged feminists plastered it with stickers labelled 'Sexist Crap!'. The last poster in the series to feature painted artwork was Brian

Bysouth's *Living Daylights* (1987), and following a startlingly clumsy photomontage for *Licence to Kill* (1989), the films have recently settled for identikit computer-assembled comps.

129 Interview with Fred Atkins, May 2003.

130 *Look-In* Annual, London: IPC, 1975.

131 *Image*, Summer 1973.

132 Unused layouts for *Xanadu* and *Jaguar Lives* exist, but his final printed artwork may well have been *The Sea Wolves* in 1980.

133 Interview with Arnaldo Putzu.

134 Interview with several ex-Downton staff, May 2003.

135 Interview with Fred Atkins, May 2003.

136 Ibid.

137 In fact, Kirby's only three subsequently admitted influences were Bosch, Bruegel and British poster artist Frank Brangwyn. David Langford, 'Obituary: Josh Kirby', *The Independent*, 5 November 2001.

138 Interview with Ken Paul, June 2003.

139 Interview with Mike Bell, June 2003.

140 Interview and correspondence with John Raymer, May 2003.

141 Raymer worked closely with creative designer Bob Berkoff, who did finished poster artwork for Charrington's Beers and other brands, and also Keith Grundon, 'a trailblazer of a creative man in his day, and a tremendously hard worker who went on to be group head with a team of designers under him'. Major accounts Raymer worked on included Australian Foods & Wines, Crosse & Blackwell, GEC and Carreras Tobacco.

142 Colin Holloway recalls that a few of the publicity managers who dealt with Downton's had good design ideas of their own to suggest, particularly George Skinner of Avco-Embassy and Charlie Berman of United Artists.

143 Correspondence with John Raymer, May 2003.

144 Writing to CIC chief Fred Sill in a letter dated 6 December 1976, Don Siegel himself commented: 'The posters are much, much better than anything we had in America. The truth of the matter is that your people are more intelligent and more with it than your counterparts over here'

145 Interview with Brian Sanders, June 2003.

146 Interview with Cecil Vieweg, June 2003.

147 Interview with John Raymer, May 2003.

148 Interview with Nancy Atwood, November 2003.

149 Interview with Mike Francis, October 2003.

150 He also painted some independent-label covers for distributor David Morlings: 'Real cheap stuff – I'd be given a copy of the video to watch at home and take my own reference photos straight off the TV. If the basic layout wasn't exciting enough, I'd just put in an explosion or something to perk it up a bit.' Ibid.

151 Interview with Ivan Rose, November 2003.

152 Interview with Tony Tenser, May 2003.

153 Interview and correspondence with Sam Peffer, November 2002.

154 American 'second rights' illustrations could be picked up for between £17 and £20 each, less than a third of what the publishers would have had to pay a British artist.

155 Interview with Marcus Silversides, April 2003.

156 Interview with Graham Humphreys, June 2003.

157 *Nottingham Journal*, May 1951.

158 The sale price was £328,000 (about £4.2 million in today's terms), with Stafford at the time declaring annual profits of around £60,000 (£780,000 today). According to a report in the *Gedling Journal* (November 1961): 'Employing 160 people, Staffords specialise in Colour Printing, with litho offset and letterpress work, mainly for cinema posters and railway material.'

The Space Children (1958). No printer credited. Four-colour hand-cut silkscreen. (AC)

159 In 1855, French chemist Louis Poitevin invented the basic technique of photolithography, in which a printing plate coated with bichromated gelatin (a light-sensitive solution) is exposed through a 'mask' – i.e. a high-contrast photographic negative – to harden the coating in the image areas, and leave the remainder as a removable liquid. In a printing press, the inked photographic image on the plate could then be transferred onto paper as normal, though this was initially limited to solid-tone black-on-white. In 1885, Frederick Ives of Philadelphia developed the first commercially viable 'halftone' crossline screen, essentially two closely ruled glass sheets cemented

together so that their lines crossed at right-angles, forming a very fine grid. When an image was photographed through this screen, the grid broke it up into a pattern of tiny different-sized dots, giving the illusion of continuous tone.

The final stage in this particular chain of innovation was the three-colour (trichromatic) halftone process, developed in 1893 by William Kurtz of New York. This provided the necessary colour separations mechanically via a sequence of three tinted light-filters placed in front of the camera lens. The resulting 'halftone separations' when overprinted in their respective ink colours would then exactly re-create the original full-colour image. However, coating the printing plates was a messy and laborious business, and as bichromated gelatin had only a very short shelf-life, preparing the plates in advance or storing them for a long time after use was out of the question. Additionally, overall results using the traditional 'direct' method of reproduction, from the plate straight onto the paper, were never really very satisfactory. Then, in 1904, an American printer from New Jersey named Ira Rubel accidentally discovered 'offset lithography', following a chance misfeed on his press: an image inadvertently first transferred from the printing plate onto the rubber blanket of his machine's impression cylinder would then reproduce a much sharper, clearer picture on paper than one simply transferred directly from the metal plate itself. Offset lithography had several distinct advantages over its predecessor: it featured a much better transference of ink, thus producing finer images; it protected the original plate from wear, allowing far larger print runs; and – as the image was now reversed twice, onto the blanket, then back onto the paper – it meant that printing plates could be prepared 'right way round' for the first time. The first purpose-built offset press was constructed in London in 1906 by George Mann. Diazonium-resin coatings, or 'diazos', were first patented in 1950 by German chemist Otto Suess of the Kalle company. Diazo coatings were considerably more stable than bichromated gelatin, and could be stored long term, which quickly led to the manufacture of smaller 'presensitised' aluminium plates, and crucially also meant that in-house preparation of the larger sizes was now a cost-effective possibility for the poster printers. See Simmons (1980).

160 Interview with Peter Lee, March 2005.
161 Distinguishing 'direct' (or hand-drawn) from 'offset' (or photographic) posters can be done quite easily, by simply closely examining the image itself. Under a magnifying glass (or a very close-up squint) either the grain of the lithographer's crayon (for direct) or the distinctive 'rosette' dot patterns making up the image (for offset) becomes visible.

162 A second takeover occurred in 1975, when L&B were bought by English Grains Ltd, a holding company that otherwise chiefly ran pharmaceutical businesses.

163 Interviews with Peter Lee, April 2002–March 2005.

164 Quoted in Edwards (1985).

165 Interview with Peter Lee, March 2005.

166 Ibid.

167 Quoted in Edwards (1985).

168 Film posters had always been printed on sheet-fed printers, whereas web-offset used huge rolls of paper that fed through the press continually, as in newspaper production.

169 The administrators initially continued to run it as a going concern with the aim of finding a buyer, but the harsh reality was that the site was worth about £4 million as an industrial property, and upwards of £20 million as a potential commercial development. In February 2004, the works' closure was announced and it was reported that the company's presses had been sold to a New Zealand printer. At the time of writing, it seems inevitable that the empty ten-acre works site will be sold for redevelopment.

170 Interview with Pida Ripley, October 2002.

171 The original company, Leonard Ripley & Co. Ltd, was finally dissolved in August 1994. Mills & Allen Printing, however, effectively took over where Ripley's left off. Following Kennington Lane's closure in 1983, M&A opened a new works on Horton Road, Yiewsley, just north of Heathrow airport. In August 1993, the

Black Sabbath (1963). No printer credited. A photographic silkscreen. The black screen carries the 'Base Art', in this case taken from the US campaign by Reynold Brown. Underneath this are highlighting patches of Day-Glo pink and green, almost certainly the work of Tom Chantrell. (AC)

company changed its name to Kingsway Press, and is now the country's biggest specialist poster printer, being one of NSS's two chief contemporary suppliers; the other, Capital Print & Display, were not established until 1980, opening their main works on Cooks Road, off Stratford High Street E15, in 1988. Interview with Graham Rowsell, February 2003.

172 Interview with Alan Broomhead, October 2002.

173 Another firm printing for Rank in the same period was W. F. Clifford of Manor Road N15, who were responsible for a handful of quads that in 1958 included Hammer's *Dracula*.

174 Berry's Peter Lee recalls that if he was in London on business, and unable to find a cheap last-minute hotel for the night, he could always rely on 'kipping on Harry Price's old sofa at 19 Beak Street'. Interview with Peter Lee, March 2005.

175 Ibid.

176 Interview with Ian Hedger, October 2002.

177 <www.kap.co.uk>

178 It was a fairly laborious and time-consuming process, taking about two hours to create the stencil, and the delicate task of lowering the big 'film positives' evenly into the developing trays was 'always a two-man job'. There were five basic stages to making a stencil:
(1) Photograph the base artwork and all subsequent overlays (colour separations) to create the negatives.
(2) 'Spot out' the negatives with 'photo opaque'.
(3) Back-project each negative onto unexposed lithographic film, to create the full-size 60" x 40" positives.
(4) Develop these positives in a darkroom – an extremely tricky operation.
(5) Expose the positives with a photo-stencil material in a large contact frame. As Witherden explains: 'Once exposed, the photo-stencil was fixed to the underside of a pre-stretched silk (natural or synthetic, depending on quality and durability), the soft gelatine layer melting into the screen when washed with a warm water spray, which dissolved away the image area that would eventually allow ink to pass through the silk. Care had to be taken when washing, as sufficient pressure was required to remove the stencil, but too much pressure could start removing the non-image areas as well. The frame holding the silk and stencil was then left to dry for what seemed like a long time – maybe several hours – and before printing, the clear backing sheet was removed, and any unwanted image areas blocked up with filler.' Interview with Dave Witherden, December 2002.

179 Interview with Ron Lawrence, February 2003.

180 Quoted in *Screen and Digital Printer*, no. 13, May 2001.

181 Interview with Peter Rosen, December 2002.

182 <www.bovince.com>

183 Interview with Derek Broomhead, June 2003.

184 Interview with Alan Broomhead, October 2002.

185 On another occasion, a different company had received some artwork Broomhead had already successfully printed, and rang Alan to ask how he had achieved such good results – they had tried scanning it in 'horizontally, vertically, every which way, but couldn't get anything like our quality'. In fact, Alan had laboriously hand-drawn a lot of the crucial detail directly onto the plates himself. Ibid.

186 Print runs on the company's quads were pretty consistent, with Alan Broomhead reckoning on an average of between 1,000 and 2,000 copies throughout. This is supported by Sam Peffer's original artwork for *Lemon Popsicle*, which has '2,000 copies' handwritten in pencil on its corner, probably by Alan Wheatley.

187 Laserscan's repro business took off in the 1990s, and at one stage Alan Broomhead was employing up to seventeen staff, printing travel brochures and similar material. <www.laserscan.co.uk>

188 Schapiro (1979).

189 Interview with Brian McIlmail, May 2002.

190 The connection with Hammer was renewed in the 1970s when Sir James Carreras became one of the directors of NSS.

191 Interview with Ian Hedger, October 2002.

192 Interview with Brian McIlmail, May 2002.

193 Ibid.

194 The story is that, after watching her blockbusting trailer for *Zulu* in November 1963, Stanley Baker was so excited that he leaped right out of his viewing theatre seat, and yelled to director Cy Endfield, 'Is that our film Cy? Is that our film?!'

195 Interview with Ian Hedger, October 2002.

196 Interview with Brian McIlmail, May 2002. Rebel closed in 1985, and the owners, Mervyn and Dawn Collard, offered all the company's remaining paper publicity for sale as a job lot, via a classified advert in a film magazine. This was answered by well-known Nottinghamshire dealers Dave and Patrick Cutts, who turned up to find hundreds of posters 'literally rotting away in a shed'.

197 Ibid.

198 Ibid.

199 Kerekes (2000).

200 Videocassettes were only declared an 'article' under the terms of the Obscene Publications Act in a test case during the summer of 1980, and for a few years nobody was quite certain where the boundaries might lie.

201 Quoted in Kerekes (2000).

202 Ibid.

203 Bryce (1998).

204 Kerekes (2000).

205 Kobal (1973).

206 Edwards (1985).

207 Lumgair (2000).

208 Ibid.

209 Interview with Ian Hedger, October 2002.

210 Interview with Brian McIlmail, May 2002.

211 Interview with Mike Cohen, March 2003.

212 Quoted in Chibnall (1991).

213 Interview with Brian Bysouth, May 2003.

214 Interview with Marcus Silversides, April 2003. Fred Atkins (interviewed May 2003) thinks that Columbia was the first of Feref's clients to issue a similar edict.

215 Interview with Vic Fair, May 2003.

216 Interview with Tom Beauvais, March 2002.

217 *The Blair Witch Project* is a slightly unfair example to pick, partly as it was famously sold principally on word of mouth (or rather word of 'mouse', i.e. internet), and partly as its celebrated poster happens to be a considerable cut above most of its contemporaries, with its economical but haunting imagery, and defiantly obtuse copy. Despite these qualifications, though, it serves as a clear example of the overall change in style.

Postscript and Conclusion

1 *Guardian Weekend*, 10 November 2001.

2 Interview with Marilyn O'Neons, March 2002.

3 Interview with Philip Nevitsky, March 2002.

4 Interview with Teddy Green, March 2002.

5 Interview with Fred Zentner, May 2002.

6 Interview with Pida Ripley, October 2002.

7 A number of private cinema memorabilia archives have been built up in Britain since the 1970s. Some, like those belonging to the historian of popular culture Dennis Gifford and the film distributor and writer John Huntley, have now been dispersed. The largest remaining collection is that of Ronald Grant, currently housed in his Cinema Museum (a registered charity) in south London.

8 Interview with Greg Edwards, March 2002.

9 One story that made most national papers in March 2003 concerned a scarce US six-sheet for *The Outlaw* (1943), auctioned at Christie's in London for £52,875. The American vendors had allegedly 'destroyed' a second duplicate copy to increase the value of the sale poster, a somewhat unlikely decision that must have raised eyebrows even among the uninitiated.

10 Chibnall (1991).

11 Tony Augarde (ed.), *Oxford Dictionary of Modern Quotations*, Oxford: Oxford University Press, 1991

Cauldron of Blood (1971). Printed by Progressive Publicity. An excellent late example of a basic two-colour hand-cut silkscreen. (AC)

INDEX